ART LIBRARIES AND INFORMATION SERVICES
Development, Organization, and Management

A list of books in this series is available from the publisher on request.

ART LIBRARIES AND INFORMATION SERVICES

Development, Organization, and Management

Lois Swan Jones

Department of Art
North Texas State University
Denton, Texas

Sarah Scott Gibson

School of Information and Library Science
Case Western Reserve University
Cleveland, Ohio

1986

ACADEMIC PRESS, INC.
Harcourt Brace Jovanovich, Publishers

Orlando San Diego New York Austin
London Montreal Sydney Tokyo Toronto

ACADEMIC PRESS, INC.
Orlando, Florida 32887

United Kingdom Edition published by
ACADEMIC PRESS INC. (LONDON) LTD.
24–28 Oval Road, London NW1 7DX

Library of Congress Cataloging in Publication Data

Jones, Lois Swan.
 Art libraries and information services.

 (Library and information science)
 Includes indexes.
 1. Art libraries--Administration. 2. Art--Information
services--Management. I. Gibson, Sarah Scott.
II. Title. III. Series.
Z675.A85J66 1986 026.7 85-28598
ISBN 0−12−389170−1 (alk. paper)

PRINTED IN THE UNITED STATES OF AMERICA

86 87 88 89 9 8 7 6 5 4 3 2 1

Contents

PART V
Appendices

List of Examples

Foreword

Art librarianship has come a very long way since 1908 when Jane Wright, librarian of the Cincinnati Art Museum, wrote to the editor of *Public Libraries*: "The art library so far has been little known or appreciated, and has existed mainly for the use of museums and a few students. . . It is so far a comparatively new field for the trained librarian. . . and the success of any art library today is almost an individual success ("Plea of the Art Librarian," *Public Libraries* [1908]: 348–49). Wright would scarcely recognize her profession today. Working to keep pace with an increasingly technological society and with the many aspects of the cultural explosion of the past few decades, the art library has found itself in a strategic position to meet the rising expectations for increased resources and services from an expanding and varied public. Contributing to this challenge have been events such as the rapid expansion of art publishing on an international scale, the development of art studies in educational institutions and continuing education programs, the steady growth in the number of art museums and museum programs, and the application of computer technology in art libraries. In this period of change and expansion, art librarianship has been aided by activities in three principal areas: (1) the professional training of art librarians and visual resources personnel through an increasingly varied and growing number of graduate courses, seminars, workshops, and internships; (2) active professional organizations, such as ARLIS/NA (Art Libraries Society of North America), the Art Libraries Society of the United Kingdom, and the Visual Resources Association; and (3) a growing body of professional literature written primarily for the art librarian and others working and researching in the arts.

Ever since the publication of Mary Chamberlin's pioneering *Guide to Art Reference Books* in 1959, the professional literature has steadily increased. Art bibliographies and guides to reference works, serials, and key works documenting the history of art have dominated the published writings. *Art Library Manual: A Guide to Resources and Practice,* edited by Philip Pacey (1977), was written from the British point of view and focused on different types of library materials. In 1980, Chamberlin's book was updated and augmented by Etta Arntzen and Robert Rainwater's *Guide to the Literature of Art History.* A unique and major contribution to the literature was Lois Swan Jones's *Art Research Methods and Resources* (2nd ed., 1984), which

provided for the first time a systematic guide to methodology and problem-solving in basic art research. The organization of visual resources also received its share of attention with the publication of such books as Betty Jo Irvine's *Slide Librarianship: A Guide to Academic Institutions* (2nd ed., 1979) and *Picture Librarianship*, edited by Helen P. Harrison (1981). In recent years many important articles on developments in art libraries have appeared regularly in the periodical literature, chiefly *Art Documentation, ARLIS/NA Occasional Papers,* the *ARLIS/NA Newsletter*, its British counterpart *The Art Libraries Journal,* and the *International Bulletin for Photographic Documentation of the Visual Arts.*

But not until the publication of this book, *Art Libraries and Information Services: Development, Organization, and Management*, has there been a single source explaining how art libraries operate and what policies and principles govern their activities. The authors, Lois Swan Jones and Sarah Scott Gibson, recognized the need for such a book—one that would be useful to students as well as staff librarians, administrators, researchers, and all others who need to know about art libraries and the policies and administrative procedures which govern them.

The authors have brought a wide range of professional skills to their task. Jones, professor of art history and coordinator of that program at North Texas State University, has published widely, especially on museum education, and is well known for the aforementioned *Art Research Methods and Resources.* As the teacher of the Art Bibliography Seminar as well as a variety of graduate courses, her knowledge of research methodology and retrieval of library information is extensive; as a member of the Advisory Board of the NTSU Library and the Library Chairperson of the Art Department, she has an understanding of library administration and collection development. Gibson, professor of library science at the Matthew A. Baxter School of Library and Information Science, Case Western Reserve University, teaches art librarianship, collection development, and cataloging among her many courses. The practical aspects of librarianship are well known to this scholar who worked for 15 years in an academic library. Included in her writings are two excellent articles: "Humanist and Secular Iconography, 16th to 18th Centuries" (*Special Libraries,* July 1981) and "The Past as Prologue: The Evolution of Art Librarianship" (*Drexel Library Quarterly,* Summer 1983). Both authors are active in a wide range of professional associations and have had the opportunity to study the many issues confronting art libraries today.

During the 5 years of research in preparation for the writing of this book, the authors examined a wide range of library policies and procedures, visited art libraries and visual resource collections of all kinds, consulted with scores of professionals, and talked with publishers and vendors of databases and

computer-based hardware and software. That Gibson and Jones diligently searched the professional literature is clear from the extensive and detailed notes, which provide an exceptionally varied and rich source of information on art librarianship. The book is made additionally useful by the inclusion of examples and charts on such topics as a database search strategy, a subject analysis of the art and art-related databases, a film/video evaluation form, an iconographical research problem, and cataloging entries for monographs and serials. The appendix further enriches the contents with such items as an extensive list of acronyms and abbreviations, the names and addresses of professional organizations which are related to art, excerpts from *The Libraries of Stanford University Collection Development Policy Statement,* a selection from the *Fine Arts Pavilion Library Building Program, Indiana University*, and a section on the Thomas J. Watson Library published in an annual report of The Metropolitan Museum of Art.

The body of the text is divided into four main parts: art libraries as information centers, the library collection, information services, and collection development and management. Jones and Gibson have offered an excellent overview of the art library today and have combined with it an accumulation of practical details on how libraries function on their many different levels. In this time of great technological change and the challenge to libraries to widen their dimensions in resources and services to a growing and diverse clientele, this book will prove to be of immense value. It fills a long-felt need.

<div style="text-align: right">

CAROLINE BACKLAND

National Gallery of Art

</div>

Preface

Art librarianship exists as the union of two disciplines: the fine arts and library and information science. As in any good merger, both are important. The day has long passed when a librarian can be involved only in purchasing books and serials and arranging them on shelves. Today's librarian must be an information specialist, with all that implies: substantive knowledge of the art discipline—its literature and all of its manifestations—skill in developing as well as utilizing computerized systems and programs, and familiarity with the art, book, serials, and visual resources markets.

Art librarianship is a relatively new profession. Over the past few decades, a number of people, working with some of the finest art collections in the world, pioneered the field. The expertise which they so generously shared through their publications has made art librarianship a profession, not only of today, but for the future. Although important material is available if one consults numerous monographs and journal articles, there is no single publication that adequately aids librarians and researchers in learning how to assemble, evaluate, and administer art library collections.

Art Libraries and Information Services was written to assist persons responsible for art libraries in developing, organizing, servicing, and managing this type of institution. This book was compiled for (1) those who have recently begun such duties, (2) librarians who wish to supplement the education of their staffs, (3) library students who desire to specialize in the discipline of art, (4) librarians who want to be apprised of some of the more recent literature in their field, and (5) professors, researchers, dealers, and free-lance information brokers who need to know how an art library is administered.

Because there are a number of different kinds of art libraries which serve the needs of various types of patrons, Chapter 1 discusses these libraries and their clientele as well as art librarianship as a profession. Due to the importance of computerization to the art discipline, Chapter 2 is devoted to an overview of this essential technology, which is discussed in more detail in the appropriate later chapters. These two chapters make up "Part I: Art Libraries as Information Centers."

Since it is the material in the art library as well as the clientele that makes it special, Part II is on "The Library Collection." Chapter 3 discusses methods for evaluating the collection, various user studies, and the core art

bibliographies which were accepted as authoritative works and published by the Art Libraries Society of North America (ARLIS/NA) in *Collection Development Standards.* The core is referred to throughout this book. Chapters 4–9 are concerned with aspects of the art library collection: reference works, monographs, catalogs and trade literature, art serials, visual resources—slides, videodiscs, films/videos, and picture collections—and special formats and collections, such as microforms, vertical files, archives, artists' books, and rare books, as well as building and decorative arts samples. The discussions of these resources emphasize the special problems that the works create as to selection, acquisition, or organization.

One of the most important responsibilities of an art librarian is the retrieval of information. Part III delineates various types of reference services: disseminating data requested by patrons; compiling bibliographic guides; providing courses, workshops, and demonstrations; utilizing online bibliographic databases; and obtaining material from external sources through interlibrary loans and networking. Part IV on collection development and library management consists of four chapters which discuss collection development and acquisitions, cataloging and preservation, management and budgets, and personnel and the physical environment. Throughout the book, references or annotated footnotes to significant literature of the profession are included at the end of each chapter. These extensive notes contain complete publication information for the material cited.

To facilitate understanding the many facets of an art collection, charts and examples that specifically relate to an art library have been included in the appropriate chapters. Two charts provide (1) a comparison of data located on a specific subject in some of the abstracting/indexing services and (2) the various online bibliographic databases that would interest art researchers, accompanied by the types of materials which they incorporate. There are examples for such items as considerations prior to purchasing computer hardware and software, a film/video evaluation form, an art indices and art periodicals guide, an interior-design browsing guide, a hagiographical research problem, the *Art Literature International (RILA) Database* blue sheet from DIALOG, on online database search worksheet, and bibliographic records for a monograph and serial. The appendices consist of (1) a list of acronyms, (2) the names and addresses of database vendors, (3) professional associations of interest to art disciplines, (4) an excerpt from a collection development policy statement, (5) the art library section from the annual report of a museum, and (6) a selection from a building-program profile. There are three indices: to authors, to books, and to subjects.

Differing markedly from other types of libraries with special collections, an art library contains a breadth of subjects covering a vast chronological span—from prehistoric times to the present. This truly international literature

is written in a multiplicity of languages and is enormously dependent upon all kinds of illustrative material. Produced by a wide range of publishers—from large commercial firms to small art galleries—a diversity of forms must be accommodated: books, catalogs, periodicals, slides, photographs, films/videos, and microforms. Not only does art literature become obsolete slowly, but the field is complicated by the problems of exhibition and auction catalogs, monographs on artists—such as catalogues *raisonnés* and *oeuvres* catalogs—*Festschriften,* iconographical and interdisciplinary references, trade literature, ephemera, and special collections. The art field is constantly changing and expanding with objects from recently discovered civilizations and cultures, or with new art forms, such as video and conceptual art. In addition, art patrons are as diverse as the materials they require.

In the future, the sphere of art librarianship activities may be expected to enlarge. The quality of service rendered to date has been of a sufficiently high order to raise users' expectations. The art librarian will increasingly need to be familiar with the most up-to-date information retrieval techniques, which demand both subject knowledge and technological expertise. More sophisticated management skills and methods of collection development will be required to make the best possible use of resources.

Prognostication is a risky enterprise. But, extrapolating from past and present, it seems safe to say that since a specialized clientele requiring the services and resources of the art library has arisen, these libraries will continue to be called upon to fulfill a vital function. No volume can give an adequate indication of the variety, challenge, satisfaction, and sheer enjoyment of working in an art library; however, it is hoped that this book will be a useful introduction to the task.

Acknowledgments

This volume could not have been written without the generous assistance of many individuals. Our greatest debt is to those who gave their time, encouragement, and expert advice by reading and commenting upon various chapters. For this our deepest thanks go to Caroline Backlund, National Gallery of Art Library, Washington, D.C.; Dr. Betty Jo Irvine, Fine Arts Library, Indiana University; Nancy Allen, Museum of Fine Arts Library, Boston; Jeffrey L. Horrell, Sherman Art Library, Dartmouth College; Margaret Culbertson, University of Houston Libraries; Christine Rom, Cleveland Institute of Art Library; Susan Wyngaard, Fine Arts Library, Ohio State University; Miranda Pao, Case Western Reserve University, Cleveland; D. Sherman Clarke, Olin Library, Cornell University; Ruta Butkus Marino, Cleveland Museum of Art Library; Jack Perry Brown, Art Institute of Chicago; and Johnnye Louise Cope, North Texas State University.

For this book, research was done at a number of kinds of art libraries. Valuable assistance was given by the art librarians with whom we discussed the work during the course of visiting these institutions. To all of them go our warmest thanks: William B. Walker, Patricia J. Barnett, and Kathryn Deiss of the Metropolitan Museum of Art; Clive Phillpot, Museum of Modern Art; Georgina Gy Toth, Cleveland Museum of Art Library; Angela Giral, Christina G. Huemer, and William O'Malley of the Avery Library, Columbia University; Evelyn K. Samuel, Institute of Fine Arts, New York City; Katharine Martinez, Cooper–Hewitt Museum Library; Frances C. Gretes, Skidmore Owings Merrill Library; Roz Narbutas, Sotheby's Library; Stephen Grove, Holzheimer's Interiors, Cleveland; Gerbrand Kotting, Rijksbureau voor Kunsthistorische Documentatie, Den Haag, The Netherlands; Janice Chadbourne, Boston Public Library; E. Jean Smith, Pennsylvania State University Library; Elizabeth W. Harter, George Washington University Library; Alice Loranth, Fine Arts and Special Collections, Cleveland Public Library; Diane Disantis, Cuyahoga County Library, Cleveland; Donna E. Rhein, Dallas Museum of Art Library; and Milan R. Hughston, Amon Carter Museum.

Many other friends and colleagues also gave us invaluable and much appreciated suggestions and assistance, particularly Susan Craig, University of Kansas Art Library; Dr. Karen Markey, OCLC, Inc.; Alexander Ross,

Art and Architecture Library, Stanford University; Toni Petersen, Art & Architecture Thesaurus, Bennington College; and Dr. Wolfgang Freitag, Fine Arts Library, Fogg Art Museum, Harvard University. In addition, we thank those who expertly typed a number of drafts—Jean Ross, Angela Welsh, and Laura Watt—as well as the IBM Personal Computer, affectionately named Hal, which worked overtime to assist us.

In looking back over the years during which this book has been in preparation, it is the pleasant memories that remain with us, most especially the opportunity afforded us to meet, talk with, and learn from so many delightful, kind, and knowledgeable art librarians.

Part I

ART LIBRARIES AS INFORMATION CENTERS

There are various kinds of art libraries which have different functions, users, and collection needs. This part will delineate the types of patrons and kinds of libraries that serve them as well as discuss the development of the art librarianship profession. In addition, because the advent of the computer has revolutionized the ability of librarians to respond to their clientele, making art libraries truly information centers, this technology has been given special treatment in Chapter 2.

1

Art Libraries and Librarians

INTRODUCTION

Art librarianship developed in response to the growth of a specialized clientele which was originally composed of connoisseurs, collectors, curators, members of art academies, and art historians.[1] With the emergence of connoisseurship and the coming-of-age of art history as an academic discipline, the search for information inevitably led to the creation of new, specialized resources. The most important development for the study of art was the invention of photography, which rapidly supplanted reproductive engravings as the visual record of works of art and which greatly enlarged the range of images available to researchers. By the end of the 19th century, an important body of monographic and serial literature had also emerged.

Following the opening to the public in 1793 of the Musée National du Louvre, the first great museum devoted primarily to the arts, major public and private museums and galleries were established in Europe and North America. Generally, European museums were organized under government auspices, while those in North America more often resulted from the impetus of private collectors, enterprising civic amateurs, or learned societies. With the museums, small libraries were often established. For instance, the Trustees of the Boston Museum of Fine Arts appropriated the sum of $1000 in 1875 for a reference library. In 1880 the founders of the Metropolitan Museum

of Art, New York City, made similar provisions for the establishment of a library to serve their institutions.[2]

Libraries were also attached to art schools and institutes. The great collection of the Ryerson and Burnham Libraries of the Art Institute of Chicago began as a shelf of books in the director's office. In a similar manner, the incomparable library of the Victoria and Albert Museum, London, was originally a small reference library for the School of Design in Ornamental Art, founded in 1837. During the 19th century, there was concern for the degradation of design in the arts and crafts in both Great Britain and North America. The burden of supplying cultural uplift, especially in the United States, fell on the public library, which was expected to exert a refining influence on its patrons. Viewed from this perspective, the development of programs became as important as the dissemination of information. The growth of Canadian libraries has followed a different path; they have been primarily regional and devoted to the documentation of local art and artists.

The 20th century witnessed a universal broadening of interest in the visual arts. In the United States, this took the form of a rise in commercial art sales, the expansion of gallery and museum educational programs, the flourishing of local and regional art associations, and the attraction of government support for the arts at all levels. Art libraries expanded as the amount of published material proliferated and the number of patrons seeking it increased. With the emergence of a clientele requiring distinct services, the specialty of art librarianship developed.

The formal appearance of art history as a discipline is variously dated, but the publication in 1764 of Johann Joachim Winckelmann's *Geschichte der Kunst des Altertums* and the establishment in 1844 of a Chair for the Study of Art History at the University of Berlin are considered to be landmark events. Wolfgang Freitag has pointed out that the principal forms of art historical literature—that is, biography, topographic monographs, and handbooks for collectors—had already appeared in classical times.[3] In the 15th century, two new types were introduced with the publication of Lorenzo Ghiberti's *Commentarii*, a general historical treatment of Italian art, and Leone Battista Alberti's *De Re Aedificatoria*, a theoretical work. The first extant auction sales catalog dates from the 17th century, as does the first journal literature. The 19th century witnessed the beginning of systematic inventories of the great museums as well as the multiplication of publications in the genres already established. During the 20th century, other important kinds of literature developed. Collection and exhibition catalogs became essential to art research. The appearance of abstracts and indices, such as *Répertoire d'art et d'archéologie* in 1910 and *Art Index* in 1930, is evidence of a distinct art discipline. Recently, the availability of microforms and other

new audio-visual media as well as the computer has widened the potential resources of the art library.

Although initially the art library came into being in response to the needs of art historians, collectors, and museum curators, over the years this constituency has expanded to include many kinds of art patrons. Paralleling this expansion has been the development of specialized art libraries—academic, museum, public, and business. This chapter discusses (1) types of art patrons, (2) kinds of art libraries, and (3) the development of art librarianship as a profession.

THE ART PATRON

Art encompasses many facets: the making of aesthetic objects plus the appreciation, understanding, and history of art. Each of these areas impinges on the other; each has a substantial literature of its own. Each has its practitioners, students, and teachers. Before the library's mission to provide its patrons with information can be accomplished, the nature of these users and their needs must be clearly identified. To aid in this process, librarians will need to develop profiles of their specific users, which will obviously vary from institution to institution and according to the user's position on the educational spectrum—student, teacher, professional, and interested layman. It is also important to remember that the patrons and their needs will change over time.

Art historians are some of the major users of the art library.[4] Needing the widest range of materials—as well as covering the greatest time span, variety of subjects, and number of languages—these patrons put the heaviest demands on the library budget. Because their work is truly interdisciplinary, they require materials from peripheral fields—such as literature, history, philosophy, religion, economics, theater, and music. The gamut of media runs from printed references to microforms and photographic images to original archival material and works of art. Their special sources include a wide variety of sometimes esoteric serials, exhibition and museum-collection catalogs, auction catalogs, catalogues raisonnés, *Festschriften*, and publications with quality reproductions. For these patrons, it is often necessary to locate and obtain items and sources of information not owned by the institution.

Some researchers in art professions have needs similar to art historians, with slight variations and different emphases. Usually beginning with a specific work of art, museum and gallery curators utilize the same resources, but with special research tools that will assist them in establishing the

provenance of the work, its authenticity, and the location of related pieces. Museum/gallery directors also require business and legal tools which will aid them in the administration of their institutions. Art dealers, auction house experts, and appraisers are primarily interested in the monetary aspects of art. For them, current auction/sales catalogs are essential. These professionals frequently purchase their own research tools and usually turn to the library as a backup system for information. Art/museum educators are especially interested in art appreciation books as well as materials which discuss educational methods and art techniques. Art conservators require tools and data of a more scientific as well as a technical nature. This emerging discipline is developing its own serials, resource tools, and monographic literature. Many conservation laboratories contain a separate reference collection; the art library is used as a secondary source and by the free-lance conservator.

Studio artists are concerned with materials, tools, techniques, and visual images, as well as how to exhibit and market their creations. Although they are infrequent users of the library, when these patrons do come, they often like to browse the collection for ideas. Picture files are of special interest to this group. Unfortunately, studio artists tend to overlook valuable sources, such as the profusion of exhibition catalogs that illustrate current international art. Many of their requirements will be met by references outside of the field of art, such as books on anatomy, gardening, and fashion. A growing concern of this group is the health hazards created by new materials.

Designers—fashion, interior, commercial, and industrial—desire a variety of visual materials, both historical and recent. Their preferred sources are reproductions in serials and pictorial archives which are international in scope. Their preferred method of research is browsing. Important illustrations are available in exhibition catalogs, which are often overlooked by this group. Some designers require specifications and standards. Others need samples of actual materials as well as trade catalogs, both retrospective and current. Information on exhibitions and marketing possibilities must also be obtained.

Practicing architects need many types of references from the fields of design, technology, engineering, historical preservation, and landscape design. Architectural librarians must be especially knowledgeable because they are frequently required to evaluate the literature, to compile specialized bibliographies and abstracts, to make reports on potential clients and sites, and to maintain archival files of past projects. Serials and trade literature are emphasized. Cost guides, standards, technical reports, and government documents, such as enviromental impact studies, must be obtained. Sources of drawings for completed architectural works and resources to assist architects in marketing programs are also important to the collection.

Picture researchers are commissioned to locate reproductions of images suitable for illustrations—such as artistic works, city and landscape views, costumes, and genre scenes.[5] This highly specialized profession demands

visual resources and assistance in copyright restrictions. Artists with advertising firms also require many visual materials—serials, pictorial annuals, and picture files.

An art library may have numerous patrons who not only do not know how to use the library but are uncertain as to what they want. They range from fairly knowledgeable collectors of works of art to someone who has just found an unidentifiable object in grandmother's attic. These patrons may be an elementary school teacher who wants pictures of Egyptians, a history professor who wants to illustrate an article on the French Revolution, a craft amateur who desires how-to books on cutting stained glass, a PTA member who must design costumes for the Columbus Day play, or a chef who is taking up the art of ice sculpture. The public library is the recipient of most of these kinds of patrons.

KINDS OF ART LIBRARIES

All art libraries have many things in common, including a collection of reference tools as well as subject-oriented materials. These libraries vary from the small reference collection in an art gallery to the large and diverse collection of a major art museum. They may be haphazardly arranged and maintained by a part-time non-professional, as is the case of many small business libraries, or they may be well organized and enjoy the services of a professional staff, as in many university or large museum libraries.

There also exist highly specialized collections which can be characterized either by format or by subject area. Thus, for example, there are institutions with large collections of visual resources, such as at the Rijksbureau voor Kunsthistorische Documentatie in the Netherlands, which is not only a picture archive primarily devoted to documenting the art of the Netherlands but also an extensive book and serials collection. Examples of subject-oriented libraries are the Freer Gallery of Art Library in Washington, D.C., which concentrates on Far Eastern art and culture, and the Museum of Modern Art of New York City with its extensive material on contemporary artists. To serve a wide range of users, different kinds of libraries have developed in various settings: colleges and universities, art schools, museums, public institutions, and businesses.[6] The following discussion centers on some of these libraries' patrons, with particular emphasis on their collection and service needs.

Art Division of a College/University Library

A college or university library must meet the teaching and research needs of its professors and students. The scope of the collection will depend upon the number and types of degrees conferred, the various art disciplines taught, the research responsibilities and interests of the individual professors, and

whether or not a gallery or museum forms part of the parent institution. Furthermore, all academic libraries are subject to review under standards imposed by accreditation boards.[7] Many private academic institutions restrict the use of their collections to their own faculty and students. Although restrictions may be placed upon them, alumni, visiting scholars, and graduate students from other universities are often accommodated.

Some college and university art libraries occupy a specially designated area within the main library. Others are housed separately and enjoy a fair degree of autonomy. If this is the case, there is usually some duplication of the materials held in the central library, such as certain reference tools. Even when the art library seems to be relatively autonomous, the librarian may have little or nothing to say about its organization. The classification scheme is dictated by that of the parent body, and valuable supportive materials, which may have been requested by the art librarian, may end up in a different division depending upon their classification. For instance, useful individual titles of a series encompassing several disciplines, such as the *Transactions of the American Philosophical Society*, may be located elsewhere.

In large libraries, tasks are usually separated along functional lines with technical services divided as to acquisitions, cataloging, and classification and with reader service divisions for reference, online bibliographic database searches, and interlibrary loans. The art librarian's responsibilities may be concentrated on collection development and reference service. On the other hand, the material in an academic art library is reinforced by the institution's whole collection that gives access to considerable support and peripheral materials with which the art librarian should also be familiar. Due to budgetary constraints, many university librarians do not obtain multiple copies of any book; students are required to purchase textbooks which the library will not acquire. An active and efficient reserve system may provide greater access to limited materials when a large number of students require them.

Frequently, one of the primary duties of an academic art librarian is bibliographic instruction. This can range from individual instruction to a one-hour class orientation to an entire course. Elaborate audio-visual instructional materials, such as slide-tape or video programs, may be developed. Special library and subject guides are often created, sometimes in conjunction with, or at the request of, faculty members. In addition, the training of student workers, who usually stay only a relatively short period, may also require the librarian's time. For studio artists at the university or college, the librarian's concerns are the same as for the art school library, which are discussed next.

Art School Libraries

One of the basic functions of an art school library is to provide visual resources for instructors and students. The scope of the collection will depend upon the art media which are taught, and if degrees are granted, the library collection must be adequate to support an entire curriculum, undergraduate or graduate. Extensive picture files and slide collections are of great importance to an art school library, as are art periodicals and exhibition catalogs of contemporary works providing data on the current international art scene.[8] Oral history programs, such as film and videodisc documentation of contemporary artists and their works, have found an important place in some art school libraries. Many of these institutions also purchase artists' books. Ephemeral materials, such as the numerous art newspapers published in California and New York, are collected, as is information about local and regional artists and alumni of the school. Much of this material entails the maintenance of vertical files as well as archives. Frequently, the art school library finds it has become the repository for unique resources, such as prints, textiles, posters, and even such oddities as stuffed animals. These require preservation and special handling of a curatorial nature.

Museum Libraries

An art museum library should contain materials pertinent to the museum's collections of objects—materials that deal with the artists, styles, and media of the works of art the institution owns.[9] The primary patrons are the museum's staff: administrators, curators, educators, conservators, and installation designers. In addition, the diverse collecting interests of trustees and some museum members may be important. While these people may have first priority, area scholars and graduate students are usually welcome, and some museums have joint program arrangements with local academic institutions. Depending upon the size, interest, and policies of the museum, patrons can also include the general public. Although there is traditionally a non-circulation policy, exceptions are usually made for the curatorial staff. A major headache for the librarian then becomes one of location control and the return of the library's holdings.

The museum library will contain (1) reference tools, exhibition catalogs, and subject-related works capable of supporting historical research and documentation of the museum's objects; (2) materials, such as auction catalogs, that will enable the curatorial staff to make wise art purchases; and (3) works which relate to conservation, installation, and museum management. Frequently, curatorial departments have extensive files on the

objects in the museums' collections. Librarians do not have jurisdiction over this data, although their patrons may require this information.

Since many of the museum's references may be foreign-language material and pamphlet-size museum and gallery publications, original cataloging may be necessary. A specialized staff with linguistic skills which reflect the museum's objects collections will be essential. Because the curators need highly specific information, the librarian may provide analytical cataloging of certain materials, such as the contents of the 47-volume *Modern Art in Paris 1855 to 1900*, which contains reprints of as many as eight exhibition catalogs published in one individual volume. In addition, some museum libraries serve as a source of information on the history of the institution itself—development of its collections, the physical building, personnel and publication history, a complete chronological list of all exhibitions and exhibition catalogs, and archival information, if there is no organized or separate archive.

Since most museums today emphasize their didactic programs, large slide collections and art films are necessary to underpin the efforts of the education departments. In addition, a special shelf of general texts, such as surveys of art history and art appreciation, may be established for volunteer guides. Volunteers may also be used to scan all incoming literature for references to the museum's objects. Information concerning any pertinent references is distributed to the museum registrar as well as other interested staff.

Most museums participate in exchange programs whereby exhibition and collection catalogs and serials are distributed to exchange partners who then reciprocate in kind. Much important material that is difficult to obtain is acquired in this fashion. If the museum is concerned with acquiring information about local or regional artists, the librarian may develop or maintain vertical files by scanning and clipping the current serial literature for news items. Although they are constrained by the museum's policies and budget, these librarians frequently have a freedom of action seldom enjoyed by their colleagues in other types of art libraries.

Art museum libraries range in size from the great research collections to several thousand volumes squeezed into left-over space. Among the former are some of the most famous art libraries in North America: the Metropolitan Museum of Art in New York City, the National Gallery of Art in Washington, D.C., and the J. Paul Getty Museum in Malibu, California. Often these libraries have a broad-based collecting policy. In contrast, there are museum libraries which have strengths in special fields, for instance, the Museum of Modern Art in New York City, the Egyptian resources of the Brooklyn Museum, and the architecture collection at the Art Institute of Chicago.

Art Library Departments in Public Libraries

The largest and most diverse audience is served by these public institutions.[10] Large public libraries or library systems usually contain a Fine Arts Division, which may include all materials pertaining to the visual arts as well as to music, and sometimes theater, sports, and recreation. This usually occurs because these divisions are assigned all materials which are classified in the 700s by the Dewey Decimal Classification system. Even if another scheme—such as the Library of Congress—is used, music and the fine and applied arts may still be collected together. Many anomalies result from this arrangement; librarians have to be as familiar with fox hunting as with the Impressionist movement and the latest fad in popular music. The diversity of patrons is enormous—scholars, university as well as high school students, art dealers and collectors, studio and design artists, architects, interior designers, and amateurs who wish to read about or produce works of art. Everything purchased by academic, art school, and museum libraries is within their purview, as are how-to books and periodicals.

In city-wide, county, or regional systems, one institution is frequently designated as the resource library. The art-division librarian then has the responsibility for guiding collection development for the branches and for assembling a research-oriented collection that the others do not need to duplicate. As in the case of large academic libraries, there are many operational aspects over which the art librarian has no jurisdiction as well as numerous peripheral and support materials which are available in other departments. For instance, Business and Technology Divisions contain information on materials, tools, and techniques valuable to the architect and the practicing artist as well as on marketing, which is of interest to the professional artist as well as the dealer. The public library should have access to multiple database services which may not be available in other types of libraries. Public libraries collect small, local periodicals and often try to maintain files of information about local and regional artists, monuments, and topography.

A major responsibility of public librarians is the maintenance of an extensive telephone reference service. This may entail duplication of certain research tools for ready access to the librarians. Other time-consuming activities are the planning of exhibits and programs for patrons. A suggested reading list should accompany these projects. In addition, dealing with problem patrons is a greater concern of the public librarian.

Some public libraries are art research centers, for example, those in New York City, Boston, and Chicago. These are often the best source for data

on regional artists and architects. Many of their resources date from the 19th century and, therefore, create special conservation problems.

Business Libraries

Business or corporate libraries—serving architectural and interior design firms, commercial art galleries, and auction houses—are a relatively new, but growing, phenomena. Established to meet the needs of their companies, they are used by the most homogeneous group. This business-oriented constituency demands currency, accuracy, and speed of information. The librarian's contact with the professional association that represents the interests of the firm may prove essential.[11] For instance, architectural librarians need to know the many services which are provided by the American Institute of Architects in Washington, D.C. Because the collections are usually small, cooperation with other area libraries—especially the public library—is particularly important.

The collections vary greatly, depending upon the type of business. Purchases include such items as standards and patent information, especially important to architectural firms; trade or suppliers' catalogs for architectural and interior design firms; auction catalogs for art galleries; and commercial materials and samples—such as drapery swatches, wallpapers, and floor coverings. Because these materials fall outside the normal book trade channels, they can be difficult and time-consuming to obtain, and even more of a problem to organize, store, and retrieve. Unlike most types of libraries, for these clients, cost may be no object. Specialized local book stores may be a source for rapid purchases.

Because librarians in business firms do not have to conform to pre-existing institutional practices, they can often organize the collections to suit the particular demands of their clients. The serials that are purchased may need to be scanned for pertinent articles which can then be copied and sent to specific patrons, as a Selective Dissemination of Information (SDI) Service. In some instances, each issue of the journals must be routed to a large number of individuals. Under these conditions, circulation control may be difficult and require great tact. The librarian is frequently requested to create specialized indices or to undertake in-depth research projects to support the work of the company. This often requires special subject expertise on the part of the librarian as well as a careful analysis of user demands. Many of these special librarians have the responsibility of organizing and maintaining archival files of the company's past projects.

Because these business libraries are usually a one-person operation, the librarian may feel isolated. Contacts with library colleagues may be infrequent, and their problems may not be similar.[12] In addition, the business librarian must constantly promote the use of the firm's collections

and services. Marketing the library in the business environment usually means impressing management that the expense of not having pertinent current information is liable to be greater than the cost of having it.

EVOLUTION OF A PROFESSION

With the development of art librarianship, the professionals became concerned with the problem of what should constitute appropriate education and training for their specialty.[13] There is general agreement that requisite expertise encompasses subject knowledge of art, familiarity with foreign languages, and professional library science studies. Specialization should include knowledge of art literature as well as national and trade bibliography, the abstracting/indexing services and databases, classification theory and methods, information and reference theory, administration, computer applications, and collection-development principles and practices. In addition, practical work experience or an internship in an art library is highly desirable.

Perhaps the hallmark of the emergence of art librarianship as a mature specialty has been the formation of professional organizations, which have provided a sense of identity and common purpose.[14] These organizations further communication among their members in various ways—setting standards, holding conferences, providing opportunities for continuing education, and publishing journals and occasional papers—as well as many other activities. Because the organizations are the mark of professionalism, it is imperative that librarians lend them wholehearted support. In North America, two main types of associations exist: (1) art interest sections within general national associations, such as ALA and SLA, and (2) independent art library associations, such as ARLIS/NA.

In the first quarter of the century, art librarians in the United States had affiliated with both the American Library Association (ALA) and the Special Libraries Association (SLA). The Art Reference Round Table (ARRT) of ALA was established in 1924. A separate art group is mentioned in SLA proceedings of the 10th Conference in 1919, and in 1929, the Museums Group was formed under SLA auspices. Although there were overlaps in membership, ARRT was composed primarily of public librarians, while the SLA group came largely from the museum world. When ALA was reorganized in 1959, an Art Subsection—which has since been made a Section—was established as part of the Subject Specialists Section of the Association of College and Research Libraries (ACRL). The SLA reorganization in 1971 resulted in the transformation of the Museums Group to the Museums, Arts, and Humanities Division. Additionally, in 1952 SLA members founded the Picture Division. Although the group was composed

primarily of picture researchers, slide and photograph librarians also joined. In 1968, the American Society of Information Science (ASIS) also endorsed a Special Interest Group for Arts and Humanities. This group provides a forum for applications of information science and technology to the arts and humanities. Automated systems, machine-edited bibliographies, and computer art have been among those topics discussed by the members. Obviously, none of these organizations is concerned exclusively with art librarianship.

By the late 1960s, art librarians on both sides of the Atlantic realized that their specialty had reached a stage where its interests called for a separate independent organization. The Art Libraries Society (ARLIS) was founded in 1969 in the United Kingdom; ARLIS/NA (North America), in 1972. ARLIS/NA immediately began to publish a journal, the *ARLIS/NA Newsletter*, and held its first annual conference in January 1973. Patterned on the British model, it seeks members from among all those interested in the visual arts, architecture, or design. Regional chapters have been encouraged, and both Canadian and Mexican members have been active participants. The regionals provide a forum for the geographically dispersed membership and undertake various activities, such as holding workshops, compiling directories and union lists, and engaging in cooperative acquisition programs. In addition, there are (1) Special Interest Groups (SIGs) for Visual Resources, Architecture, Cataloging and Indexing Systems, and Serials and (2) Type of Library Groups (TOLs) for Academic, Public, and Museum Librarians. Since its inception, the Society has flourished: membership has grown, programs have expanded, and its publications have increased. The *ARLIS/NA Newsletter* was enlarged in 1982 to form *Art Documentation*, which is published four times a year. Directories and Occasional Papers are frequently issued, and the Standards thus far approved have been published.

ARLIS/NA has also been active in maintaining international rapport with ARLIS/UK and with the International Federation of Library Associations (IFLA).[15] Two important events on the international level were held in 1976 in England: the first International Conference of Art Librarians at Brighton and the International Conference of Art Periodicals at London's Victoria and Albert Museum and the University of Sussex. Two major international conferences have been held in Pisa on automatic processing of art history data and documents. Keeping abreast of developments internationally is of special importance for art librarians, given the truly universal nature of their subject matter.

Unfortunately, the question of organizational unity has arisen. While the visual image is essential to the study of art, collections of photographs, slides, and video/TV tapes have been maintained separately, and education for this specialty has followed a different route. Perhaps predictably, another

organization has been formed. The Visual Resources Association seeks to ensure cohesion among these professionals. Many art librarians think that such fragmentation will weaken their efforts, because both groups, although distinct, ultimately are serving the same users and have very similar concerns.[16] The dichotomy which seems to have arisen between text and image librarians should be resolved to ensure the unity of the profession.

Besides ARLIS/NA, art librarians frequently affiliate with other organizations. Association with ALA, ASIS and/or SLA helps overcome parochialism and enables one to stay in touch with developments in the profession as a whole, providing unparalleled opportunities to exchange ideas and to keep current. Specialized societies also make it possible to accomplish projects which one person or library could not undertake alone; setting standards is a prime example. Because of their subject interests, some librarians also adhere to non-library oriented organizations, such as the College Art Association (CAA), the Society of Architectural Historians (SAH), or the American Association of Museums (AAM). In 1941, the CAA devoted a Round Table session to the problems of art libraries and in 1969, sponsored a national gathering of slide curators. Many art librarians continue to meet at CAA annual conventions, where there is usually a joint CAA-ARLIS/NA session. The group interaction that transpires as a result of all of these associations has proved to be not only an effective problem-solving device, but also of inestimable value to each individual's professional development.

NOTES

[1]See Wolfgang Freitag, "Art Libraries in Collections," *Encyclopedia of Library and Information Science* (New York: M. Dekker, 1968–82), Volume 1, pp. 571–621; Trevor Fawcett, "The Compleat Art Librarian, or What It Takes," *Art Libraries Journal* 22 (March 1975): 7–9; and William B. Walker, "The Development of National and International Co-Operation Between Art Libraries," *Art Libraries Journal* 3 (Spring 1978): 9–20. For a discussion of Canadian art librarianship, see Mary F. Williamson, "The Tyranny of Distance: Art Libraries in Canada," *Art Libraries Journal* 8 (Spring 1983): 59–72; and Karen McKenzie, "Art Librarianship in Canada," *Art Libraries Journal* 8 (Spring 1983): 73–79.

[2]Etheldred Abbott, "The Special Library Profession and What It Offers: Art Museum Libraries," *Special Libraries* 25 (November 1934): 243–50.

[3]Freitag (Note 1), p. 572.

[4]User studies are discussed in Chapter 3. See Deirdre Corcoran Stam, *The Information-Seeking Practices of Art Historians in Museums and Colleges in the United States, 1982–83* (Ph.D. dissertation, Columbia University, 1984). Also see Stam's "How Art Historians Look for Information," *Art Documentation* 3 (Winter 1984): 117–19. For a related article see Margaret F. Stieg, "The Information Needs of Historians," *College & Research Libraries* 42 (November 1981): 549–60. Two interesting publications are Lois Bebout, Donald Davis, Jr., and Donald Oehlerts, "User Studies in the Humanities: A Survey and a Proposal," *RQ* 15 (Fall 1975): 40–44;

and W. C. Simonton, *Characteristics of the Research Literature of the Fine Arts During the Period, 1948–1957* (Ph.D. dissertation, University of Illinois, 1960).

[5]*Picture Librarianship*, edited by Helen P. Harrison (Phoenix, AZ: Oryx Press, 1981); Renata V. Shaw, "Picture Professionalism, Part I," *Special Libraries* 65 (October/November 1974): 421–29; and "Part II," *Special Libraries* 65 (December 1974): 505–11.

[6]Freitag (Note 1).

[7]The FIDER Committee members in their accreditation reports sometimes mention the quality of the library collection. FIDER—Foundation for Interior Design Education Research—accredits Interior Design programs. The National Association of Schools of Art and Design and the North Central Association of Colleges and Schools are examples of accrediting agencies that evaluate a library's collection.

[8]Philip Pacey, "How Art Students Use Libraries—If They Do," *Art Libraries Journal* 7 (Spring 1982): 33–38.

[9]Amy Navratil Ciccone, "Accreditation and the Museum Library: Whither Now?" *Art Documentation* 2 (October 1983): 129; and Nina J. Root, "Role of the Museum Library," *The Role of the Library in a Museum.* Session Proceedings, Joint Annual Meeting of American Association of Museums and Canadian Museums Association, chaired by Rhoda S. Ratner and Valerie Monkhouse (Washington, DC: Smithsonian Institution, 1980). For a still timely overview, see E. Louise Lucas, "The Museum Library," *Museum News* 7 (January 1, 1930) reprinted in *Art Documentation* 1 (December 1982): 202. Also Barbara Lipton, "The Small Museum Library: The Experience of the Newark Museum Library," *Special Libraries* 65 (January 1974): 1–3; and Frank H. Sommers, "A Large Museum Library," *Special Libraries* 65 (March 1974): 99–103. A book which was published in 1985—by Shoestring Press, Hamdon, CT—is *Museum Librarianship*, edited by John C. Larsen; of particular interest to art librarians is the chapter on staffing by Elizabeth R. Usher.

[10]For an interesting overview, see Malcolm Getz, *Public Libraries: An Economic View* (Baltimore: The John Hopkins University Press, 1980). Also see, Magarita Cano, "How to Bridge the Art Gap: The Role of the Public Library," *ARLIS/NA Newsletter* 4 (April 1976): 83–84; and Betty Vogel, "The Art Department or How Do You Make a Nativity Scene Out of an Old Ham Can," *ARLIS/NA Newsletter* 6 (November 1978): 102–03.

[11]A list of some art-related professional organizations constitutes Appendix C.

[12]Joan Benedetti, "Cost Effective Management: Some Hints for Libraries in Small Museums," *Cost Effectiveness in Museum Libraries.* Session Proceedings, American Association of Museums Annual Meeting, Rhoda S. Ratner, Session Chairperson (Washington, DC: Smithsonian Institution Libraries, 1983); Janice Holladay, "Small Libraries: Keeping the Professional Position Professional," *Special Libraries* 72 (January 1981): 63–66; Antje B. Lemke, "Joint TOL Session: Special Issues Facing the One-Person Library," *ARLIS/NA Newsletter* 8 (May 1980): 73.

[13]See Sarah S. Gibson, "The Past as Prologue: The Evolution of Art Librarianship," *Drexel Library Quarterly* 19(Summer 1983): 3–17; Antje Bultmann Lemke, "Education for Art Librarianship: The First Decade and Beyond," *Art Libraries Journal* 7(Winter 1982): 36–41; and Claire Richter Sherman, "Women Librarians as Interpreters of the Visual Arts," *ARLIS/NA Newsletter* 9 (October 1981): 185–89.

[14]For a bibliography see Gibson (Note 13).

[15]For an extensive discussion of art libraries and IFLA, see Walker (Note 1) and "IFLA & CNLIA—Library Assocation Networks," *ARLIS/NA Newsletter* 8 (October 1980): 157–61. There is a newsletter for the IFLA Special Libraries Division, Section of Art Libraries; this publication is issued by Philip Pacey, The Library, Lancashire Polytechnic, St. Peter's Square, Preston PR1 2TQ, Lancashire, UK.

[16]Wolfgang Freitag, "Indivisibility of Art Librarianship," *Art Libraries Journal* 7 (Autumn 1982): 28.

2

Computerization and the Art Library

INTRODUCTION

Access to the world's body of knowledge was revolutionized in the 1940s by the invention of the digital computer, which has made it possible to manipulate and disseminate data at rapid speeds. As information service centers, art libraries must utilize this technology.[1] For the library, it is no longer a question of whether or not to have a computer, or access to one, but a problem of how many, what kinds, and for what purposes.

This modern technology has vastly increased the library's capability to deliver information quickly, reduce routine record keeping, and streamline everyday operations. Most importantly, because of the computer's manipulative ability, it is possible to search for data in ways that used to be unbearably tedious. For instance, this technology facilitates discovering references to material which combines two or more ideas or items which were previously hidden in the body of an article.

All phases of library operations have felt the impact of computerization.[2] And with the advent of the microcomputer, automation was put within the reach of even the smallest art library. Although only the larger institutions may utilize an integrated computer system, most small libraries will eventually need microcomputers to provide access to the online bibliographic databases as well as for regular office work.

Within a library, computerized systems are used to perform such operations as: (1) housekeeping tasks—maintenance of dealer and exchange files, cataloging, serials check-in, circulation control, accounting, and word processing; (2) documentation of the library's own collection through an online public access catalog of its holdings; (3) access to the holdings of other libraries by provision of a union catalog and an interlibrary loan system; (4) information retrieval through online bibliographic database services; and (5) the maintenance of individual in-house generated databases, such as special indices to the collection and archival or ephemeral material.

A bibliographic database is a file of document descriptions—frequently called surrogates—which can be used to decide whether or not a person wishes to search for the document itself. These surrogates can either be created in-house by the library staff or acquired through a bibliographic utility.[3] In an integrated computer system, the information needs to be captured only once for a central file, then the data can be automatically handled from the ordering process through cataloging and circulation. This chapter discusses bibliographic control through (1) the bibliographic utilities, (2) integrated systems which include an online public access catalog, (3) commercial online databases, and (4) microcomputers which not only can be used for word processing and file keeping but can also provide the means for special indexing of archival and visual materials. Art-related computer projects, some of which are still being developed—such as *SCIPIO* (*Sales Catalog Index Project Input Online*), the Art and Architecture Thesaurus, and various museum projects which utilize computers in the registration of objects—are discussed in the appropriate chapters of Part II.

BIBLIOGRAPHIC UTILITIES

The key to computerized bibliographic control was the development of the MARC—an acronym for Machine Readable Cataloging—communications format by the Library of Congress (LC) in the 1960s. With MARC as the catalyst, organizations developed catalog support systems to further cooperation in the new context of automation. These organizations, now frequently known as bibliographic utilities, process bibliographic information on their own computers by gathering and transmitting records. Begun as cataloging support systems, they have since developed additional services.[4] Although OCLC (the Online Computer Library Center) was the first of these facilities, there are currently three other major North American utilities: Research Libraries' Information Network (RLIN), Washington Library Network (WLN), and University of Toronto Library Automation Systems (UTLAS).

The databases of these utilities are composed of records created by national agencies, such as the Library of Congress and the National Library of Canada, plus records contributed by other participating libraries. Some of the bibliographic utilities have the capability of providing subject searches utilizing Boolean logic. But as these databases multiply in size—one has more than 11 million records—the search time becomes slower and more expensive.[5] Basically, catalogers at remote locations can use the databases as sources of derived cataloging, and reference librarians can use them as a union catalog for locating material not in their own collections. Additional functions, such as acquisitions, circulation, and serials control, which are based on bibliographic records, can also be used to constitute an integrated library system.

Because OCLC developed first, it gained an advantage over the systems that came later.[6] The others have been able to compete by offering different services. OCLC's products include catalog cards, spine labels, book cards, and archival tapes, which are MARC-formatted magnetic tapes containing all the records an individual library has used or created through the system. The archival tapes can be used to create a variety of other products, such as COM (Computer Output Microform) and online public access computer catalogs, regional union catalogs, specialized bibliographies, and files for circulation systems. A component for interlibrary loans acts as an electronic mail device from a borrowing library to a proposed lending library. An acquisitions system generates orders in similar fashion; a serials check-in system is also available. OCLC plans to make available through BRS their records of the last four years; this will allow subject access with full text and Boolean searching of this portion of their database. Under the name LS/2000 (Local Systems/2000), OCLC markets the Integrated Library System (ILS)—originally developed at the National Library of Medicine—to individual institutions. LS/2000 is a micro- or minicomputer-based local system that can provide bibliographic file maintenance, circulation control, and online cataloging searching. Serials control, acquisitions, and materials-booking modules are under development. Compatible with the MARC format, the system is designed to allow flexibility to meet individual library requirements.

RLIN is operated by the Research Libraries Group (RLG), which was founded in 1974 by a network of major research institutions. RLG is particularly important to art libraries, partly because of the special databases of its Art and Architecture Program. Participants in this program are the art and architecture libraries of member institutions and museum and independent art libraries which are special members of RLG. These institutions are linked by the shared use of the RLIN databases as well as their concerns with shared resources, collection management and development, bibliographic description, and subject analysis.

RLG acquired a software system originally developed at Stanford University, called BALLOTS (Bibliographic Automation of Large Library Operations using a Time-sharing System). It provides cataloging and acquisitions support functions, including fund accounting, serials control, and electronic messaging. The *RLG Conspectus*—discussed in Chapter 3—is primarily of value to collection-development librarians, but it can be searched to determine locations of strong subject collections. RLIN's search capabilities, which include the ability to search by subject, are flexible and more powerful than those of the other utilities. It permits the use of Boolean operators, which are explained in detail in Chapter 11. The bibliographic database represents the online union catalog of RLG, and only members of RLG may add their holdings.

Full membership in RLG is limited, but searching access to RLIN is provided to associate members as well as to libraries which have search-only accounts. RLIN has several special online databases which may be used for a fee. Two of these, which will be discussed in later chapters, are of particular interest to art librarians: *On-Line Avery Index to Architectural Periodicals* and an art sales catalog database, *SCIPIO*.

Membership in WLN is restricted on a regional basis to libraries in the Pacific Northwest, Alaska, and Arizona. It is unique in that its software—the instructions needed to operate the computer—can be purchased (1) directly for use in other locations on local computers or (2) as a package with compatible hardware through a marketing and development agreement with Biblio-Techniques. WLN offers shared cataloging with sophisticated authority control—a method by which a library maintains consistency of names, series, and terminology—whereby each new entry must be approved by an editorial staff. Control is maintained by creating a file of names and terms in a standardized form with a record of the references made to them. WLN has available retrospective conversion and acquisitions services with fund accounting. An interlibrary loan system is under development; search-only access to its database is also offered. The database—which can be searched under author, title, subject, series, LC card number, ISBN (International Standard Book Number), and ISSN (International Standard Serial Number)—includes Boolean logic capabilities as well as key word access to corporate headings and titles.

UTLAS is a Canadian bibliographic utility using an automated system developed for the University of Toronto. Its services include online cataloging and authority control, interlibrary lending, and electronic messaging. Cataloging products include COM and printed book catalogs. Online ordering capabilities are provided through INNOVACQ (available from Innovative Interfaces, Inc.), which has a computer-based, stand-alone acquisitions system.[7] UTLAS is, therefore, similar to the other utilities, but its file

structure differs in that each user, or consortium of users, has a separate file. While UTLAS has appealed mostly to Canadian libraries, it is by no means limited to them. UTLAS announced that under a joint marketing agreement, CL Systems, Inc. (CLSI) will market UTLAS database products and services in the United States, while UTLAS will market local library systems and services in Canada.

All of these utilities are constantly developing new or improved functions and services. All have experienced periodic difficulties due to the growing complexity of computer and communications technology. All have limitations: records of older and nonprint materials are frequently not available through a database, duplication of records is sometimes excessive, and quality control is not uniform. Nevertheless, most librarians agree that these computer systems represent significant improvements over manual techniques.

INTEGRATED SYSTEMS

An integrated system is a computer-based library system capable of performing two or more distinct functions. These functions, or subsystems, are the traditional divisions of library work, such as acquisitions, cataloging, and circulation. Many libraries have installed several types of computer-based systems that operate simultaneously, but not necessarily in relation to each other. These have been characterized by the way in which they were developed rather than by function. The four basic methods are: (1) purchasing or leasing a turnkey system—one that is ready to install and operate; (2) sharing a system with other libraries by means of networking through organizations like OCLC, Baker and Taylor, or Brodart; (3) adapting another library's system; or (4) developing a unique local system.[8] Initially these systems were monofunctional, that is, they did one thing, such as circulation, fund accounting, or cataloging. But by the late 1970s, computer software designers were interested in developing systems that could handle many functions, based on the premise that most library operations involve handling one piece of data—the bibliographic record—many times. It is also possible to link separate subsystems by using microcomputers.

The desirable components of an integrated system include acquisitions, online cataloging, an online circulation system, serials control, interlibrary loan, and an online public access catalog. Some systems also provide materials booking systems, binding control, and other subsystems, such as an interface with commercially vended online databases. In the past, the first target for computerization was usually circulation because it involves a large number of transactions plus expensive filing and sorting. Circulation systems—such

as CLSI and DataPhase Systems, Inc.—were developed to run on minicomputers and were later expanded to include other library functions, such as cataloging.[9] Cataloging systems—based on networks, such as OCLC and RLIN— were designed to run on large mainframe computers; these too, have been successfully expanded to encompass other operations, such as acquisitions.

The online public access catalog is one of the components of an integrated system, which supports all library operations and may provide access to information from many other sources. Soon the decision will not be whether or not to have an online public access catalog, but what information it should contain to serve the users as quickly and as inexpensively as possible. Although the card catalog is still prevalent, it is rapidly being overtaken by the computerized online catalog, with some libraries using a COM catalog as a stage between the two. Many libraries expect to maintain their catalogs in two—or perhaps even more—formats for a period of time, because they have not been able to convert all of their records to a single form.

Advances in computer and telecommunications technology have put the online public access catalog within reach of most libraries. Local catalogs can be operated by in-house computers; however, the large network databases will continue to be invaluable sources for bibliographic data, not only for technical services but for public service librarians as well. The latter will find that knowledge of cataloging codes and conventions will increase their ability to respond to reference and interlibrary loan requests.

The online public access catalog can be a far more powerful tool than the conventional card catalog.[10] Although few existing online catalogs incorporate all desirable features, among their advantages are these capabilities:

(1) to include a greater variety of access points;
(2) to retrieve information not only from the local library file, but to expand the search to other libraries' files;
(3) to have access terminals installed at locations remote from the central library building;
(4) to reproduce, by means of a printer, the printout of citations retrieved;
(5) to provide an automatic name-subject-series authority control structure;
(6) to display detailed holdings, status, and circulation information;
(7) to incorporate a system that provides keyword searching of titles;
(8) to utilize Boolean operators for searching refinement; and
(9) to augment the bibliographic record—with such data as index information, tables of contents, abstracts, and notes—to which free-text searches will give access.

An example of a successful in-house automated system incorporating some of these features is the Ohio State University (OSU) Libraries' online public

access catalog and automated circulation control system, known as LCS (Library Control System).[11] LCS typifies the advantages of such a system to the clientele of a university environment. The OSU libraries are in a large decentralized system with the Fine Arts Library housed in a building some distance from the Main Library. Frequently used by the Fine Arts patrons are the collections on architecture in the Engineering Library, the crafts materials in the Home Economics Library, and the humanities collections in the Main Library.

Throughout the campus are terminals for the online public access catalog, which provides information on the monographic and serials holdings of all OSU libraries. In addition, circulation data are immediately available. Moreover, requests for the recall of materials which are charged out can be initiated via any terminal. A further refinement is the "snag function" used to indicate that an item is neither charged out nor in its designated place. If the item is not found within a specified period of time, it is automatically withdrawn, and cards are generated to be used in selecting replacements. The patron also has access to information in the technical services in-process files. This indicates whether a title is on order or is being processed; a save request can be put on any of these materials. Users can search by author, title, a combination of author/title, subject, call number, and, in the case of serials, volume number or year. At many locations, printers are attached to terminals and can be used to supply printed bibliographies, eliminating the need to copy this data. Assistance in subject searching is provided by placing copies of the *Library of Congress Subject Headings* (*LCSH*) adjacent to the terminals. Thus if users are uncertain of a heading, they can consult this list. Subject access is improved over that offered by a card catalog in that while patrons have to know how a subject heading is constructed, they do not need to be as knowledgeable about the filing rules, which often create classified hierarchies in an otherwise alphabetical sequence.

Because automation development was often piecemeal, many libraries still have different computer systems performing separate tasks. And many smaller, specialized art libraries are not able to afford any sort of automation, because it is not possible to identify tasks sufficiently repetitious or time-consuming to justify the expense. The library may choose to automate some functions and not others. Whatever decisions are made about automation, a needs assessment is an absolute prerequisite. This comprises a review and critical analysis of current procedures to determine what actions are essential, and what, if any, can be eliminated or combined. For most components of an automated system—such as an online public access catalog or circulation control—a sizable collection of machine-readable cataloging records is the indispensible starting point. The lack of such records has impelled some librarians to undertake full retrospective conversion of their records to machine-readable form.[12]

Prior to adding or altering a computer system, the library staff should formulate a written priority list of exactly what tasks the computer system should encompass. This is essential—having a clear idea of what needs to be accomplished. A list of questions should be compiled prior to interviewing prospective vendors in order to elicit the same information from each of them. Before deciding on a specific vendor, such items as the exact work to be performed, who is to do what, a realistic work schedule, the quality expected, specific criteria which will be used to evaluate the bids, and the amount of money which is to be allotted to the project should be clearly delineated. Computer systems are expensive; a great deal of time, effort, and expertise needs to be expended prior to purchasing one.

COMMERICAL ONLINE DATABASES

A commercial online database is a computer file that contains a set of related records which are stored together and which can be searched to retrieve certain information. These records can be a bibliographic entry, with or without an abstract or notation, or full-text material, such as a complete article from the *Academic American Encyclopedia*. A vendor—such as DIALOG, BRS, and ORBIT—is a company which obtains these special bibliographic databases from various producers, standardizes the basic procedures for searching them, and sells the service to interested parties. Commercial online databases can be divided into three types: (1) files that correspond to the printed publication of an abstract/indexing service, (2) files which combine the information from a printed index with additional material, and (3) files of new data which have never been published.

The producers of these computer files are either the same companies that publish the printed volumes, if there are such equivalents, or companies that organize the collection of information to form specific databases. ABC-Clio, Inc.—which produces *ARTbibliographies MODERN*, both in printed volumes and through the DIALOG online database—is an example of the former. Information Access Corporation, which has formulated *Magazine Index Database* through DIALOG, is an example of the latter. Several vendors may have the same database. For instance, *ERIC Database*, which coincides with the printed versions of *Resources in Education* (*RIE*) and *Current Index to Journals in Education* (*CIJE*) can be accessed through DIALOG, BRS, and ORBIT. Other databases can be searched through only one vendor. Due to the importance of *RILA* and *ARTbibliographies MODERN*, an art library will need the services of DIALOG, the only vendor which presently provides access to these files.

An online bibliographic database search can be used to find information on (l) specific topics; (2) the relationship of two or more subjects; (3) artists,

designers, or craftsmen; (4) the writings of particular authors; (5) the existence of exhibition or auction catalogs; (6) the identification of articles or references, (7) sales data; and (8) the contents of *Festschriften*. In addition, the investigation can be limited to material published during a special period of time or in a specified language. Unlike most printed abstracts and indices— which require that the researcher examine material in a linear manner, one volume and one subject at a time—databases have the great advantage of allowing researchers to scrutinize more than one set of records at a time and to locate citations that reflect relationships between two or more items. But each file covers only the references abstracted by one individual database. To discover information from a varied group of journals, more than one database will need to be used. Details on how to conduct online bibliographic database searches are provided in Chapter 11.

When conducting an online search, it is possible to download data, that is, to capture the results of a search in machine-readable form and transfer them to a storage medium, such as floppy disks, which can be processed by a microcomputer. This permits further use of the data, such as reformatting or refining it, as for instance, deleting citations. Several microcomputer software programs can manipulate these downloaded citations by sorting and searching the subfiles by author, title, or keyword. Current awareness or SDI profiles can be stored in the computer in order to match them periodically against special files. Although the horizons appear to be almost limitless, searchers must remember that many databases are copyrighted. It is, therefore, necessary to make appropriate arrangements with the vendors and publishers before downloading.

The prices charged by vendors vary. The cost depends upon the specific database, the time actually spent for the investigation, and whether or not the material is typed online through the library's terminal or printed later— offline—and mailed to the patron. Some companies have a minimum amount that must be spent each month; others have a one-time set-up fee or an annual charge. Even within one vending service, the expense of using the different databases is not the same. Government-sponsored computer tapes, such as ERIC (Educational Resources Information Center), are always less expensive. One service that most libraries use is DIALOG, a company which has no monthly minimum; the researcher pays for the actual time online plus sometimes a small fee for each citation printed. In many libraries, only the computer-time charge is paid by the patron; the overhead library expenses are not included.[13] In the future, the price structures may change. Because it is difficult, if not impossible, to discover if users are downloading records into their own computers, in order to save and reuse the data later, some producers have considered an annual fee rather than an hourly price. This may make some databases out of the monetary reach of researchers.

Some vendors have special features, such as DIALOG with DIALORDER,

SDI Service, and *DIALINDEX Database*. The first allows the user to order, online, the complete text of a bibliographic citation; the article is mailed to the requestor who is billed directly for the service. The SDI Service—for which there is a charge—permits a researcher to set up a search for a specific subject which will be searched every time the producer updates the file. *DIALINDEX Database* assists researchers in evaluating the various databases for particular subjects. The broad categories include Biographies, Books, Education, Humanities, and People.

Although all vendors provide information on their various databases, not all of these services are of equal value. DIALOG has an impressive array of good aids: (1) *Database Catalog*, revised twice a year, gives descriptions and prices for the numerous databases that are available through the system; (2) *Guide to DIALOG Searching*, a lengthy basic-reference manual for which there is a charge provides information on searching each database;(3) *Database Documentation Chapters*, with a separate one for each individual database, include sample searches and other valuable data; (4) *The Chronolog*, a monthly newsletter, reports searching tips, changes and additions in the databases, and various types of announcements; and (5) training workshops provide both introductory and refresher courses in numerous cities throughout North America and Europe. One of the best ways to keep current with this ever-changing field is to study the information which the various vendors provide.

Once a person has the individualized vendor account number, all the databases serviced by that company can be used. For instance, when an account is opened with DIALOG, all of the more than 200 separate databases are available for searching. In making the decision as to which databases need to be made available, the librarian must consider: (1) the types of databases and the information they provide, (2) the difficulty in obtaining the materials which the computer citations report, (3) the methods of searching the database, (4) the expense in obtaining accounts with the various vendors, and (5) the needs of patrons. A list of vendors with their addresses and toll-free telephone numbers is provided in Appendix B.

In signing an agreement with a database vendor, the following items should be taken into consideration:

(1) What equipment is to be used? Will the present computer terminal be adequate or does the transaction call for a capital outlay?
(2) Are the services—abstracts, full-text, offline printing—which are desired available? Is there a method for ordering articles from bibliographic citations?
(3) How helpful is the vendor? Does someone who has knowledge concerning the computer files reply to the queries or is the person who

answers the telephone someone who is totally ignorant concerning databases? How prompt and courteous are the vendor's staff?

(4) Are there user manuals and training workshops available? Is there a magazine or some publication which will inform the librarian of current changes in the databases? Are these at a cost which the library can afford? Are they of any value?

(5) How expensive is the service? Is there a charge for the individualized search number? A monthly minimum? Do the rates include royalty charges for the database producer and all taxes? Who pays the postal fees for offline printing? Are there discount periods?

In order to access the computer, the librarian must use a telecommunications network—such as UNINET, TYMNET, TELENET, or DIALNET—or some other telephone connection, such as direct dial or a WATS line. The information booklets of the various vendors discuss the type of equipment that is compatible with their computer service and the prices charged by the telecommunication services. Prior to choosing which system to use, the librarian should check (1) the cost, (2) the ease of use, (3) any technical advantages, and (4) security. The pricing schedule depends upon the location of the city from which the patron is calling and the density of use of the service from that city. Although a larger population usually has a higher-density use, this may not always be the case. Because a data communications company provides telephone connection between two computers, the means by which they implement this service may determine the cost, ease of use, and technical advantages. Sometimes the most recent company to enter the field has the best equipment. Various means are used to transmit the signals; the quality or clearness of the communications is important. Security is a recent problem. Obviously, an art library cannot afford to have unauthorized people charging database searches to its account. For some telecommunication services, two numbers—a user ID and a password ID—are required prior to accessing the database.

The database field is one of constant and rapid change. By obtaining additional records, a producer can greatly increase the size of the database. For instance, until Spring 1985, *Dissertation Abstracts International* of BRS did not include master's theses; however, at that time these citations were added which then made the database equivalent to *Dissertation Abstracts Online* of DIALOG. Moreover, producers periodically evaluate the serials that are being abstracted; deletions, additions, and changes can follow. The date of coverage of different serials within a database often vary; for example, *Magazine Index* of DIALOG has indexed some periodicals from 1959–1970 and 1973 to date—such as *American Artist, Art in America*, and *Art News*—but since 1977 has continually added other periodicals, such as *American*

Photographer in 1980. Databases can even be eliminated, such as the *Society of Architectural Historians Database*, which was carried by BRS until Summer 1984. Example 11/5 is a chart of art and art-related databases and their primary subjects.

Librarians must keep informed by (1) attending database workshops, (2) reading the pertinent literature, such as *Online, Data Base, Online Review*, and *Information Manager*; (3) attending the National Online Conferences or one of the local online user groups which have been organized under the aegis of this organization; (4) conferring with colleagues who have similar problems; and (5) keeping in touch with the vendors as well as the producers in order to stay current with any changes in the composition of the files.

MICROCOMPUTERS FOR LIBRARIES

In a library, there are four predominate uses for the microcomputer: word processing, database management, financial management, and telecommunications.[14] Word-processing packages are used for the production of routine documents.[15] This software enables the computer to (1) format a document; (2) insert and delete paragraphs, lines, or words; (3) number pages; (4) center copy; (5) underline; (6) save and repeat the same document or variations of it; and (7) proofread the document for misspelled and mistyped words prior to printing. Data management systems use the microcomputer to create and maintain files from which information can be retrieved. For example, a simple package can be used to replace a manual index card file of local artists or to maintain a data file of curators' interests. Financial management software—featuring electronic spreadsheets—is used to aid in budget preparation and forecasting where a number of variables must be considered. A telecommunications system, which was discussed previously, can be used for online database searching.

Microcomputers can assist in many library functions: reference, interlibrary loan, serials control, index production, circulation transactions, vertical file maintenance, computer-assisted instruction, special in-house indexing of materials, budgeting, and access to online database systems, such as DIALOG and BRS.[16] Many kinds of in-house databases can be formulated with the aid of a microcomputer such as: (1) ready-reference files which store answers to frequently asked questions, (2) records of titles of publications of the parent institution or of faculty members, (3) indices to ephemeral materials or local newspaper articles, and (4) data on catalogs of special collections distinguished by format, such as microforms or photographs.[17]

The Second International Conference on Automatic Processing of Art History Data and Documents—which was held in Pisa, Italy, September 24 to 27, 1984—examined nine areas of computer application: lexicons, thesauri,

biography, general catalogs, special catalogs, bibliography, documents and sources, integration, and iconography. Conceived as a series of seminars and sponsored by the J. Paul Getty Trust in collaboration with the Scuola Normale Superiore of Pisa, this conference provided a forum for the presentation of many diverse computerized projects, many of which involved the use of microcomputers. The publications which resulted document many exciting uses of computers.[18]

Successful use of a microcomputer is based upon judicious choice of software—for examples of some questions to ask prior to buying the hardware and software, see Example 2/1 at the end of this chapter. If possible, the decision about what computer to purchase should come after the decision about what software to buy.[19] There are a number of general purpose software products that may be adapted for particular library applications as well as some that have been designed specifically for libraries by nonprofit organizations, such as OCLC and CLASS (the California Library Authority for Systems and Services). Purchasing a package generally proves to be less expensive than creating or contracting for a customized program. General purpose packages can be classified as word-processing systems, database management systems, or financial, modeling, and statistical analysis systems.

Computer hardware and the software which controls it change rapidly. To keep informed, librarians must (1) read the numerous articles which are published in the professional literature and by the various firms that sell computer systems;[20] (2) visit other libraries which are utilizing the same computer technology that is being considered in order to observe the working operations and interview the staff members who actually use the system; and (3) attend lectures, demonstrations, and workshops at library conferences and computer fairs. Supervisors must provide adequate time for their staff members to learn the idiosyncracies of the computer; this is a technology which cannot be learned overnight.

EXAMPLE 2/1: CONSIDERATIONS PRIOR TO PURCHASING COMPUTER HARDWARE AND SOFTWARE

The various reasons for obtaining a computer should be delineated as carefully as possible, since these will determine the course of action. The following questions should be answered prior to acquisition.

Computer Uses

1. Why is a computer needed, both now and in the foreseeable future? What diverse activities will be performed with it?

2. How many computers or terminals will be needed? What type of printer—dot-matrix or daisy-wheel letter-quality—should be purchased? What accessories—modem, mouse interface, power surge director—will be required?

3. Who will use the computer? Will a number of people use one terminal? Will adequate training and practice time be provided for the various users? Is an expert readily available to assist in the training process?

4. Where will the computer be placed? Will it be convenient for all users? Will there be adequate space and electrical connections for the system?

5. How much money can be budgeted for the purchase of the system? Is the money in the form of additional funding or is it to be taken from an already budgeted source, such as the book budget? Have all the costs—paper, printer ribbons, backup and data disks, and storage containers—been calculated? Has the long-range cost of maintenance and repair been calculated and budgeted?

6. When does the system need to be purchased? How much time, money, and effort can be expended to study the current computer market—both software and hardware—in order to decide on the best course for the library?

Buying Software

1. What hardware does the software require? What size memory is needed? Is the software compatible with the hardware already owned or that the library administration is considering for purchase? If there are other computers in the library, will the software be compatible with them?

2. How easy is the software to learn? Is it menu driven or command driven? Is there a template available for the keyboard? Is there any hardware/software interface, such as a mouse attachment? Is this software owned by colleagues, who could be used as resource people when problems arise? Does the software have a tutorial? Are the instructions for using the software easily understood?

3. What kind of support—workshops, demonstrations, telephone assistance—will be available for the software package? Are these local or national? Is there an 800 number from which help with technical difficulties can be obtained? Or is this type of information available only through a paid long-distance telephone call?

4. What kind of documentation is there? Is the book which accompanies the software well written and easily comprehended? Are there any other books on the software which will help in learning the system? Is the text of these written manuals organized in an understandable format and indexed for easy accessibility?

5. What safeguards are there to prevent deletion of material from a program disk? If a number of people are to utilize the software, is there

adequate protection against an inexperienced user's undoing what someone else has put into the system?

6. What is known about the company which produces the software? Is the software copy-protected? Is there a warranty on the product? Can backup copies of the various program disks be made? If updates are produced, will these be made available to registered purchasers? At what fee? Are replacements available for damaged software program disks?

7. Are any additional products available with this software? For instance, does a speller accompany the word-processing program?

Buying Hardware

1. What is known about the company which produces the computer? Will the machine be out-of-date quickly? Is the company in a good financial situation? Is the company noted for creating new products and updating or upgrading earlier versions? Does the firm guarantee its products? How long is the warranty?

2. What is known about the company which sells the computer? How much assistance—workshops, demonstrations, telephone conversations—will be available?

3. What is known about the specific computer? If it is to be used with other computers in the institution, will the machine be compatible with them? Does the computer have adequate memory for present and future needs? Does the computer have room for expansion? How many ports does it have? How many will be used with the accessories which are to be purchased? What accessories are available for the machine? What are the machine's idiosyncracies, such as number of parallel or serial accessories which can be used?

4. If purchasing a modem, will it be internal or external and will it be compatible with the computers with which it will correspond?

5. Where can the computer be serviced and repaired? Is a service contract available?

NOTES

[1] See Paul G. Zurkowski, "The Library Context & The Information Context: Bridging the Theoretical Gap," *Library Journal* 106 (July 1981): 1381–84; and William F. Birdsall, "Librarianship Professionalism, & Social Change," *Library Journal* 107 (February 1982): 223–26. See also, William Saffady, *Introduction to Automation for Librarians* (Chicago: American Library Association, 1983).

[2] For an historical overview in art libraries, see Michael Rinehart, "Art Databases and Art Bibliographies: A Survey," *Art Libraries Journal* 7 (Summer 1982): 17–30.

[3] For a bibliography of early professional literature on the subject, see "Bibliographic Utilities," edited by Ferris Olin, *ARLIS/NA Newsletter* 8 (October 1980): 177–78.

[4]For discussions of the utilities, see Emily G. Fayen, *The Online Catalog: Improving Public Access to Library Materials* (White Plains, NY: Knowledge Industry Publications, 1983); and Karen L. Horny, "Online Catalogs: Coping with the Choices," *The Journal of Academic Librarianship* 8 (March 1982): 14–19.

[5]This figure is ever changing. For the latest information, see the newletters of the various bibliographic utilities. An advertising brochure indicates that UTLAS contains 23 million records.

[6]Kathleen I. Maciuszko, *OCLC: A Decade of Development—1967-1977* (Littleton, CO: Libraries Unlimited, 1984); and Jean Slemmons Stratford, "OCLC and RLIN: The Comparisons Studied," *College & Research Libraries* 45 (March 1984): 123–27.

[7]For information on INNOVACQ, see Sandra Weaver, "Developing an Automated Acquisitions Package," *Library Acquisitions: Practice and Theory* 7 (1983): 189–94.

[8]For an in-depth discussion on how to choose which method might be best for a specific library, see "Toward an Online Catalog—The Online Circulation System: University of Rochester," *ARLIS/NA Newsletter* 9 (October 1981): 195–96. The article includes a bibliography and a list of "Academic Libraries with Commercially Vended Online Circulation Systems 1979–80." See also, David C. Genaway, *Integrated Online Library Systems: Principles, Planning and Implementation* (White Plains, NY: Knowledge Industry Publications, 1985).

[9]Audrey N. Grosch, *Minicomputers in Libraries, 1981-82: The Era of Distributed Systems* (White Plains, NY: Knowledge Industry Publications, 1982).

[10]On automated catalog systems see: Emily Gallup Fayen, *The Online Catalog: Improving Access to Library Materials* (White Plains, NY: Knowledge Industry Publications, 1983); Joseph R. Matthews, *Public Access to Online Catalogs: A Planning Guide for Managers* (Weston, CT: Online, Inc., 1982), pp. 92–94; Grace Anne A. DeCandido, "Automation and Art Libraries: A Case Study in Retrospective Conversion," *Art Documentation* (February 1983): 6–7.

[11]Susan Wyngaard, "Automation and Art Libraries: The Ohio State Experience," *Art Documentation* 1 (February 1982): 22–24.

[12]The literature is vast, and ever-expanding. For a discussion of a change to a computer circulation system, see David J. Patten, "Automation and Art Libraries: The Oberlin College Experience," *ARLIS/NA Newsletter* 9 (December 1981): 238–40. For an excellent article on what, when, and how to convert, see Jane D. Collins, "Planning for Retrospective Conversion," *Art Documentation* 1 (Summer 1982): 92–94. For information on Archon—the New York University project which converted archaeology and ancient art references and artists' books owned by Parsons School of Design for RLIN—see Grace Anne A. DeCandido, "Automation and Art Libraries: A Case Study in Retrospective Conversion," *Art Documentation* 2 (February 1983): 6–8. For data on online public access catalogs, refer to Emily G. Fayen, "The Online Public Access Catalog in 1984: Evaluating Needs and Choices," *Library Technology Reports* 20 (January/February 1984): 7–61; Joseph R. Matthews (Note 10); and Stephen R. Salmon, "Characteristics of Online Catalogs," *Library Resources and Technical Services* 27 (January/March 1983): 36–67. For an overview, see John Corbin, *Developing Computer-Based Library Systems* (Phoenix, AZ: Oryx Press, 1981); Sandra Weaver, "Developing an Automated Acquisitions Package," *Library Acquisitions: Practice & Theory* 7 (1983): 189–94. For up-to-date information, contact the various firms that market computer systems and request their publicity brochures. Frequently, reprints of published articles concerning the system will be included. For example, LIAS sends out: Sylvia MacKinnon Carson, "LIAS: Online Catalog at Penn State University," *Cataloging & Classification Quarterly* 4 (Winter 1983): 1–15; and Kimi Hisatsune, "Authority Control—Beyond Global Switching of Headings," *Technical Services Quarterly* 1 (Fall/Winter 1983): 121–27.

[13]For some examples of subsidizing computer search costs, see Paula Baxter, "Using an Art Database in an Academic Library," *Art Documentation* 2 (Summer 1983): 89–90; and Elizabeth DeMarco, "Database Searching at Onondaga County Public Library," *Art Documentation* 2 (Summer 1983): 90–91.

[14]For a discussion of these four applications, see Allan D. Pratt, "Microcomputers in

Libraries," in *Annual Review of Information Science and Technology* (ARIST), edited by Martha E. Williams (New York: Knowledge Industry Publications, Inc., 1984), Vol. 19, pp. 247-69.

[15]For a detailed article on buying and using this type of computer assistance, see Celine Alvey, "Word Processing in Art Libraries," *Art Documentation* 2 (May 1983): 63-65.

[16]Carol Tenopir, "Online Searching with a Microcomputer," *Library Journal* 110 (March 1985): 42-43; Lawrence A. Woods and Nolan F. Popek, *The Librarian's Guide to Microcomputer Technology and Applications*, published for American Society of Information Science (White Plains, NY: Knowledge Industry Publications, 1983); Mark E. Rovig, *Microcomputers and Librarians: A Guide to Technology, Products and Applications*, published in cooperation with the American Society for Information Science (White Plains, NY: Knowledge Industry Publications, 1982); Monica M. Ertel, "A Small Revolution: Microcomputers in Libraries," *Special Libraries* 75 (April 1984): 95-101.

[17]The literature is a rich source for discovering new uses for special in-house computer projects. To name just a few: Virginia Carlson Smith and William R. Treese, "A Computerized Approach to Art Exhibition Catalogs," *Library Trends* 23 (January 1975): 471-81; Eileen F. Bator, "Automating the Vertical File Index," *Special Libraries* 71 (November 1980): 485-91; Thomas H. Ohlgren, "Computer Indexing of Illuminated Manuscripts for Use in Medieval Studies," *Computers and the Humanities* 12 (1978): 189-99.

[18]For a brief discussion of the conference, see Jeffrey Horrell and Elizabeth O'Donnell, "Second International Conference on Automatic Processing of Art History Data and Documents: Pisa, Italy, September 14-17, 1984" *Art Documentation* 4 (Spring 1985): 9. The conference publications include (1) *Census: Computerization in the History of Art*, edited by Laura Corti, which contains 167 abstracts that were submitted and is intended to be the first volume of an ongoing series which will describe various computerized programs, and (2) *Automatic Processing of Art History Data and Documents: Papers*, edited by Laura Corti, two volumes which reprint 49 papers. The diverse papers included the following: William Y. Arms, "The Museum Prototype Project: The Search for Integration"; Lutz Heusinger, "Marburger Index"; Radomil Hruska, "An Information System for Art History Research and Management of the National Gallery in Prague"; T. H. Carpenter, D. C. Kurtz, and J. Boardman, "The Beazley Archive Computer Project: An Inventory of Athenian Figure-Decorated Clay Vases c. 625 to 350 B. C."; Toni Petersen, "The Role of the Art and Architecture Thesaurus in Automated Data Retrieval"; Bezalel Narkiss, "The Jerusalem Index of Jewish Art"; Eunice D. Howe, "A Computerized Index to Roman Guidebooks and Their Contents"; Arnold Nesselrath, "The Census of Antique Works of Art and Architecture Known to the Renaissance"; Daphne C. Roloff, "Scipio: The Art Sales Catalog Data Base"; John R. Clark, "Correlational Comparison of Poses of Greek Sculpture"; Russell A. Kirsch, "Making Art Historical Sources Visible to Computers: Pictures as Primary Sources for Computer-based Art History Data"; and George K. Atkins, "Computer Assisted Research on Coptic Textile Design." Another publication, *The Proceedings* will also be issued. To order contact Scuola Normale Superiore, Piazza dei Cavalieri, 7, Pisa 56100, Italy.

[19]William Saffady, "Data Management Software for Microcomputers," *Library Technology Reports* 19 (September/October 1983): 451-592; *Online Microsoftware Guide and Directory* (Weston, CT: Online Inc., 1984), which contains 700 microsoftware package descriptions; Carol A. Tenopir, "Identification and Evaluation of Software for Microcomputer-Based In-House Databases," *Information Technology and Libraries* 3 (1984): 21-34; Mark E. Rovig, *Microcomputers and Libraries: A Guide to Technology, Products, and Applications* (White Plains, NY: Knowledge Industry Publications, Inc., 1981).

[20]See Allan D. Pratt, *A Selective Guide to the Microcomputer Literature* (Tucson, AZ: Graham Conley Press, 1983). Pratt indicates that as of 1983 there were over 300 journals devoted to microcomputers. Some are general, such as *Microcomputers for Information Management: An International Journal for Library and Information Services* and *Software Review*; others are system specific, such as *Softalk* and *Nibble*, which are for Apple computer owners.

Part II

THE LIBRARY COLLECTION

An art library is judged by its collection. The librarian must build upon strengths that are present, anticipate needs before they arise, and enrich areas prior to requests for the material. In order to fulfill this obligation, the art librarian must have an intimate and detailed knowledge of art bibliographic tools and other resources. Chapters 3 through 9 discuss various kinds of materials collected and provide guidance on (1) how to appraise and choose items and (2) methods of purchasing and organizing special resources.

3

Collection Evaluation

INTRODUCTION

It is essential that the art librarian have a thorough knowledge of the existing collection in order to select materials and disseminate information. The first step is to analyze and evaluate the collection in relationship to the special clientele of the library. Various methods for evaluating collections—some quantifiable, others qualifiable—have been developed. Usually used in combination, these methods consist of: (1) the application of standards and the checking of bibliographies; (2) the interpretation of various factors such as use, circulation, interlibrary loan requests, and observed patterns in the literature; (3) the direct examination of the works on the shelves; and (4) the questioning of patrons.[1] Due to their importance, the first two methods will be discussed in more detail later in this chapter, which also includes a list of the Core Art Bibliographies that have been considered as authoritative works in the discipline of art librarianship.

Inspecting the materials on the shelves is, of course, subject to varying interpretations, but it does serve the very useful purpose of helping the librarian to know the existing collection. To be effective, it requires that the art librarian have subject expertise. Even a cursory examination will reveal duplicate copies and incomplete journal runs. Furthermore, one can observe the physical condition of the collection and obtain an impression of binding and microfilming needs.

Asking for user opinions is also a time-honored method. Underlying all selection activities is the assumption that the librarian knows the patrons and

their needs, but wise selectors will constantly solicit suggestions for orders from their clientele. Many curators and art faculty members have either the responsibility for collection building in their own subject areas or act in an advisory capacity to the art librarian. Public librarians are often apprised by patrons of their wants. Methods for obtaining patrons' views are to distribute a formal questionnaire, conduct interviews, or combine these two techniques. Prior to distributing the questionnaire, a pilot study should be conducted, because formulating unambiguous questions designed to elicit specific kinds of information is not easy. Sometimes ambiguities can be resolved by follow-up interviews, but unless the interviewers are careful, they may unconsciously influence the respondents.

COLLECTION STANDARDS

The most widely used method for evaluating a collection is to check the materials in the collection against authoritative bibliographies which are cited by particular standards. Two standards for art libraries are those developed by ARLIS/NA and the *RLG Conspectus Online*. In order to assist professionals in the field, *ARLIS/NA Collection Development Standards for Art Libraries* was published to establish a means of evaluating present holdings and formulating goals.[2] Standards were set for libraries in academic systems, museums, and public institutions. The procedures to be followed include: (1) establishing levels of collection development and (2) evaluating the present collection by checking the holdings against the basic Core Art Bibliographies, which are discussed at the end of this chapter.

Each library administrator should determine the research level of various aspects of the collection as specifically as possible in accordance with (1) the library's function within the parent institution, (2) the patrons to be served, (3) the scope and the size of the existing collection, (4) the formats of materials to be included, and (5) the budgetary constraints. The Resources & Technical Services Division of the American Library Association (RTSD) has published a list of research levels; most standards—including those of ARLIS/NA— have adopted some form of this list.[3] The research levels include:

(1) Comprehensive—acquiring as much significant material, in applicable foreign languages, as possible in order to achieve a thorough, and almost complete, special collection.

(2) Research—acquiring all major reference works in a specific area as well as the important serials and abstracting services in order to support independent, postgraduate, and dissertation research; foreign-language materials will be abundant.

(3) Study or instructional—acquiring the fundamental bibliographic tools, serials, and monographs to sustain work required in undergraduate and graduate courses. Some academic librarians further refine the study level by differentiating between advanced study-level and initial study-level. The former would be adequate to support advanced undergraduate and master's degree programs or to sustain independent study; the latter to support undergraduate courses only.

(4) Basic—acquiring materials that will assist patrons in discovering the existence of additional references in the field of study; includes encyclopedias, dictionaries, and some major serials; most works will be in English.

(5) Minimal—acquiring only a few basic reference works on subjects that are outside the scope of the library's collection.

Not all parts of the collection will follow the same levels. For instance, a museum that specializes in American art might have mainly works concerned with Americana at the research level plus some materials on English art, which complement and supplement American art, at a study level. Works on Oriental art, however, might be kept at the basic or minimal level.

Tending to be quantitative rather than qualitative, standards frequently include formulas for measuring the collection. The ARLIS/NA standards follow this pattern: defining collecting levels, listing the 12 basic Core Art Bibliographies, and providing descriptions of the formats of materials acquired by art libraries. For each type and size of library, a specific number of volumes and serial subscriptions is indicated. For academic and public libraries, a percentage of the parent institution's budget is suggested. For academic libraries, an appropriate percentage is prescribed for titles in Mary Chamberlin's *Guide to Art Reference Books* or indexed in *Art Index*, *RILA*, and/or *ARTbibliographies MODERN*. A formula is proposed for museum libraries that specifies a number of volumes plus an additional number for each curator on the staff. An average annual growth rate is also given.

In evaluating the collection of the library, the holdings are checked against the titles of an established list of authoritative works, such as that provided by *ARLIS/NA Collection Development Standards*. Moreover, this list needs to be augmented by special bibliographies and other references: catalogs of important art libraries, such as *Catalog of the Library of the Museum of Modern Art*; periodical listings, such as those found in RILA; scholarly book-dealers' catalogs—such as those by Ars Libri, Ltd.—that cite works accompanied by the corresponding numbers used in Arntzen/Rainwater's *Guide to the Literature of Art History* and Chamberlin's *Guide to Art Reference Books*; and subject bibliographies compiled by scholars. Art librarians need to either identify relevant bibliographies or create their own lists by consulting scholars or by doing their own citation studies.

The use of scholarly subject bibliographies cannot be overemphasized. Bibliographies, such as those which will be discussed in Chapter 4, are important, as are the briefer ones published in *Art Documentation*. Some of the specialized bibliographies in the ARLIS/NA journal provide data which would be difficult and time-consuming to compile. An example is "Health Hazards of the Studio and Darkroom," a list of books, periodicals, and pamphlets reported in the "Academic TOL" column, edited by Barbara Polowy.[4]

A powerful tool for collection assessment from the Research Libraries Group is the *RLG Conspectus Online*, a special RLIN database. In November 1982, RLG member libraries began assigning research level codes—from 0 (do not collect) to 5 (most comprehensive)—for their materials in the LC classification. These codes represent both their extant collections and current collecting policies. The core bibliographies recommended by RLG are similar, but not exactly the same as those of ARLIS/NA. For instance, a suggested supplement for libraries collecting current art is *Contemporary Art Trends 1960–1980* by Doris L. Bell.[5]

Unlike the *ARLIS/NA Standards*, the *RLG Conspectus* makes no reference to the size or type of library. As stated in Chapter 2, membership and associate membership in RLG—the Research Libraries Group—is limited. Within the various research levels, percentages are provided for the number of journals—to which a library should subscribe—in *Art Index, RILA, ARTbibliographies MODERN,* and *Répertoire d'art et d'archéologie*. Percentages are also included for works cited in some of their core bibliography. Using the *RLG Conspectus*, member librarians can identify fields where collections are strong. The potential for extending the *RLG Conspectus'* usefulness is great; its value in cooperative collection building and interlibrary loans is just beginning to be realized.[6]

Although both of these standards are realistic and authoritative in that they have been based on actual practice in ARLIS/NA member libraries, a few caveats might be mentioned.[7] These basic bibliographies will have to be augmented and changed as new publications appear. In addition, one might ask why in the *ARLIS/NA Standard* a percentage of the journals indexed in the *Répertoire d'art et d'archéologie* is not included for a large academic library or a percentage of *Art Index* journals for public libraries. Neither of these standards solve the problem of exhibition catalogs, which are among the most important references in art libraries. A more basic criticism of the application of standards is that they measure only holdings and not the use to which such holdings are put.

In her article, "Collection Evaluation in Fine Arts Libraries," Loren Singer provides a practioner's viewpoint on the subject.[8] Discussing various methods, both quantitative and qualitative, Singer gives concrete examples

of evaluating the art education and photography collections of Concordia University, Montreal, Canada. In the study, the levels of adequacy for the library's holdings were decided prior to the checking of the library's holdings against specialized bibliographies.[9] For this project, the following levels of adequacy were established for the percentage of books, held by the Canadian library, which were cited in the various bibliographies: minimal—below 50%, adequate—50–60%, good—60–80%, and excellent—80–100%. In addition to the numerous tables which illustrate the study, there is a lengthy bibliography.

ANALYZING THE COLLECTION AND ITS USE

There are several additional ways in which a collection can be evaluated. These analytical methods tend to fall into two categories: studies of the patron and of the literature. Many of these studies rely upon the gathering and interpretation of statistical data. In spite of the apparent validity of research projects, many librarians prefer to augment statistical analyses with qualitative judgments based on subject knowledge and familiarity with their patrons.[10]

Among the most widely employed methods for analyzing a library collection are those based on use, which have as an underlying assumption that the past is a good predictor of the future. A record of circulation statistics compiled over a period of time is usually a prerequisite. Academic and public libraries are most likely to have such data, but there are also methods available for the study of in-house use which can be utilized by non-circulating libraries. These various methods are discussed in detail by F. W. Lancaster in his article "Evaluating Collections by Their Use."[11]

But even the very concept of use itself is elusive. Is merely handling a book only to reject it to be counted as use? Generally speaking, most studies have been based on the broadest possible interpretations, that is, even the briefest consultation of material is considered use. Additionally, interlibrary loan requests have been analyzed as good guides to collection gaps. By compiling lists of the categories requested, one can identify major omissions.

There have been very few user studies for the humanities, although there is some indication that these patrons utilize library materials more than do their colleagues in other disciplines.[12] In one study of 1900 interlibrary loan requests in academic libraries, it was discovered that for the humanities, the requests were for 58% monographs, 25% serials, 5% dissertations and theses, with the rest being miscellaneous works.[13]

One of the few specifically art-related user studies which has been reported in the literature is "Survey of Periodical Use in an Academic Art Library" by Betty Jo Irvine and Lyn Korenic.[14] This two-year study of serials—which is discussed in Chapter 7—used shelving statistics to determine the frequency

of use. Because the methodology is detailed in the article, this procedure can be used as a model by other art librarians.

In her 1981 user-study on the information needs of a particular group of patrons—historians—Margaret F. Stieg describes the results from her questionnaire which was sent to 767 historians.[15] Twenty of the respondents were art and architectural historians. Although the statistics reported in the article were for all the respondents, not just the 20, the methods used to discover relevant published information by these researchers is revealing. The order of usefulness, from the most important to the least, was as follows: (1) bibliographies or references cited in books or journals, (2) book reviews, (3) specialized bibliographies, (4) discussion or correspondence with acquaintances elsewhere, (5) abstracts or indexes—with *RILA* being the strong preference of the art historians, (6) library catalogs, (7) browsing, (8) discussions with colleagues at their own institution, (9) conferring with known experts, and (10) requesting information from librarians. Librarians should take note of the order of the historians' preferences. Moreover, the low rating of librarians on the historians' information-seeking scale is cause for concern.

Notice the importance of browsing to the historians, as reported in the Stieg study. Open shelves are appreciated by this group of patrons. But since art books frequently contain expensive color reproductions, tipped-in plates, and sometimes original graphic work, these can pose a special preservation problem. If an expensive book is placed on an open shelf, even if made non-circulating, the work may become a candidate for mutilation and vandalism. Put in limited access areas, books may be safer, but the patron can not find them through physical browsing. Some computer catalogs allow for electronic browsing by book titles, but to many patrons this does not replace surveying the actual works.

A more specific group of users was queried by Deirdre Corcoran Stam, whose study included 49 art historians from the Metropolitan Museum of New York City, the Cleveland Museum of Art, the State University of New York College at Purchase, and Oberlin College. Stam reports that the formats art historian use "have been common to the field for fifty years: monographs and basic reference works, black-and-white photographs, and the *Art Index* . . . librarians are contacted seldom except for procedural advice such as matters connected with interlibrary loan."[16]

One method of analyzing art collections is to study the patterns of the literature. In his pioneering study of monographic and serial material, *Characteristics of the Research Literature of the Fine Arts During the Period 1948–1957*, W. C. Simonton analyzed the footnote references of six periodicals. The serials chosen were from different countries—*Archivo español de arte, Art Bulletin, Bollettino d'arte, Burlington Magazine, Gazette des beaux-arts, and Zeitschrift für Kunstgeschichte.*[17] Of the 3058 citations studied,

2182 or 71.4% were for books, 876 or 28.6% for serials. Of the book citations, 39 titles or 2.26% accounted for 241 or 11.04% of the total citations. This analysis clearly indicates the importance of monographic literature to the arts. Although Simonton's study needs to be replicated—for instance, there has been a radical change in the number and quality of exhibition catalogs published since 1957—librarians should be aware of this classic.

Simonton found that of the 3058 monographic titles that were cited, 2140 or 70% derived from the fine arts, 507 or 16.6% from history, 99 or 3.2% from language and literature, and 93 or 3% from religion and theology. This study revealed that of the articles which pertained to architecture, 62.6% were from fine arts serials. For articles on drawing, 86.1% of the publications dealt with the fine arts. He concluded that "the subject balance of library collections in the Fine Arts may vary considerably depending on the pattern of subject interests of the clientele of the library."[18] Although this study underlines the need for peripheral non-art material for the art patron, a choice of other source serials may have yielded different results.

Simonton reported that only 32.7% of the citations in the issues of *Art Bulletin* referred to books and articles written in English; for *Burlington Magazine*, 44.9% of the citations were for references in this language. German was the language used in 20.6% of the citations in *Art Bulletin*; 15.1% were in French. For *Burlington Magazine*, 14.5% were in German, 16.7% in French. Remember, these serials were published between 1948 and 1957.

It is evident that much art historical research requires the use of foreign-language materials. In a 1970s British study on the language barrier in an academic community, the most frequently used material, other than English, was written in French.[19] In the United States, French or German is usually the required language for a master's degree in art history. Unfortunately, the reading level of foreign languages by graduate students is not always sufficient to translate large bodies of text, especially of non-art material. Librarians should be careful to match purchases of foreign-language materials to the reading abilities of their clientele. For instance, a book written in Lithuanian with no illustrations will probably never be read except in the most specialized libraries. However, a research library will collect even materials in esoteric languages because of the valuable documentation and photographic reproductions provided by these works.

Another method of studying the dynamics of the literature is through bibliometric studies, which have been defined by William Gray Potter as "the study and measurement of the publication patterns of all forms of written communication and their authors."[20] Although these studies have been conducted most often on scientific and technical literature, rather than for the humanities, there are a number of indications that the same patterns hold true, albeit with some variation.[21] For instance, it is often said that scientific

literature obsolesces rapidly while literature of the humanities does not.[22] On the other hand, it does indeed obsolesce, just at a slower rate. Citation analysis is a technique that has been widely used to determine patterns of scholarly publication. Obsolescence and most predominant languages have been determined from citation counts. Applications of Bradford's Law, another bibliometric technique, will be discussed in relation to serials in Chapter 7.

Art librarians should become familiar with some of the seminal quantitative studies as well as attempt to keep up with new research reported in both the art and the general library and information science literature. This research can be augmented by compiling comparative data from their own subject fields. The end result will be a better understanding of the literature that they are responsible for collecting and disseminating.

CORE ART BIBLIOGRAPHIES

The *ARLIS/NA Collection Development Standards* cites 12 essential major bibliographic works which can be used to access the wide spectrum of art materials and for collection evaluation and development. The contents of this core should be studied intently. Each work emphasizes special research materials of which librarians must be aware, regardless of the type or size of their institutions. Some of the references in the core are updated on a regular basis; others are out of print and useful only for older material. Moreover, this core of art bibliographies will need to be augmented as newer, more up-to-date references are published. The call numbers of the material owned by the library or a check to indicate the serials to which the institution subscribes should be added beside the entries in these bibliographic tools. This will reveal the extent of the library's collection as well as make it easier to locate the books on the shelves.

The 12 references that constitute the Core Art Bibliographies can be divided into works which concentrate on or are noted for (1) general art bibliographic material, (2) architectural and decorative arts bibliographic material, (3) monographs on artists, (4) methodology for art research and for utilizing art bibliographic materials, and (5) abstracting/indexing of serials, exhibition and museum-collection catalogs, books and book reviews, visual resources, and collective works of congresses, symposia, and *Festschriften*. This section follows these categories. In order to discover the strengths of the 12 references—all of which cite materials in Western European languages—librarians should read some of the reviews of these works which are recorded in the notes at the end of the chapter. Because these research tools are discussed throughout this book, the abbreviations by which each of the works will be cited is provided in parentheses.

General Art Bibliographies

The following references can be used to identify books that pertain to specific subjects, such as Scandinavian furniture, sculpture techniques, or Egyptian painting. It should be noted that none of these works contains monographs on individual artists. By carefully reading the annotations, librarians can make decisions as to what books should be added to their collections.

Arntzen, Etta, and Rainwater, Robert. *Guide to the Literature of Art History.* Chicago: American Library Association, 1980. (Abbreviated Arntzen/Rainwater)[23]

An extension of Chamberlin's 1959 work, cited below, the contents are divided into four principal sections. Part I, "General Reference Sources," has chapters on bibliographies, directories, sales records, visual resources, dictionaries and encyclopedias, and iconography. Part II, "General Primary and Secondary Sources," contains sections on historiography and methodology, sources and documents, and history and handbooks. Part III, "The Particular Arts," provides extensive listings for works on architecture, sculpture, drawing, painting, prints, photography, plus decorative and applied arts. These sections are subdivided by historical styles and countries. Part IV provides entries for periodicals and works written in series. There are two indices: to authors/titles and to subjects. Lengthy annotations are added for the more than 4000 entries.

This important bibliography, which contains numerous foreign-language references, repeats 40% of the works cited by Chamberlin. Most titles are in Western languages; where applicable, English translations are given. Essential for all art libraries, this is one of the most extensive bibliographies of art references which has been compiled. The various editions, translations, and publication changes that have occurred for each reference are all indicated. Some important exhibition and museum-collection catalogs are included. At times, quotations from book reviews are reprinted. Special appendices, indices, and glossaries are noted. Some of the citations refer to other bibliographies which are not individually listed in the Arntzen/Rainwater book. For example, under "Sculpture, Ancient, Egypt and Western Asia," there is a cross reference to the basic bibliography in the fourth edition of Henri Frankfort's *The Art and Architecture of the Ancient Orient*, 1969.

The last part of the guide has two important chapters. In "Periodicals" there are 356 entries for serials which update the entries in Chamberlin's book. There are about 100 additional serials. Each citation provides (1) pertinent data on title and volume number changes, (2) information on

the contents, and (3) a list of abstracting/indexing services that cover the serial. The chapter "Series" lists 78 European and American art publications, including such exhibition series as the Council of Europe, Documenta, and the Venice Biennale. Although only representative titles are recorded, the data will greatly assist research librarians in locating these often elusive titles. Antiquarian dealers frequently add numbers from this reference book to their sales catalogs in order to indicate the stature of a particular book.

Chamberlin, Mary W. *Guide to Art Reference Books*. Chicago: American Library Association, 1959. (Abbreviated Chamberlin)[24]

Although most of them are now out-of-print, the more than 2500 entries—many of which are in foreign languages—are still important references for researchers and are useful for retrospective purchasing and collection evaluation. The chapters are divided as to bibliographies, indexing services, directories, sales records, reproductions, dictionaries and encyclopedias, biography, methodology, histories and handbooks of art, architecture, sculpture, drawings, paintings, prints and engravings, applied arts, documents and sources, periodicals, series, plus special collections and resources. Numbered consecutively, the annotated entries provide location aids. These numbers are often used by antiquarian book dealers to indicate the stature of a particular book they are trying to sell. This guide was updated by Arntzen/Rainwater, which was discussed previously.

Ehresmann, Donald L. *Fine Arts: A Bibliographic Guide to Basic Reference Works, Histories, and Handbooks*, 2nd edition. Littleton, Colorado: Libraries Unlimited, Inc., 1979. (Abbreviated Ehresmann *FA*)[25]

Any references cited in this book must treat two or more of the major media of architecture, sculpture, and painting. Originally conceived as a supplement to Chamberlin, this revised edition consists of two parts. The first section on reference works is subdivided into bibliographies, library catalogs, indexing services, directories, dictionaries and encyclopedias, and iconography. The second part encompasses histories and handbooks of world art history, representing prehistoric and primitive art, periods of western art history—from ancient to the 20th century—plus national histories and handbooks of European, Oriental, and North and South American art, as well as art of Africa and Oceania. There is an author-title-subject index to the more than 1670 entries. This is one of a series of bibliographies, the others cover or will cover (1) architecture, (2) decorative arts, (3) painting and graphic arts, and (4) sculpture.

Muehsam, Gerd. *Guide to Basic Information Sources in the Visual Arts.* Santa
 Barbara, California: Jeffrey Norton Publishers, Inc., 1978. (Abbreviated
 Muehsam)[26]

A guide primarily for undergraduate art history majors, the book consists
of a list of 1045 chiefly English-language works categorized by historical
periods of Western art, art forms and techniques, and national schools
of art. The lack of annotations makes quick reference work difficult.

Architectural and Decorative Arts Bibliographies

All art librarians will find these works useful.

Avery Library. *Catalog of the Avery Memorial Architectural Library of
 Columbia University.* 2nd edition enlarged. Boston: G. K. Hall &
 Company, 1968. 19 volumes. *First Supplement,* 1973. 4 volumes. *Second
 Supplement* 1975. 4 volumes. *Third Supplement,* 1977. 3 volumes. *Fourth
 Supplement,* 1980. 3 volumes. The records which date from 1980 are
 available through RLIN. (Abbreviated *Avery Catalog*)[27]

The finest architectural library in the United States was founded in 1890
by Samuel Putnam Avery. Its first catalog was published five years later.
Subsequent editions emphasize not only architecture but also related
subjects, such as archaeology, rare topography prints, landscape and
military architecture, sculpture, mosaics, stained glass, tapestries,
armour, costume design, metal work, furniture design, ornament,
interior decoration, and city planning. A dictionary catalog of authors,
subjects, and selective titles, this is a union list of all of the art and
architecture libraries in the Columbia University system: the Avery
Library, the Fine Arts Library, and the Ware Library. Although the
records which date from 1980 are available through RLIN, this online
system will be accessible to fewer researchers. In addition, the subject
search capabilities of the computerized version are limited.

Ehresmann, Donald L. *Applied and Decorative Arts: A Bibliographic Guide
to Basic Reference Works, Histories, and Handbooks.* Littleton, Colorado:
 Libraries Unlimited, Inc., 1977. (Abbreviated Ehresmann *A&DA*)

More than 1,200 books written in Western European languages,
published between 1875 and 1975, constitute this bibliography for the
general reader as well as the expert. Sections cover general dictionaries,
histories, and handbooks on applied and decorative arts and the specific
subjects of ornament, folk art, arms and armour, ceramics, clocks and
watches, costume, enamels, furniture, glass, ivory, jewelry, lacquer,
leather and bookbinding, medals and seals, metalwork, musical
instruments, textiles, plus toys and dolls. The chapters are subdivided

by countries. There are two indexes—to authors and to subjects. Works on collecting, investing, and restoration are excluded. Brief annotations are provided.

Ehresmann, Donald L. *Architecture: A Bibliographic Guide to Basic Reference Works, Histories, and Handbooks.* Littleton, Colorado: Libraries Unlimited, Inc., 1984. (Abbreviated Ehresmann *Arch*)[28]

Although published too late to be included in the ARLIS/NA Standards, this work supplements this core of art bibliographic references. Books published between 1875 and 1980 are annotated. The 1359 entries are categorized into reference works, general histories and handbooks, eight periods of architectural history—Primitive and Prehistoric, Ancient, Early Christian, Byzantine, Medieval, Renaissance, Baroque and Rococo, and Modern—and four geographical locations—Europe, Orient, New World, and Africa and Oceania.

Monographic Works on Artists

Of the references in this core of bibliographies, only the following two books and the abstracting/indexing services, which are discussed later, provide access to monographic works on artists.

Freitag, Wolfgang. *Art Books: A Basic Bibliography.* New York: Garland Publishing, Inc., 1985. (Abbreviated Freitag)

Includes all of the citations from Lucas' *Art Books* and expands the coverage to more than 1870 artists working in all media: painting and drawing, sculpture, architecture, graphic arts, photography, and decorative and applied arts. Significant publications of a monographic nature are listed—biographies, *œuvre* catalogs, catalogues raisonnés which are indicated by a CR, and catalogs of major exhibitions and sales. Artists' writings of an autobiographical or theoretical nature are also included. There are about 10,540 citations. Because it includes, augments, and updates Lucas' work, this book will replace *Art Books* as a core art bibliography.

Lucas, E. Louise. *Art Books: A Basic Bibliography on the Fine Arts.* Greenwich, Connecticut: New York Graphic Society, Ltd., 1968. (Abbreviated Lucas)

Although there are no annotations, which curtails its usefulness, the list of monographs on about 550 artists is often used by antiquarian book dealers.

Methodology for Art Research and Art Bibliography

The following reference can be used (1) to study the kinds and means of research art students and scholars will be conducting, (2) to assist patrons

in understanding in-depth research methods, and (3) to train the library-staff members who may not have art expertise. The types of materials discussed are more varied than in the other resource tools.

Jones, Lois Swan. *Art Research Methods and Resources: A Guide to Finding Art Information*. 2nd edition, enlarged and revised. Dubuque, Iowa: Kendall/Hunt Publishing Company, 1984. (Abbreviated Jones)[29]

Written to instruct art students in the methodology of art research and the use of the library, this book provides detailed discussions on various kinds of art reference works. It is divided into four sections. "Part I: Before Research Begins" contains three chapters which (1) describe the methods of stating the purpose and problem of a study; (2) detail how to utilize a library, including the differences between various catalog formats and library services; (3) define terms used in exhibition and auction catalogs; and (4) discuss bibliographies, chronologies, museum-collection and exhibition catalogs, and auction information.

Using specific examples, the second part explains methodology—in a step-by-step approach—to basic research, research on specific people, research on individual works of art, and architectural research. This section also suggests solutions to additional problems, such as those encountered by art/museum educators, buyers and sellers, artists wishing to locate competitive exhibitions, and film researchers.

The reference works in the third section are organized according to the kinds of information they provide. Detailed annotations are cited for more than 1500 works, including microforms and online databases. English-language books are emphasized. The subdivisions cover art encyclopedias and dictionaries; biographical dictionaries; catalogs of holdings of famous libraries; abstracting/indexing services and databases; art references; museum-collection catalogs; exhibition information; sales data; sources for reproductions of works of art and architecture; fashion and jewelry; references on subjects and symbols in art; book and film review resources; reference aids and directories; special references for architects, art/museum educators, commercial designers, film researchers, photographers, and printmakers; and marketing aids and suppliers of products and services.

Part IV discusses how to decipher incomplete bibliographic citations and how to use interlibrary loan services. It also lists the collection strengths and entrance requirements for major research centers in Europe and North America. The appendices consist of three dictionaries of French, German, and Italian art terms, plus a multi-lingual glossary of French, English, German, Italian, and Spanish terms designating proper names; geographical locations; words denoting time, numbers, and animals; plus names used in Greek and Roman mythology. There are

indices to publications and institutions and to subjects, terms, and professions. In addition, material on how to conduct an online bibliographic database search is included.

Abstracting/Indexing Services for General Art Subjects

The four abstracting/indexing tools cited below are particulary important for obtaining data on current material.[30] These services have online bibliographic databases which are discussed in Chapter 11. This computerized cumulation of material makes these references easier and quicker to use than checking each of the paper copies. Although some of the periodicals covered by these services may overlap, it is important to subscribe to as many of them as possible, since it is exceedingly easy for pertinent material to be overlooked by one of the services. The periods covered, the scope, and the types of materials included differ from service to service. Librarians and researchers should study the reviews of these abstracting/indexing tools carefully in order to distinguish the extent and depth of their coverage. A complete run of the indices must be maintained.

Art Index. New York: H. W. Wilson Company. Volume 1 (1929) + .

Prior to 1929, indexing of art journals was done by individual libraries, resulting in great duplication of effort. It was to eliminate this duplication and thus bring uniformity to the indexing that the directors of the American Association of Museums and the Association of Art Museum Directors requested the editors of the H. W. Wilson Company to publish a tool for retrieving information from art journals. The first issue of *Art Index* was published in January 1930. Eventually, indexing was done retrospectively to cover all of the 1929 publications of the 135 periodicals then covered by Art Index.

The original subject fields were archaeology, architecture, ceramics, decoration and ornament, graphic arts, landscape architecture, painting, and sculpture. These topics have altered somewhat over the years and now also include art history, city planning, crafts, fine arts, industrial design, interior design, museology, as well as photography and films. Some magazines written in English, Dutch, French, German, Italian, and Spanish were indexed then, as they are now. During the first years of publication about 55% of the 135 periodicals were in the English language, today this has increased to around 70% of the almost 200 journals covered.

Frequently, the subscribers to *Art Index* are requested to vote on the selection of periodicals to be included. Naturally, most librarians want coverage of the serials already owned by their institutions. This is one of the reasons the list of periodicals covered over the years has changed,

not only in numbers but in titles. In the early issues the preface clearly indicated those publications which had merged, were discontinued, or had been added. No longer is this recorded. When looking for articles in a specific magazine, each issue of *Art Index* should be checked to be sure that the coverage has been continuous for the desired periodical.

As in any work that is published over a long period of time, *Art Index* has changed slightly in format. Book reviews are now listed twice: (1) under the subject of the book being reviewed, there is a notation of the book reviewer and the periodical where the article was published, and (2) at the end of each issue there is a separate section for book reviews with the critiques cited under the names of the authors of the books. Certain headings have been changed, such as "INTERIOR design" instead of "INTERIOR decoration," and others have been added— "PRE-COLUMBIAN" and "REMODELING." In 1976 the subheading "Influence" was created and appeared as a subdivision under the names of artists.

Using a subject-author dictionary format, *Art Index* covers all historic periods and media of art. Although no annotations or abstracts describe the contents of the articles, *Art Index* is one of the best sources for locating specific works of art. When illustrations accompany an article, up to ten titles of these reproductions will be recorded. If the number exceeds ten, the number alone will be provided. Reproductions of works of art that have no text are listed by title. *Art Index* is available as an online database through WILSONLINE.

ARTbibliographies MODERN. Santa Barbara, California: ABC-Clio Press. Volume 1 (1969) + [31]

For libraries whose clientele require information on 19th- and 20th-century art, *ARTbibliographies MODERN* is essential. This semi-annual publication is only concerned with art since 1800. The first three volumes, for 1969–1971, were published as annuals under the title *LOMA: Literature of Modern Art*. With the name change, Volume 4 (1973) became a semi-annual. Each issue includes: (1) "Classification Headings," (2) "List of Periodicals," (3) the subject and author entries interfiled in dictionary format, (4) "Author Index," and (5) "Museum and Gallery Index." Each publication contains abstracts or brief annotations for entries from about 125 to 190 periodicals, in addition to pertinent material from other selected serials.

Throughout the years, the headings have changed and expanded, increasing from about 150 major divisions to around 225. The greatest explosion has been in the number of combinations used with the term *Art*— such as "Art and Light," "Art and Metaphysics," and "Art and Psychoanalysis"— increasing from about 12 in the early years to more

than 30 in current use. One of the assets of *ARTbibliographies MODERN*
is the many listings of exhibition catalogs compiled for private
galleries. The section "Museum and Gallery Index" increased from more
than 200 entries to about 385; but some of these are multiple listings
as traveling exhibitions are cited for each museum where the show was
displayed. Since 1983, architectural serials have received increased
coverage. The *ARTbibliographies MODERN Database* with its
cumulation of files from 1973 is available through DIALOG.

Répertoire d'art et d'archéologie. Paris: Centre de Documentation Sciences
 Humaines. Volume 1 (1910) + [32]

The oldest continually published index for art material is the *Répertoire
d'art et d'archéologie,* which began in 1910. There were no issues during
World Wars I and II, and the scope of the coverage has changed over
the years. About 1750 periodicals are scanned on art and history from
Christian times (circa 200 A.D.) to the present, although post-1940,
Islamic, Far Eastern, and Primitive art are excluded. Many Eastern as
well as Western European serials are covered. About 30% of the articles
cited are written in English; approximately 16% are in French.

 In 1973 the format was changed to make the *Répertoire d'art et
d'archéologie* more useful. Each volume is now divided into (1) *"Plan
de Classement,"* the table of subject headings; (2) *"Analyses et
Signalements,"* the abstracts; (3) *"Liste des revues depouillées,"* a list
of serials with their years of publication and volume numbers recorded
in that issue; (4) *"Liste des recueils collectifs,"* an index begun in 1981
to record *Festschriften* and reports of congresses covered in that issue;
(5) *"Index,"* subdivided into (a) *"Index des artistes,"* (b) *"Liste des codes
de pays utilisés dans l'index des matières,"* abbreviations for the countries
discussed, and (c) *"Index des matières,"* the subject index; and (6)
"Tables des Auteurs," authors cited only by last name and first initial.
The abstract section, *"Analyses et Signalements,"* is subdivided into (a)
"Principes et Organisation," which includes reference works, art theory,
science of art, iconography, techniques and restoration, professional and
educational institutions, and collections; (b) *"Histoire generale de l'art;"*
(c) *"Moyen Age";* (d) *"Renaissance, XVII^e et VIII^e siècles,"* and
(e)*"XIX^e et XX^e siècles."* The last four sections are subdivided into
general works, architecture, sculpture, painting and graphic art, plus
decorative art. These subjects are further subdivided by country. For
many entries in the *"Analyses et Signalements,"* there are brief
annotations. This service has computerized information available
through QUESTEL; the database—with records dating from 1973—is
entitled *Repertory of Art and Archeology*, which is Chapter 530 of the
Francis-H Database.

RILA; International Repertory of the Literature of Art. A Bibliographic Service of The J. Paul Getty Trust. Williamstown, Massachusetts: Sterling and Francine Clark Art Institute. Volume 1 (1975) + [33]

The project that produced *RILA* commenced in 1971 under the auspices of the College Art Association and Washington's National Gallery of Art. A demonstration issue was printed for 1973, but regular, semi-annual publications began with Volume I (1975), which was a double issue in two parts that covered 1974 and the first half of 1975. Originally entitled *Répertoire international de la littérature de l'art*, abbreviated to *RILA*, the abstract service covers periodicals, current books, exhibition catalogs, dissertations, and *Festschriften*. The historical periods include post-classical European and post-Columbian American art to the present. Because many of the abstracts are submitted by the authors of the material, a single issue does not have complete coverage of each periodical reported in that volume.

Each issue of *RILA* clearly records the volume numbers of the magazines that are indexed. For instance, in Volume 7/1 (1981) of *RILA*, in the "Journal Index," for *American Art Journal* there are entries for Volume XI, numbers 1, 2, 3, and 4 plus Volume XII, numbers 1, 2, and 3. Volume 7/2 (1981) of *RILA*, has entries for *American Art Journal*, Volume XII, 1, 2, 2, and 4 plus Volume XIII, 1. Throughout the issues of *RILA*, there is complete coverage for *American Art Journal* since Volume IV, 1 (Spring of 1972) when *RILA* was first published.

Although there have been minor format changes over the years, *RILA* is divided into (1) "Journal Index," the list of periodicals covered in that issue, (2) the subject section containing the abstracts of each publication, (3) "Author Index," (4) "Subject Index," and (5) "Abbreviations." The subject section is subdivided as follows:

(1) Reference Works: bibliographies, dictionaries and encyclopedias;
(2) General Works: collected works including *Festschriften*, art historians and critics, miscellanea, iconography, architecture, sculpture, pictorial arts, and decorative arts;
(3) Medieval Art: 4th-14th centuries;
(4) Renaissance, Baroque and Rococo Art: 15th-18th centuries;
(5) Neo-Classical and Modern Art: late 18th century to 1945;
(6) Modern Art: 1945 to present;
(7) Collections and Exhibitions: miscellanea, public collector, and exhibitions listed by city. Sections 1 through 6, from Medieval to Modern, are subdivided as to miscellanea, architecture, sculpture, pictorial arts, decorative arts, and artists, architects, and photographers.

The original 1973 issue covered 154 serials, all of which were published between 1969 and 1972. Under a separate section, "Exhibitions," there were around 355 cross references for the 250 exhibitions which were abstracted in the subject section of *RILA*. If a show traveled to more than one museum, each institution was listed. For example, the Winslow Homer exhibition catalog was cited under "ALBANY (NY), Institute of History and Art"; "BUFFALO (NY), Albright-Knox Art Gallery"; and "NEW YORK, Metropolitan Museum of Art." All of these entries had cross references to the abstract for the catalog which was under the subject, "MODERN ART, Artists." Over the years, the coverage has expanded. More than 400 periodicals are now included, about half of which are in the English language. The section "Exhibitions" often cites as many as 1200 references to exhibition catalogs.

RILA has some interesting features. For current books that are listed, the ISBN and LC numbers as well as the prices are included. For illustrations that accompany articles, the total number plus the ones in color are given. In the "Subject Index," country of origin, media used, as well as birth and death dates are usually provided for artists. Under the abstract section, "COLLECTIONS, Public Collections (by city)," there are citations for catalogs of permanent museum collections which have been recently published. This information is exceedingly difficult to find elsewhere.

RILA provides one of the best sources for the indexing of (1) *Festchriften* and (2) the proceedings of congresses and conferences. Under "General Works: Collected Works," the following information is recorded for each *Festschrift*: title, bibliographic data, the person honored, and an individual listing of the authors, titles, and contents of the essays. In addition to this main abstract of the *Festschrift*, each individual author of the collected essays is cited in the "Author Index."

RILA has published several aids for researchers. *Cumulative Subject Index 1975–1979* provides quick information on the material covered in these five years; *RILA Subject Headings*, which is a comprehensive listing of terms—4182 accepted terms and 1045 "see" references—used in this subject index, will greatly aid database searches. *Raphael: A Bibliography 1972–1982* consists of 553 references on the famous Italian painter, only 270 of which were previously cited in *RILA*; the other entries were culled from 16 other bibliographic sources. In addition, *Art Literature International (RILA) Database*—with cumulative files since 1974—is available through DIALOG.

In 1985 it was announced that *RILA* and *Répertoire d'art et d'archéologie* will enter a cooperative arrangement with the intention of

providing both a single comprehensive database as well a paper publication. Negotiations may take a number of years, but the potential for art historians is great.[34]

NOTES

[1]For a useful discussion of evaluation methods available to the academic art librarian, which can readily be applied to museum and public libraries, see Peggy Ann Kusnerz, "Collection Evaluation Techniques in the Academic Art Library," *Drexel Library Quarterly* 19 (Summer 1983): 28–51.

[2]Published in *Standards for Art Libraries and Fine Arts Slide Collections*, Occasional Papers No. 2, (Tuscon, AZ: Art Libraries Society of North America, 1983).

[3]American Library Association, Resources & Technical Services Division, Collection Development Committee, *Guidelines for Collection Development*, edited by David L. Perkins (Chicago: American Library Association, 1979).

[4]"Health Hazards of the Studio and Darkroom: A Brief Guide to Sources of Information," edited by Barbara Polowy, *Art Documentation* 3 (Winter 1984): 125–26.

[5]Doris L. Bell, *Contemporary Art Trends, 1960–1980: A Guide to Sources* (Metuchen, NJ: Scarecrow Press, 1981). Includes definitions and brief discussions of the historical development of a number of late 20th-century art movements —such as body art, earthworks, and holography and laser art. Lists relevant books, journal articles, and exhibition catalogs.

[6]Research Libraries Group, Inc., *Annual Report, 1982–1983* (Stanford, CA: RLG, 1983), pp. 23–25.

[7]See review of these standards by Trevor Fawcett, *Art Libraries Journal* 8 (Winter 1983): 36–38. Fawcett points out that these are guidelines rather than objective standards.

[8]Loren Singer, "Collection Evaluation in Fine Arts Libraries," in *Current Issues in Fine Arts Collection Development*, Occasional Papers No. 3 (Tucson, AZ: Art Libraries Society of North America, 1984).

[9]For a discussion of the term *adequacy*, see Michael Moran, "The Concept of Adequacy in University Libraries," *College and Research Libraries* 39 (March 1978): 85–93.

[10]See Kusnerz (Note 1).

[11]For an overview of methodologies available for use studies, see F. W. Lancaster, "Evaluating Collections by Their Use," *Collection Management* 4 (1982): 15–43.

[12]See J. E. Burchard, "How Humanists Use a Library," in *Planning Conference on Information Transfer Experiments, Woods Hole, Mass., 1964*, edited by F. J. Overhage and R. Joyce Harman (Cambridge, MA: M.I.T. Press, 1965): 219–23; and Lois Bebout, Donald Davis, Jr., and Donald Oehlerts, "User Studies in the Humanities: A Survey and a Proposal," *RQ* 15 (Fall 1975): 40–44. For a British survey, see Cynthia Corkill and Margaret Mann, *Information Needs in the Humanities: Two Postal Surveys*, CURS Occasional Paper 2 (Sheffield, England: Centre for Research on User Studies, 1978).

[13]See V. E. Palmour et al. *A Study of the Characteristics, Costs and Magnitude of Interlibrary Loans in Academic Libraries* (Westport, CT: Greenwood Publishing Company, 1972): 33–42.

[14]Betty Jo Irvine and Lyn Korenic, "Survey of Periodical Use in an Academic Art Library," *Art Documentation* 1 (October 1982): 148–51.

[15]Margaret F. Stieg, "The Information Needs of Historians," *College and Research Libraries* 42 (November 1981): 549–60.

[16]These findings were reported in Stam's article, "How Art Historians Look for Information," *Art Documentation* 3 (Winter 1984): 117–19. See also, Deirdre Corcoran Stam's

Ph.D. dissertation, *The Information-Seeking Practices of Art Historians in Museums and Colleges in the United States, 1982–83* (Columbia University, 1984).

[17]*See Wesley Clark Simonton's Ph.D. dissertation, Characteristics of the Research Literature of the Fine Arts during the Period 1948–1957* (University of Illinois, 1960). On page 10, Simonton lists the ten most cited books in his study: Giorgio Vasari's *Le vite de piu eccellenti pittori, scultori ed architettori,* Ulrich Thieme and Felix Becker's *Allgemeines Lexikon der bildenden Künstler von der Antike bis zur Gegenwart* (often called *Theime-Becker Künstlerlexikon*), Adolfo Venturi's *Storia dell'arte italiana,* Raimond van Marle's *The Development of the Italian Schools of Painting,* Jacques Paul Migne's *Patrologiae cursus completus: Series Latina,* Chandler Post's *A History of Spanish Painting,* Josef Wilpert's *Die römischen Mosaiken und Malereien der kirchlichen Bauten vom IV bis XIII Jahrhundert,* André Michel's *Histoire de l'art,* Juan Agustín Caén Bermúdez's *Diccionario histórico de los mas ilustres profesores de las bellas artes en España,* and Universidad Seville, Laboratorio de Arte, *Documentos para la historia del arte en Andalucia.*

[18]Ibid, p. 66.

[19]W. J. Hutchins et al., *The Language Barrier: A Study in Depth of the Place of Foreign Language Materials in the Research Activities of an Academic Community* (Sheffield, England: University of Sheffield Postgraduate School of Librarianship and Information Science, 1971), p. 107.

[20]William Gray Potter, "Introduction," *Library Trends* 30 (1980): 5.

[21]For an overview and bibliography of some of the important bibliometric studies, see Kusnerz (Note 1).

[22]Eugene Garfield, "Is Information Retrieval in the Arts and Humanities Inherently Different from That in Science?" *Library Quarterly* 50 (1980): 40–57. See also Johanna Ross, "Observation of Browsing Behavior in an Academic Library," *College & Research Libraries* 44 (July 1983): 269–76; and George D'Elia and S. Walsh, "User Satisfaction with Library Service—A Measure of Public Library Performance," *Library Quarterly* 53 (April 1983): 109–33. For a British study, see Clyve Jones, Michael Chapman, and Pamela Carr Woods, "The Characteristics of the Literature Used by Historians," *Journal of Librarianship* 4 (July 1972): 137–56.

[23]Reviewed: Katherine Haskins, *Library Quarterly* 51 (October 1981): 474–76; Janis Ekdahl, *ARLIS/NA Newsletter* 9 (October 1981): 208–10; Alex Ross, *The Art Bulletin* 65 (March 1983): 169–72.

[24]Reviewed: Marchal E. Landgren, *Library Journal* 84 (November 15, 1959): 3553–54.

[25]Reviewed: 1975 first edition by Christina Bostick, in *ARLIS/NA Newsletter* 3 (Summer 1975): Supplement 4–5.

[26]Reviewed: Lamia Doumato, *College & Research Libraries* 39 (July 1978): 324; Martha Kehde, *ARLIS/NA Newsletter* 6 (November 1978): 109–10.

[27]Reviewed: Stephanie Frontz, *ARLIS/NA Newsletter* 3 (October 1975): Supplement 1–5.

[28]Reviewed: Jack Perry Brown, *Art Documentation* 3 (Fall 1984): 108.

[29]Reviewed: *Museum Studies Journal* 1 (Fall 1984): 53–54; E. Jean Smith, *Museologist* 46 (Summer/Fall 1984): 31, 33; Christine M. Smith, *Art Documentation* 3 (Winter 1984): 142.

[30]Alexander D. Ross, "Abstracts and Indexes," in *Art Library Manual,* edited by Philip Pacey (New York: R. R. Bowker, 1977), pp. 168–85.

[31]Reviewed: Alexander D. Ross, "*ABM* and *RILA*: A Review," *ARLIS/NA Newsletter* 2 (December 1973): 1–5; Alexander D. Ross, *ARLIS/NA Newsletter* 2 (April 1974): 40–42; Christina H. Bostick *ARLIS/NA Newsletter* 4 (October 1976): 172–73.

[32]Reviewed: Alexander D. Ross, *ARLIS/NA Newsletter* 2 (Summer 1974): 57–61; Ilene R. Schlecter, "The Arrangement of the *Répertoire d'Art et d'Arch*éologie," *ARLIS/NA Newsletter* 8 (Summer 1980): 120.

[33]Reviewed: Stephanie Frontz, *ARLIS/NA Newsletter* 5 (December 1976): 19–20; Michael Rinehart, *ARLIS/NA Newsletter* 9 (December 1981): 225–26; Alexander D. Ross, *"ABM* and *RILA"* (Note 31).

[34]See *News from RILA* 3 (February 1985): 1, 3.

4

The Basic
Reference Collection

INTRODUCTION

The basic reasons for having a reference section are (1) to bring together certain frequently used, non-circulating works, which are often multi-volume, in a single place; (2) to facilitate the librarian's finding answers to patrons' questions; (3) to protect these resource tools from mutilation and vandalism; and (4) to provide table space for patrons using these materials. Although each individual library will require specific research materials to suit the needs of its clientele, many of the basic tools will be the same.

Academic and public libraries often have a special reference room; small libraries may have little need for such a space. In most libraries, there is at least a shelf, on which the most used reference books are placed. The position of the reference area and the works placed on the shelves depend mainly upon the research level of the library collection. The larger and more research-oriented the library, the more numerous and varied the materials.

To develop a reference section, a collection policy statement should be formulated to give direction to the selection; this processes is described in Chapter 12. Present holdings should be evaluated to indicate specific strengths and weaknesses. While checking the library's holdings against the pertinent works discussed in Chapter 3, a desiderata list should be compiled. The subject areas in which the collection is sufficient to support the research levels that have been selected should take precedence. By carefully reading the

annotations provided in the works which constitute the Core Art Bibliographies, a list of publications for retrospective purchasing can be compiled.

Which specific reference tools should a particular library own? Unfortunately, there is no magic formula or one publication which can answer this question.[1] It is for this reason that an art library should be administered by an art librarian—one who is proficient in the discipline of art as well as in library and information services. The skill of evaluating and choosing the correct materials is one of the greatest assets possessed by an art librarian. This expertise comes only with long diligent study and extensive experience.

Although subject expertise can come from obtaining a second master's degree from a university art department or from taking graduate art courses, subject awareness also comes from studying various reference tools and reading reviews and articles in library journals—especially the two important art-oriented ones: *Art Documentation*, formerly entitled *ARLIS/NA Newsletter*, and *Art Libraries Journal*. Once the selection is made, most of the resource tools can be purchased through regular acquisition channels, as described in Chapter 12.

Because they are usually not available through interlibrary loans and because of their frequent use, reference works should be studied closely and as many pertinent works as the budget can afford should be purchased. In a research library, these tools are usually the most important part of the collection. This chapter discusses (1) five types of resources—encyclopedias and dictionaries, catalogs of famous libraries, abstracting/indexing services, separate subject bibliographies, and location directories; and (2) some methods for evaluating reference works.

TYPES OF REFERENCE WORKS

In order to learn more about the various types of reference works—which ones are valuable for what kinds of research and which titles might be pertinent to their collections—librarians will need to consult the references which compose the Core Art Bibliographies cited in Chapter 3. Because not all of these resource tools are of equal value for specific types of work, this section includes additional details on these materials.

Encyclopedias and Dictionaries

Encyclopedias and both term and biographical dictionaries are part of every art collection. How many or what kinds may depend upon the size and purpose of the library. Although a high percentage of the questions patrons ask can usually be answered by a small group of these works, there are always

definitions of art terms and styles or biographies of artists and designers which are difficult to locate. For this reason, it is essential to have numerous good, well-researched encyclopedias and dictionaries, even if the subjects they cover overlap.

An art library should have encyclopedias and dictionaries on both general and specific subjects. *The Encyclopedia of World Art* is a basic art research tool, but *The Encyclopedia Britannica* should also be available in larger libraries. If patrons seek references for iconographical or hagiographical research, such tomes as *The New Catholic Encyclopedia* and *The Encyclopaedia of Religion and Ethics* may be required. For some institutions, the latest editions of specialized reference works will be essential. For instance, an architectural library may require the most current edition of Sir Banister Fletcher's *A History of Architecture*, which was first issued in 1898 and has had some 17 revisions; patrons of other institutions may be satisfied with one of the earlier versions. Nor should older material be overlooked; a reprint can be invaluable. For instance, the *Adeline Art Dictionary*, which was first translated into English in 1891, is still useful for some reference work.

The librarian should be vigilant in discovering any reference tools which will assist researchers in utilizing the works already owned. For instance, *Iconographic Index to Stanislas Lami's Dictionnaire des Sculpteurs de l'école français au dix-neuvième siècle*,[2] published in 1983, covers four of Lami's eight volumes. Thus, the new publication assists researchers in locating specific works of art depicting subjects and people. Lami's *Dictionnaire des sculpteurs de l'école française*, 1898–1921 was reprinted in 1970.

Dictionaries which are not specifically on art subjects, but which will assist patrons in their research, should also be made available. These would include such diverse works as guides to pronunciation, heraldry, and geneaology as well as dictionaries of saints, periods of history—such as the Classical World or the Renaissance—and construction terms. An unabridged dictionary and books of familiar quotations might be placed in this area. In addition, foreign-language dictionaries should be purchased for the reference shelf to assist patrons in using biographical dictionaries, such as Bénézit's *Dictionnaire critique et documentaire des peintres, sculpteurs, dessinateurs, et graveurs* and *Thieme-Becker Künstlerlexikon*. Specialized foreign-language dictionaries should also be available. For instance, *Dictionnaire de l'ancienne Langue Française* would be important for a museum with a medieval collection.

In order to compile a list of pertinent titles of encyclopedias and dictionaries—for both retrospective and current purchases—the following Core Art Bibliographies will prove the most useful.

Arntzen/Rainwater, Section E, "Dictionaries and Encyclopedias," includes both term and biographical dictionaries. Specialized references are listed under architecture, painting, photography, decorative and applied arts, costume, furniture, clocks and watches, pottery and porcelain, and glass.

Chamberlin can be used to become familiar with some of the references

already owned, but as a buying guide, it is too out-of-date for most material.

Ehresmann *FA* has a chapter on "Dictionaries and Encyclopedias." Ehresmann *A & DA* has brief annotated listings under general works, arms and armour, ceramics, clocks, watches and automata, costume, enamels, furniture, glass, gold and silver, textiles, embroidery, and lace. Ehresmann *A & DA* has entries under reference works, building technology, and city design.

Jones provides lengthy annotations for general and specific encyclopedias and term dictionaries plus entries for biographical dictionaries of artists. There are special entries for art/museum educators, film researchers, and pronunciation dictionaries as well as for some specialized non-art dictionaries. Under "Art Research Methods," there are detailed discussions on the use of these resource tools.

For a listing of recently published encyclopedias and dictionaries, the librarian will need to consult the abstracting/indexing services, checking each volume because Arntzen/Rainwater's research covers works mostly published prior to 1977. Of the four abstracting/indexing services, only *RILA* has a separate listing for "Reference Works, Dictionaries and Encyclopedias." The annotations are brief, but publication data and information on reviews of the works are included.

In addition to the library review journals—*Choice, Library Journal (LJ), College and Research Libraries (C&RL), RQ,* and *American Reference Books Annual*—there are regular signed reviews of recent reference books in *Art Documentation.* As the most detailed, current critiques that are published, these accounts are the best sources available for discovering new, pertinent works for the discipline of art. In addition, this ARLIS/NA quarterly contains information and warnings concerning bogus publications. When the International Translations Publishing Company advertised an English translation of the biographical dictionary *Thieme-Becker Künstlerlexikon*, the *ARLIS/NA Newsletter* warned its readers against prepaying for this yet-to-be issued work; follow-ups on the affair were later published.[3] This type of information is essential for art librarians.

Catalogs of Famous Art Libraries

In the 19th century, publishing a list of titles of the books and manuscripts in the collection of an individual art library was used as a means of informing scholars of the location of research materials.[4] In the 1960s and 1970s, a number of these catalogs were issued by G. K. Hall & Company.[5] The data in these reference works, especially those dictionary catalogs which cover author-subject, are invaluable to historians and researchers who use them to discover pertinent works. Some of these catalogs include analytical cataloging which is especially important to scholars. These hardbound books

will probably soon cease to be published, as microform and computerized versions of library holdings replace them.

In 1895, an author-title catalog of the some 13,000 books in the collection of the Avery Memorial Architectural Library of Columbia University was issued. By 1958 when the *Catalog of The Avery Memorial Library* was published, information on the collection required six volumes. The second edition of 1968 expanded to 19 volumes. The following four supplements required 14 volumes. Partly due to this voluminous quantity of material, there will be no more printed versions. Since 1980, entries for the titles of the book collection at the Avery Library have been available through RLIN. Unfortunately, not all libraries have access to this computer system of the Research Libraries Group, Inc. Future architectural historians may have trouble locating the research books they want. And even those who have access may have to pay for a special search of the RLIN database.

Some libraries are making rare books in their collection available by copying the complete contents on microfilm. For instance, The Royal Institute of British Architects, London—which issued its first library catalog between 1889 and 1899 and a two-volume version in 1937/38 which was reprinted in 1972—is now making some of its collection available on microform through World Microfilm, London. *The Microfilm Collection of Rare Books* consists of 35 reels; *Unpublished Manuscripts*, 14 reels; and *Catalogue of the Great Exhibition, 1851*, 5 reels.

Not all art libraries will have these expensive multi-volume works. University libraries that award a masters- or doctorate-level degree, large museums whose curators are responsible for compiling exhibition and museum-collection catalogs, and large public and research libraries will need some of the general as well as the more specialized catalogs. By discovering which titles are available in the area libraries and by utilizing a network system, even a moderate-size city can provide most of these reference works for scholars. Chamberlin has a list of 22 libraries which published catalogs between 1837 and 1958. Arntzen/Rainwater include 19 entries. Jones organizes the catalogs of 38 institutions by professions, geographical areas, and centuries; includes general art and national libraries; details any special databases that have been developed for this information; and discusses how to utilize these catalogs in research.

Abstracts/Indices

There are a number of reference tools that provide subject access to material published in periodical literature. These tools will assist patrons in discovering (1) articles on a particular subject or by a specific author; (2) exhibition and auction catalogs; (3) book, exhibition, and film reviews; (4) illustrations of works of art; and (5) obituary notices. Care must be taken to be sure that

the subject areas covered are the ones desired. Because the frequency with which these references are published often determines their usefulness, these tools have been divided into (1) indices, abstracts, and databases with quarterly or semi-annual issues and (2) publications providing access to past articles.

Both an index and an abstract provide subject access to journal articles. There is a difference, however, in the two services. With each issue, an *index* covers a specific number of serials, although these publications may change over the years. Under various subject headings, the entries are abbreviated citations providing the author and title of the article; the name, volume, and date of the periodical; pagination; and some indication as to the inclusion of bibliographic and illustrative material. An *abstract*— which provides the same information as an index with the added attraction of a brief summary of the article—often uses material submitted by the authors of the works. Although more periodicals may be covered, an abstract does not include every article and every magazine on a consistent basis. Some abstracting/indexing companies, which utilize magnetic tapes for setting type for the printed publications, have used these tapes to develop databases for computer searches, a subject discussed in Chapters 2 and 11.

The Core Art Bibliographies section lists four basic art abstracting/indexing services—*Art Index, ARTbibliographies MODERN, Répertoire d'art et d'archéologie* and *RILA*. Large libraries should provide access to these four, either by subscribing to the services or by having the capability of searching the online bibliographic databases. Small or specialized libraries may have subcriptions to only some of these services, because the others are available at area institutions.

Besides the four basic art abstracting/indexing services, there are other such services—both published in printed form and through online databases—that will be required by certain patrons. For instance, since 1966, ERIC (Educational Resources Information Center) has published *Resources in Education (RIE)*, a monthly abstract that covers educational reports, summaries, and documents throughout the United States. Most of these reports are available on microforms. *Current Index to Journals in Education (CIJE)*, which abstracts articles from more than 700 education and educational-related journals, is a supplement to the ERIC material. Through DIALOG, the complete records of these two abstracting services are available for an online computer search. In a recent inquiry as to the records in this database for material on outreach programs in museums, it was discovered that there were 704 records on museums, 807 on outreach programs, but only 9 that included both museums and outreach programs. The searching and typing of the complete entries for all nine abstracts took 11.5 minutes, for a computer time cost of $3.57. The information was the same as in the printed volumes. For the library that does not need the full *RIE* and *CIJE* published

volumes, the database searches provide quick, relatively inexpensive access to this material.

There are other specialized abstracting/indexing services, such as *The Architectural Index* and the *Architectural Periodicals Index. The Biography Index* provides references to biographical material found in the some 2200 periodicals that are scanned. For current news items and obituaries, *The New York Times Index* and the *Index of the Times* of London are available for those newspapers. Arntzen/Rainwater discuss the services which cover current serials and retrospective material. Jones includes a chapter on abstracting/indexing services and discusses methodology for their use, both in hard-copy and database format.

Some journals include articles which list or discuss abstracting/indexing services that cover specialized fields of art. Since locating these references can be a problem, the librarian must continually study art and library periodicals—especially *Art Documentation*—for reviews and mentions of these references. For example, the article "Archaeology in the Fine Arts Library" has an important section by Maria Collins, "Abstracts and Indexes of Archaeological Literature," which describes 17 sources that cover current articles on archaeology.[6]

Indexing sources for 19th- and early 20th-century material may be required by some libraries. Some indices are for all types of material and are difficult to use—such as *Poole's Index to Periodical Literature, Wellesley Index to Victorian Periodicals, 1824–1900,* and *Nineteenth-Century Reader's Guide to Periodical Literature, 1890–1899, With Supplementary Indexing 1900–1922.* But there are several excellent indices for art journals from this period. *Index to Art Periodicals Compiled in Ryerson Library, The Art Institute of Chicago,* 1962, in 11 volumes with the 1974 one-volume supplement, includes articles from about 350 English and foreign-language serials, some dating from 1907 when the indexing began. The strength of this reference tool is for works published between 1900 and 1930. Covering fewer magazines—about 84 art periodicals of which 25 are indexed in depth—*The Frick Art Reference Library Original Index to Periodicals,* 1983, consists of 12 volumes. Some of the serials were indexed as early as 1850. The *Concordia University Art Index to Nineteenth-Century Canadian Periodicals,* 1981, covers 26 journals published from 1830 to 1900. The material in these reference works is not available through an online bibliographic search.

Abstracting/indexing services do not continuously cover the same material. It is important for librarians to be familiar with the lists of indexed journals that are usually recorded in each of these publications. *RILA* provides a complete list of the volumes and issue numbers which are included in each volume. *Art Index* formerly provided this documentation, but now only cites the names of the magazines. Since the librarians who subscribe to this service periodically vote on which journals they wish covered, *Art Index* may add

or drop serials. This can be confusing for patrons. For example, the most outstanding English-language publication in the field of Byzantine studies, *Dumbarton Oaks Papers* was covered by *Art Index* only for Numbers 1 (1941) through 12 (1958). Fortunately, since the first issue and on a continuous basis, this journal has been included in *Répertoire d'art et d'archéologie*. In its Volume 8/2 (1983), *RILA* finally began coverage of *Dumbarton Oaks Papers*, beginning with Number 31 (1977). Number 20 (1966) of *Dumbarton Oaks Papers* contains two indices—to authors and to titles by subject categories— for the first 20 issues; Number 30 (1976) covers the same material for Number 21 (1967) through Number 30 (1976). Students will not be aware of the complexities of discovering information published in *Dumbarton Oaks Papers* as well as the other serials that have had checkered histories in their coverage by the abstracting/indexing services.

With the advent of the online bibliographic databases, more and more researchers have begun to utilize these computerized services. Frequently produced by the abstracting/indexing services which have printed volumes, these databases do not always have files equivalent to the published volumes. For instance, *Repertory of Art and Archeology*—Chapter 530 of the *FrancisH Database* of QUESTEL— includes the same citations as does *Répertoire d'art et d'archéologie*, but these files date only from 1973. For earlier material, the printed volumes must be searched.

The availability of an online bibliographic database does not necessarily mean that the subscription to the printed volumes can be cancelled. The printed volumes should be purchased, if there is a great demand for the use of the material. An online bibliographic database search is an expense for someone—the library, the patron, or both. Heavy usage and the inability of financially strapped students and patrons to shoulder the burden of additional costs should be considered before a decision is made concerning the feasibility of using the computerized service to the exclusion of the printed version. Moreover, the ethical question of whether or not information should only be for patrons who can afford it should be pondered.

Deciding on which abstracting/indexing reference tools to purchase is a major problem for a small art library. A large academic institution will usually subscribe to most of the major services plus have online computer capabilities. The automated searches—which are more current—are frequently less expensive than subscription to a printed service that may require extensive shelf space. Some of these printed reference tools charge on a service basis by which the annual fee is based upon the number of periodicals to which the library subscribes and which are covered by the index. Small institutions that subscribe to relatively few periodicals pay less than the larger libraries. Before deciding on which abstracting/indexing services to choose, librarians should evaluate these references. As for most purchases, librarians must consider budgetary constraints, the subject needs of their constituencies, the

breadth of the coverage, the frequency of the service, and the availability of the cited material—either at their own institution or through interlibrary loans.

Remember that any alterations in arrangement, format, subject and journal coverage, or number of indices can modify the usefulness of a specific service. Reviews, evaluations, and comparisons of abstracting/indexing services, both present and future, should be read in order to keep abreast of this ever-changing field. For instance, Ruth H. Kamen's *"The Architectural Periodicals Index*—Ten Years On,"* discusses the various aspects of this service of the British Architectural Library of the Royal Institute of British Architects as well as provides a comparison of the publication with other indices.[7]

When arranging the reference area, it is more convenient for patrons if the abstracting/indexing publications are adjacent to the current and bound periodicals. In each printed volume, the serials to which the library subscribes should be indicated. In addition, a record of the library's serial holdings should be placed nearby, in order that patrons can immediately check to see if the indexed material is readily available. A union list of art periodicals—such as the one developed by the art libraries in Washington, D.C.—which are located at the area libraries could also be accessible.[8]

Separate Subject Bibliographies

Of the utmost importance to librarians, separate subject bibliographies are available in several forms, as (1) separate printed volumes, (2) an addendum to reference works or serials, and (3) photocopied hand-outs provided at conferences amd workshops. A continual effort must be made to locate and study these bibliographies. A separate file of these bibliographies, organized by specific subjects, will assist the librarian in helping patrons. These bibliographies can be checked against the present collection and used as buying guides.

The works that compose the Core Art Bibliographies are all subject bibliographies; these reference tools provide access to other titles of works under a number of art subjects. Most of them cover a wide variety of topics. Retrospective, separately published subject bibliographies can be discovered by using the Core Art Bibliographies. Arntzen/Rainwater is organized by areas—Western, Oriental, and primitive; specialized subjects—such as color theory, fakes, and forgeries, and aesthetics and philosophy; and such subjects as iconography, architecture, sculpture, painting, prints, photography, and decorative and applied arts. This guide is unusual in that it sometimes provides access to bibliographies published on a regular basis in serials, such as the "Bibliography of Asian Studies" reported in the *Journal of Asian Studies*.

For some forms of historical research the older bibliographies cited by Chamberlin are essential. Ehresmann *FA* has a special chapter on

bibliographies; his *A & DA* includes bibliographies for folk art, ceramics, clocks and watches, costume, enamels, glass, textiles, and tapestry. Ehresmann *Arch* includes listings under reference works, building types, and city design. Jones cites bibliographies on general topics, iconography, architecture, art/museum education, and film literature.

For bibliographies published in serials, *Art Index* has listings under the subject followed by that subheading, for example, "Architecture, Bibliography" and "Textiles, Bibliography." *RILA* has a special section for "REFERENCE WORKS, Bibliographies," which provides publication data and information concerning reviews written for printed volumes. In addition, in 1984 the editorial board of *RILA* published *Raphael: A Bibliography 1972–1982*, which consists of 553 citations, only 270 of which had been previously cited in *RILA*, the rest being culled from 16 other bibliographic sources. This may be the beginning of other special bibliographies.

Julius von Schlosser's extended bibliographic essay covering Western art from the Middle Ages to the end of the 18th century is entitled *Die Kunstliteratur: ein Handbuch zur Quellenkunde der neuren Kunstgeschichte*. This book was first published in Vienna in 1924. An expanded edition, entitled *La letteratura artistica: manuale delle fonti della storia dell'arte moderna*, appeared in Italian in 1935.[9] Not surprisingly, German critical texts are emphasized; it is also somewhat restricted chronologically. A later Italian edition brings the references up to date as of 1963 and augments earlier bibliographic information. A French translation, with an introduction by André Chastel, was issued in 1984.

Schlosser's work is an excellent compendium and discussion of the source materials as well as of the history of criticism and art historiography. For example, Schlosser lists the manuscript versions, as well as various editions and translations, of Cennino Cennini's *Libro dell'arte*. In addition, there are a bibliography of works written about the *Libro* and Schlosser's discussion of the book itself. In many instances, spurious and doubtful works are cited as is the case with Leone Battista Alberti's treatises. *La letteratura* is enhanced by two indices: of artists and of sources. Thus, if one needs to know the date of the initial publication of Roger de Pile's *Dialogue sur le Coloris*, it is readily located in the index, which will also lead the reader to the appropriate discussion of the text itself. Even without the ability to read German or Italian, Schlosser can provide a valuable starting point for scholarly research, especially in the field of Italian art.[10]

In addition, there are excellent bibliographies on specific subjects, such as the four-volume work on American art—*Arts in America: A Bibliography*, 1979, edited by Bernard Karpel and published by the Archives of American Art.[11] About 25,000 entries are organized under 21 divisions which include such headings as "Art of Native Americans," "Art of the West," and "Dissertation and Theses" as well as the more usual architecture, painting,

sculpture, graphic arts, design, decorative arts, and photography. This bibliography, which contains lengthy annotations for each entry, is essential for any library whose patrons do research on American art.

There are several series of art bibliographies which are currently being published. The *Art and Architecture Information Guide Series*—Gale Research Company under the general editorship of Sydney Starr Keaveney—consists of some 15 varied subject bibliographies, such as *Art Education, Color Theory, Stained Glass,* and *Pottery and Ceramics.* The series is especially concerned with American art, with such works as *American Drawing, American Painting, American Sculpture,* and *American Decorative Arts and Old World Influences.* Moreover, architecture is highlighted: *American Architecture and Art, American Architects from the Civil War to the First World War, American Architects from the First World War to the Present, British Architects 1840–1976, Indigenous Architecture Worldwide,* and *Historic Preservation.*

The G. K. Hall Art Bibliographies Series, eventually will have about 50 separate annotated bibliographies organized under nine broad classifications.[12] Some of the bibliographies are on individual artists—such as Walter S. Gibson's *Hieronymus Bosch: An Annotated Bibliography*, 1983. Others cover a period of time—James H. Stubblebine's *Dugento Painting: An Annotated Bibliography*, 1983—or a type of art—Dorothy F. Glass' *Italian Romanesque Sculpture: An Annotated Bibliography*, 1983.

Available free, dealers sales catalogs are valuable bibliographic aids, but it must be remembered that only the books which the company has for sale are listed. Ars Libri, Ltd. of Boston publishes extensive lists of books which are for sale under specific topics, such as *British Art, Photography,* and *German Art Before 1800.* In 1979, the Jenkins Company of Austin, Texas, issued *Five Centuries of Printing 1450–1978*, a book by John H. Jenkins which contains 848 annotated entries for rare books—at least one work for every year of the past five centuries. The informative data provided for each work make this a valuable bibliography.

Most reference books have bibliographies. Some of these are important contributions to the discipline. For instance, most of the *Pelican History of Art Series* contain important annotated bibliographies organized under numerous subheadings.[13] Finding separate subject bibliographies published in serials can be difficult. A notation, and perhaps a photocopy of the article, should be kept on file. Some bibliographies have been included in *Art Documentation*; for instance, Diane Guzman's "Egyptian Art—A Reference Bibliography,"[14] Michele Finerty's "19th-Century Photographically Illustrated Material: A Bibliography,"[15] and Barbara Polowy's "Photography: Basic Reference Sources."[16]

When attending conventions—such as the ARLIS/NA or the College Art Association—if bibliographies are distributed, the librarian should be sure

to obtain a copy. For instance, at the 1985 ARLIS/NA Conference, the Session on Photography: The Art Librarian's Bibliographic Survival Guide had four extensive bibliographies which were shared with the participants.[17] Librarians who are unable to attend a special session should ask colleagues to share the information, since not all of the hand-out sheets are published in other forms.

In addition to locating and saving bibliographies directly concerned with the discipline of art, librarians should seek bibliographic data on peripheral subjects which are needed by their patrons. For instance, theater has always had an impact on art, and vice versa. Specialized bibliographies on theater of different historical art periods—Medieval, Renaissance, Baroque, and Neo-Classicism—may be needed. It is important for art librarians to be aware of bibliographies for other specific areas, such as literature, history, and religion. Some important bibliographies on specific subjects can be located through the same methods as for finding ones related to art. In addition, librarians should consult Sheehy's *Guide to Reference Books*, 9th edition, 1976—with its updates, *First Supplement*, 1980 and *Second Supplement*, 1982—and the annual publication, *Bibliographic Index: A Cumulative Bibliography of Bibliographies*.

Location Directories

There are a number of directories which assist patrons in locating certain types of material—information on museums and libraries, the location of art objects, reproductions of works of art, past and current addresses and telephone numbers, and the existence of specific archives. Location directories can not only be erratic in their publication but also frequently change titles. For example, *American Art Directory* was originally entitled *American Art Annual*. Although not always consistent in the frequency of its issues since the first volume in 1898, this reference is now a biennial. In the Core Art Bibliographies, only four authors list location directories: Arntzen/Rainwater, Chamberlin, Ehresmann, and Jones. Reviews in the art literature provide access to recent publications.

Librarians must purchase not only the current issues, but also must often save the older volumes of location directories, for these references sometimes become the research tools of the future. For instance, *The American Art Directory* provides a wealth of information: listings of major museums, libraries, art associations, and art schools; art magazines; State Arts Councils; Directors and Supervisors of Art Education in school systems; U.S. newspapers and the names of their art critics; scholarships; open exhibitions; and traveling exhibitions booking agencies. Only the current issue will provide the latest data on certain subjects, such as personnel, opening hours, and telephone numbers. But prior to its separation into two works—the directory

and *Who's Who in American Art*—this publication sometimes included such items as brief biographical sketches on living American artists, a directory of architects, and sales data on American auctions.[18] This resource material is essential for certain researchers.

Often later editions of publications delete important data, which may or may not change. For instance, in the 12th edition of *International Directory of Arts*, 1974/75, there are numerous cross references. Under "Schweiz, Lugano," there is a cross reference for the Sammlung Thyssen-Bornemisza to the little town of Castagnola, where the museum is located. By the 13th edition (1977/78), many such cross references had been deleted. Yet, how many patrons realize this Swiss art collection is located in a small municipality which is adjacent to Lugano and in the United States would be considered a suburb of the larger city?

One type of primary data which art patrons often must study is the work of art or artifact itself. Directories and indices to the present location and to photographs or reproductions of specific works of art are especially important research tools.[19] Most of these types of reference works require that the artist and title of the work be known. Several books provide wide coverage for paintings in a particular country: *Census of Pre-Nineteenth-Century Italian Paintings in North America Public Collections, Old Master Paintings in Britain, Paintings in Dutch Museums,* and *Paintings in German Museums.* Under artists' names, each book has an index to the institutions which own specific works by these painters; exact titles are usually provided as well as any catalogs in which they are cited or reproduced.

Indices to reproductions in books and periodicals—such as Patricia Havlice's *World Painting Index* and Jane Clapp's *Sculpture Index*—frequently provide the location of a work of art, if known. In addition, the abstracting/indexing services may assist researchers who are investigating the location of a specific work of art. For instance, *Art Index* regularly lists reproductions of works under artists' names. The titles are cited with the probable date the work was created and sometimes the medium. Using this type of resource tool is usually a two-step process in that the patron must check each issue to locate the title of the work of art and then consult the article which has published the reproduction in order to discover the location of the object. However, if the title is ambiguous—for instance, "*Vase* [Toledo Museum of Art] (1950)"—the location is frequently placed in brackets.

Larger libraries usually have a telephone book section where directories for the local area—as well as those of large cities in the state, North America, and foreign metropolises—are stored. The use of city directories as reference tools was recognized when Research Publications, Inc. issued *City Directories of the United States in Microform*. This series is a reprint of the actual city directories of major cities and regions in the various states. On microfiche,

Segment 1, which is based upon Dorothea N. Spear's *Bibliography of American Directories Through 1860*, provides access to the earliest known directories. The other sections are on microfilm: Segment 2 covers 1861–1881; Segment 3, 1882–1901; and Segment 4, 1902–1935. These microforms can be purchased by state as well as segment.[20]

Location directories that provide data on archival material will also be needed. The *Directory of Archives and Manuscript Repositories* gives a description of the archives in all 50 states of the United States. *The National Union Catalog of Manuscript Collections*, which uses a register format with cumulative indices, often includes the location of architects' drawings and papers. The various COPAR (Committee for the Preservation of Architectural Records) publications—*Architectural Research Materials in New York City, Architectural Research Materials in Philadelphia,* and *Architectural Research Materials in Boston*—record the names of institutions which have preserved individual architects' archival material. Kathleen Cummings' *Architectural Records in Chicago* uses the same COPAR format.[21]

EVALUATING REFERENCE WORKS

Most reference works are expensive, and since budgets stretch only so far, a concerted effort must be made to purchase the best. Librarians need to employ a systematic method for judging research tools in relationship to the clientele who will use them. For instance, research tools which are published on a continuing basis frequently do not exhibit their true usefulness until they have been issued over a period of time, during which a certain refinement in coverage and format usually occurs. This is especially true of indexing services. As mentioned in Chapter 3, *Répertoire d'art et d'archéologie*, which began in 1910, did not become a useful tool for undergraduate students until the format changed in 1973. As a consequence, expensive multi-volume references, which may initially have been rejected, need to be reappraised periodically and perhaps added to the collection.

In order to evaluate each reference, the librarian should (1) study reviews and abstracts concerning the work (2) check the publication for format as well as against a set of criteria, and (3) for particularly expensive material, personally investigate the resource tool by conducting a mini-research project. The availability of excellent and timely reviews published in *Art Documentation* and *Art Libraries Journal* and informative abstracts or annotations in the works which compose the Core Art Bibliographies have already been discussed.

Prior to evaluating reference material, librarians should select specific criteria which pertain to the type of resource tool being considered and to the needs of the library's clientele.[22] Some of the following items might be

considered: (1) the scope of the data and whether or not it is already covered by other reference books in the collection; (2) the extensiveness, currency, and uniqueness of the information; (3) any basic problems inherent in the type of reference tool; (4) the relationship of the material to the needs of the library's patrons and the research level stated in the collection policy; (5) the ease of using and reading the resource tool; (6) the language in which the text of the reference is written; (7) the stability of the publisher—if a multi-volume work, whether all the components of the set will be issued; (8) the availability of the material through an online bibliographic database search; (9) the currency of the material—whether or not it will become rapidly out of date; (10) the quality of the visual material; (11) the type of paper on which it is published; (12) the scholarly standing of editor/publisher; (13) the expense of the research tool; (14) the availability of the reference work at a nearby library; and (15) the approximate number of art patrons who would use it.

In order to demonstrate a mini-research problem, the *Arts & Humanities Citation Index*, abbreviated *A&HCI*, was re-evaluated for a medium-size university which awards master's degrees in various art subjects, including art history. Reviews were studied; the most informative analysis was published in *ARLIS/NA Newsletter* by Carolyn Adams.[23] The article discusses: (1) the advantages of citation indexing—an author's view of pertinent literature can be discovered, the problem of choosing subject headings is avoided, and the currency of the material is greater than in more conventional types of abstracting/indexing publications; (2) the format of the citation index and how it can be used; (3) the number of journals in various categories which are covered; (4) a comparison of the list of art and architecture serials with those covered by *Art Index* and *RILA*; (5) an indication of the users of citation indices; and (6) a list of three articles for further reading.

Utilizing the 15-point criteria previously listed as well as checking for data on Pieter Bruegel the Elder, an evaluation was made as to what information was covered by *A&HCI* and whether or not the material differed or overlapped that derived from the four core abstracting/indexing services— *Art Index, ARTbibliographies MODERN, RILA*, and *Répertoire d'art et d'archéologie*. From the first 1976 issue to the 1983 publication, *A&HCI* had dramatically increased the number of serials: 5 more in archaeology, 10 in architecture, 12 in art, 57 in arts and humanities, as well as 9 in film, radio, and TV. Other areas were classics, dance, folklore, history, language and linguistics, literary reviews, literature, music, philosophy, poetry, religion, and theater. In her review, Adams reports that in art and architecture serials, the 1978 *A&HCI* had a 51.5% (35 journals) overlap with *Art Index* and 50% (34 journals) with *RILA*.[24] In the 1983 issue of *A&HCI* for the art and architecture serials, there was a 70% (74 journals) overlap with *Art Index*,

30% (31 journals) with *ARTbibliographies MODERN*, 53% (56 journals) with *RILA*, and 53% (56 journals) with *Répertoire d'art et d'archéologie*. In 1976, the citations in 963 journals were indexed completely by *A&HCI*. By 1983, the number had increased to 1300 fully covered journals plus the addition of 5600 selectively covered serials and 91 books, *Festschriften*, and proceedings. Each issue provides a complete list of these works. No other one service covers this number of serials plus the analytical indexing of books.

The extensiveness of the material was determined by checking the titles of the serials. For certain fields, many important publications—such as *Afterimage, Cahiers Archéologiques, Ceramic Review, Dumbarton Oaks Papers, or Textile Museum Journal*—were missing, although these works were covered by *Art Index, RILA,* or *Répertoire d'art et d'archéologie. Yet, A&HCI* indexes numerous history and literature journals not included by the other services—*Canadian Historical Review, Harvard Journal of Asiatic Studies,* and *Studies in Twentieth Century Literature.*

The currency of the reference was to be judged by the frequency of publication and the flexibility of the research tool to the inclusion of new material. *A&HCI* is issued three times per year; the last issue is cumulative and hardbound. This compared favorably with the semi-annuals, *ARTbibliographies MODERN* and *RILA*, but was less frequent than the quarterlies, *Art Index* and *Répertoire d'art et d'archéologie*. The speed with which recent publications are covered appears to be good. For instance, *Representations*, a magazine first issued in 1983 by the University of California Press, was added that same year by *A&HCI*. This was not true of the other services.

artists, works of art, or specific subjects in the text, footnotes, or bibliographic references in the covered articles and books. Some of these citations may be unimportant in themselves, but can lead researchers to pertinent material. For instance, *A&HCI* had a citation under "Bruegel, P." to a footnote in an article on Rembrandt in the 1981 *Art Bulletin*. The comment was of value, because it mentioned an article by Irving Zupnick which had been published in *Actes du XXIIᵉ Congrés International de l'Histoire de l'Art, 1969*, Budapest, 1972. Neither reference was found in the other abstracting/indexing publications.

Because it indicates whether or not specific authors have been quoted, *A&HCI* is one method for discovering: (1) whether or not certain ideas and references are later discussed in print, (2) which authors are the most quoted in the literature covered, and (3) articles or books that cite specific works of art. These are unique features of *A&HCI.*

There are several problems in utilizing citation studies.[25] All of the citations, whether of prime importance to the research or of just incidental interest, are given the same value. Moreover, authors do not footnote in the

same way—some refer only to the most essential references, others include every item examined. Because an article may mention a specific work of art does not necessarily mean that the entry is pertinent. Citation indexing may create a longer, but not necessarily better, list of references. This may result in a greater use of interlibrary loans.

The value of the entries to a research-oriented constituency can only be determined by obtaining and reading some of the articles that are included in the reference tool being evaluated. Research on Pieter Bruegel the Elder was chosen. As seen in Example 4/1, over a three-year period, 1981–1983, there were 27 different 1981 articles and books cited by *A&HCI*, 12 by *Art Index*, 5 by *RILA*, and 17 by *Répertoire d'art et d'archéologie*. In 1981 there were four heavily documented research articles written on Bruegel: three in *Art Bulletin*, one in *Master Drawings*. Although all of the research tools— except *ARTbibliographies MODERN*, which does not cover this historic period—eventually included these articles, the earliest coverage was through *A&HCI*.

One of the biggest drawbacks to using *A&HCI* is the small print which is used; it is so minute that a magnifying glass is needed for extensive study. In *A&HCI*, there are four indices: (1) "Citation Index" has listings under artists and authors' names to articles and books that cite their works—there are subdivisions for specific works of art and publications; (2) "Source Index," under authors' names, provides (a) complete bibliographic data for the articles or books included in that issue of *A&HCI*, (b) an indication of the type and language of the material, and (c) a list of the references which are cited in the bibliography or footnotes of the articles; (3) "Permuterm Subject Index" gives subject access—by utilizing all significant English words—to the titles of the articles that are covered; and (4) a "Corporate Index." Although the researcher must check entries in the "Citation Index" and then consult the entries for each item in the "Source Index," this is no more difficult than the same two-part process necessary for utilizing most of the other abstracting/indexing tools.

A difficulty arises from the lack of an authority file for either artists' or authors' names. For instance, there are a number of variant spellings for the name of Pieter Bruegel the Elder. *RILA*, which uses an authority file, grouped all citations under "Bruegel, Pieter the elder, the painter, d. 1569." Although there was also a listing under "Brueghel family, the painters, 16th-17th cs," this article was repeated under Pieter's name. *Art Index* had separate entries under both "Brueghel, Pieter the Elder" and "Brueghel family"; these were not repeated. *Répertoire d'art et d'archéologie* had citations for "Bruegel (les)," meaning family of Bruegel, as well as "Bruegel, Pieter" and "Bruegel, Pieter l'Ancien." With no authority file for personal names, *A&HCI* had entries under "Bruegel," "Bruegel, P.," "Brueghel," and

Example 4/1

Comparison of Citations for Pieter Bruegel the Elder in *A&HCI*, *Art Index*, *RILA*, and *Répertoire d'art et d'archéologie*

Abstracting/indexing service	Citations of books and articles		Range of years of publications	Number of different listings for Bruegel	Number of individual works of art mentioned
	Number of different citations	Number of 1981 citations			
1. A&HCI					
Volume 1981	24	20	1980–1981	4	54
Volume 1982	20	5	1980–1982	1	44
Volume 1983	10	2	1981–1983	3	12
2. Art Index					
Vol 29 (Nov80–Oct81)	12	6	1979–1981	2	19
Vol 30 (Nov81–Oct82)	7	6	1980–1982	2	15
Vol 31 (Nov82–Oct83)	7	0	1980–1983	1	16
3. RILA					
Vol 7/1 & 7/2 (1981)	7	0	1977–1980	1	3
Vol 8/1 & 8/2 (1982)	5	3	1978–1982	1	3
Vol 9/1 & 9/2 (1983)	11	2	1979–1982	1	3
4. *Répertoire d'art et d'archéologie*					
Vol 17 (1981)	25	5	1976–1981	3	9
Vol 18 (1982)	16	10	1979–1981	2	12
Vol 19 (1983)	12	2	1977–1983	2	10

"Brueghel, P." In addition, the titles of the articles listed in *A&HCI* can often be confusing. Titles are translated into English, which helps patrons in establishing the content of the material, but makes it difficult to order the material through an interlibrary loan. Entries for individual creative works of art are not translated or grouped together. Different titles may appear for the same work. For instance, *Adoración de los Magi* and *Adoration of the Magi* are cited separately.

The stability of the publication had already been established, since it had been issued since 1976. Although the articles are written in many languages, *A&HCI* is in English. The files of *A&HCI* from 1980 are now online through BRS; there will soon be more users for this indexing service.

Following the list of criteria, it was determined that the material in *A&HCI* would not become rapidly out-of-date; there are no visual materials; and the paper on which the text is printed is thin, but sturdy stock. The editor—Eugene Garfield—has written extensively on citation indexing, publishing in such journals as *American Behavioral Scientists, Journal of the American Society for Information Science,* and *Library Quarterly.* The cost of the publication was a stumbling block, more than $2500 a year in 1985. Unfortunately, it did not fulfill criteria number 15 in that no area libraries subscribed to the service. As to the number of art patrons who would use it, this would vary depending upon the familiarity of researchers with *A&HCI*. The librarian would need to have demonstrations in order to introduce the material. In her review, Adams stated: "Users of the citation indexes are not only individuals who know the research field by scholars' names but individuals who have located one good article and need more on the topic. If library's users focus on interdisciplinary research, this reference tool is recommended."[26] This assessment was validated by the mini-research project.

NOTES

[1]There have been attempts to develop lists for specific art libraries, but they are out-of-date before they are published as well as being highly subjective in their selection. One such bibliography is Julia M. Ehresmann's "Selected List of Fine Arts Books for Small Libraries" published as an appendix to Donald L. Ehresmann's *Fine Arts: A Bibliographic Guide*, 1975; this material was not repeated in the 2nd edition of 1979.

[2]Reviewed by June S. Hargrove, *Art Documentation* 2 (Summer 1983): 122.

[3]See *ARLIS/NA Newsletter* 8 (October 1980): 181; and 9 (February 1981): 63.

[4]Chamberlin cites five such publications, pp. 2–21, 229.

[5]Robin Kaplan, "G. K. Hall Art Publications," *ARLIS/NA Newsletter* 3 (October 1975): Supplement 1–5. For a list, see Jones, pp. 151–59.

[6]Maria Collins, "Abstracts and Indexes of Archaeological Literature," *ARLIS/NA Newsletter* 7 (October 1979): 121–23.

[7]Ruth H. Kamen, "*The Architectural Periodicals Index*—Ten Years On," *Art Documentation* 2 (Summer 1983): 93–95.

[8]*Art Serials: Union List of Art Periodicals and Serials in Research Libraries in the Washington, D. C. Metropolitan Area*, edited by Carolyn S. Larson (Washington, DC: Washington Art Library Resources Committee, 1981). Review by Bonnie Postlethwaite, *Art Documentation* 1 (December 1982): 213–14.

[9]For its publishing history, see Arntzen/Rainwater. For references on its scholarship, see W. Eugene Kleinbauer and Thomas P. Slavens, *Research Guide to the History of Western Art* (Chicago: American Library Association, 1982): 28, 33–34; and *Encyclopedia of Library and Information Science* (New York: M. Dekker, 1968), "Art Libraries and Collections" by Wolfgang Freitag, Volume 1, p. 575, and "Art Literature" by E. Louise Lucas, Volume 1, p. 624.

[10]For English-language references to some of these items, see Arntzen/Rainwater.

[11]Reviewed by Janis Ekdahl, *ARLIS/NA Newsletter* 9 (February 1981): 66–67. Also see, Jones, pp. 77, 149, 165, 183, 240, 244.

[12]These include: Art of Antiquity; Medieval Art and Architecture; Italian Renaissance, Art of Northern Europe, 15th and 16th Centuries; 20th Century Art in Northern Europe and America; Non-Western Art; Afro-American Art; Southern Baroque and Rococo, 17th and 18th Centuries; and Northern Baroque and Rococo, 17th and 18th Centuries.

[13]Jones, pp. 54, 176.

[14]Diane Guzman, "Egyptian Art—A Reference Bibliography," *ARLIS/NA Newsletter* 7 (October 1979): 128–30.

[15]Michele Finerty's "19th-Century Photographically Illustrated Material: A Bibliography," *ARLIS/NA Newsletter* 8 (February 1980): 44–45.

[16]Barbara Polowy, "Photography: Basic Reference Sources," *Art Documentation* 2 (Summer 1983) 104–07.

[17]These bibliographies included: *A Selective, Annotated Bibliography of Biographical Resources about Artistic Photographers* by Susan Wyngaard, *Selected Photography Periodicals* by Rachel Stuhlman, *Researching Photographers* by Amy Stark, and *Before the Halftone: The 19th Century Photo-Illustrated Book Bibliography* by Annette Melville.

[18]See Barbara Polowy's "*American Art Annual*: A Guide to Biographical Information, Volume 1 to 30," *Art Documentation* 3 (Spring 1984): 3–4.

[19]See Jones, pp. 62–63, 203–06.

[20]Ibid., pp. 78 and 238.

[20]Ibid., p. 111.

[22]Isadore Gilbert Mudge, "Reference Books and Reference Work," in *Guide to Reference Books* 9th ed., edited by Eugene Sheehy, (Chicago: American Library Association, 1976) refers to six ways to study reference books: (1) examining the title page, (2) reading the introduction and preface, (3) studying the layout of the work, (4) scanning the articles for bias, (5) checking the arrangement, such as the alphabetizing, and (6) if a later edition, comparing the recent work with the past ones. William Katz, *Introduction to Reference Work* 3rd ed. (New York: McGraw-Hill, 1978) discusses, at length, four questions to be asked about each book under consideration; the librarian should determine the work's purpose, authority or authors' qualifications, scope of material, and proposed audience. In addition, the format must be considered. For each type of reference work, Katz cites an individual set of criteria.

[23]Carolyn Adams, "A New Bibliographic Tool for the Arts and Humanities Fields," *ARLIS/NA Newsletter* 6 (Summer 1978): 73–74.

[24]Ibid. (Note 23), p. 74.

[25]For a brief history and discussion of this type of reference work, see M. S. Batts, "Citations in the Humanities," *IPLO Quarterly* (Institute of Professional Librarians of Ontario), 14 (July 1972): 20–40; and Melvin Weinstock "Citation Indexes," in *Encyclopedia of Library and Information Science*, edited by Allen Kent and Harold Lancour (New York: M. Dekker, 1971), pp. 16–40. Also see, Eugene Garfield, "Is Information Retrieval in the Arts and Humanities Inherently Different from that in Science?" *Library Quarterly* 50 (1980): 40–57.

[26]Adams (Note 23), p. 74.

5

Materials for Special
Types of Users

INTRODUCTION

It has been estimated that throughout the world, there are some 600,000 new titles available annually as well as about 200,000 out-of-print titles which can be purchased in any given year.[1] From this vast number of works, only a portion of which will be art or art-related, librarians must identify the most essential materials which the library budget can afford. For this reason, the importance of the art-subject specialist can not be overemphasized. But it must also be remembered that the art library is not an entity unto itself; not all resources required by art patrons will be located in an art library.

Because librarians must be aware of the important references needed by their various users, this chapter is divided into the following sections: (1) art and architectural historians, (2) studio artists, (3) art/museum educators and administrators, and (4) professional designers—architects, interior designers, commercial designers, and fashion designers. The majority of the books required by these patrons will be monographs. Due to their importance, various types of catalogs and serial publications—which can also be monographs—are discussed in Chapters 6 and 7. Since most of the acquisition and cataloging of monographs is based on standardized procedures, as outlined in Chapters 12 and 13, the main concern of this chapter is in evaluating, identifying, and selecting these items.

ART AND ARCHITECTURAL HISTORIANS

In choosing monographs, librarians should be aware of the following: (1) the methods needed for identifying various types of art-historical references and (2) the various peripheral materials which will be required.

Art Historical Materials

In choosing references used for the discipline of art history, the librarian must consider the types of publications—books in series, *œuvres* catalogs and catalogues raisonnés, *corpora*, dissertations, and *Festschriften*.[2] If there is a particularly scholarly multi-volume set of works written for a series, the librarian should make a special effort not only to purchase all of the works but, if at all possible, to provide a listing of the volumes which the institution owns either under the name of the series in the library's catalog or in a special file.[3] Constant perseverance may be necessary in order to obtain a complete set. Many of these multi-volume references are published over great expanses of time. Some are never completed. For instance, the *Oxford History of Art Series*, which published *Volume V: English Art 1307–1461* by Joan Evans in 1949, has yet to issue volumes I and IV of the proposed 11 works. Only two volumes of Gertrud Schiller's outstanding four-volume work, *Iconography of Christian Art*, have ever been translated. The librarian has the problem of deciding whether or not to purchase the last two books of *Ikonographie der christlichen Kunst* or hope that someday these last two volumes will be issued in English.

There are a number of important art monographs which have been published by learned societies and foundations, such as the *Bollingen Series*, the *A. W. Mellon Lectures in the Fine Arts Series, The CAA Monographs on Archaeology and Fine Arts Series,* and the *Wrightsman Lectures Series.* The publications of the Bollingen Foundation include such areas as aesthetics, archaeology, cultural history, ethnology, mythology, and symbolism. Originally printed and distributed by Pantheon Books, the series since 1967 has been published by Princeton University Press.[4] Eventually about 250 separate series titles, some in multi-volumes, will be issued. The art-related works include such titles as *Jewish Symbols in the Greco-Roman Period* by Erwin R. Goodenough, *Samothrace* edited by Karl Lehmann and Phyllis Williams Lehmann, *The Karye Djami* by Paul A. Underwood, and *Studies in Religious Iconography* by Emile Mâle. Volume 35 constitutes the *A. W. Mellon Lectures in the Fine Arts Series*, monographs based on the annual lectures which since 1952 have been given at the National Gallery of Art, Washington, D.C.

Since 1944, the College Art Association of America has sponsored more than 35 books for the *Monographs on Archaeology and the Fine Arts Series.*

The back cover of the issues of *Art Bulletin* report the complete list and purchasing instructions. Between 1966 and 1972, New York University Press published the Wrightsman Lectures, which have been presented annually since 1964 through the auspices of the Institute of Fine Arts of New York University. In 1976, Cornell University Press became the publisher. These are just a few examples of some of the important art history monographic series of which the librarian should be aware.

An *œuvre* catalog and a catalogue raisonné discuss all of the works of a particular artist or all of the works of a specific media, providing an extensive catalog entry for each piece. Usually the most scholarly publications on an artist, these books can be expensive. For research libraries, they are some of the most important works to be collected.[5]

There are several methods for identifying *œuvres* catalogs or catalogues raisonnés. Freitag's bibliography, covering 1870 artists, includes all significant works of a monographic nature; a CR indicates a catalogue raisonné. This book can be used to locate references on artists and to determine needed additions to the collection. Another method is through book dealers sales lists, some of which are concerned specifically with these forms of monographs. One such reliable company is Ars Libri, Ltd., whose in-depth, fully annotated descriptions provide invaluable information. At the end of each issue, *The Art Bulletin* has a "List of Books Received," which indicates if the phrase—*œuvre* catalog or catalogue raisonné—is in the title of the book. However, it must be remembered that the actual review of the catalogue raisonné may not appear in this or any other journal for many years. Librarians should regularly scan all these resources.

Covering a group of artists or a type or period of art, a *corpus* aims at comprehension. Originating from the 17th- and 18th-century compilations made by antiquarians who arranged such artifacts as gems and coins according to their primary characteristics, modern *corpora* have evolved to include entries similar to catalogues raisonnés. *Corpora* may include extensive bibliographies, letters and documents, lists of exhibitions, and lengthy discussions of doubtful works and forgeries. Many *corpora* have been the work of a single individual, such as Max J. Friedlander's 14-volume *Early Netherlandish Painting* or Sir John Beazley's *Attic Black-Figure Vase-Painters* and his three-volume work plus supplement, *Attic Red-Figure Vase-Painters*. Other *corpora* have been written by international teams of scholars.

Examples of two *corpora*, which are still being issued, are the *Corpus Vasorum Antiquorum*, started in 1921, and the *Corpus Rubenianum Ludwig Burchard*, begun in 1969. The former is being compiled by experts in specific museums owning Greek vase collections; the number of fascicules is around 200. The Rubens *corpus* is a collection of individual analytical volumes on individual topics written by various specialists. Specific volumes include *The*

Ceiling Painting for the Jesuit Church in Antwerp by John Rupert Martin, *The Decoration of the Torre de la Parada* by Svetlana Alpers, and *The Achilles Series* by Egbert Haverkamp-Begemann. Because these works are published over a great span of years, librarians may have trouble keeping up with the latest volumes issued.

Another form of art historical literature, dissertations can be important references. Often these research reports are never rewritten, edited, and published through commercial firms. *Dissertation Abstracts International: Abstracts of Dissertations Available on Microfilm or as Xerographic Reproductions*, also available through a database search, lists available works that can be ordered from Xerox University Microfilms of Ann Arbor, Michigan, either on microfilm or as a paperback photocopy. But not all academic institutions participate in this endeavor. A listing of universities and the dates when they began sending their graduates' research to *Dissertation Abstracts International* is included in each volume of this publication. Other sources must be used for dissertations written prior to the date when a university began submitting its graduates' works. For example, it was not until 1982 that the dissertations from the Graduate School of Arts and Sciences at Harvard University were included in *Dissertation Abstracts*.

In the 1980s, Garland Publishing issued a series of *Outstanding Dissertations in the Fine Arts* which provided hardbound copies of a selected group of dissertations. Librarians must be discriminating in their choices, since dissertations from Garland might also be available from Xerox University Microfilms in either microform or paperback. UMI Research Press has also published dissertations in *Studies in Fine Arts,* which includes such series as *Studies in Iconography* and *Art Criticism Series.* Librarians should carefully scrutinize these publications since the reproductions are often inferior.

Festschriften—collections of essays on various subjects compiled to honor a person or an event—can be particularly troublesome to locate.[6] Each issue of *RILA* records under ''GENERAL WORKS, collected works,'' various *Festschriften* as well as reports of symposia and studies published by learned societies. *Répertoire d'art et d'archéologie* cites these works under ''Liste des recueils collectifs depouillés.'' Unfortunately, both abstracting services list these important references long after they are published. A good method of discovering *Festschriften*, if only the honored person is known, is through the *LC MARC Database*.[7]

Of all of the varied subjects which monographs encompass, two of the most important are works on individual artists and specific works of art. As has been discussed, these monographs include *œuvres* catalogs, catalogues raisonnés, *corpora*, and dissertations. These monographs must be monitored carefully in order to achieve a balanced collection. Although a public library may

acquire numerous books on Picasso at various levels to accommodate high school students as well as scholars, references on this popular 20th-century artist should not be allowed to dominate the library shelves. Material on lesser artists, contemporary with Picasso, should also be purchased. Remember that the research done on one artist's work often provides data for the interpretation of other contemporary artists' works. For instance, iconographical studies on the paintings by Jan van Eyck will probably provide insights into the works of art by other 15th-century Flemish artists.

This selective buying may require making a list of the more popular, as well as the lesser known, artists for each artistic style collected. Survey books on specific artistic periods will assist librarians in formulating such compilations. A good start would be Frederick Hartt's *Art: A History of Painting, Sculpture, Architecture*; H. W. Jansons's *The History of Art*; or *Art Through the Ages*, originally written in 1926 by Helen Gardner and later revised by Horst de la Croix and Richard G. Tansey. But because they omit important artists and monuments, these general survey texts must be augmented by utilizing college survey texts for specific art-historical periods, such as Frederick Hartt's *History of Italian Renaissance Art*, 1969, or *Art of the Ancient World,* 1977, by H. A. Groenewegen-Frankfort and Bernard Ashmole.

In addition to dealing with a wide range of subjects and formats, librarians must deal with levels of complexities. Art historical subjects and the research levels at which they are collected—a topic discussed in Chapter 3—must be decided in order to acquire materials effectively. These subject categories should be broad in character to encompass the wide range of material and interests of patrons. For instance, if medieval art history is to be collected at the research level, it may be essential to purchase, at a similarly high level, books concerned with the historical periods which influenced this art—such as Early Christian and Byzantine. References on the different media within a particular time span should be represented. Sculpture could influence painting, or vice versa; books on both media will be required. Resources on art from various countries should also be acquired even if these other geographical locations are not the primary collection area. For example, 14th-century Bohemian art was greatly affected by French artistic works, because Charles IV, King of Bohemia and the Holy Roman Emperor, was raised at the Parisian court.

Other monographs will be required: books that analyze specific works of art, discuss aesthetics and historiography, cover ornaments and the migration of symbols, relate changes in taste and the habits of art collectors, reprint documents and sources pertinent to art, reproduce good illustrations of works of art, and provide data on symbols and iconography.[8] Most of these references are covered in the Core Art Bibliographies, discussed in Chapter 3.

Peripheral Materials

Art and architectural historians need a great deal of supplementary references from other disciplines. Most art researchers are concerned with resources from other areas of the humanities—literature, history, religion, philosophy, theater, and music.[9] Other disciplines—law, science, and technology—are also important. Public and academic libraries have departments which will provide access to these materials. Although a small library may not be able to afford to purchase many of these works, institutions with specialized fields should attempt to acquire the most important inter-disciplinary research tools.

Because these references are usually outside the normal province of the art librarian, additional effort may be necessary to identify them. The following methods will assist the purchaser in this task: (1) checking retrospective bibliographies, such as those found in Sheehy's *Guide to Reference Books*, 9th edition, 1976—with its updates, *First Supplement*, 1980, and *Second Supplement*, 1982—and the annual publication, *Bibliographic Index*; (2) conferring with patrons and colleagues; (3) consulting footnotes and bibliographic references in the most scholarly art journals; and (4) being alert to bibliographies of art-related topics—published or unpublished.[10]

The language of the research tools should be carefully appraised. For instance, in medieval European art, St. Augustine's writing had a tremendous influence. Although the *Patrologiae Cursus Completus, Series Latina*, 1844–82, and the *Corpus Scriptorum Ecclesiasticorum Latinorum*, 1866—both available on microform—can be essential tools, the question of how many patrons can translate Latin sufficiently to utilize these texts is one that should be asked.[11] More useful may be the *Fathers of the Church*, which plans 100 books on the various writings of these churchmen and the *Select Library of the Nicene and Post-Nicene Fathers of the Christian Church*, 14 volumes.[12] Both of these resources contain English translations of the best-known writings of the early founders of Christian thought.

Iconographical research can require an extensive and varied list of inter-disciplinary material. For any inquiry into Christian art, certain basic tools must be available, such as (1) the Douay-Rheims Bible, which is probably the closest translation to the Latin Vulgate, that during the Middle Ages was the official Roman Catholic Bible, and (2) the King James Bible, which was used by Protestants, especially during the 17th through the 19th centuries. Translations of *The Infancy Gospels, Meditations on the Life of Christ,* and *The Golden Legend* are essential. Hagiographical references must be purchased for the study of saints and their attributes. Emblem books will be needed for inquiry into Western art of the 16th through 19th centuries. Librarians unfamiliar with these resources should scrutinize the entries and

the bibliographies for these subjects in the *Encyclopedia of World Art* as well as read Jones, pp. 92-104 and 223-32.

All types of mythology books should be collected. Being aware of important international compilations will assist librarians in deciding what to purchase and when. For instance, the *Lexicon Iconographicum Mythologiae Classicae*, a proposed seven-volume set containing scholarly encyclopedia entries accompanied by extensive bibliographies, is being published in the languages—mainly German, English, French, and Italian—of the various contributors. This scholarly work is expensive. *Volume I: AARA-APHLAD*, 1981, consisting of two books—one text, one plates—sells for almost $650.00. Volume II, 1984, costs more than $500.00. Libraries that do not begin acquiring this encyclopedia during the early publication period may discover that the completed set is too expensive for the budget or that some of the volumes are out of print.

One type of resource which art historians require are travel books—Baedecker, the Blue Guides, or Touring Club Italians—recent publications as well as old ones. The former are needed to find monuments and works of art for which the location is uncertain. The latter assist researchers in discovering changes which have occurred to the art over the years. In addition, good detailed maps and historical atlases are also needed.

STUDIO ARTISTS

While studio artists utilize various types of art historical works, they need additional kinds of references with information on (1) competitive exhibitions, (2) methods for displaying and selling works of art, (3) the legal aspects of the art field, (3) the latest facts on the combinations and uses of different chemicals and substances utilized in the production of art, (4) recent exhibitions of contemporary art, (5) works on safety,[13] and (6) numerous illustrations of all kinds and types of artistic works. Some of this data will only be accessible through articles in serials or from the numerous exhibition catalogs which are published. These library tools are discussed in later chapters.

It is especially difficult to acquire adequate material on competitive exhibitions, because the sources of this information are constantly changing.[14] Reading newspapers, such as *Artweek,* and serials—such as *American Artist, American Craft*, and *Ocular*—as well as local magazines—such as *Art New England*—which discuss and are important to area artists will assist librarians in this endeavor. There are numerous books being published to help artists in marketing their work and in learning some of the pitfalls of the legal system.[15] The librarian should keep up with the newest publications through publicity brochures and book reviews. Although

the library may have an outstanding collection of material for studio artists, unless these references and aids are promoted, they will be under-used.

Studio artists often need references on the business of art. Such works as Betty Chamberlain's *The Artist's Guide to His Market, Artist's Market,* and *Photographer's Market: Where to Sell Your Photographs* may assist this group of patrons. Books—such as *Photography and the Law* by George Chernoff and Hershel Sarbin—will provide insights into the legal aspects of art. Studio artists frequently wish to discover sources for their basic materials. *MacRae's Blue Book: Materials, Equipment, Supplies, Components* and *Thomas Register of American Manufacturers and Thomas Register Catalog File* are references with long publication histories. These multi-volume works list suppliers and their addresses. *The Thomas Register,* which is available online through DIALOG, reprints the sales catalogs of companies.

As in all fields, studio artists include professionals, students, and novices. Public libraries will need references explaining the process of making art for all of these constituents. These how-to books will be written for various levels as well as different media. Craft books are a large part of this category. In acquiring these works, care must be taken not to buy only the simplest level. Academic libraries may also purchase a few of the how-to references, although librarians in some institutions consider the process of art making to be the province of textbooks, which as a category may be excluded from the collection policy.

ART/MUSEUM EDUCATORS AND ADMINISTRATORS

In addition to the references used by the previously mentioned groups, art/museum educators frequently need: (1) articles and references on a wide range of educational programs, (2) books which provide suggestions and ideas for the making of art, especially by children, (3) guides to films and other media which can be used in their programs, and (4) elementary and survey art-history texts for teacher and docent training. A great many of these patrons' references are found in the serial literature, which is discussed in Chapter 7.

Some sources for locating pertinent literature can be discovered by reading the reviews in the publications of professional groups as well as by purchasing the works actually issued by these organizations. For example, *Art Education,* the official journal of NAEA (National Art Education Association), frequently has reviews of books. The NAEA publishes numerous pamphlets and some books pertinent to this field. ICOM/CECA (International Council of Museums/Committee of Education and Cultural Action) published *Museums and Education,* 1982, a series of essays on various international didactic programs.[16] *Museum Education Anthology; Perspectives on*

Informal Learning: A Decade of Roundtable Reports, 1984, was edited by Susan K. Nichols from articles first issued in the official publication of the Museum Education Roundtable.

Art and museum educators also require books—at various levels of sophistication—on art appreciation. For docents and college students, texts such as William McCarter and Rita Gilbert's *Living with Art* and Edmund Burke Feldman's *Thinking About Art* cover the material. Both books discuss (1) the purposes, themes, and vocabulary of art; (2) two- and three-dimensional media; and (3) historical periods. McCarter/Gilbert include a lengthy bibliography, brief biographies of some of the outstanding artists of the world, a section which for different historical periods compares Eastern and Western art, and a chronology of styles, political/social events and personalities, and monuments and major artists. Profusely illustrated and containing glossaries of art terms, both books are good introductions to the discipline of art, not only for the library's patrons but for the art librarians themselves.

Museum administrators need books concerned with business and legal matters as well as texts on conservation and preservation. Some resources on these subjects can be purchased through professional groups, many of which are listed in Appendix C. For example, AASLH (American Association for State and Local History) publishes technical leaflets and educational materials with such varied titles as *Museum Public Relations* by G. Donald Adams, *Museums and the Law* by Marilyn Phelan, *Access to the Past: Museum Programs and Handicapped Visitors* by Alice P. Kenney, and *Funding Sources* by Hedy A. Hartman. The AAM (American Association of Museums) offers an array of titles, such as *Museum Trusteeship* by Alan D. Ullberg, *Professional Standards for Museum Accreditation* edited by H. J. Swinney, *Museum Ethics* by the AAM Committee on Ethics, and *Fine Arts Insurance: A Handbook for Art Museums* by Patricia Nauert and Caroline M. Black. Another source is SITES (Smithsonian Institution Traveling Exhibition Service), which in 1981 published *Good Show! A Practical Guide for Temporary Exhibitions* by Lothar Witteborg. Founded in 1952, SITES has approximately 110 packaged exhibitions which can be rented by museums. Many of these exhibitions have comprehensive catalogs which are available to the public.

Although some books may be shelved in another department, art librarians should be aware of the existence of peripheral references needed by their patrons and may need to advise colleagues on these purchases. For instance, books that deal with the legal aspects of art should be available in order to assist all of those interested in the field to become aware of the legal ramifications which can result from certain acts. For example, Leonard D. DuBoff's *The Deskbook of Art Law*, 1980, and its *1984 Supplement* contain

legal information on such important subjects as U.S. Customs, international treaties and thefts, censorship of obscenity and pornography, art as an investment, authentication, insurance, auctions, charitable deductions, copyright laws, museum trustee/director liability, artists' legal rights, and museum deaccessioning.

PROFESSIONAL DESIGNERS

Professional designers require (1) data on the latest tools and materials, (2) visual material on current as well as past projects in their field, and (3) references on the business aspects of art.[17] Some of these needs will be met through the serial literature, both of professional organizations and the popular commercial magazines. Trade literature and a product file, both of which are discussed in Chapter 6, can be essential to some of these designers. Photographic archives, referred to in Chapter 8, can also be important. For instance, *Fashion Update* from Emmett Microform, Ltd., is a biannual publication which provides about 500 photographs taken during the showings of the Haute Couture Collections from 50 to 60 fashion houses in Paris, London, Milan, and New York City.

Business resources include: (1) practical cost guides, standards, and technical references; (2) directories of firms and consultants in the industry; (3) detailed city maps and building plans; (4) archival research materials; (5) historical references; (6) specific guides for historic preservation; and (7) works which provide data on potential clients. In a large public library, a separate business section will meet the needs of the professional designer. Librarians of smaller institutions, especially those attached to a business firm, may need to (1) study the references which have been purchased for the business section of a large public library, (2) peruse the titles available at various book stores, (3) read reviews, (4) ask the assistance of the professionals themselves, and (5) confer with colleagues who have the same problems.

The professional groups to which designers belong frequently provide reviews of current books in their official journals as well as the titles of literature published or recommended by the organization. For a list of art-related professions, see Appendix C. Librarians should utilize these professional aids when purchasing materials for this constituency. For instance, the American Institute of Architects (AIA) publishes numerous books and brochures for the practicing architect, and, in some cities, the local chapters sponsor special bookstores which sell only material pertinent to this profession.

If the institution's clientele includes interior design students, the librarian should study the requirements for the national examinations, which are given

twice a year in more than 30 cities in the United States and Canada by NCIDQ (National Council for Interior Design Qualification). Established in 1972, NCIDQ is a consortium of national design societies, including the American Society of Interior Designers, Interior Design Educators Council, Institute of Business Designers, and Interior Designers of Ontario. A bibliography of suggested books which should be read prior to the examination can be obtained from the New York City office. Librarians should have these books available for their patrons.

NOTES

[1]*The Libraries of Stanford University Collection Development Policy Statement*, edited by Paul H. Mosher (Stanford, CA: Stanford University Libraries, 1980), p. 1.

[2]For a discussion of these terms, see Jones, p. 35.

[3]For listings of some important art references published in a series, see Arntzen/Rainwater, pp. 513–20, which details 78 international series, but gives only representative titles for each series, and Jones, pp. 174–78, which cites only 12 series but strives for a comprehensive list of titles. Remember that not all titles in a series are of equal merit.

[4]For a current list of the *Bollingen Series*, contact Princeton University.

[5]For an excellent article which describes the separate card file for catalogues raisonnés at the Metropolitan Museum of Art and lists various references for discovering catalogues raisonnés and lists some international publishers who issue them, see "Catalogues Raisonnés," edited by Courtney Shaw and Eileen Markson, *ARLIS/NA Newsletter* 8 (Summer 1980): 133–34.

[6]For research methodology, see Jones, pp. 259–63.

[7]Ibid, pp. 261–63.

[8]For suggestions of these types of references, see Jones, pp. 177–83, 206–10, 223–32.

[9]For examples of this material, refer to Jones, pp. 104–06, 112–13, 184–86.

[10]For example, Courtney Ann Shaw, *Researching Festivals and Their Relationship to the Visual Arts* and Katherine T. Freshley, *Contemporary Fiber Art, Ancient and Ethnographic Textiles, Oriental Rugs*; both were distributed at the 1979 ARLIS/NA Toronto conference. See also such works as Hilaire Hiler and Meyer Hiler, *Bibliography of Costume: A Dictionary Catalog of About Eight Thousand Books and Periodicals* (New York: H. W. Wilson, 1939; reprint ed.: B. Blom, 1967); and Raymond Toole-Stott, *Circus and Allied Arts: A World Bibliography 1500–1970* (Derby, England: Harpur Distributors, 1958–71), 4 volumes.

[11]*Patrologiae Cursus Completus, Series Latina*, called *Patrologia Latina*, edited by Jacques Paul Migne, Paris, 1844–82, is available on microform through Information Handling Services, Englewood, CO. *Corpus Scriptorum Ecclesiasticorum Latinorum*, edited by Joseph Zycha, Vienna, 1866, is available on microform through Scholars Facsimiles and Reprints, Delman, NY, and Inter-Documentation Company, Leiden, the Netherlands. A hardcover edition is available through Johnson Reprint Corporation, New York.

[12]*Fathers of the Church*, editorial directors Roy J. Defferari and Ludwig Schopp (New York: Fathers of the Church, Inc., and Washington, DC: The Catholic University of America Press, 1947–); and *Select Library of the Nicene and Post-Nicene Fathers of the Christian Church*, edited by Philip Schaff (New York: The Christian Literature Company, 1887–95 and Charles Scribner's Sons, 1898–1907; reprint editions available.

[13]For instance, Gail Coningsby Barazani, *Safe Practices in the Arts & Crafts: A Studio Guide* (s.l.: College Art Association of America, 1978).

[14]For a brief discussion of the problem, see Jones, pp. 128–29.

[15]Ibid, pp. 253–54.

[16]This book can be ordered from Danish ICOM/CECA, Haabets Alle 5, DK-2700 Bronshoj/Copenhagen, Denmark.

[17]For a discussion of pertinent references for designers, see Jones, pp. 79–80, 115–18, 243–56, and Muehsam, pp. 128–37, 157–67.

6

Exhibition, Museum-Collection, Auction, and Trade Literature

INTRODUCTION

A distinguishing feature of an art library is the need for a collection of catalogs and references which provides data on exhibitions of works of art, museum collections, and auction items. These materials, in addition to serials, have become the primary media through which the international community of scholars communicate. In addition, certain institutions collect trade brochures, especially publications by commercial firms that manufacture materials used by architects, builders, and interior designers. For art librarians, these resources pose several problems: (1) determining the essential catalogs and literature needed; (2) procuring the materials; (3) organizing and cataloging them; and (4) assisting patrons in retrieving and using the data. This chapter discusses these aspects of the above mentioned references.

EXHIBITION CATALOGS AND REFERENCES

When objects are displayed for the public, a catalog of the exhibition is usually written to inform visitors about the works of art and to produce a permanent record of the event. In the 19th century, most of these exhibition

catalogs were 10- to 20-page brochures that listed only the titles of the works each artist displayed. If the work was not owned by the artist, the collector's name might be added. The scarcity of data in these brochures, as well as the lack of illustrative material, limited their value to researchers who were trying to establish—for a specific work of art—provenance, various title changes, or an exhibition record.

Because of the increased amount of research material now included in many exhibition catalogs, they have assumed greater importance to the art world. For instance, the 1984 catalog *Watteau: 1684–1721*—for the exhibition of this 18th-century Frenchman's work at the National Gallery of Art in Washington, D. C.—consists of 580 pages of information. The 73 paintings, 143 drawings, and 8 etchings are provided with detailed catalog entries of media, dimensions, location, provenance, exhibitions, and bibliography plus a list of related paintings, drawings, and prints. Each work is illustrated, usually in color, accompanied by numerous preliminary drawings. In addition, this scholarly catalog contains a chronology of Watteau's life, an extensive bibliography, a list of important exhibition catalogs containing the artist's work, and essays on the restoration of two of Watteau's paintings, a history of the period, a discussion of theater costumes depicted in Watteau's work, Watteau and musical instruments, and the importance of the French artist to Frederick the Great of Prussia.

Exhibition catalogs are issued by small, relatively unknown galleries as well as by the great museums of the world. Their size and quality vary tremendously, from small photocopied pamphlets to expensive hard-cover books. The catalogs can be monographs on a subject, condensed versions of more detailed monographs by the same author, and even a catalogue raisonné. In order to understand the types of information available from these various kinds of catalogs, some of the outstanding ones should be studied, because familiarity with these reference tools and their terminology is imperative for an art librarian.[1]

Produced on a wide variety of subjects, exhibition catalogs are essential for most people associated with art. Because these catalogs may include photographs of objects from private collections—which are seldom seen and thus bring together, in juxtaposition, works never before viewed in this relationship—and because they are important historical documents, scholars need to study these catalogs long after the exhibition has closed. Frequently, this material is the latest research on the subject. Documentation of contemporary art exhibited throughout the world assists artists in discerning recent trends and in developing new approaches and ideas in their own work. In this case, neither the language in which the catalog is written nor the caliber of the text is as important as the quality of the reproductions. In addition, dealers and collectors must keep informed as to the changes in an artist's

reputation, since after a large retrospective exhibition of an artist's *œuvre*, the value of his or her works usually increases.

No one library can afford to have all of these publications, which are issued throughout the world in astronomical numbers. Which catalogs and how many should be acquired for a library depends upon the subject interests as well as the type, size, and collecting levels of the institution. In a museum or university library, the choice of subjects will be determined by the art collections, special exhibitions, and courses taught. Because the numbers are so staggering—estimates of 10,000 to 20,000 annually—just trying to discover the existence of some of these reference tools can be a problem.

Exhibition catalogs cover displays of art from the local, national, and international scene. Unless librarians develop systematic plans for acquiring these catalogs, they will be out of stock before knowledge of their existence is known.[2] Unfortunately, since there is no simple way to discover the existence of exhibition catalogs which may be pertinent to a specific library, many sources are required. Newspaper and magazine reviews of exhibitions often include information on existing catalogs. Museum brochures may advertise the publications for their forthcoming shows. The abstracting services provide information on catalogs, but usually long after the show has closed. Other sources are the local museums and galleries which may include the library on their mailing lists. At many institutions, patrons are encouraged to donate materials as one method for collecting archival material on local artists.

Museums are frequently part of an exchange program whereby all of the publications of each museum are sent free to others on the list. An accurate check-in system must be devised in order to assure that essential exhibition catalogs actually arrive at the library. The exchange program list must be constantly revised and maintained, as discussed in Chapter 12. Decisions as to whether or not specific institutions should be included in the exchange program must also be made, for a contemporary art museum library will not be augmented by purchasing or receiving an illuminated manuscript catalog from an institution that collects only medieval art.

Because it is impossible to know about all of the important exhibition catalogs that are published currently in the world, many librarians have a standing order with a commercial firm, such as Worldwide Books, Inc.[3] This company culls catalogs from about 3500 different museums and galleries around the world. From this list, about 700 to 900 catalogs are chosen annually to be distributed through their purchase plans. Since 1963, catalogs from more than 2000 art museums in some 50 different countries have been chosen. The media represented in these shows are divided as to (1) architecture; (2) arms and armour; (3) assemblages and constructions; (4) ceramics; (5) conceptual, video and environmental art; (6) decorative arts

and design; (7) drawings; (8) graphic art; (9) kinetic and light art; (10) manuscripts and bookbinding; (11) medals and coins; (12) memorabilia; (13) mixed media and collage; (14) painting; (15) photography; (16) posters; (17) sculpture; and (18) tapestries and textiles. The catalogs range chronologically from the prehistoric to the contemporary. Topics include African, American, Canadian, Primitive, and Near and Far Eastern art as well as exhibitions of private collections, women artists, and trends—political, religious, and current.

The firm's quarterly publication, *Worldwide Art Catalogue Bulletin*, provides reviews of the catalogs and various indices to the material. These publications, plus the annual index, have become an important tool for assisting researchers in locating information on exhibitions. The catalogs are indexed by (1) titles, (2) major artists represented in exhibitions, (3) chronology, (4) media, and (5) topics. Many librarians place the call numbers of the catalogs that have been purchased in each *Bulletin* and have the four issues plus the annual cumulative index bound together.

Worldwide Books provides about 22 plans from which librarians may choose, either separately or in combination. Plans include such selections as Post-1945, Oriental, American, Canadian, Monographs on Artists, Architecture, and Photography. The basic standing order is for about 400 to 450 titles; the most inexpensive plan, 20 to 30. Sent prior to the quarterly bulletin, the *Pre-Review List* provides bibliographic data on the catalogs which will be sent for each standing order. These brochures also include a special order list of exhibition catalogs that were not deemed appropriate for the regular standing-order plans due to the price, looseleaf format, or a foreign-language version of a catalog previously offered. Librarians may purchase not only from this special order selection but from any of the other catalogs on the list. For museums with exchange programs, special plans are devised.

Worldwide Books also provides two other services: *Short-Listed Titles* and COBRA (Collaboration for Bibliographic Records in Art). The former is a 15- to 20-page list of exhibition catalogs which have too small an audience to be included in the regular order plan. These works are not reviewed in the bulletin, nor included in the annual index. COBRA is the joint endeavor of Worldwide Books and the Boston Public Library. The former provides the catalogs; the latter creates bibliographic records which are distributed by LC and thus are available through such services as OCLC, RLIN, and UTLAS. The program encompasses all titles reviewed since volume 20 (1984) of the *Bulletin* plus the titles—about an additional 700—cited in the Special Order Selections of the *Pre-Review Lists* and the *Short-Listed Titles*. Since LC does not catalog all exhibition catalogs—especially the foreign-language ones—COBRA assists librarians in quickly getting these references on the shelves.

Because the material in exhibition catalogs can be vital to research, several companies have reprinted some of the more important historical ones. Due to problems of paper deterioration and lack of complete runs of catalogs, even libraries with extensive holdings of these old catalogs may need to purchase reprinted editions. Garland Publishing has issued *Catalogues of the Paris Salon 1673 to 1881*, 60 volumes; *Exhibition Catalogues from the Fogg Art Museum*, 10 volumes; *Encyclopédie des arts décoratifs et industriels modernes au XXeme siècle*, 12 volumes; and *Modern Art in Paris, 1855 to 1900*, 47 volumes. Chadwyck-Healey has reprinted an extensive list of more than 2000 out-of-print exhibition catalogs on microfiches. Available both through the Knoedler Gallery and Chadwyck-Healey, *The Knoedler Library of Art Exhibition Catalogues on Microfiche* is an especially rich source for American catalogs. It contains such holdings as the National Academy of Design, from 1832 to 1918, and the Pennsylvania Academy of the Fine Arts, from 1812 through 1969.

Exhibition catalogs can be organized in a number of different ways. Depending upon the institution, they can be (1) classified as monographs and cataloged, (2) indexed in separate files under the name of the exhibiting institution, or (3) treated as ephemeral material and placed in vertical files. In some institutions, all three methods may be used. For small brochures which provide only a summary listing of an exhibition, the publication is often placed in a vertical file under the name of the first or only artist. If the exhibition covers the work of numerous artists in a touring exhibition, the catalog is usually entered under the name of the first institution at which the art was displayed. The biggest problem with these catalogs is providing enough access points by which patrons can locate the material.

If published through the auspices of a part or department of a museum, an exhibition catalog is sometimes listed under the name of the parent institution. If an individual author is responsible for writing the catalog, the work is cataloged under this person's name. These various methods of entry for catalogs make it difficult for both patrons and librarians, although the provision of multiple access points and appropriate references in the library's own catalog will alleviate this situation. As an example, *The Secular Spirit: Life and Art at the End of the Middle Ages*, published in 1976, was an exhibition catalog for works of art displayed at the Cloisters, the medieval museum in Fort Tryon Park, New York City, which is administered by the Metropolitan Museum of Art. Although the book consists of a number of essays by various authors, was published by the commercial firm of E. P. Dutton, and referred to an exhibit at a separate museum building, the Cloisters, the pre-AACR2 LC main entry was under the Metropolitan Museum. Some libraries have neither changed their old cataloging records nor provided adequate references.

Librarians prefer entries filed under the name of the museum or gallery displaying the works of art, on the theory that the most consistent trait of such exhibitions is that they are held in an identifiable place. But the principle of authorship responsibility—whether personal or corporate—still obtains. Lacking such an author, a title entry is prescribed. One problem is that catalogs of traveling exhibitions have often been issued under varying titles with different sponsoring bodies and places of publication. The inability of some catalogs to show all the variant titles—and indeed to indicate if they are new or revised publications, as they sometimes are—can result in frustrated patrons or in duplicate orders on the part of the acquisitions department.

The adoption of AACR2—the second edition of the *Anglo-American Cataloging Rules*—altered many library practices. Exhibition and museum-collection catalogs are now frequently cataloged under the accepted name of the museum. This has caused numerous listings under "M" for Musée, Museo, Museum, or Muzeum and "A" for Accademia, Academia, or Academy. The same confusion occurs under "U" with the variants of the word University. If a museum is governed by a central authority, such as a municipality, the entry may be placed under the name of the city, followed by the name of the individual institution. This apparent lack of consistency can create tremendous problems for patrons. For instance, the Parisian Impressionist museum is now entered under "Musée du jeu de paume (France)" and the Munich industrial museum under "Deutsches Museum (Germany)." Neither entry pinpoints the exact location, a guideline used by many researchers. Nor is it easy to explain the following differences: "Haus der Kunst, München" and "Neue Pinakothek (Munich, Germany)." In the former, the German name of the city, München, is used; in the latter, the anglicized version.

AACR2 has dictated the use of the name by which the institution is most commonly known and material in a library's collection is cataloged under that name rather than the city. A listing for "Galleria degli Uffizi" is preferred to "Firenze. Galleria degli Uffizi." But the Italian name of this museum may not be known to the patron who wants to refer to an exhibition held at the art gallery in Florence, and there may be no references from the English form.

One library catalog system may include the name of a museum or gallery in more than one form, but if this is the case, they must be linked by "see also" references. For instance, at one time the J. Paul Getty Museum would have been cited under an inverted form of the institution's name: Getty (J. Paul) Museum. Now it is entered directly under the form J. Paul Getty Museum. In the same manner, the Solomon R. Guggenheim Museum is now listed under that name instead of its former entry, Guggenheim (Solomon R.) Museum. This requires that patrons know the complete names of museums, unless the appropriate references are made. The librarian must

know the complexities of the cataloging system in order to assist patrons in finding these works once they are cataloged and shelved.

Many libraries have only a small portion of the exhibition catalogs needed. Yet, if the patron can discover the existence of a catalog, the work can frequently be obtained through an interlibrary loan. To assist patrons and librarians in finding an exhibition reference, there are a number of research tools: (1) the abstracting services, (2) indices of commercial firms, (3) catalogs of holdings of famous libraries, and (4) various database searches. Two semi-annual abstracting publications—*RILA* and *ARTbibliographies MODERN*—have separate indices that provide cross references to the exhibition catalogs included in that issue. In *RILA*, "Exhibits" provides between 1000 and 1200 cross references per issue. Under "Museums and Gallery Index," *ARTbibliographies MODERN* has about 385 citations. Both of these publications provide multiple listings for traveling exhibitions—reporting each individual museum where the exhibition has been shown—and give access to exhibitions which occurred within the past few years, the lag time being as much as three years.

Many librarians use the quarterly *Bulletins* and the annual indices published by Worldwide Books, which were discussed previously, as an index to the catalogs issued since 1963. For historically important exhibitions, the catalogs of the holdings of famous libraries, which were discussed in Chapter 4, can be used. Exhibition catalogs are interfiled with other entries in the publications for the Metropolitan Museum of Art and the Fogg Art Museum of Harvard University. A separate volume, *The National Art Library Catalogue: Catalogue of the Exhibition Catalogues* cites the more than 50,000 exhibition brochures owned by London's Victoria and Albert Museum. The *Index to Art Exhibition Catalogues on Microfiche*, produced by Chadwyck-Healey, provides indexing for the reproductions of a wide range of out-of-print gallery and museum catalogs on microfiches.

The University of California at Santa Barbara has one of the outstanding collections of exhibition catalogs. This collection of more than 45,000 catalogs includes (1) those from significant North American, British, and European museums and galleries; (2) all of those reproduced by Chadwyck-Healey; (3) the salon and exhibition brochures owned by the Knoedler Gallery Library; and (4) all of the works sold through the Worldwide Books subscription program. This list of the Santa Barbara school's holdings, *The Art Exhibition Catalogs Subject Index*,[4] is on microfiche. Updated periodically, it has two indices: for subjects and for the publication agents, such as museums, galleries, and commercial firms. Subject indexing is arranged by artists, styles or movements, media, subjects, and collections; subdivisions are by country, city, date by century, as well as by specific time periods.

For retrospective exhibition information, there is a wide variety of

references.[5] For instance, the books compiled by Algernon Graves index works of art—often reporting the titles—displayed at various British institutions. These works include: *The British Institution 1806–1867, A Century of Loan Exhibitions 1813–1912, A Dictionary of Artists Who Have Exhibited Works on the Principal London Exhibitions from 1760 to 1893,* and *Royal Academy of Arts.* For 20th-century art, *Modern Art Exhibitions 1900–1916: Selected Catalogue Documentation,* compiled by Donald E. Gordon, provides indexing for 851 exhibition catalogs, which are from 15 European countries and are owned by 55 different libraries.

Past North American annual exhibitions—such as those held by the American Academy of Fine Arts, Boston Athenaeum, Brooklyn Art Association, National Academy of Design, Pennsylvania Academy of Fine Arts, and the Royal Canadian Academy of Arts—have also been indexed.[6] The data recorded vary from book to book but often include such information as exact titles, names of owners, artists' membership status in the organization, and the prices which the artists placed on the objects that were for sale. Most of the exhibition catalogs are available through an interlibrary loan from the Archives of American Art, which after microfilming more than 20,000 catalogs from exhibitions that were held from the early 19th century to 1960s made them available for loans. The Archives' *Collection of Exhibition Catalogs*—which is arranged by gallery, museum, and personal names—has the microfilm roll and frame number needed for ordering these exhibition catalogs.

MUSEUM-COLLECTION CATALOGS

Information concerning art objects in the permanent collections of various museums around the world will be required by curators, art historians, publishers, collectors, and travelers. The easiest method of obtaining this data is from a museum-collection catalog.[7] Unfortunately, many of the world's art museums have neither a scholarly catalog nor a checklist of their inventories. Although sometimes difficult to collect, art librarians should make a decided effort to purchase the catalogs from the prestigious museums of the world as well as the area institutions which have collections that reflect the interest of their patrons. Nor do these catalogs become obsolete.[8] Scholars will require earlier—as well as the latest—editions in order to discover whether or not there have been any changes in attributions or if any objects have been deaccessioned. For the same reason, inventory lists of famous collections can be of the utmost importance to researchers.[9]

The names of museum-collection catalogs can be obtained from such publications as (1) *Art Books 1950–1979,* which has a section that lists over

3300 such works; (2) *Old Master Paintings in Britain*, which cites catalogs issued for more than 150 collections; and (3) *Paintings in Dutch Museums*, which provides information for about 30 institutions. A source for current publications is the abstract section, "Collections, Public Collections (by city)" of *RILA*.

A catalog or book published to coincide with an exhibition sometimes contains a listing of some aspect of a particular museum's collection. For example, *The English Miniature*, issued in 1981 by Yale University Press, is concerned with the permanent collection of London's Victoria and Albert Museum. Another recent development is the museum catalog that is published with a combination of color microfiches of reproductions of works of art and printed catalog entries. These require special storage; in some libraries the printed book is cataloged and placed on the shelf with a notation that the microfiches are at the media center or at the reference desk. Other institutions have the printed work and the microfiches stored in the same area.

In the future, there may be a tremendous change in museum-collection catalogs since, in many museums, information on the art objects is being placed in computer files. In order to aid museum registrars in collection management, the first level of computerization has usually been acquisition data. For instance, The Royal Ontario Museum, Toronto, which closed its doors for two years in the early 1980s to allow for expansion and renovation, placed data on the more than 350,000 objects of the Art and Archeology Department in computer files in order to determine the exact location of each item.[10] Originally, only accession and location data were recorded. Later administrative and descriptive data will be added. Another level of automation is object cataloging, which forms a computerized museum-collection catalog in which the data can be manipulated and retrieved in a greater variety of ways. Eventually, some museums may include even further information in these files—for instance, scholarly references or inter-disciplinary data—to aid experts in the field of humanities.

Although most of the automated systems are in-house or individual projects, there has been an interest in developing national computerized projects. Two programs should be watched: (1) Museum Prototype Project, which is supported by the J. Paul Getty Foundation in cooperation with eight various-size institutions[11] and (2) ARTIS (Art Museum Information System), which is being developed by The Art Museum Association of America with the assistance of the staffs of four medium-size museums.[12] The ideal would be for the staff at one museum to have the capability of retrieving data concerning the objects in the collections of the other institutions. The museum that owns the collection would be able to suppress sensitive information, such as the monetary value of items, from other users of the database. This hypothetical system would allow art researchers, in other

places in the world, to have specific information—tailored exactly to their needs—from the museum database, just for the price of a search. The future possibilities are staggering. Although these catalogs are still in the future, art librarians need to be aware of the potential of such a system.[13]

AUCTION REFERENCES

In the fall of 1983, the art collectors of medieval manuscripts were elated to learn of the rediscovery of *The Gospels of Henry the Lion*. Although there were a number of good illustrated articles concerning the work,[14] the most complete and scholarly publication on the 12th-century German manuscript was the 77-page Sotheby auction catalog. The catalog included 31 color reproductions of full-page miniatures and decorated pages plus a depiction of the outside cover of the book and a list of 85 references to the manuscript. The detailed text describing the German work and all 24 full-color illuminations of the complete work made this catalog the most scholarly monograph on *The Gospels of Henry the Lion*. Until some day in the future— if and when the Wolffenbüttel Library near Brunswick, Germany, which now owns the work, decides to produce a facsimile copy—the Sotheby catalog is the best reference on this outstanding illuminated manuscript. And how outstanding can be measured by the fact that at the London auction house on December 6, 1983, the *Gospels* brought £ 7.4 million— roughly about $10.7 million, not counting the 10% buyer's premium. This auction catalog was given special treatment at some libraries by being cataloged and classified.[15]

References relating to the buying and selling of works of art are essential for museum libraries and public institutions that serve the art dealers and collectors of the community. These research tools are used by scholars, who are (1) studying economic and price trends, (2) checking the provenance of a work of art, and (3) trying to locate data on little-known or recent artists whose works have sold but for whom little documentation is available. In addition, auction catalogs can be rich sources for illustrative material, especially works which are in private collections.

Throughout the world, there are more than 200 auctioneers and salesrooms. The two largest auction houses—Christie, Manson and Woods, and Sotheby Parke Bernet—publish two major kinds of references: (1) an annual hardback volume that gives a summary of the highlights of the season and (2) numerous publicity brochures and auction catalogs that report data on forthcoming activities. Providing the highlights of the sales for the year, *Christie's Review of the Season* and *Art at Auction: The Year at Sotheby Parke Bernet* have excellent color illustrations of some of the outstanding works of art sold plus

signed scholarly articles on various aspects of selling.[16] For libraries that do not need the numerous brochures that advertise forthcoming sales, these yearly summations provide interesting insights into the success of these two auction houses and can be used to discern changes and trends in taste and the economic market.

Annually, both Sotheby and Christie's issue more than 1000 sales brochures for their auction houses located in various cities throughout the world. The brochures report auctions on pictures and drawings; engravings and etchings; furniture and works of art; tapestries, rugs, and textiles; silver and plate; ceramics and bronzes; jewelry; arms and armour; coins and medals; books and manuscripts; and Oriental works of art. The brochures can be purchased individually or by annual subscription. The standing order plan can be for all the sales during the year or for specific kinds of art, such as ceramics and bronzes. The purchase price of these brochures can include both the pre-sale list of estimated prices that the works are expected to bring and the post-sale list of the actual prices for which the items sold.

An auction catalog can include any work of art that is sold at auction—old master paintings, drawings, sculpture, ceramics, furniture, or jewelry. The items which are to be sold can be (1) in a separate auction for just that one item, such as *The Gospels of Henry the Lion*; (2) for an individual collector, such as the contents of Gallison Hall in Farmington, Virginia; or (3) a number of items, owned by various collectors, which have been grouped together under a common classification, such as Impressionist and Modern Paintings and Sculptures.[17] Not only may an auction catalog be the latest reference work on specific art objects, the reproductions may be of prime importance to researchers. For instance, John James Audubon's *The Birds of America* was sold by Christie's in Houston, Texas, on October 15, 1982. Since Christie's catalog contained an illustration for each engraving, the sales catalog is a ready reference for identifying Audubon's work on American birds.

Auction catalogs provide various data—the artist's name or the school from which the work derived, the title of the work, the medium, and the dimensions in both inches and centimeters. The present owner is often identified. If the owner provides more information, this additional data may be reported—name, dates, provenance, exhibitions and literature concerning the work of art, and if a portrait, information on the sitter. Depending upon the value of the piece, the information may or may not be checked by the auction house experts. The sellers of the works of art not only provide documentation—if such exists—for the pieces to be sold, they also pay for the illustrations in the catalogs. In 1984, a black-and-white quarter-page reproduction cost about $40; a color illustration, as much as $600.

In the past, some of the auction houses have listed an artist's name in

various ways to indicate the opinion of the auctioneers as to the degree of the involvement of the artist in the work of art. If the complete given names and surname of an artist are cited, the work of art is considered to be by the artist. If the surname and only the initial of the first name of the artist are provided, the work of art is thought to be of the period of the artist and may be wholly or partly the artist's work. If the artist's surname is printed alone, the work of art may be of the school or by one of the followers of the artist or in the artist's style. Currently, the terms *attributed, circle of, studio of, school of, manner of,* and *after* are being used. The auction catalog glossary should be checked for specific definitions of terms.

There are other differences between past and present auction catalogs. Obviously, color reproductions have added greatly to the value of these resources. In addition, until the early 1970s, the London houses of Sotheby's and Christie's frequently included the names of the buyers as well as the purchase prices of the items in the Post-Sale Price List. This was a tremendous asset for curators and historians who were tracing the provenance of a work of art or studying the changes in a specific art collection. Unfortunately, with a concern for theft and a wish for anonymity, this practice was suspended. The New York office of Sotheby Parke Bernet has never published the names of buyers.

Sales catalogs are more of a problem for museum and gallery libraries than for other types of institutions because they collect more of them. Most large museum libraries, such as the Metropolitan Museum of Art in New York City, subscribe to most of the catalogs from a number of auction houses, especially Christie's and Sotheby's. Smaller museum libraries purchase only the sales catalogs pertinent to the museum's particular art collection. In a museum library, the curatorial staff usually decides which auction houses and which types of art catalogs will be collected. In a public library, the choice should be determined by the type of patrons who would use these references.

There are an estimated 4000 or more sales catalogs published annually.[18] No one library will have more than a fraction of these references.[19] A small collection can be integrated into the book or serial collection, but when these resource tools constitute a vast collection, a simpler treatment may be needed. In many libraries, sales catalogs are entered with short titles in a separate file similar to the ones used to register serials. These catalogs are generally arranged chronologically under the name of the auction house, sub-arranged by city of sale. Post-Sale Price Lists, which are usually not available until two or three weeks after the sale, are attached to the appropriate catalogs. One of the problems in some museum libraries is the retrieval of auction catalogs from curatorial offices. Because this can be a political football, the librarian should establish guidelines for the use of these materials and, with great diplomacy, try to encourage patrons to follow them.

Because it is too expensive to do in-house indexing to connect all objects and sales, most librarians rely upon the printed books that index recent auctions. After the sales are concluded, the indices of current auction sales report the events. These annual publications provide information on the sales of works of art by various auction houses. Most of these references record, under the artist's name, the title of the work sold, its medium and dimensions, signature and date, auction house, date and lot number of sale, and sales price quoted in the currency of the country where the auction took place. There is often some indication of whether or not the work of art is illustrated in the sales catalog. In addition, these indices may use terms and abbreviations of which the librarian should be aware. A *reserve price* is the minimum amount for which the owner of the work of art is willing to sell the piece. This amount is always confidential, known only to the seller and the auction house. If the reserve price is not met, the work is taken off the list of items for sale, rather than allow the object to be sold at too low a price. The price at which the auction was stopped is called a *Bought In* or *B.I.* price. A *hammer price* excludes any commissions or premiums which may have been charged. Librarians should study the various indices and their abbreviations in order to assist patrons in using these materials.

Auction catalogs are often under-used due to the lack of adequate indexing.[20] Most researchers seek to access auction catalogs through the name of an artist. For 20th-century auctions, there are a number of good annual publications that index the auctions under artists' names. Most libraries do not subscribe to all of these references to auction sales. However, if the librarians in a metropolitan region try to coordinate some of their purchasing, all of these works can be represented in an area.

The following indices cover American and Western European art sales: (1) since 1946, *World Collectors Annuary*, paintings, watercolors, and drawings; (2) since 1961, *International Art Market: A Monthly Report*, paintings, drawings, prints, posters, antiquities, furniture, objects of art, Orientalia, photographs, pottery and porcelain, rugs and carpets, and silver; (3) since 1967, *International Auction Records*, engravings, drawings, paintings, and sculpture; (4) *Annual Art Sales Index*, paintings since 1969, drawings since 1975, and sculpture since 1983/84; (5) since 1978, *Gordon's Print Price Annual*; and (6) since 1980, *Leonard's Index to Art Auctions*, paintings, prints, and drawings. Although two indices for current auction houses have ceased publishing English-language versions, they are still of value. *Art Prices Current* reported sales information on paintings, drawings, and prints, from 1907 to 1973; *Art-Price Annual*[21] reviewed auction data on paintings and prints, non-European art, furniture, and antiques from 1945 to 1979. There are other reference tools which can be used for discovering auctions in which an artist's work sold, such as (1) Emmanuel Bénézit, *Dictionnaire critique et*

documentaire de peintres, sculpteurs, dessinateurs, et graveurs; (2) Algernon Graves, *Art Sales from Early in the Eighteenth Century to Early in the Twentieth Century*; (3) Hypolyte Mireur, *Dictionnaire des ventes d'art faites en France et à l'étranger pendant les XVIIIme et XIXme siècles*; and (4) Gerald Reitlinger, *The Economics of Taste*.[22]

Computerization of auction information has greatly assisted researchers in the retrieval of this type of data. One system is to provide the same information available in printed indices to auction sales through a database which can be frequently up-dated. These searches save time, but expense is incurred. For instance, information dating from October 1970, which is printed in the volumes of *Annual Art Sales Index*, can be accessed through the special database, called *ArtQuest*. The coverage has changed over the years: drawings were added in 1975, sculpture in 1983. Moreover, the works must sell for more than a specific price before they are added to this computer file. In 1984 for known artists, this was £ 300 for oil paintings, £ 250 for watercolors and drawings, and £ 500 for sculpture. It was £ 2,000 for any items listed as school pieces. Included are works by some 80,000 artists from Old Masters to the contemporary. Added each year are the names of about 1,000 to 2,000 artists whose works either have not been auctioned previously or have just obtained the required minimum for inclusion in this index to auction data. For a fee, this English database can be searched to answer such questions as how many works by a specific artist sold, the titles of works of art sold by one of the auction houses, paintings sold on a particular subject during a span of years, or the range of prices for which the works of art sold by an individual artist. The same information that is recorded in the printed volumes can be obtained. Because it is more versatile and provides a cumulative list, the database is more efficient for obtaining certain answers than the printed volumes. Since the *ArtQuest* files are updated nine to ten times a year, the most current auction information is immediately retrievable through this database.[23]

Since 1982, access to the auction catalogs owned by the Art Institute of Chicago, the Cleveland Art Museum, and the Metropolitan Museum of Art has been available through the *SCIPIO Database*. In this arrangement, the Art Institute is responsible for adding to this computer file all the records for Christie's catalogs; the Cleveland Museum, for Sotheby's; and the Metropolitan Museum, for French auction houses.[24] In February 1983, the J. Paul Getty Museum was included in the group and given the responsibility of inputting data from retrospective catalogs. For instance, in 1985, information on a reprint of what is thought to be the earliest auction catalog—to a book sale in Leiden, Holland, July 1599—was added to the database. In 1985 the group was augmented by the inclusion of the National Gallery of Art, Washington, D. C., which will input data from European

auctions other than those which take place in France. The growth of the files has greatly accelerated. For example, in 1983, there were some 11,000 auction catalogs in the computer files; by July 1985, there were about 47,000. The ultimate aim is to include all major auction catalogs.

SCIPIO (an acronym for *Sales Catalog Index Project Input Online*) is available only online through RLIN, either for members of RLG or those with a special search account. The records contain information from the title pages of the auction catalogs. The items sold or the artists represented at the specific auction are not cited unless this information is on the title page. For retrospective catalogs, the numbers assigned to them by Frits Lugt's *Répertoire des catalogues de ventes publiques*—for catalogs dating from 1600 to 1900—or Harold Lancour's *American Art Auction Catalogues 1785–1942* are included. An authority file for auction-house names has been developed because these institutions have frequently altered the method of designating the firm on the title pages of auction catalogs. For instance, Sotheby Beresford Adams, Chester is the same company as Sotheby's Chester. *SCIPIO* can also be used to locate auction catalogs which are owned by the RLG participating museums. Photocopies of the catalogs, or of specific items, can sometime be obtained from these institutions.

There are a number of hardbound indices that list auction catalogs and their locations. Most entries are recorded chronologically by date of sale or by auction house. Some provide access through collectors' names. Unfortunately, none has an index to artists' names. There are special catalogs for the holdings of such libraries as the Bibliothèque Forney in Paris, the Fine Arts Library of Harvard University, the Thomas J. Watson Library of the Metropolitan Museum of Art, and the Winterthur Museum Library, Wilmington, Delaware. In addition, there are two important hardbound publications of union lists of sales catalogs: Lancour's *American Art Auction* Catalogues 1785–1942, which lists the holdings of 21 U.S. libraries, and Lugt's *Répertoire des catalogues de ventes*, four volumes which refer to 150 institutions that own the almost 100,000 catalogs cited. These union lists provide the location of early auction catalogs which are out of print and usually difficult to locate. *SCIPIO* uses these numbers for identification of the auction catalogs which are entered into the database.

Because of their importance to certain kinds of research—tracing provenance and collectors or establishing monetary trends—some auction catalogs are being reprinted in microform. For instance, the Archives of American Art photographed about 15,000 auction catalogs of American sales that occurred between 1785 and 1960. Although at present there is no published catalog of this collection, the number provided in Lancour's *American Art Auction Catalogues* can be used for interlibrary loan purposes. *The Knoedler Library on Microfiche* contains about 13,000 auction catalogs

which have notations added by the Knoedler staff as to the purchasers and the sales prices. Another reprint, *Sotheby's Sales Catalogues* consists of four parts: *I: 1734–1850*, 71 reels; *II: 1851–1900*, 148 reels; *III: 1901–1945*, 155 reels; and *IV: 1946–1970*, 164 reels. Annotations providing the names of buyers and the sales prices are often included; access is by date only. Even though their institutions do not own these reprints, librarians should know where the closest copies are in order to assist their patrons.

 Christie's Pictorial Archive provides access to more than 70,000 photographs of items—paintings as well as decorative and applied arts—that sold from 1890 to 1979.[25] *Christie's Pictorial Archive: Index to Artists* is a list of the 5000 artists' names whose works are represented in this archive. Although it includes some late 19th-century artists, there are no works from the Impressionist or early modern schools. Unfortunately, the poor quality of reproductions and the deletion of the dates of the sales as well as the sales prices make this research tool of limited value. *Christie's Pictorial Archive: Impressionists and Modern Art* is a microfiche publication of some of the artists not included in the other Christie's publication. In this instance, the dates of the auctions were included.

TRADE LITERATURE

 Trade literature is any brochure, pamphlet, broadside, or advertising copy produced by a business firm in order to encourage people to purchase certain items.[26] Two frequently used types of trade pamphlets are those for building and architectural materials and for items used by interior designers. Business offices that represent these professions as well as public and university libraries which cater to these type of patrons will have the greatest use for trade literature.

 For current trade building catalogs, the library should have an annual subscription to one or more of the pertinent multi-volume sets of *Sweet's Catalog File: Products for General Building, Products for Industrial Construction and Renovation and Renovation Extension, Products for Light Residential Construction, Products for Interiors, Products for Engineering,* or *Products for Canadian Construction.* These volumes contain the actual advertising trade brochures, which are organized under broad subject headings. This trade literature provides important data on the various products as well as technical information. For each subject of *Sweet's Catalog File,* there are three indices: to firms, to products, and to trade names.

 To assist interior designers, the librarian should either subscribe to *Sweet's Catalog File: Products for Interiors* or develop an interior design product file. Both of these together would provide better coverage. The latter is a special

collection of distributors' catalogs and publicity brochures which the various manufacturing firms will provide the library for their clientele.[27] For some brochures there is a charge; others are free. For access to a collection of trade literature, a minimum of two files should be developed: (1) a list of the names of the manufacturing firms whose products are represented and (2) a subject file with numerous cross references.

Over and beyond the current trade literature, there is often need for past dealers' brochures. Historical preservationists, architects, and designers require this material in order to repair or preserve ancient buildings or period rooms. The trade pamphlets can also be used by patrons interested in various historical approaches—design, style, industry, advertising, fashion, or taste of a specific period. Another use is browsing, in order that designers can glean new ideas. A number of institutions—such as the Winterthur Museum, Wilmington, Delaware, and the Avery Library, Columbia University, New York City—have extensive collections of this type of material. Most libraries that collect trade literature have devised their own subject heading categories and have kept the pamphlets in a special storage area. Small brochures are encapsulated in acid-free plastic sheets or placed in portfolio folders.

In 1984, Clearwater Publishing Company issued the *Decorative Arts Trade Catalogs from the Winterthur Museum*, 1885 catalogs reproduced on microfiche. These catalogs can be purchased as the entire set, any of the 30 subject headings, or individual titles. *Trade Catalogues at Winterthur: A Guide to the Literature of Merchandising 1750 to 1980*, by E. Richard McKinstry, has an annotated entry for each catalog, citing firm name, number of illustrations and pages, and type of goods represented. There are also chronological, geographical, and alphabetical indices to the catalogs. If the library's patrons do not need all of the 30 categories—which include such subjects as brass goods, ceramics and glassware, clothing and accessories, furniture, jewelry and clocks and watches, lighting fixtures and electrical supplies, silver and silver-plated goods, and wall and floor coverings—the library should still own *Trade Catalogues at Winterthur* in order that patrons will know the extent of the holdings. There are plans for the Avery Library collection of trade literature to be filmed by the same publisher.

NOTES

[1]For a detailed discussion of these references, including definitions of the terminology used in them, see Jones, pp. 27–33. In this same reference, see pp. 55–60, 76–77 for methodology for using these tools and pp. 85–90 for problems associated with compiling a catalog entry. For an overview, see Anthony Burton, "Exhibition Catalogues," in *Art Library Manual*, edited by Philip Pacey (New York: R. R. Bowker Company, 1977), pp. 71–86.

[2]For a discussion on the economics of publishing these reference tools, see Brian Gold,

"Exhibition Catalogues," *ARLIS/NA Newsletter* 8 (Summer 1980): 116–17.

[3]See Brian Gold, "Acquisition Approaches to Exhibition Catalogues," *Library Acquisitions: Practice and Theory* 7 (1983): 13–16.

[4]Formerly entitled *Catalogs of the Art Exhibition Catalog Collection of the Arts Library, University at Santa Barbara.*

[5]For an annotated list, see Jones, pp. 192–95.

[6]Ibid, pp. 192–93. The National Museum of American Art, Washington, DC, has a "Pre-1877 Art Exhibition Catalogue Index" that provides access to exhibitions held in such cities as St. Louis, Louisville, and New Orleans. The some 130,000 entries are organized by artist. A multi-volume publication on this data is in preparation.

[7]For an overview, see Antony Symons, "Museum and Gallery Publications," in *Art Library Manual*, edited by Philip Pacey (New York: R. R. Bowker Company, 1977), pp. 47–70. Also see Jones, p. 28.

[8]See the study of ten museum-collection catalogs concerning Chinese bronze vessels: Diane M. Nelson, "Methods of Citation Analysis in the Fine Arts," *Special Libraries* 68 (November 1977): 390–95. Nelson found that there was a broad range of users for these catalogs—from the subject specialist to the beginning student. For a listing of some scholarly catalogs from 17 museums, see Jones, pp. 187–90. For deciphering some of the intricacies of various editions of such series as *Inventaire des Collections publiques françaises*, see Arntzen/Rainwater, pp. 109–10, 267–70, and 279–81.

[9]For an interesting article on the authenticating of Raphael's *Madonna di Loreto*, see Cecil Gould, "The Millionaire and the Madonna: J. Paul Getty's Last Obsession," *Connoisseur* 183 (December, 1984): 98–101.

[10]The PARIS (Pictorial and Artifact Retrieval and Information Sytem), developed by Central Data Corporation, was used.

[11]Museum of Fine Arts, Boston, Massachusetts; Dartmouth College, Dartmouth, New Hampshire; Metropolitan Museum of Art, New York City; Guggenheim Museum, New York City; Museum of Modern Art, New York City; National Gallery of Art, Washington, D.C.; Princeton University, Princeton, New Jersey; and the J. Paul Getty Museum, Malibu, California.

[12]Albright-Knox Art Gallery, Buffalo, New York; Amon Carter Museum, Fort Worth, Texas; Honolulu Academy of Arts, Honolulu, Hawaii; and The Toledo Museum of Art, Toledo, Ohio.

[13]For an overall view of various projects see *Census; Computerization in the History of Art*, 3 volumes (Pisa, Italia: Scuola Normale Superiore Ufficio Publicazioni, 1984). For additional information, see Chapter 2, Note 18.

[14]Such as Thomas Hoving's "The Rivals," *Connoisseur* 182 (December 1983): 79–83.

[15]In the auction-catalog survey conducted by Wanda V. Dole and David Allerton of 25 art libraries, 48% put information concerning auction catalogs into a national automated system, nine in OCLC, two in RLIN, one in UTLAS. See their article, "On Collecting Art Auction Sales Catalogs," *ARLIS/NA Newsletter* 9 (December 1981): 240–41.

[16]For a more far-ranging account see Thomas E. Norton, *100 Years of Collecting in America: The Story of Sotheby Parke Bernet* (New York: Harry N. Abrams, Inc., 1984), which documents the seasons from 1884 to 1984 and provides a history of the firm with its various name changes and affiliations.

[17]For a good overview, see Caroline Backlund, "Art Sales—Sources of Information," *ARLIS/NA Newsletter* 6 (Summer 1978): 65–72; Elizabeth Leach, "Sales Catalogues and the Art Market," in *Art Library Manual*, edited by Philip Pacey (New York: R. R. Bowker Company, 1977), pp. 87–99; Arntzen/Rainwater, pp. 33–36; and Jones, pp. 33–35.

[18]This is the figure given by Katharine Haskins, "Sales Catalog Index Project Input Online (SCIPIO)," *Art Documentation* 1 (Summer 1982): 91.

[19]For an abbreviated listing of the holdings of 25 libraries, see Amy Navratil Ciccone, "Survey of Auction Material," (distributed at the llth Annual ARLIS/NA Conference, Philadelphia, Pennsylvania, February, 1983).

[20]In the study by Dole/Allerton (Note 15), 87% or 21 of the museums said there was not a large user demand for auction catalogs.

[21]In 1980, the name was changed to *Kunstpreis-Jahrbuch*; it is published only in German.

[22]For methodology, see Jones, pp. 60–61, 76, 78.

[23]Art Sales Index, Ltd. is both the producer and the vendor for *ArtQuest*; the English office must be contacted to make arrangements for using this system.

[24]For an overview, see Haskins (Note 18).

[25]For a review, see Caroline Backlund, *ARLIS/NA Newsletter* 9 (October 1981): 211.

[26]For an overview of the subject, see Valerie J. Bradfield, "Trade Literature" in *Art Library Manual*, edited by Philip Pacey (New York: Bowker Publishing Company, 1977), pp. 117–39.

[27]For details on setting up an interior design product file, see Lois Swan Jones, *ARLIS/NA Newsletter* 5 (February 1977): 69. The subject headings for organizing the file were from *A.I.D. Standard Filing System 1971 Issue*, Document #502 (New York: American Institute of Interior Designers).

7

Serial Publications

INTRODUCTION

A serial is any publication usually issued on a regular basis; the term encompasses journals, magazines, museum bulletins, proceedings of learned societies, and newspapers.[1] In this category can also be placed auction catalogs—which were covered in Chapter 6—and many government publications. At some institutions, the serials librarian is responsible for all of these items. This chapter is concerned with the distinctive characteristics and selection of art serials and art-related government publications. Acquisition of the latter is discussed in this section; for acquisition and bibliographic control of serials, see Chapters 12 and 13.

ART SERIALS

The vast numbers of periodicals and newspapers that include art-related subjects are staggering. Wolfgang Freitag estimated in 1976 that about 6000 current titles could be considered of interest to various patrons of art libraries.[2] Serials—which can offer brief, thought-provoking, or speculative views on a subject—usually require less time than a monograph to be published. Much of the subject matter in these articles never appears in a monographic publication. Serials are an important aspect of most research problems, because they are frequently international in nature, can be concerned with minute details, and usually include important illustrative

material, some of which is unique. Although the articles may be significant, some magazines are perused for other reasons—for their reproductions, advertisements, or announcements and information of various kinds.

Periodical articles, as well as exhibition catalogs, are the major published means by which scholars throughout the world communicate. The international nature of art literature is apparent from the lists of serials covered by the abstracting/indexing services. Some—such as *Gazette des beaux-arts, L'Architecture d'Aujourd'hui,* and *Domus*—have English summaries; the texts of others—such as *Art International* and *Graphis*—are in English although they are published in a foreign country. Still others— such as *Simiolus*—have articles in several languages.

Distinctive Characteristics

Serials may be one of the biggest problems with which the art librarian must deal.[3] Their peculiarities include (1) changes in titles and volume numbers; (2) frequency of publication; (3) variations in issuing bodies; (4) confusion resulting from similar titles; (5) problems in deciphering abbreviations; (6) variable index coverage; (7) difficulties in keeping track of certain types of periodicals—museum publications, little magazines, and 19th century serial reprints; and (8) anomalies in classifying, shelving, and binding. Noted for their instability, periodicals often change titles and volume numbers. The title changes can be as minor as from *The Burlington Magazine for Connoisseurs*—used from 1903 to 1947—to *The Burlington Magazine,* which it has been called since 1948. The volume changes for this serial have been erratic: volumes 1 through 4 consisted of 3 monthly publications per volume; there were 6 issues in volumes 5 through 28; 8 issues in volume 29; 6 issues in volumes 30 through 85; and 12 issues beginning with volume 86.

Some title changes are so radical that the new issue seems to be another publication. For instance, in 1982 *The Archive* changed to *Center for Creative Photography,* and in 1983, *National Calendar of Indoor-Outdoor Fairs and Festivals* became *Arts & Crafts Catalyst.* Some periodicals split into two or more parts, resulting in title changes. For example, in 1940 with volume 14, *Archivo español de arte y arqueologia* divided into two separate works: *Archivo español de arqueologia* and *Archivo español de arte.* Both journals continued the old numbering system.

Adding to the confusion, serials frequently absorb other publications. For instance, *Architectural Review*—published, at one time, by Bates, Kimball & Guild of Boston—was issued erratically from 1891 to 1921. Superseding *Technology Architectural Review,* it was combined in 1921 with *American Architect* under the title, *The American Architect and The Architectural*

Review. This serial should not be confused with *The Architectural Review*, which has been published monthly in London since 1896.

Volume irregularities include not only cessation of publication but the combination of volume numbers and the beginning of a new series of numbers. For instance, *Camera Obscura* had a triple issue with numbers 8/9/10. *Gazette des beaux-arts* has begun six series: volumes 1 through 25 (1859–1868), volumes 1–38 (1869–1888), volumes 1–40 (1889–1908), volumes 1–15 (1909–1919), volumes 1–18 (1920–1928), and in 1929 began again with volume 1. Each issue bears a designation, called *année*, which corresponds to the number of years that the *Gazette des beaux-arts* has been published; these have been consecutive. In addition, the *Gazette des beaux-arts* has suspended publication a number of times: 1870–1871, 1914–1916, 1939–1942, and 1955–1956.

Other good examples of the problems which art librarians encounter with the numbering of serials and the variations in issuing bodies are *Gesta, Aegyptiaca Helvetica,* and *Visual Resources*. Published originally by the International Center of Romanesque Art—an organization which changed its name to the International Center of Medieval Art—the first issue of *Gesta* in 1963 was unnumbered. The two 1964 issues were designated as numbers 1 and 2, but in reality constituted volumes 2 and 3. In 1982, volume 9 of *Aegyptiaca Helvetica* was published, although volume 8 had yet to see the light of day. Variations in publishers of serials are changes in companies, cities, and even countries. For instance, *Visual Resources: An International Journal of Documentation* was originally issued from Iconographic Publications in Redding Ridge, Connecticut; with volume 3 this changed to Gordon & Breach of London, England.

Many art serials seem to have the same titles, although some of these are for older periodicals which have long ceased publication. For instance, *The Portfolio: An Artistic Periodical*, volumes 1–24 (1870–1893), changed its name to *The Portfolio: Monographs on Artistic Subjects* and changed from volumes to numbers, No. 1–48 (1894–1907). There was a previous serial by this name but with a different spelling: *Portfolio* (1801–1827). In 1979 a new *Portfolio* was begun, with no connection to the earlier works. This last serial ceased publication in 1983. Moreover, there are two art journals: *The Art Journal* published in London from 1839 to 1912 and *Art Journal*—which was originally entitled *College Art Journal*, a publication that superseded *Parnassus* (1929–1941)—issued by the College Art Association of America since 1941. Some titles are so similar, one to the other, that it is difficult to distinguish them. For instance, these are three magazines: *Art and Antiques, Art & Antiques,* and *Arts and Antiques*.

Deciphering abbreviated titles, especially in early publications, can be a

tremendous problem. One of the best tools for unlocking this material is the *Union List of Serials in Libraries of the United States and Canada*. For instance, it can be used to solve such problems as the following:

A. de Chasteigner, *Essai sur les Lanternes des morts*, lu au congrès archéologique de Poitiers en 1843, apud *Mémoires* de la Société des Antiquaires de l'Ouest, t. x, 1843, pp. 286 et 302.

Dessin autographié par M. Arthur Bouneault, apud *Mémoires* Soc. stat. Deux-Sèvres, 3 série, t. VI, 1889.

The first citation was discovered listed not under the title but under "Société des antiquaires de l'Ouest, Poitiers" in the *Union List of Serials*, which cited both the bulletins and the *Mémoires* published by this society. The second one was more difficult since there was no reference under "Deux-Sèvres," and the exact title was not provided. However, in Volume 5 of the *Union List of Serials*, under "Place index to French Societies" just prior to the word "Société," there are several pages of listings for various French societies. The full names of the five societies in the department of Deux-Sèvres are given. The entry was found under "Société de statistique, sciences, lettres et arts du departement des Deux-Sèvres, Niort."

Similar problems arise in identifying citations to articles in proceedings of other societies or academies as the following Italian example will illustrate:

V. G. Fabris, "Una redazione volgare inedita degli 'Annales Patavini'" published in *Atti e Memorie dell R. Accademia di Padova*, 1938–39.

In the *Union List of Serials*, there is a reference under "Accademia di Padova" to the entry, "Accademia patavini di scienze, lettere ed arti." Yet, if one had tried "Atti," "R. Accademia," or "Reale Accademia," for which the "R" stands, the result would have been negative. It is necessary to read first the introductory matter to the *Union List of Serials*, because there it clearly states:

Learned societies and academies of Europe, other than English, with names beginning with an adjective denoting royal privilege are entered under the first word following the adjective. The adjectives, Kaiserlich, Königlich, Reale, Imperiale, etc., are abbreviated to K., R., I., etc., and are disregarded in the arrangement.

Consider the following citation: "'Islamische Tongefasse aus Mesopotamien' in *Jahrb. der Kgl. Preuss. Kunstsamml*, 1905." This was found in the *Union List of Serials* under "K. Preussischen Kunstsammlungen, Berlin," with the "K" ignored in the alphabetical arrangement. In case one

had looked first under "Jahrbuch," there is an appropriate reference to *Preussische Kunstsammlungen*. Art librarians must become attuned to the vagaries of abbreviations, since bibliographies and lists are by no means consistent with authors' citation methods.

Other sources for deciphering abbreviations of serials are the lists found in the front of the hard-copy volumes of the various abstracting/indexing publications. In addition, periodicals will occasionally include abbreviations pertaining to their particular subject areas. For example, *Dumbarton Oaks Papers* has often provided such references. Number 27 (1973) has a list of more than 650 abbreviations of titles of periodicals, monographs, and research materials which are utilized in Byzantine research. Especially useful are the abbreviations for Eastern European publications, which are difficult, if not impossible, to find elsewhere. Art librarians should be ever vigilant for this type of material; steps should be taken to photocopy, save, and make it available to patrons.

Although abstracting/indexing services provide access to articles in serials, art librarians must be aware of some of the inadequacies of these organizations. Specific serials may (1) not be included in every service, (2) not always be covered continuously or promptly, and (3) be reported differently by various services. In addition, some patrons are not aware of which abstract or index to use for which serial. Some periodicals—such as *Art Bulletin, Burlington Magazine,* and *Art Journal*—are included in all of the major abstracting/indexing services; many are not covered at all. For an extended discussion of this topic, see sections on abstracting/indexing services in Chapters 3 and 4.

Librarians must also be informed concerning non-art indices. For example, none of the art abstracting/indexing services include *The Renaissance Quarterly*, which often publishes articles of interest to art historians. Yet, this periodical is covered by *Historical Abstracts*. In addition, the online databases are providing access to newspapers and magazines heretofore not covered by such services. For instance, a number of newspapers—such as the *New York Times, Los Angeles Times, The Washington Post,* and *The Christian Science Monitor*—are now indexed through NEXIS.

Publications of the major museums are obviously important serials which most art libraries should have. Many museum libraries will obtain them through their exchange programs. Before subscribing to these publications, art librarians should consider whether or not the subject matter is of interest to their clientele. For instance, only libraries which have patrons concerned with 19th-century art should purchase the *Bulletin du Musée Ingres*. It is important to keep up with the changes that can occur in these publications, since many of them began as calendars of coming events and have evolved into scholarly, well-illustrated journals. But by nature, many of these serials

are erratic in their publication, causing an additional problem for librarians.

Art librarians should also try to obtain those publications referred to as little magazines—or the alternative press—that will be of interest to their clientele. Not only do these publications seem to defy description, they are hard to identify, appear irregularly, and often have brief life spans. Many little magazines are primarily literary, but there are a number of specialized, experimental, and local art journals that should be considered. Some of these fall into the category of original artistic creations and are, therefore, comparable to artists' books, which are discussed in Chapter 9. Others contain writings by artists—or interviews with them—and provide documentation of contemporary art activity. The regional news periodicals—frequently appearing in tabloid newspaper format and containing calendars and reviews of events—are useful for up-to-date information on arts activity in a given area. The identification of little magazines can be a problem, although it is less difficult than it once was, due to increasing interest in them. *Bowker's Irregular Serials and Annuals* does not include many of them, but the serials column in *Art Documentation* often will. Coverage is also afforded by the *International Directory of Little Magazines and Small Presses*, an annual edited by Len Fulton and Ellen Ferber. Two excellent bibliographies of little arts magazines are those compiled by Susan Gurney, which appeared in a 1981 issue of the *Art Libraries Journal*, and Doris L. Bell's *Contemporary Art Trends 1960–1980: A Guide to Sources*.[4]

Scholars may also require periodicals published in the 19th century. The serial chapters in Chamberlin and Arntzen/Rainwater provide valuable information which will assist in the identification of these materials. Some of the important late 19th-century and early 20th-century periodicals, which have been reprinted on microforms, can now be purchased. Only a few of these serials—such as *Arts et métiers graphiques* (Numbers 1-68, 1927-1939)—include a general index. Presently there are only a few indices which cover these publications—*Nineteenth-Century Reader's Guide to Periodical Literature, 1890–1899 with Supplementary Indexing 1900–1922, Poole's Index to Periodical Literature,* and *Wellesley Index to Victorian Periodicals 1824–1900.* Unfortunately, none of these are sufficient for art research. However, if and when the "Index to 19th-Century American Art Journals" is finished and published, this may change the demand for these publications.[5]

Serials require special handling. For preservation purposes, they should be bound. Prior to sending a periodical to the bindery, care should be taken that all of the issues have been received and that nothing has been cut out. If an annual index accompanies the publication, it should be bound with the appropriate year. Even though the binding process may be centrally handled, the art librarian should keep accurate records of what has been sent and when it is due to return. Often, the binding of serials can be an inordinately long operation. If a patron desperately needs material which

is at the bindery, the librarian should make every effort to obtain it, even if this requires ordering a photocopy on interlibrary loan.

Some serials are provided with class numbers and are shelved apart from the book collection; others are classified with monographic series. If both methods of treatment are used the patrons may be utterly confused. Items—such as the *Journal of the Warburg and Courtauld Libraries, Winterthur Portfolio,* and *Graphis Annual*—are sometimes classed as monographic series. And *Graphis Annual* may not even be in the art section of the library. Because the reasons for this separation is unclear to the user, librarians should provide guidelines to the shelving for their clientele. If a printout of serial holdings is available, it should include location symbols. Another method is to place notations, with specific locations, in either the library's catalog or a separate serial holdings file. In addition, a special location guide to art periodicals might be developed, such as the one illustrated in Example 10/3.

Many libraries do not classify their serials, preferring to arrange them alphabetically by title. In some libraries, museum publications are shelved under the name of the city or the institution issuing them, regardless of the title. When a journal changes title, decisions must be made as to whether or not to keep the different titles together in one spot on the shelf. If not, cross‑references should be supplied in the serials holdings list as well as a dummy volume—with the appropriate information—placed in the stacks. Having the bound periodicals, the microforms, and the abstracting/indexing services in as close proximity as possible will assist researchers.

For background material, librarians should be cognizant of the history of art serials. Chamberlin discusses 249 periodicals; Arntzen/Rainwater, 356. There are also various books and articles which detail the history of art serials.[6] In addition, art librarians faced with serial problems have a good source to consult. The Serials Column in *Art Documentation* frequently includes a "Periodical Update" which provides information on serials, such as delayed publications, changes in format, temporary suspensions, discontinuations, publishing irregularities, title changes, publisher or publisher address changes, and new periodicals. The advantage of this column is that it brings together essential information that is otherwise scattered and difficult to glean.

Selection

Selecting the periodicals needed for the library's constituency must be done with great care. Research libraries should contain the complete volumes of important serials. A survey of the needs of patrons should be tempered by the requirements of researchers, although the latter may be few in number. Reviews of the journals should be read and some issues should be personally studied. Fortunately, many publishers will supply sample copies upon request. Having the item in hand makes selection and the application of criteria easier.

This section deals with the selection process; Chapter 12 discusses the acquisition of these materials.

In 1976, using the *New Serials Titles 1950–70: Subject Guide*, Wolfgang Frietag made a selection of 6002 titles—2.7% of the reported world output—which would be useful to an ideal, hypothetical art library.[7] This figure was then compared to the number of titles held or currently subscribed to by several major art libraries. At that time, London's Victoria and Albert Museum included 1200 titles; the Fine Arts Library of Harvard University, 945. Obviously, no one library can have all of the pertinent art serials, but each institution should have a basic core which satisfies most of the needs of its clientele. Networking will be necessary to expand the collection.

In selecting a core of serials, librarians have utilized both qualitative and quantitative methods. Qualitative methodology frequently measures the present serial holdings against a set of criteria and specialized bibliographies of the collection of some recognized institution. Quantitative methods include citation analysis, user studies, circulation statistics, and information from interlibrary loan requests. In her article, "Collection Evaluation in Fine Arts Libraries," Loren Singer discusses these methods and provides some examples.[8]

While the selection of serials is never easy, there are a number of qualitative criteria which can be used to evaluate periodicals for potential subscriptions, such considerations as whether or not the articles are scholarly, the caliber of the illustrations, some form of available indexing to the material, the stability of the publisher, the quality of the paper, the ease of binding, and the cost of the periodical.

In a 1984 research study of North American academic art libraries,[9] the 59 librarians who responded to a questionnaire stated that the most important criteria to be considered in choosing serials were that the material was (1) coordinated with the curriculum; (2) abstracted/indexed in *RILA, Art Index,* or *ARTbibliographies MODERN*; and (3) requested by faculty members or administrators. Other important considerations were whether or not the articles are indexed by some other service, the scholarly standing of the publisher, and the cost of the subscription. For purchasing retrospective issues of serials, including reprints and microforms, it was also deemed important to determine the availability of past issues, in order to have as complete a set as possible. Although this was a study of academic art libraries, there is no reason to believe that the results would have been different if other types of art libraries had been surveyed.

Librarians can easily identify the most prominent journals in the art field by checking to see which publications are covered by the major abstracting/indexing services, not only the general English-language ones—

RILA, Art Index, and *ARTbibliographies MODERN*—but the ones specializing in particular disciplines. For other serial choices, librarians need to check bibliographies and the holdings of similar art libraries as well as to ask patrons —faculty, curators, administrators, and researchers—for suggestions. Bibliographies are often published in *Art Documentation* and *Serials Review.* For instance, there have been special compilations of magazines on interior design, architecture, textiles, crafts, and antiques as well as current art journals published in Eastern Europe and the Soviet Union.[10]

Quantitative methods are sometimes used as an aid in selecting serials. For some time librarians have made use of S. C. Bradford's bibliometric method—often referred to as his law—which concerns the concentration and dispersion of the literature of individual disciplines. Bradford's Law indicates that within any given topic "a large number of the relevant articles will be concentrated in a small number of journal titles [while] the remaining articles will be dispersed over a large number of titles."[11] One can, thereby, establish zones of periodical titles, with each zone becoming progressively larger.

A Bradford distribution can be developed for a field or subfield which is substantially represented by an online database or printed index. For each journal included in the index, the librarian must count the number of entries and group them into zones before the Bradford multiplier—the number of journals in a zone divided by the number of journals in the preceding zone—can be determined.[12] A small library need only subscribe to the journals in the core or first zone and possibly some from the second zone; these will yield the most extensive coverage for money expended. Titles in succeeding zones may be added as the budget permits. For most subject experts, the central or core journals are immediately apparent without counting articles or citations. But it is about titles in the last zone that uncertainty and disagreement may occur. Furthermore, the titles of some low-yield journals—in terms of citations to their articles—often come as a surprise. Even the best subject expert has had the experience of locating an article in an unexpected place. Knowledge of such titles, even if the library does not own them, is useful. The implications for a scholarly library are clear, but Bradford's Law can also be applied to other types of libraries and materials.

Bradford's Law is only a quantitative method; it says nothing about the quality of the material. In a study published in 1982, Boyce and Pollens have suggested that perhaps there is no correlation between the Bradford rank of a journal and the number of times its articles are cited.[13] If this is true, then Bradford-based serial selection may identify art journals with the largest number of articles—the most productive ones—but these publications may

not include the most important articles, or the ones with the greatest impact as revealed by citation analysis. Therefore, previous assumptions—that the articles which are published in the low productivity journals of the last zone are less important—may be wrong. In other words, the purchase of journals publishing the most articles in any given field may not result in the acquisition of high-quality or high-impact articles.

One of the few statistical studies on citations used in art literature is W. C. Simonton's pioneering research on six international serials of the fine arts during the period of 1948 through 1957.[14] Simonton discovered that ten serials accounted for 26.7% of the serial citations; 48 accounted for 54.5%; and 126, for 75.5%. Of the 341 serials cited, 215 or 63% were cited only once. The most popular publications were *Burlington Magazine, Gazette des beaux-arts,* and *Art Bulletin.* This study confirmed the slow obsolescence rate for the literature of the fine arts compared to that of the physical and social sciences. In his conclusion, Simonton states that "serial literature need not constitute a very large proportion of the library's collection, since only one fourth of the citations are to serial titles and one fourth of all serials cited account for one half of all serial references." Simonton's study is in need of replication; these conclusions may not be true today. Unfortunately, there are few published statistical studies on fine arts literature.[15] Such studies, which contribute to the understanding of the literature, are essential.

The two-year user study of periodicals in the Fine Arts Library of Indiana University—reported by Betty Jo Irvine and Lyn Korenic in "Survey of Periodical Use in an Academic Art Library"—is the only published one of its kind.[16] Using shelving statistics, this study found that of the 160 serials analyzed, 130 (81%) were indexed in at least one of the four major abstracting/indexing services; 37 (23%) of these were covered by all four services. Although the project was initiated as a means of determining which serials were of marginal use for their patrons and thus could be dropped from the subscription list, the statistical information is useful to other art librarians. For instance, the 34 titles which were used the most—at least 90 times during the 24 months—made up only 21% of the titles but accounted for 51% of the use. In their article, Irvine/Korenic list each of the 160 serials, the frequency of their use, and which of the four abstracting/indexing services cover them. This is an excellent list for librarians to use as a guide for evaluating their own collections.

GOVERNMENT PUBLICATIONS

Government publications constitute a generally under-used resource for art libraries, even those—the majority of which are academic—that enjoy depository status. A depository library is one that receives documents

distributed by the superintendent of Documents in Washington, D.C. Most depository libraries are selective in that only those items chosen to be received are shipped. In addition, there are regional depository libraries which must take everything that is distributed. The statutes and regulations which govern the depository library system have been summarized in Joe Morehead's *Introduction to United States Public Documents*, a book which is an excellent guide to the topic.[17]

If a library is a depository, it may have chosen to receive a series of works, such as those from the Smithsonian Institution. Depending upon local policy, these publications may have to remain in the documents collection, which is often kept apart and classified by the Superintendent of Documents (SUDOCS) Classification System. Some libraries permit extraction of certain materials from the documents collection for shelving in other parts of the library. In this case the records must be clear, since the deposited materials are not the library's property, but belong to the U.S. government. If the library is not a federal depository, art librarians should visit one in their area in order to familiarize themselves with these publications. The *American Library Directory* designates these institutions.

Although there are often difficulties in identifying information on art-related government publications, since 1981 one of the best sources has been *Art Documentation*. In his article "Government Documents and the Art Librarian: A Selected Annotated Bibliography of Art and Art-Related Documents," Stephen Allan Patrick provides annotations and purchasing data for a random sample of more than 85 publications from 22 government departments.[18] Although the Smithsonian Institution and the Interior Department issue the majority of the art-related documents, other agencies also produce pertinent material. For example, the Department of Health, Education, and Welfare issued such works as *Design and Drawing Skills* (HE 19.312:06-A-01), Sheila Dubman's *Exploring Visual Arts and Crafts Careers* (HE 19.108:Ex7/4), and *Art Therapy: A Bibliography* (HE 20.8113:Ar 7/940-73) compiled by Linda Gantt and Marilyn Schmal. The diverse pamphlets and books available from the Commission of Fine Arts, Department of Housing and Urban Development, Library of Congress, National Endowment for the Arts, and the Advisory Council on Historic Preservation can be valuable assets to the art library.

Developing from his article, Stephen Patrick's regular column—"New Docs in Sudocs—Artistically Speaking"—has continued to be published in *Art Documentation*. Some of the data in this column is almost impossible to discover elsewhere. Two important sections were "An Introduction to British Government Publications in Art" by Valerie J. Bradfield[19] and "CANadian ART DOCuments/DOCuments CANadiens sur l'ART," a retrospective bibliography of Canadian government documents on art compiled by Vivienne Monty and Mary Williamson.[20] Since 1983, Canadian art documents have

become a section of Patrick's column, which not only has annotations and purchasing data for new publications but also provides material concerned with this field, such as the brief essay on the World Heritage List of Historic Properties.[21] With the Summer 1982 issue, microfiche were added to the bibliographic citations.

Another valuable source for identifying government publications is the quarterly journal *Government Publications Review*. First published in 1973, it includes information on government documents at all levels—municipal, federal, state, provincial, and international. State and municipal documents are especially important to architectural libraries, which need to collect specifications, laws, and regulations.

Libraries which are not depositories may wish to purchase materials from the government, since not only are many valuable, but they are relatively inexpensive additions to the collection. For example, two recent Smithsonian publications include: (1) a catalog of an exhibition of the work of R. B. Kitaj, held at the Hirshhorn Museum and Sculpture Garden, the Cleveland Museum of Art, and the Städtische Kunsthalle Düsseldorf and (2) a catalog of an exhibition at the National Portrait Gallery entitled *Adventurous Pursuits: Americans and the China Trade, 1784–1844*. Purchases may be made from the Office of the Superintendent of Documents (SUDOCS), which is responsible for the sale of publications produced by or through the Government Printing Office (GPO). The Government Printing Office has retail bookstores in 20 cities throughout the country plus seven departmental ones in the Washington, D.C. area. Current addresses and phone numbers can be located in the *Monthly Catalog of U.S. Government Publications*.

A few large bookstore chains—notably Walden Books and B. Dalton—carry selected government publications; some jobbers and dealers also will handle them. *Documents to the People*, a periodical issued by the Government Documents Round Table (GODORT) of the American Library Association publishes lists of jobbers and book dealers with addresses, telephone numbers, and types of documents handled. There are also standing orders available for certain types of GPO sales publications, such as the *United States Government Manual* and the *Statistical Abstract of the United States*, but these are likely to be of peripheral interest to most art libraries.

In order to disseminate information concerning government publications, SUDOCS issues current awareness sources: (1) *U.S. Government Books*, (2) *New Books*, (3) *Price List 36*, (4) *GPO Sales Publications Reference File (PRF)*, (5) *Subject Bibliographies Series*, and (6) *Monthly Catalog of United States Government Publications (MC)*.[22] Assistance in locating documents can also be found in *Guide to U. S. Government Publications*, edited by John L. Andriot. This book also provides an explanation of the SUDOCS

classification scheme. When ordering, it is essential to remember that the GPO Stock Number is not to be confused with the SUDOCS Classification Number. The latter is a classification notation based on the archival principle of provenance and reflects the agency that issued the publication.

Not all government publications are obtainable from SUDOCS. Technical reports—which are occasionally of interest to architects, engineers, and designers—have to be purchased from the National Technical Information Service (NTIS), an agency under the control of the Department of Commerce. Its indexing and abstracting service is called *Government Reports Announcements and Index (GRA&I)*. Moreover, NTIS does not limit itself to technical reports but includes business, social science, and humanities publications, not all of which are duplicated in the *Monthly Catalog*.

Educational materials are obtained through the Educational Resources Information Center (ERIC), a nation-wide information network of clearing houses which is a unit of the National Institute of Education, currently within the Department of Education. Bibliographic control of materials acquired by the clearinghouses is afforded by *Resources in Education* (*RIE*) and the *Current Index to Journals in Education* (*CIJE*). These tools may be searched online via DIALOG, ORBIT, and BRS. Most of the documents announced in *RIE* may be purchased from the ERIC Document Reproduction Services (EDRS) in Arlington, Virginia, in paper copy or microfiche. Each issue of *RIE* has an order form with current price schedules.

All of these government indices provide some access to information about audiovisual materials—films, slide sets, audio and videotapes, and recordings—but they are by no means comprehensive. Another source, the National Audiovisual Center is a division of the National Archives and Records Service (NARS) of the General Services Administration (GSA). The Center rents and sells government-produced audiovisuals, maintains a reference service, and provides catalogs. The basic publication is *A Reference List of Audiovisual Materials Produced by the United States Government*, which has periodic supplements.

The literature of patents and trademarks forms another vast body of material. There is a relatively small patent depository library program. The Patent and Trademark Office, an agency of the U.S. Department of Commerce, issues a number of publications designed to disseminate information about patents and trademarks. An example of a preliminary patent search that a librarian can perform is given in an article by Joe Morehead, "Of Mousetraps and Men: Patent Searching in Libraries."[23] Patent information databases are available for searching online through DIALOG and the BRS/Search system.

Publications on the state, provincial, and city level can also be important;

for instance, architects need reports on local building codes. In addition, there are a number of materials issued by UNESCO and ICOM. For a list of UNESCO publications, the national distributor should be contacted.[24] In each ICOM issue of *The Bulletin of the International Council of Museums*, there is a regular "Documentation Centre's Column," which provides reviews and purchasing information for brief worldwide reports of recent research on museum subjects.

NOTES

[1]The AACR2 definition of a serial is "a publication in any medium issued in successive parts bearing numerical or chronological designations and intending to be continued indefinitely. Serials include periodicals; newspapers; annuals (reports, yearbooks, etc.); the journals, memoirs, proceedings, transactions, etc. of societies; and numbered monographic series." *Anglo-American Cataloging Rules* 2nd ed. (Chicago: American Library Association, 1978), p. 570.

[2]Wolfgang Freitag, "Tapping a Serviceable Reservoir: The Selection of Periodicals for Art Libraries," *Art Libraries Journal* 1 (Summer 1976): 10–21.

[3]For a good general discussion, see Clive Phillpot and Beth Houghton, "Periodicals and Serials," in *Art Library Manual*, edited by Philip Pacey (New York: R. R. Bowker, 1977): 140–67. Also, see Winberta Yao, "Developing Methodologies for Art Periodical Collections," *ARLIS/NA Newsletter* 7 (February 1979):17.

[4]See Susan R. Gurney, "A Bibliography of Little Magazines in the Arts in the U.S.A.," *Art Libraries Journal* 6 (Autumn 1981): 12–55 and Bell, Chapter 3, Note 5.

[5]"The Index to 19th-Century American Art Journals," a project undertaken by Mary Schmidt, was originally funded by a National Endowment for the Humanities Grant. This index will cover 40 journals dating from the 1840s to about 1910. For a listing of the titles, see *ARLIS/NA Newsletter* 7 (May 1979): 48–49. For information on early serial publications, see Helene E. Roberts, *American Art Periodicals of the Nineteenth Century* (Rochester, NY: Rochester University Press, 1964); and Helene E. Roberts, "British Art Periodicals on the Eighteenth and Nineteenth Centuries," *Victorian Periodicals Newsletter* 9 (1970).

[6]For a general history of art serials, see *The Art Press: Two Centuries of Art Magazines*, edited by Trevor Fawcett and Clive Phillpot (London: Art Book Company, 1976); John Tagg, "Movements and Periodicals: The Magazines of Art," *Studio International* 192 (September/October 1976): 136-44; Clive Phillpot, "Art Periodical, Indexes and Abstracts, and Modern Art: An Annotated Topography," *ARLIS/NA Newsletter* 2 (June 1974): 11-24; and Stanley T. Lewis, "Periodicals in the Visual Arts," *Library Trends* 10 (January 1962): 330-52. An example of the history of a specific journal is Clive Ashwin, "*The Studio* and Modernism: A Periodical's Progress," *Studio International* 192 (September/October 1976): 103-12. Winberta Yao is editing *International Art Periodicals*, a book on the history of art serials which is to be published by Greenwood Press, probably in 1987.

[7]See Freitag (Note 2.)

[8]Loren Singer, "Collection Evaluation in Fine Arts Libraries," in *Current Issues in Fine Arts Collection Development*, Occasional Papers No. 3. (Tucson, AZ: Art Libraries Society of North America, 1984).

[9]In a 1984 project, funded by the North Texas State University Faculty Research Committee, Lois Swan Jones sent questionnaires to 75 academic art librarians in North America; 59 (79%) were returned. The criteria used by these librarians were ranked in this order.

[10]See Rosemary K. Lopiano, "Furniture and Interior Design: A Bibliography of Periodicals." *Art Documentation* 2 (Summer 1983): 100-03; Frances Young, "A Survey of Interior Decoration and Design Magazines," *Serials Review* 7 (April/June 1981): 22-25; "A Survey of Architectural Magazines," edited by Edward H. Teague, *Serials Review* 7 (April/June 1981): 9-21; Katherine T. Freshley, "Textile History and Techniques: A Bibliography of Periodicals," *Art Documentation* 2 (October 1983): 145-46; Joanne Polster, "Crafts Periodicals," *ARLIS/NA Newsletter* 8 (Summer 1980): 128-30 and the supplement *ARLIS/NA Newsletter* 8 (October 1980): 170; Bonnie Postlethwaite, "New Antique Periodicals," *ARLIS/NA Newsletter* 8 (October 1980): 169-70; and Alexandra de Luise, "A Bibliography of Current Art Journals & Bulletins Published in Eastern Europe + The Soviet Union," *Art Documentation* 1 (Summer 1982): 105-09.

[11]M. Carl Drott, "Bradford's Law: Theory, Empiricism and the Gaps Between," *Library Trends* 30 (Summer 1981): 41-52. Drott points out weaknesses, based on empirical evidence, in the mathematical formulas generated by the Bradford phenomenon. For Bradford's original formulations, see Samuel Clement Bradford, *Documentation* 2nd ed., edited by J. H. Shera (London: C. Lockwood, 1953). For a summary and discussion, see also Ferdinand Leimkuhler, "An Exact Formulation of Bradford's Law," *Journal of Documentation* 36 (December 1980): 285-92; and Daniel O'Conner and Henry Voos, "Empirical Laws, Theory Construction and Bibliometrics," *Library Trends* 30 (Summer 1981): 9-19.

[12]The Bradford distribution is stated as a ratio: $1:a:a^2$. If the zones are identified as P, P_1, P_2, each contributing an equal number of papers, the minimum number of journals necessary to create the zones of papers P would vary according to the ratio $P:P_1:P_2:n:nb:nb^2$, where b is a constant unique to the particular group of papers. Note that the number of articles in each zone is not exactly, but only approximately, equal. Example:

Number of Articles	Number of Journal Titles
200	10
205	50 (10 × 5)
189	250 (10 × 5 × 5)

The first ten journal titles yield 200 articles; the next 50, 205; and the last 250, 189. In this instance, 5 is the Bradford multiplier, a number which changes with the distribution of articles in the zones.

[13]Bert R. Boyce and Janet Sue Pollens, "Citation-Based Impact Measures and the Bradfordian Selection Criteria," *Collection Management* 3 (Fall 1982): 29-36.

[14]Wesley Clark Simonton's Ph.D. dissertation, *Characteristics of the Research Literature of the Fine Arts during the Period 1948-1957* (University of Illinois, 1960). Simonton found that only 28% of the material cited in art literature was from serial publications, but the study was for material published from 1948 through 1957, right after World War II, and probably would not be true today. For a further discussion of Simonton's study, see Chapter 3.

[15]For a brief discussion of Simonton's article, see Diane M. Nelson, "Methods of Citation Analysis in the Fine Arts," *Special Libraries* 68 (November 1977): 390-95. See also Graeme Hirst, "Discipline Impact Factors: A Method for Determining Core Journal Lists," *Journal of the American Society for Information Science* 29 (July 1978): 171-72; and Eugene P. Garfield, "Citation Analysis as a Tool in Journal Evaluation," *Science* 178 (1972): 471-79.

[16]Betty Jo Irvine and Lyn Korenic, "Survey of Periodical Use in an Academic Art Library," *Art Documentation* 1 (October 1982): 148-51. The four major abstracting/indexing services are the ones discussed in Chapter 3.

[17]Joe Morehead, *Introduction to United States Public Documents* 3rd ed. (Littleton, CO: Libraries Unlimited, 1983).

[18]*ARLIS/NA Newsletter* 9 (December 1980): 1–7. Patrick purposely chose few Smithsonian publications because of the completeness of the list in Edith L. Crowe's "The Federal Government as Art Publisher: A Select Bibliography," *RQ* 18 (Fall 1978): 73–85.

[19]Valerie J. Bradfield, "An Introduction to British Government Publications in Art," *Art Documentation* 2 (October 1983): 149–50. This was a revised version of her article "Official Publications and the Art Librarian" from *Art Libraries Journal* 7 (Spring 1982): 17–26.

[20]Vivienne Monty and Mary Williamson, "CANadian ART DOCuments/DOCuments CANadiens sur l'ART," *Art Documentation* 2 (February 1983): 3–5.

[21]*Art Documentation* 2 (Summer 1983): 115.

[22]The quarterly *U.S. Government Books* contains annotated entries for monographs and serials of popular, general interest. A bimonthly, *New Books* is an unannotated list of all new titles placed on sale during the preceding two months. *Price List 36: Government Periodicals and Subscription Services* is a quarterly annotated list of about 500 serial publications. The *PRF* is available bimonthly on microfiche and also online through DIALOG. Those customers subscribing to DIALORDER, which was discussed in Chapter 2, can order directly online from the GPO.

The *Subject Bibliographies Series* provides free data on specific subjects in a looseleaf format; they are updated periodically. Among those of interest to the art librarian are: *Anthropology and Archeology, Printing and the Graphic Arts, Public Buildings, Landmarks and Historic Sites of the United States,* and *Art and Artists.* The last includes works ranging from *Study of Airports: Design Art and Architecture* to *Mary Cassatt, Pastels and Color Prints.*

Probably the most used tool for identification of government publications, other than the *PRF,* is the *Monthly Catalog.* Entries are arranged by SUDOCS classification notation. Each issue contains separate indices for authors, titles, subjects, series/report numbers, stock numbers, and title key words. Full bibliographic information is given as well as detailed information on how to order. The *Monthly Catalog* is online through DIALOG, BRS, and ORBIT. An annual serials supplement augments the monthly lists.

[23]Joe Morehead, "Of Mousetraps and Men: Patent Searching in Libraries," *The Serials Librarian* 2 (Fall 1977): 5–11.

[24]For the United States, contact UNIPUB, 205 East 42nd St., New York, NY 10017; books are purchased from UNIPUB, Box 1222, Ann Arbor, MI 48106. In Canada, the distributor is Renouf Publishing Company, Ltd., 2182 St. Catherine Street West, Montreal, Que. H3H 1M7.

8

Visual Resources

INTRODUCTION

Because the use of visual materials is central to the study of objects, most art libraries provide various types of reproductions of works of art, including images on slides, videodiscs, film/video, and photographs. The treatment of visual collections varies enormously from library to library and relates primarily to the manner in which the collections developed rather than how they are used. Whether or not the art librarian is directly responsible for these materials may be more a result of historical accident than of rational planning. Nevertheless, art librarians should be familiar with basic problems in the acquisition, organization, care, and handling of these important resources. This chapter is concerned with various types of visual resources: (1) slides, (2) videodiscs, (3) film/video, (4) photograph and picture collections, and (5) published pictorial archives.

Art librarians should consult *Reference Tools for Fine Arts Visual Resources Collections*, edited by Christine Bunting.[1] This 1984 guide contains annotated references to professional literature for visual resources, general art reference works, and art historical sources. Discussed are (1) important periodicals in the field, (2) sources for reproductions, (3) manuals for cataloging and subject heading lists, (4) photographic and conservation manuals, (5) equipment directories and guides, and (6) sources on computerization. Although the main concern of the guide is slides, photographs, and prints, the bibliography is pertinent for any visual resource librarian.

SLIDES

Slide libraries are sometimes completely separate entities operating independently of the book library, such as the Metropolitan Museum of Art Slide Library or the numerous slide collections under the jurisdiction of art departments in academic institutions.[2] Other slide collections are under the aegis of a parent library, but may have their own administrators and staff as for example at the Cleveland Museum of Art.

Slides have become such an integral part of the teaching of art and art history that it is sometimes forgotten that they are also used to illustrate a wide variety of topics as disparate as travel and gardening, historical events and fashion design, children's story hours and biographical lectures. Many, but by no means all, public libraries have slide collections which are not necessarily exclusively related to art. If the collection is the responsibility of the fine arts librarian, the range of needs of the entire community must by kept in mind.[3]

The fullest treatment of slide libraries is to be found in Betty Jo Irvine's *Slide Libraries: A Guide for Academic Institutions, Museums, and Special Collections.*[4] This comprehensive manual covers the historical development of slide collections as well as administration and staffing for collections in different environments, such as colleges and universities, art schools, and museums. Also included are cataloging and classification, acquisition and production, storage and physical facilities, projection systems, and other necessary equipment. Additional valuable features are (1) an extensive, 38-page bibliography, (2) a directory of distributors and manufacturers of equipment and supplies, (3) a list of sources for slides which is arranged by subject area, and (4) a directory of slide libraries in the United States.

ARLIS/NA has promulgated standards for staffing slide libraries based upon such factors as the rates of accession and circulation, the size of the collection, and the extent of service.[5] All of the factors are considered in relation to the institution within which they are located. A museum slide library which serves the general public in addition to its own curators, and perhaps associated art history faculty and students, will clearly require a larger staff than one whose service is more limited. The Mid-America College Art Association (MA/CAA) has issued a *Guide for the Management of Visual Resources Collections* which augments the ARLIS/NA standards.[6] There are not many formal programs for training staff, so this generally has to be done on the spot, although special workshops and institutes are offered on a fairly regular basis at various locations throughout the country.[7]

There are two means of acquisition of slides: purchase and in-house production. In the past, purchase was hampered by the lack of standard selection tools and guides, but this situation has improved with the issuing

of a number of articles and guides by ARLIS/NA and MA/CAA.[8] Communication among slide librarians and curators has been greatly facilitated through the annual meetings of these associations. Slides may also be purchased on standing order, as for instance, those available from *Art in America* showing contemporary art.[9] Slide sets are being produced of special museum exhibitions, such as *A New World: Masterpieces of American Painting 1760–1910* at the Museum of Fine Arts, Boston. However, most slides must be purchased individually.

There are several books which discuss the acquisition of slides. Irvine includes a directory of slide sources and suggests ways of evaluating slide producers.[10] James Cabeceiras' *The Multimedia Library: Materials Selection and Use*, which has a chapter devoted to slides that covers selection and evaluation, also includes a discussion of local production and an assessment of projection equipment.[11] *Slide Buyer's Guide*, edited by Nancy DeLaurier, is another essential book for slide librarians.[12]

Many slides are made in-house. In a museum, these include photographs taken of the objects in the permanent collection and works of art in special exhibitions as well as children's projects. In an academic situation, these might be reproductions of students' works, views of local and foreign buildings and monuments photographed by faculty members, art displayed in traveling exhibitions, or illustrations published in books or magazines. The U.S. copyright laws cover the legality of this last method for obtaining slides. In "The Copyright Law and Art: Reproduction by Libraries and Archives," Carolyn Owlett Hunter discusses the problems of whether or not copying materials might be considered fair use.[13] Every art librarian should read this article as well as obtain *Circular R21: Reproduction by Libraries and Archives*, which is published by the Copyright Office of the Library of Congress.

The majority of most slide collections consist of the works of art of individual artists or specific monuments. These collections frequently become skewed, containing numerous slides of the Cathedral of Chartres but few, if any, of La Madeleine at Vézelay. Slide librarians should systematically check the collection to be sure that it is as balanced as possible in the areas and periods of art in which their patrons are interested. Compiling a list of the primary and secondary artists and monuments in various historical periods will provide a framework for acquisitions.

It should be noted that during the 1960s many slides were produced on motion picture film which had a life span of only five years. The cyan dye faded with the result that many slides turned magenta or pink. Current films, such as Kodachrome and Ektachrome, are reported to have a life of up to 50 years, if properly stored.[14] Periodically, the slide collection should be weeded. Discolored slides or those in black and white of colored objects

should be discarded and replaced. Some slide collections still have a large number of lantern slides—$3\frac{1}{4}'' \times 4''$ on glass—which may retain some historical value. They may, for instance, depict objects or buildings that have since disappeared. Decisions must be made as to whether or not to discard these items or to transfer them to 35-millimeter slides in order to make them more useful to the library's clientele.

Duplicate slides can be a problem. Inferior copies should be discarded. In an academic situation, heavy users of the library may need to be provided with an extra set of slides. In some situations, certain popular works of art or monuments, such as Leonardo da Vinci's *Last Supper* or Versailles, will be in such demand that more than one duplicate will be necessary.

There are three basic methods of organizing slide collections: accession order, classified order, and subject order. A collection arranged in accession order requires a catalog of some nature; a classified order presupposes a formal classification scheme, such as Dewey or LC. By far the most prevelant among art libraries, subject-order arrangement is based upon subject classes subarranged in alphabetical order. The classes are usually based upon geographical, historical, chronological, or stylistic characteristics as well as medium.

Regarded as self-indexing, a subject-order arrangement assumes some familiarity of the topic on the part of the user. For instance, patrons wanting to locate slides depicting the *Klosterneuberg Altarpiece* would have to know that it (1) comes from Mosan, an area between the Meuse and the Rhine Rivers, (2) dates from the last quarter of the 12th century, and (3) is an enamel work. Clearly, this search is not easy for a neophyte. On the other hand, such an arrangement makes sense in terms of the primary clientele of a museum or academic library—curators, professors, and graduate students. Two schemes that have been frequently copied and modified are those of the Metropolitan Museum of New York City and the modified and expanded version of this system used by the Fogg Art Museum of Harvard University.[15]

Because of the expense, many art libraries do not have separate subject catalogs for the slide collection.[16] Nevertheless, usually an authority file of artists' names is maintained. If the slide collection is in fairly close proximity to the book catalog, the latter's authority file can, and should, be shared. Most slide libraries have shelf lists, either separate or interfiled with the slides. The asset to interfiling is that the shelf list, in addition to the usual identification information, should give the source of the slide in case it has to be duplicated. In some cases, slides are acquired without proper identification or are in sets with little or no information about individual items in the set. The task of the slide librarian, then, comes close to that

of a curator in determining just what the object pictured is, its date, and its location.

As Irvine points out, one of the major problems facing administrators of slide collections is the tendency to expand at an exponential rate. Moreover, slides carry a variety of information and meaning beyond their art-historical context. For these reasons, computer manipulation can be used to provide quick and more sophisticated retrieval of subjects and items depicted on the slides. *Introduction to Visual Resource Library Automation*, a 1981 MA/CAA publication edited by Arlene Zelda Richardson and Sheila Hannah, contains a collection of essays and examples of automated programs.[17] Included are separate articles on (1) an historical review of automation, (2) a general approach to slide library automation, (3) how to initiate a program, (4) basic considerations prior to beginning such a project, (5) an estimation of the costs of an automated project, and (6) a discussion of computer software for information retrieval systems. The examples include the projects called SELGEM, SLIDEX, Sheridan Library Slide Program, SPIRES, Slide Retrieval System at the School of Architecture at Ohio State University, the Santa Cruz System, and SPIN.[18] This important MA/CAA booklet also provides an extensive bibliography, a discussion of thesaurus construction, and suggestions for writing grants for funding automated slide projects.[19]

The literature has reported some of the many projects which have been developed; two well-known ones are those of Diamond and Simons/Tansey.[20] In attempting to design a prototype retrieval system that could be used by searchers in disciplines other than art history, such as history and literature, Diamond developed and tested a list of descriptors to identify reproductions of art works. With the same notion of a scheme that could be used by non-art historically oriented persons, Simons and Tansey constructed a classification scheme based upon data categories similar to those used in manual systems. Coded for computer input, their scheme could manipulate and combine the data elements to respond to multi-faceted queries such as: find all representations of Dutch still-life paintings of the 17th century. The program was adopted at the University of California at Santa Cruz and at the Architecture Slide Library of Georgia Institute of Technology.[21]

A further modification of the Simons/Tansey plan has been used at Iowa State University's College of Design, which utilized SPIRES, an interactive general purpose information storage and retrieval system.[22] Cornell University developed its own computer fields and then also adopted the SPIRES system, partly because it can be used without a thesaurus and indexing can be done by non-experts. This system can produce a printed catalog, standardized labels for the slides, and shelf list cards.[23]

Some of the automated projects incorporated several programs which had

already been developed. A number of these automated projects utilize the ICONCLASS system, which will be discussed later in this chapter under "Photograph and Picture Collections." For about 1000 color filmstrips containing illustrations and partial texts of the illuminated medieval manuscripts and books in the Bodleian Library of the University of Oxford, a computer catalog with indices, including a subject index, was developed by Thomas H. Ohlgren at Purdue University. In his article, "Computer Indexing of Illuminated Manuscripts for Use in Medieval Studies," Ohlgren discusses exactly how this system was formulated and provides examples of the computer files.[24] His article relates some of the many problems which must be solved before beginning such an extensive and expensive project.

Also available are slide-library management computer programs, such as SLIDE RUN and IMAGE RUN—the former was designed for inputting records into computer files which can than be searched by using the latter. Designed around the Simons/Tansey Santa Cruz Slide Classification System, these software programs also have special fields so that searching can be done by using the Art and Architectural Thesaurus terms, a system explained in Chapter 13 under "Access Points." Prior to initiating an automated program, librarians should study these various systems as well as actually visit and interview the staff who are responsible for any of the projects which resemble those they wish to imitate.[25]

VIDEODISCS

The potential of optical-laser videodisc technology combined with computer searching of the images may offer a new research tool for visual information and retrieval.[26] A videodisc, which has the storage capacity for up to 54,000 still frames or images, has a number of advantages: it is easy to reproduce, inexpensive to produce and store, and is considered permanent unless scratched or warped. Played on a videodisc player, an auxiliary keyboard can be used to call up the required image providing random access to any single image within five seconds. Private industry has employed these dense storage disks with great success. The fine arts are just beginning to utilize this advanced technology.

In 1983, the Metropolitan Museum of Art utilized a videodisc for a public exhibit in the Michael C. Rockefeller Wing of Primitive Art. Chicago's Museum of Science and Industry and the Smithsonian Institution's National Air and Space Museum have had similar programs. These projects, which are practically maintenance free, have been used in place of a multi-image slide/tape show. Other museum projects have utilized the videodisc for collection management. The International Museum of Photography of the

George Eastman House in Rochester has experimented with this technology with *To Search for Treasure*, a videodisc which contains a 30-minute tour of the gallery, a section on the making of the disk, and over 150 original photographs owned by the museum. With a collection of more than 500,000 photographs and negatives plus 3,000,000 movie stills, this could be a boon to the museum registrar.

The Museum of Fine Arts, Boston, developed a videodisc as a means of documenting objects from their permanent collection. A number of problems were encountered, for instance, the format of an oblong slide having to fit a video screen. In 1984, a videodisc was produced containing 1645 of the paintings and sculptures owned by the National Gallery of Art, Washington, D.C., along with a tour of the museum by Director J. Carter Brown. The videodisc is similar to other microforms in that it (1) requires special viewing machines, (2) is inflexible in that it cannot be edited or changed once made, (3) cannot be used to compare objects, (4) does not produce an image of high enough quality for some research and viewing, and (5) often encounters copyright problems.[27] At the present time, the quality of videodisc images is such that they have not begun to replace 35-millimeter slides or other media, but a number of projects utilizing the technology have been reported.

FILMS/VIDEOTAPES

Although a large library system will probably have a media department which is in charge of films and videotapes, librarians in smaller institutions may discover that these celluloid publications are within their jurisdiction. These media are frequently purchased by (1) academic libraries for faculty and student use; (2) museum libraries for augmenting specific exhibitions or the permanent collection, for a film series, and for educational programs; and (3) public libraries for special programs and for a rental film/video library. For some uses of films/video, rental may be a better solution than purchase. In addition, there are a number of sources for free films of which the librarian should be aware.[28]

Those librarians who are in charge of films/videotapes should study some of the terminology and technological aspects of these media.[29] Knowledge of photography and editing will assist buyers in their evaluation.[30] In addition, surveys on the history of film will provide some of the necessary background for organizing the material.[31]

The possibilities of this familiar medium are many and well-known: up-to-date material, unusual aerial views, quality productions, views showing scale and works in the round and *in situ*, and visual material inaccessible

to most people. But films/videos also have a debit side: they often simplify complicated subjects, cater to a diverse and general audience, become easily dated, do not always include the latest scholarship on a subject, and have a specific shelf life after which the color changes or they disintegrate. In addition, films can be expensive unless the proposed audience and the monetary cost are carefully weighed. Videotape is less expensive, but is limited as to the size of the audience which can view it. For these reasons, before a film/video is purchased, it should be viewed. Librarians should solicit the assistance of a varied group of interested parties to preview the film. Example 8/1 provides sample questions which could be used in this evaluation process.[32]

While videotapes may be simply reproductions of movies or TV programs, they can be important primary sources of art information. There are two important types of video art: (1) the oral-history projects of interviews with artists and people in the discipline of art and (2) the video used as a medium for art. One extensive oral-history project on artists and persons involved with the arts is the Video Data Bank at The School of the Art Institute of Chicago. There are more than 200 videotape programs—interviews, performances, documentations, and experimental forums—which can be purchased or rented. Obviously, these human documentations of the contemporary art scene will be essential for future historians. The videotapes include interviews with famous artists—such as Judy Chicago, Christo, Chuck Close, Jim Dine, and Buckminster Fuller—as well as with artists who someday may be famous. With some programs, slides are available to be shown simultaneously with the videotape in order for patrons to see the art of the person being interviewed.[33]

With the advent of less expensive, portable videotape equipment in the mid-1960s, artists turned to creating video art. In 1969, the Howard Wise Gallery held Television as a Creative Medium, the first gallery exhibition devoted to video art. A number of libraries now collect this newest art form; the Donnell Branch of the New York Public Library has a collection of more than 300 artworks by approximately 200 artists. Distributors of this video art include Video Data Bank, Museum of Modern Art, Electronic Arts Intermix, and Art Metropole.[34]

If a patron—such as a professor or curator—desires a copy of a TV program, the librarian must be in compliance with the rules and regulations of the copyright laws—both the actual laws and all interpretations. This is a situation which can be changed radically by a single court decision. It is imperative that librarians read the current literature on the subject.[35]

Films/videos must frequently be cataloged on the premises, since some of these are produced locally or are not covered by LC. Example 8/2 illustrates

for the film *Sleepers* the shelf-list card and final version of the record which was input into OCLC by the catalogers of North Texas State University. Viewing the film is the only way to provide the proper data for the various fields: title, author statement, distributor and date, duration and type of reel, credits on cast and technical advisers, summary notes which detail the story or type of work, original media and date, subject headings, and tracings or subject indexing terms. Tracings can include famous movie stars or directors. The shelf-list card, in this case, includes acquisition data and price. The proper equipment for projecting films and videotapes is essential. Numerous books are available to assist librarians in choosing the proper course in caring for this film media.[36]

PHOTOGRAPH AND PICTURE COLLECTIONS

Photographs can be classified as reproductions of works of art or as works of art themselves. The former may be under the jurisdiction of the art librarian; the latter are usually in a curatorial department.[37] Photograph and picture collections are a mixture of black-and-white· glossy—or less frequently, colored—photographs and illustrations culled from magazines, exhibition and auction catalogs, postcards, book jackets, publishers' fliers, and any other conceivable source. These image banks are mainly (1) collections of works by individual artists or of specific art monuments and (2) illustrations depicting subjects and events. These collections are utilized by patrons doing research on a particular artist or monument, picture researchers who are trying to locate illustrative material for publication, and artists and designers seeking inspiration and ideas.

Photographs are usually purchased directly from museums, galleries, or from the owners of art objects. The illustrative material can be obtained from the widest range of sources. Photographs should be mounted on heavy acid-free stock. The verso should contain as much information as possible about the object pictured, its subject matter, condition, provenance, and source from which the photograph was obtained. Unfortunately, there is no manual comparable to Irvine's *Slide Libraries* to aid librarians who have these collections. However, *Picture Librarianship*, edited by Helen Harrison, is a useful introductory work which covers acquisition, arrangement, mounting, preservation, and services to users.

The organization of photograph and picture collections presents problems analogous to those of slides. The subject arrangement is often different from that used for slides, even in the same institution. It would seem to make sense, from the user's viewpoint, to have a similar arrangement, but this is not

```
FILM/VIDEO EVALUATION FORM

STATISTICS:

Name of Film/Video:

Name of Distributor:

Price for film_____  video_____

Year Produced:

Running Length:      minutes

Format: FILM _____8mm, _____16mm, VIDEO:__1/2"  ____VHS
Color____yes, _____no                    __1/2"  ____BETA
        Sound____yes, _____no            __3/4"  ____U-Matic

EVALUATION (check all pertinent answers):

GIVE BRIEF SYNOPSIS:

STATE PURPOSE:____didactic, _____enrichment,___motivational
        Does it accomplish it? ___yes,___no,___somewhat

AUDIENCE: ___elementary school,_____high school,
             ____college/university,____ mature audience
             ____general audience (all ages)

TYPE OF PROGRAM: ___interview, ___historical reenactment
                 ___documentary, ___biography, ___fiction
                 ___adaptation, ___lecture format
                 ___animation, ___how-to-do art

LENGTH OF PRODUCTION:___too long,___too short,___adequate

IS THIS THE ONLY FILM/VIDEO AVAILABLE ON THIS SUBJECT?
    ___yes, ___no, ___not sure  If not, what other films
    could be substituted?  Please give titles:
```

Example 8/1. Film/Video evaluation form.

```
JUDGE THE FOLLOWING AS TO ITS APPROPRIATENESS TO THE PURPOSE
OF THE FILM/VIDEO:
                        Poor          Adequate          Good
Visually
Script (writing/
   vocabulary)
Information
   provided
Scholarship
   level
Acting/Narration
Editing
Music or Sound
Color
Over-all program
   quality

HOW QUICKLY DATED WILL THIS FILM/VIDEO BECOME, AS TO
      COSTUMES, AUTOMOBILES, LANGUAGE, SUBJECT?
      ___Not at all, ____in the next 10 years, ___sooner

ARE ANY WRONG FACTS PRESENTED:____yes,___no
      If yes, what are they?

IS IT BIASED, in that it shows one side of a question?
      ___no, ___not sure, ___not applicable, ___yes
      If biased, in what way:

HOW MANY DISCIPLINES WOULD BE SERVED BY THIS FILM/VIDEO?
      ___art history, ___art education, ___studio art
      ___humanities orientation, ___other, please state:

CAN IT BE SHOWN IN THE TIME PERIOD PLANNED:
      (i.e., class period or exhibition orientations)
      ___yes, ___no, ___for some periods, state which:

DO YOU CONSIDER IT TO BE ___too costly, ___about right,
      ___inexpensive for the number of times it will be used

WOULD YOU RECOMMENTD THIS FILM/VIDEO? ___yes,___no,
      ___with the following reservations:

IF THIS IS AVAILABLE IN MORE THAN ONE FORMAT, which would be
      better suited for the library: ___film, ___video

Viewer:_____Name, _____Date
```

```
M.P.
1359        Sleepers [motion picture] / a film by
            Anthony Jones. -- [New York, N.Y.] :
            Togg Films, [197-?]
            1 film reel (ca. 8 min.) : sd., col.
            ; 16 mm.
            Summary: Shows how sculptor John De
            Andrea works to make a plaster
            sculpture called Sleepers using two
            human models.

            1. De Andrea, John.  2. Plaster
            sculpture.  3. Sculpture--20th century.
            I. Togg Films.

    TxDN    14 DEC 84    11494931    INTTnt
```

```
INT
  OCLC: 11494931      Rec stat: n Entrd: 841214         Used: 841214
Type: g Bib lvl: m Govt Pub:    Lang:   eng Source: d Lens: 008
        Enc lvl: I Type mat: m Ctry:  nyu Dat tp: q MEBE: 0
  Tech: 1 Mod rec:          Accomp mat:
  Desc: a Int lvl: e Dates: 1970,1979
    1 010
    2 040        INT c INT
    3 007        m b r d c e a f a g a h d
    4 099        M.P. a 1359
    5 049        INTA
    6 245 00     Sleepers h motion picture / c a film by Anthony Jones.
    7 260        [New York, N.Y.] : b Togg Films, c [197-?]
    8 300        1 film reel (ca. 8 min.) : b sd., col. ; c 16 mm.
    9 520        Shows how sculptor John De Andrea works to make a plaster
  sculpture called Sleepers using two human models.
   10 590        TR16100/153.29
   11 600 10     De Andrea, John.
   12 650  0     Plaster sculpture.
   13 650  0     Sculpture y 20th century.
   14 710 21     Togg Films.
```

Example 8/2. A shelf-list card and record for a film. The librarians at North Texas State University created the bibliographic record and input it into the OCLC database.

usually the case. There is no commonly accepted means of treatment. Collections of works by artists can be organized by (1) name of artist, (2) country, historical period, name of artist, or (3) country, medium, name of artist. Illustration collections are usually organized by subject headings, which can include not only names of famous artists, designers, and geographic locations, but such varied topics as horses, flowers, fruits, shells, cars, and human anatomy. A postcard collection is usually arranged geographically. Some collections have been given by donors who expect them to be kept as originally constituted. The unfortunate researcher must then cope with yet another organizing principle, which might be quite idiosyncratic.

Because of the lack of organizational standards and due to the increasing size of these collections, some librarians view computerization as the best means for providing access to the material. The Photographic Archive at the Yale Center for British Art has developed a computer system to provide access—to images, motifs, themes and concepts in addition to artists and historical periods—to their more than 80,000 photographs, a collection which is expanding by more than 3000 works annually.[38]

One of the few classifications for the iconography of Western art is ICONCLASS, which was developed in the Netherlands.[39] Originally ICONCLASS (Iconographic Classification System) was applied to the *Decimal Index to Art in the Low Countries (DIAL)*—postcard-size photocards depicting Flemish and Dutch art from the 16th and 17th centuries arranged by subject. DIAL, which is available by subscription, is owned by a number of American libraries. ICONCLASS has most recently been used in the indexing of the *Marburger Index*, which is discussed later in this chapter.

An elaborate scheme which has been issued in 18 slender volumes, ICONCLASS provides a systematic arrangement of nine major subjects utilizing a notation of numbers and letters.[40] The system has some problems. It is difficult to use because it is so detailed. For instance, the usual depiction in art of the Old Testament prophet Job is of Job sitting on a dung-hill. The ICONCLASS, in three pages of text, gives 66 variations from which the indexer can choose a notation. These include such differentiations as Job on the dung-hill visited by his wife (71 W 53), Job with his wife abusing him (71 W 531), and Job scolded by his wife (71 W 53 11). It would take a knowledgeable indexer to make these distinctions. It is highly doubtful that iconographical researchers would want someone else to make these decisions for them.

Over an approximate 45 years of development, some of the notations of ICONCLASS have changed, creating yet another problem for researchers. For instance, in the pre-publication *DIAL* numbers, Jonah was provided the number 71 L. Later this was changed to 71 V. Librarians who maintain a *DIAL* file have to decide whether or not to change to the new notations. In spite of its drawbacks, ICONCLASS is being considered by the J. Paul Getty Trust for their project of providing computerized subject access to the more than 1.3 million photographs owned by London's Witt Library. The magnitude of this undertaking can be judged from the estimate of time needed to complete it, which is the equivalent of 270 man years.[41]

Many photograph and picture collections are world famous. These include the Witt and Conway Libraries of the Courtauld Institute of Art in London, the Rijksbureau voor Kunsthistorisches Documentatie in The Hague, the Bildarchiv Foto Marburg in West Germany, and the National Gallery of Art,

Washington, D.C.[42] In recent years, copies of some of the large picture collections have been reproduced on microfiches and, thus, become available to even the smallest library, albeit at a price.

The *Marburger Index* illustrates some of the pros and cons of these extensive published picture collections. To be completed by 1987, the *Marburger Index* will cost more than $13,000. This includes the photographic inventory, a group of five COM indices, and *The Handbook of the Marburger Index*, a small, ineffectual guide to the collection. Reproducing photographs—of such items as works of art, architectural plans and drawings, ecclesiastical dress, arms and armour, and furnishings—not otherwise available without traveling throughout Germany, both East and West, the *Index* provides access to both public and private collections as well as illustrates many destroyed works of art. Slides and/or photographs, in black-and-white or in color, can be ordered from the owner of the work or through the Bildarchiv Foto Marburg.[43]

But there are also some difficulties in using the *Marburger Index*. Because the fiche were published over a period of years, researchers must look in several places to find all of the images on a given subject. It is impossible to compare two images on the same fiche. The COM indices include access by five means: objects, artists, primary iconography (the main subject of the work of art), secondary iconography (things in the background or incidental to the work of art), and portraits. For the two iconographical indices, ICONCLASS is used. Only the numbers are given, which requires researchers to refer constantly to the notations quoted in the 18 volumes that detail this system.[44]

NOTES

[1]*Reference Tools for Fine Arts Visual Resources Collections*, Occasional Papers No. 4, edited by Christine Bunting (Tucson, AZ: Art Libraries Society of North America, 1984). Helene Roberts compiled the entries on Reproduction; Kim Kopatz, for Oriental Art. Nancy McCauley assisted with the modern art section; Elizabeth Gibb recommended the titles for the photographic manuals. Also see Helene E. Roberts, "The Image Library," *Art Libraries Journal* 3 (Winter 1978): 25-32.

[2]For a general introduction, see John Sutherland, "Image Collections: Librarians, Users, and Their Needs," *Art Libraries Journal* 7 (Summer 1982): 45; and Philip Pacey, "Slides and Filmstrips" in *Art Library Manual*, edited by Philip Pacey (New York: Bowker Publishing Company, 1977), pp. 272-84. For the evolution of a departmental library into a central one, see Maria Antonietta Graf, "The Importance of a Slide Library in a University," *Art Documentation* 1 (February 1982): 12.

[3]See Julie A. Page, "Slides in the Public Library," *ARLIS/NA Newsletter* 4 (April 1976): 84-85.

[4]Betty Jo Irvine with the assistance of P. Eileen Fry, *Slide Libraries: A Guide for Academic Institutions, Museums, and Special Collections* 2nd ed. (Littleton, CO: Libraries Unlimited, 1979).

[5]*Standards for Art Libraries and Fine Arts Slide Collections* (Tucson, AZ: Art Libraries Society of North America, 1983).

[6]*Guide for the Management of Visual Resources Collections*, edited by Nancy S. Schuller (Austin, TX: Mid-America College Art Association, 1978).

[7]Margaret N. Webster, *Training Manual for Slide Library Employees* (Ithaca, NY: Cornell University Press, 1979).

[8]The MA/CAA has published a series of booklets, including: (1) *Guide for the Management of Visual Resources Collections*, edited by Nancy Schuller, 1979; (2) *Guide to Equipment for Slide Maintenance and Viewing*, by Gillian Scott, 1978; (3) *Guide for Photograph Collections*, edited by Nancy Schuller and Susan Tamulonis, 1978; (4) *Guide to Copy Photography for Visual Resource Collections*, edited by Rosemary Kuehn and Arlene Zelda Richardson, 1980; (5) *Slide Buyers Guide*, edited by Nancy DeLaurier, 1980; and (6) *Introduction to Visual Resource Library Automation*, edited by Arlene Zelda Richardson and Sheila Hannah, 1981. These are available through the Visual Resources Association; contact Nancy Schuller, University of Texas, Department of Art, Austin, TX 78712.

[9]William J. Dane, "Art Departments and Standing Orders: A Symbiotic Relationship," *Art Documentation* 2 (December 1983): 185-86.

[10]See Irvine (Note 4): "Directory of Slide Sources," pp. 292-303; commercial vendors, pp. 158-62.

[11]James Cabeceiras, *The Multimedia Library: Materials Selection and Use* (New York: Academic Press, 1978).

[12]See Note 8.

[13]Carolyn Owlett Hunter, "The Copyright Law and Art: Reproduction by Libraries and Archives," *Art Documentation* 1 (October 1982): 139-40.

[14]See also Nancy DeLaurier, "Slide Quality," *ARLIS/NA Newsletter* 7 (February 1979): 12-14.

[15]The Fogg Art Museum has a manual, *Photography and Slide Classification for Western Art* (Cambridge, MA: Harvard University, Fine Arts Library, 1973). The Metropolitan Museum of Art has information available for those who inquire.

[16]For discussions of subject headings for slides in catalogs, see Irene Zahova, "Use of Extensive Subject Headings for an Art Slide Collection," *ARLIS/NA Newsletter* 6 (November 1978): 97-100; and Irene Zahova, "More Uses of Subject Headings in an Art Slide Collection," *ARLIS/NA Newsletter* 8 (Summer 1979): 118-19.

[17]See Richardson/Hannah (Note 8).

[18]SELGEM (Self-Generating Master) was developed by the Smithsonian Institution's Information Systems Division as a joint venture with the National Museum of Natural History. SLIDEX (System for Indexing, Filing and Retrieving Slides and Other Visual Aids) was developed by Woodrow W. Lons, Jr., and implemented by Howard University, Architecture and Planning Library. The program at Sheridan College of Applied Arts & Technology of Oakville, Ontario, was developed by Bruce MacArthur. SPIRES (Stanford Public Information Retrieval System) was developed by Stanford University and implemented by the College of Design, Visual Resource Collection of Iowa State University. The project directors for the system used at Ohio State University School of Architecture were Laurence Gerckens and Paul E. Hadinger. Wendell Simons and Luraine Tansey developed the system for the University of Santa Cruz in California. SPIN (String Processing Information Network) was developed by David Parsons and implemented by the School of Architecture and Urban Planning of the University of Wisconsin at Milwaukee.

[19]"The Granting Game" by Gail Kana—published in the Richardson/Hannah book (Note 17)—provides a step-by-step explanation of how to locate funding sources and how to write a proposal.

[20]Robert M. Diamond, "Retrieval Systems for 35 mm Slides," and Wendell W. Simons, "Development of a Universal Classification System for Two-by-Two Inch Slide Collections," in *Bibliographic Control of Nonprint Media*, edited by Pearce S. Grove and Evelyn G. Clement

(Chicago: American Library Association, 1972), pp. 360-73; and Wendell W. Simons and Luraine C. Tansey, *A Universal Slide Classification with Automatic Indexing* (Santa Cruz, CA: University of California, University Library, 1969). For a use of their system at Tompkins Cortland Community College, see "Use of Extensive Subject Headings for an Art Slide Collection," *ARLIS/NA Newsletter* 6 (November 1978): 97-98.

[21]Maryellen Lopresti, "An Automated Slide Classification System at Georgia Tech," *Special Libraries* 64 (November 1973): 509-13.

[22]"Computer Applications in Slide Collections," *ARLIS/NA Newsletter* 6 (May 1981):98.

[23]Ingeborg Wald, "The Evolution of the Cornell SPIRES Slide Indexing System," *Art Documentation* 1 (February 1982): 13-15. See also Karin Ozudogru, "Computer Applications in Slide Collections," *ARLIS/NA Newsletter* 9 (May 1981): 104.

[24]Thomas H. Ohlgren, "Computer Indexing of Illuminated Manuscripts for Use in Medieval Studies," *Computers and the Humanities* 12 (1978): 189-99.

[25]Karen Markey, "Visual Arts Resources and Computers," in *Annual Review of Information Science and Technology (ARIST)*, published for the American Society for Information Science (ASIS) (New York: Knowledge Industry Publications, 1984), Vol. 19, pp. 271-309. For information on SLIDE RUN and IMAGE RUN, contact Peter A. Dulan, University of Denver, School of Art, 2121 East Asbury Avenue, Denver, CO 80208.

[26]For an excellent article, see Janice Sorkow, "Videodiscs and Art Documentation," *Art Libraries Journal* 8 (Autumn 1983): 27-41.

[27]F. William Troost, "A Practical Guide to Dealing with Copyright Problems Related to Emerging Video Technologies in Schools and Colleges," *Library Trends* 32 (Fall 1983): 211-21.

[28]See *Educators' Guide to Free Films* (Randolph, WI: Educators Progress Service, annual); and *Index to Educational Video Tapes* 6th ed. (Albuquerque, NM: NICEM: National Information Center for Educational Media, 1985).

[29]There is an excellent annotated bibliography of audio-visual references in Elizabeth Sacca and Loren Singer, *Visual Arts Reference and Research Guide* (Montreal: Perspecto Press, 1983). For an excerpt from this book, see Loren Singer and Diana Brewer, "Audio-Visual Materials in the Art Library," *Art Documentation* 2 (October 1983): 131-35. See Jones for methodology on film research, pp. 129-30; bibliographical references, pp. 156, 164, 235, 249-51, 255-56; film libraries, pp. 281-82. Also see John A. Walker, "Sound Recordings, Video, and Films," in *Art Library Manual*, edited by Philip Pacey (New York: Bowker Publishing Company, 1977), pp. 256-71.

[30]See Jerrold E. Kemp, *Planning and Producing Audiovisual Materials* 4th ed. (New York: Harper & Row, 1980), which includes (1) a glossary of terms, (2) a listing of service companies, and (3) chapters on the fundamental skills for photography, graphics, and recording sound as well as the production of slides, tape recordings, motion pictures, and videotapes. For terminology, see Frank F. Beaver, *Dictionary of Film Terms* (New York: McGraw-Hill Book Company, 1983). An interesting 20-minute film on editing is the 1983 movie *The Hold-Up*, which is also on video and was written and directed by Stephen Hank at the University of New Orleans Performing Arts Center; it is available from this source.

[31]Numerous readable books are available, such as Arthur Knight, *The Liveliest Art: A Panoramic History of the Movies* (New York: Macmillan Company, 1957; revised edition, 1979); and Arthur R. Fulton, *Motion Pictures: The Development of an Art from Silent Films to the Age of Television* (Norman, OK: Oklahoma Press, 1960).

[32]This Film/Video Evaluation Form was developed by Lois Swan Jones for the Los Angeles 1985 ARLIS/NA Convention workshop, Films as Art/Films About Art, which was coordinated by Loren Singer.

[33]For information on this specific program, contact the Video Data Bank, The School of the Art Institute of Chicago, Columbus Drive at Jackson Boulevard, Chicago, IL 60603. For discussions and a bibliography on oral history programs, see *Drexel Library Quarterly* 15 (October 1979); the entire issue was on this subject. For a list of distributors, see *Directory of Film &*

Video Distributors (Washington, DC: American Association of Museums, Nonprint Media Committee).

[34]Video Data Bank (Note 33); Museum of Modern Art, 11 West 53rd Street, New York, NY 10019; Electronic Arts Intermix, 84 Fifth Avenue, New York, NY 10011; Art Metropole, 217 Richmond Street West, Toronto, Canada M5V 1W2.

[35]See Troost (Note 27); Roger D. Billings, Jr., "Fair Use Under the 1976 Copyright Act: The Legacy of Williams & Wilkins for Librarians," *Library Trends* 32 (Fall 1983): 183-98; *Copyright and Educational Media: A Guide to Fair Use and Permissions Procedures* (Washington, DC: Association for Educational Communications and Technology, 1977). For off-air recording of broadcast programming for educational purposes, the *US Congressional Record* (October 14, 1979): E4750-52 provides guidelines: tapes which are recorded can be kept no longer than 45 days, with only the first 10 days being available for class presentation, the other 35 days for evaluation purposes only.

[36]See Note 29.

[37]John Sunderland, "Photographs and Reproductions of Works of Art," Anthony J. Coulson, "Illustrations," and Colin Ford, "Photographs as Works of Art," in *Art Library Manual*, edited by Philip Pacey (New York: R. R. Bowker Company, 1977), pp. 285-97, 372-88, and 298-315. For an example of use, see "The Westport Public Library Picture Collection," *New York Times*, Connecticut edition (September 11, 1977), reprinted in *ARLIS/NA Newsletter* 6 (Summer 1978): 75-76.

[38]Mary Jane Sobinski-Smith, "The Yale Center for British Art: The Photographic Archive and Iconographic Access," *Visual Resources* 1 (Fall 1980): 173-87. For additional information, see the various projects which were discussed at the Second International Conference on Automatic Processing of Art History Data and Documents at Pisa, Italy, September 1984. See Chapter 2, Note 18.

[39]See L. D. Couprie, "Iconclass: An Iconographic Classification System," *Art Libraries Journal* 8 (Summer 1983): 33-49.

[40]The nine groups include: Religion and Magic; Nature; Human Beings and Man in General; Society, Civilization, Culture; Abstract Ideas and Concepts; History; Bible; Literature; and Classical Mythology and Ancient History. The bibliography published with the ICONCLASS system is useful for certain subjects.

[41]See Markey (Note 25).

[42]For a list of some important picture archives, see John Sunderland, "Photographs and Works of Art," (Note 37), pp. 293-97 and Jones, pp. 279-81. For a list of references, see Carl H. and Arlyle Mansfield Losse, "Motion Picture Reviews, Posters, Picture Files," *Art Documentation* 1 (Summer 1982): 124.

[43]Bildarchiv Foto Marburg im Kunstgeschichtlichen Institut der Philipps-Universität Marburg, Ernst-von-Hulsen-Haus, Wolffstrasse, P. O. Box 1460, D-3550 Marburg, West Germany.

[44]Lutz Heusinger, "Marburger Index," *Automatic Processing of Art History and Data and Documents* (Pisa: Scuola Normale Superiore, 1984), Volume I, pp. 45-62. (See Chapter 2, Note 18). See also Lois Swan Jones, "Research Strategy for Microforms: Methods for Locating Specific Artists' Works Illustrated in Photographic Archives," *International Micro News* 1 (February 1986).

9

Special Formats
and Collections

INTRODUCTION

Patrons usually utilize the reference works they already know and use the library in the way they were taught. The library's recent reference tools and new technologies may need to be promoted and demonstrated if they are not to be under-used, since librarians frequently purchase and collect new resources before patrons know they want them, thus creating the need. Not always visible to the public, special collections may require this particular treatment.

Not every library should accept or develop special collections, which are often labor-intensive and costly.[1] Only material which will be used by the library's patrons should be collected. An architectural library is an ideal place for collections of architectural drawings and blueprints. But it would just be a waste of space, time, and money for this same type of library to house fashion and costume drawings. If the public library has extensive vertical files on local artists, the art museum may not need to duplicate this material.

For the special collections which already exist, the problems for the library staff become those of enlarging, preservation/conservation, maintenance, weeding, additional storage, and making the material accessible to the public. For newly formed collections, there are other considerations, such as whether or not to accept or add to the material and the organizational scheme to be used. In accepting or developing these types of collections, the library

administrator must consider: (1) the importance of the data, (2) the patrons, (3) storage, (4) the collection and organization of the materials, (5) the frequency of use, (6) the staff time required to organize and maintain the material, (7) the special conditions—such as air conditioning or low lights— required for storage, (8) the additions to be made to the material and their frequency, (9) other similar material collected for the library, (10) any needed indices or information retrieval systems, (11) whether the material is conducive to computerization, (12) the difficulty in publicizing the material, and (13) most important of all, the expense of the project in terms of budget, staff, maintenance, and development of information retrieval systems.

Many art libraries contain special collections and resources. Included in these categories are (1) microforms, (2) vertical files, (3) archival material, (4) artists' books, (5) rare books, and (6) building and decorative arts samples. In order to assist patrons, librarians have developed methods to aid in the retrieval of this material; in some institutions, this is in computerized form. This chapter discusses these six aspects of a library's non-book collection

MICROFORMS

All types of art materials now are published using a microform format. Microforms are the most cost effective means of storing large quantities of bibliographic material; text and illustrative material are reduced and printed on a film roll or card. Two basic types are popular: (1) microfilm, which contains images or frames of material in a continuous role of film, and (2) microfiche, which is a 4″ × 6″ film card containing numerous images or frames—usually 98 or more. Special equipment is required in order to magnify and to read the reduced material as well as to photocopy any of the data on the microform.

The larger the microform collection, the more the library's clientele will consider it as an integral part of the collection and utilize this film format. Thus, librarians are faced with the choice of developing microform collections and purchasing a number of quality readers and printers or not offering this type of service. If the former is elected, a concerted effort should be made to acquire some of the excellent resource material offered in this media.[2]

When purchasing microforms, the librarian should consider using a vendor, such as Clearwater Publishing Company, Inc. Time and money can be saved by having a vendor order the material, much of which is produced in Europe; check it for accuracy; handle the financing and customs officials; and provide assistance in selection and cataloging. Librarians who do order direct must convert their currency into the required foreign exchange, which is not always

an easy matter; hope that the correct items are sent; and often spend time with custom officials clearing the items.

There has been resistance to the use of microforms. Patrons may appreciate some of the same assets that librarians find appealing: the tremendous amount of data reproduced on a card or a roll of film, the availability of out-of-print or inaccessible material, the reduction in expense, and the ease of storage.[3] On the other hand, patrons are concerned with the disadvantages of microforms: (1) material does not circulate and viewers are confined to a machine; (2) essential data—such as the dimensions of the work of art—are often missing; (3) eye fatigue results from long periods of reading the material; (4) most illustrations have no indication of scale; (5) fiches can be easily misfiled or taken; (6) patrons cannot mark their place when a break is taken; (7) microforms are often updated by completely reprinting all of the film, fiche, or series of fiches; (8) the index and footnotes may be placed at the end of the work and hence are inconvenient and time-consuming to use; and (9) the user cannot browse. In addition, many patrons dislike machines. For hundreds of years, printed books have been the common form of disseminating information. It will take time and patience before any new method will be wholly accepted.

In order to minimize patrons' resistance to using microforms, care must be taken to assure the comfort of the person using the machines. Proper seating, machine height, lighting, and noise are particularly important. In addition, the patron will require space for writing and reference materials. Easy-to-follow directions should be posted next to each machine. If the index to the material is also on microform, two machines may be required. For example, the vast size of the *Marburger Index: Photographic Documentation of Art*—about 4800 microfiches in the first printing, some 3000 in the addition—makes it difficult to use the microfiche index unless two microfiche readers are available.

There are three major obstacles in using microforms: (1) the difficulty in locating material due to cataloging and retrieval problems, (2) the lack of adequate indexing for microforms, and (3) the inflexibility of the illustrative material on these celluloid cards. These are not new problems; the microform literature has been discussing them for years. Unfortunately, the problems have yet to be solved.

In large cataloging departments, some librarians handle microforms; others, monographs. If the index for a microform work does not accompany the microforms, these two materials may be cataloged by two separate librarians. For instance, *The Drawings of Robert and James Adam in the Sir John Soanne's Museum* consists of 11 rolls of microfilm, of which 2 rolls are in color. There is also a hardbound book, entitled *Catalogue of the*

Drawings of Robert and James Adam in Sir Soanne's Museum, that provides a description of the drawings on the microfilm. In the OCLC System, which many librarians use for cataloging purposes, one of the entries for the microfilm provides no reference to the hardbound book. In many card catalog systems, there would be no card in the subject file for the microfilm, since cards would have been put under "Adam, Robert" and "Adam, James" in the author file. Not all patrons realize that artists and designers are listed in the author file for works which predominantly reproduce their works.

The librarian should check these materials carefully to be sure that proper identification of both microforms and any hardbound materials related to them are cataloged properly. Some museum-collection catalogs have been published in these two formats. For example, the Chicago Visual Library issued by the University of Chicago Press includes text-fiche for numerous museums, such as The Art Institute of Chicago, the Isabella Stuart Gardner Museum, and the Whitney Museum of American Art. In addition, the microfiche and hardbound materials should be shelved in such a way as to assure their being used together. For instance, the microform section could have a special shelf for the hardbound materials and a note could be added to the microform folder informing patrons of any hardbound book.

Another problem is caused by multiple microfiche sets which are not analytically cataloged. Additional access points and cross references will facilitate the use of this material. For example, the French Salon microfiche are grouped under *Explication des ouvrages*, a title few patrons would consider checking.

Simplified organization of microforms is important. Filing under a complicated numbering system does not always facilitate use. In the French Salon example used above, the easiest filing system could be one individual number for all microforms on the French Salons. The individual microfiche can then all be filed under the one number and organized by the year of the exhibition. If alphabetical cards do not already separate large microfiche sets, these should be added. The extensive number of fiches of *The Art Exhibition Catalogs Subject Index* of the University of California at Santa Barbara is easier to use if some type of alphabetical dividers are inserted.

For the convenience of patrons, both the microforms and any index that covers them should be in close proximity. For example, the indexing services for specific microform sets—such as ERIC, the Educational Resources Information Center—should be kept close to the microforms. This abstracting service, which indexes material to a vast number of publications in the educational field, reprints many of the articles and reports on microfiche which are available through the ERIC Document Reproduction Service.

An almost insurmountable problem with microforms is the inflexibility

of the illustrative material. Because it is impossible to compare works of art on the same microfiche adequately, some reproductions may need to be available in another form or on separate microfiche cards and two microfiche readers used. Printouts or photocopies of illustrative material on microforms is inferior to that of books. Patrons—especially professors, graduate students, and curators—may need to transform illustrative material on a microform into some other format, such as a photograph or slide. This is not only difficult, but the results are unsatisfactory. Commercial firms often refuse even to attempt taking photographs from these celluloid formats. Some photographic archives—such as the *Alinari Photo Archive* and the *Marburger Index*—sell slides of the images that are reprinted on their microfiche sets.

Attending the ARLIS/NA annual conference at which most of the large vendors display their microforms is one of the best ways to see microform materials. Essential is the regular reading of serials especially geared to this media, such as *Microform Review* and *International Micro News*. In a special *Visual Arts Issue* of *Microform Review*, there were nine pertinent articles, reviews of 13 microform publications, and a visual arts bibliography.[4] *International Micro News* is available free of charge from Clearwater Publishing Company, which usually issues a special ARLIS/NA edition that discusses and lists microform sets important to an art library. Visiting other art libraries and consulting with colleagues are other methods which will provide additional insights into selection and purchase.

Although microforms are obviously here to stay, they may not be the best format for all data. Color illustrations will continue to be a problem due to their inflexibility within this film framework. And for some libraries— such as small art schools—microforms may never be needed. Educating patrons may be required in order to assure the continued and proper utilization of the material. Workshops, demonstrations, and publicity brochures may need to be employed. For as with any other balky, reticent beginners, the more librarians do to make the lessons palatable to their constituency, the sooner the material will be accepted and used.

VERTICAL FILES

In some libraries, ephemera are saved, placed in folders, and stored in vertical files. The word ephemera is a misnomer because much of the material has lasting value.[5] The items are conserved in this manner because they may be only a couple of pages long, of flimsy material, or too expensive or awkward to bind. Some of the artists' files in major collections are treasure troves for researchers. For instance, one of the most famous 20th-century collections is that of the Museum of Modern Art in New York City, which

has files containing rare material on approximately 15,200 artists. In addition to their importance for biographical data, these collections can be a rich source of visual images.

The type of material preserved in vertical files is almost limitless. This can include such items as newspaper and magazine clippings, small brochures and pamphlets, gallery exhibition checklists and catalogs, and announcements and newsletters. Some vertical files contain beer coasters, book jackets, and invitations to gallery and exhibition openings. The material which is saved is limited only by the librarian's imagination.

There are various methods for securing these materials, such as (1) saving specific items on a regular basis, (2) getting patrons and interested parties to collect for the library, and (3) purchasing pertinent items. Scanning and clipping articles, news items, and illustrations must be done consistently. For instance, if a public library is saving information on local artists, each issue of the area newspapers as well as regional magazines must be searched and saved. Sometimes this requires photocopying in order to include the complete article. Clearly, this can take an exorbitant amount of the librarian's time. Although this clipping may be done by volunteers, it still takes time for training.

Patrons can aid the library in collecting material for vertical files by contributing such items as catalogs, gallery announcements and invitations, and photographs. Librarians should be sure that local galleries and museums have placed their institutions on mailing lists. In academic libraries the faculty should be encouraged to donate important items to the library. But the librarian must be sure that these files do not become a dumping ground for useless material. Discretion as to what goes into these collections must be used.

Most libraries utilize only the above methods for obtaining material. Yet, there is an additional source which can be used to discover items that can be purchased or obtained for the price of postage. The *Vertical File Index*, issued 11 times a year by The H. W. Wilson Company, is a subject and title annotated index to selected pamphlet material. The items listed range from annotated bibliographies to exhibition catalogs. Unusual material can often be located, such as the one cited under "ARTS, Economic aspects," to *Visual Artists in Houston, Minneapolis, Washington, and San Francisco: Earnings and Exhibition Opportunities*, which was issued by the Publication Center for Cultural Resources. Complete bibliographical data is provided as well as the prices and addresses needed for ordering.

The subject under which the folder is placed in a vertical file is usually the only indexing system. In public libraries, the *Vertical File Index* is sometimes used as a basis for the subject headings of local files. But since many art librarians find these headings too general, they prefer to create their own subject headings. Public and art school libraries use many topical

headings in addition to artists and gallery names.[6] Museum libraries tend to prefer organizing their files by using the latter. Since problems can arise in maintaining consistency in the choice of name, an authority file is needed. Unfortunately, implementing a cross-reference system is usually considered too expensive. Because these files are frequently not mentioned in the library's central catalog, they must be advertised if patrons are to use them. For the art librarian, the problem is that of maintaining existing files or developing them where they do not exist.

Because weeding files is a great chore, careful initial selection is the best method for containing the size of the files. These collections, if unchecked, have a tendency to grow at a phenomenal rate. For instance, the Dallas Public Library, which has been clipping from local newspapers as well as the *New York Times* and the *Christian Science Monitor* for only 20 years, now has files for approximately 16,000 artists. For some older files, which go back to the 19th century, microfilming is being investigated as a method of preserving and reducing the size of the collection.[7]

Maintenance of these types of files—obtaining, organizing, and weeding— is extraordinarily labor intensive and time-consuming. Because of the problems inherent in vertical files, the art librarian should think very carefully before initiating such a collection. It is important to investigate the area libraries to avoid any duplication. Prior to making a commitment, the following should be considered: staff time, space, difficulty in retrieval of material, the inevitable deterioration of wood-pulp paper, and the overall expense of the operation.

ARCHIVAL MATERIALS

Art librarians most likely to be involved in the maintenance of archival collections are those employed by museums, art schools, architectural and design firms, or other business enterprises. Although, generally speaking, American institutions have not been particularly careful about preserving their records, in recent years greater awareness has developed about their value, both to the institution and to scholars.[8] Academic and public libraries also acquire archival materials, some of which may fall within the domain of the art librarian. In some instances, the services of a professional archivist may be obtained, if the records are extensive, but in many cases the librarian will have to assume the function of the archivist. Archival collections are assembled because they are believed to possess permanent value and, therefore, should be indefinitely preserved. They represent the documentary heritage of recorded memory of an institution, an individual, or a group of individuals. Because of the concern for preservation, they are treated rather

differently from other types of library collections. One major difference is that archivists work not so much with individual items or records as with bodies or groups of items or records.[9]

Archivists make a distinction between archives and manuscript collections, because they usually serve different functions and their method of acquisition is not the same.[10] Archives are the past records of an organization or institution maintained primarily for their usefulness to the body that created them. Over time these records may come to be of historical interest to scholars outside of the originating organization. Thus, archives, which usually come in more or less orderly fashion to the repository directly from the offices where the records were originally created, may remain the property of the organization. As a rule only 3 to 5% of an organization's records end up in the archives.[11] It is, of course, possible for one organization to collect the records of another for purposes of research, as, for example, when a university library acquires the records and drawings of an architectural firm.

Manuscripts are single documents, such as letters and diaries, which are kept primarily for research and scholarly purposes. They are usually actively solicited or purchased by the archivist or librarian. Collections of manuscripts, which sometimes begin in fairly modest ways, can ultimately expand to include artifacts and even works of art. A good example is that of the graphic arts collection of Eric Gill owned by the William Andrews Clark Memorial Library at the University of California, Los Angeles.[12] The Clark Library obtained most of Eric Gill's personal library, incoming correspondence, surviving manuscripts, diaries, and account books. It then acquired several sculptures, original drawings, original blocks, and a set of annotated engravings. This collection has become a comprehensive archival repository serving historians of art, culture, and typography.

Work with archival materials centers on four basic tasks: (1) assessment or appraisal of the items, not in terms of monetary but of potential historical value; (2) organization and arrangement of the collection; (3) description of the whole collection and the individual parts of it; and (4) assistance to researchers in locating pertinent files. Appraisal always precedes acceptance of any items. Ultimately a subjective process, an appraisal is a guess about not only what may be needed today—as, for example, documentation for litigation—but also about what future users will want. Among the many factors to be considered are the age of the documents; the volume of material; and the informational, administrative, and research values inherent in the collection.

Records do not appear automatically. The archivist must decide what materials to solicit and, in the case of an organization, set up a channel whereby records are routinely received. Collections of papers external to an organization must be accumulated with a knowledge of research needs in

the particular subject area. The archivist should be aware of other collections of similar materials, since by definition, archives are collections of unique items and should never duplicate one another. Two basic guides describing the contents of individual repositories are the *National Union Catalog of Manuscript Collections*, compiled at the Library of Congress, and the *Directory of Archives and Manuscript Repositories in the United States*, prepared by the National Historical Publications and Records Commission.[13] Using these reference works, the librarian can become familiar with art-related repositories and guide their users to them.

The two fundamental principles of archival arrangement differ markedly from library practice. These are *respect des fonds*—respect for the integrity of the group—and the principal of provenance. The former implies that groups of records should be protected as groups, the latter that records should be filed in the order of their origin. Because every collection is unique, no description will be transferable to any other. Archivists do not have codifications of rules of description similar to AACR2, nor does the concept of cooperative cataloging exist. Databases such as OCLC can only provide information about extant archival holdings; the records cannot be copied to describe one's own materials. The arrangement of each archive depends upon the order imposed on it, guided by the principles of *respect des fonds* and provenance.

In the process of arranging archival materials, various descriptive inventories are created, the most basic of which is the accession record. Also developed by the archivist are a number of finding aids, which are the descriptions, sometimes published, used to establish physical and intellectual control over the records. The most common finding aids are (1) inventories describing a single body of papers or records and (2) annotated lists, guides, and indices which may be arranged by subject, chronology, geographical region, types of material, or combinations of these categories. RLG has developed a program entitled Archival and Manuscripts Control (AMC), which is designed to make possible through RLIN a national information system. Modifications to the MARC format have facilitated the provision of multiple access points, the means of maintaining donor lists and other files, as well as the capability of updating records for new acquisitions.

Regardless of the materials the repository contains, a long-term commitment to permanent preservation is understood: old records are not weeded to make room for new ones. A great deal of time is required to process records; a great deal of storage is required. These factors explain why archivists are not only cautious in their appraisals but are always concerned with conservation and security. Conservation practices include proper storage in acid-free containers under temperature and humidity controls.

Encapsulation—or placing a previously deacidified document between two sheets of polyester film—is a currently popular method of treatment for single sheets, because it is a process that uses no heat or pressure and, most importantly, is reversible. Conservation assistance, usually expensive, can be obtained from a number of commercial laboratories.[14]

Archivists make considerable effort to prevent theft, mutilation, or disturbance of filing order. For this reason, stacks are closed and materials are used only under supervision, never circulated. Patrons are always registered and shown the rules and regulations for use, which usually include a specific prohibition against fountain pens, and sometimes ball-point pens. Librarians must also be aware of any copyright problems.[15] Since many users are not familiar with standard citation practice, rules may suggest a form for citing archival or manuscript materials.

Within the last ten years archivists have begun to inquire into automated management of and access to their collections.[16] These efforts have been channeled through the Society of American Archivists, resulting in greater cooperation and interest in standardized methods of description. The use by OCLC of the MARC2 format and AACR2 cataloging rules is regarded by most archivists as restrictive, and the lack of subject access continues to be troublesome. For this reason, computerized projects, such as those which were discussed in Chapter 8 under "Slides," have been initiated.[17]

ARTISTS' BOOKS

Artists' books are works designed by artists in a book format—or something vaguely resembling a book—in either multiple copies or unique one-only issues.[18] Varied as to subject and design, these works of art explore the book form in unconventional ways. There are numerous innovations used in these creations: hand-made metal covers with string and balls attached, pop-up designs or accordion-folded pages, a plastic bag full of dirt, and unusual page material or writing tools, such as tinfoil, talcum powder, or blocks of wood. The message can be all pictorial, machine or hand printed, or non-existent. In his well-illustrated article, "Two Decades of Book Art," Clive Phillpot differentiates between two broad types: (1) ones that look like books but may be more like sculpture and (2) ones that behave like books in that they have a sequence of pages. In addition, he warns that "many so-called 'artists' books' are merely writings or photographs by artists and not examples of Book Art at all."[19]

Artists' books are usually stored in a limited access area and, if needed, in some form of acid-free containers. Cataloging can be LC or Dewey with

the general subject heading "Artists' Books." As usual, LC should not be followed blindly as the subject headings "Literature" or "Photography" are often assigned to items librarians consider to be artists' books. Care must be taken that these works are not sent to be rebound or in any way altered in appearance. At Virginia Commonwealth University, a Rolodex index file is used to facilitate browsing through the more than 1500 items in their collection. Each 4" × 6" card has a brief description of the book and several black-and-white contact prints illustrating how it works.[20]

There are a number of extensive collections of artists' books. At the Franklin Furnace Archive in New York City, there are more than 3500 of these creations.[21] Most collections consist of multiple-copy works, which are readily available through mail-order catalogs from such firms as Art Metropole, Printed Matter, and Writers & Books.[22] Comparatively inexpensive—some range as low as $10 or under—these books are frequently published in 1000 to 2000 edition sizes. To document their collections, most libraries with substantial numbers of artists' books save data concerning the artists and the creation of these works of art—articles, press notices, photographs, and other ephemera. And, of course, there is always the hope that some of these artists' books will become tomorrow's rare books.

RARE BOOKS

While many art libraries contain rare books, few have major separate collections of these and other similar materials within their jurisdiction. The term *rare book* is used to refer to items—not necessarily books, nor old or rare in the sense used by a book collector, or even expensive—which are treated differently from the rest of the collection because of the need to preserve them for future use. The custodial and conservation function the librarian assumes for rare materials is thus close to that assumed for archival materials.[23] In art libraries, the passage of time alone has meant that some books—such as auction and salon catalogs—have become rare.[24] Museums and art schools founded in the 19th century frequently have accumulations of older materials which are now scarce. Museums may own manuscripts, incunabula, or 16th-century emblem books which are neither housed nor cataloged by the library. Even more recent publications, like the Kelmscott Press Books, may be held by another department of the institution. Librarians should be able to provide patrons with location information for these materials.

If an institution owns a large number of rare books, a separate collection is usually maintained. In this case, the art librarian's primary function is to determine which books should be transferred from the open shelves to the

rare book repository; this task is accomplished by weighing demands of preservation against those of current usage. In smaller institutions, rare materials may be merely segregated from the main collection and their use more closely supervised. Of course, limiting access does not mean forbidding it; there should be as few impediments to use as absolutely necessary.

In addition to recognizing which books should receive special treatment, the art librarian may also be involved in purchasing rare materials from antiquarian book dealers as a result of collection development policies. For a discussion of the out-of-print market and restrospective collection building, see Chapter 12.

Knowledge about rare books and their value develops over time, but a number of aids are available to assist in estimating current prices. These tools may be used for determining a book's rarity as well as for insurance purposes. *American Book-Prices Current*, an annual publication dating back to 1895, provides details of all but the most inexpensive books sold at auction houses. The scope was broadened in 1958 when British sales were included. Published by Gale Research since 1964, *The Bookman's Price Index* is a cumulation of selected booksellers' catalogs. This is a quick source of information on prices, although it represents only a small proportion of the trade.[25]

To augment these tools, the catalogs of large general dealers as well as those specialists who produce catalogs pertaining to art subjects should be scanned. These dealers may be identified by referring to the advertisements in trade journals, such as *AB Bookman's Weekly*, as well as to special directories, such as those produced by the International League of Antiquarian Booksellers. In these catalogs the information provided about any given book is usually brief; any condition or special features, such as an author's inscription which might affect the price, are not always stated.[26]

Although not generally concerned with cataloging rare materials, art librarians should recognize that rare books entail processing and cataloging procedures that are different from those accorded the average acquisition. Rare books need to be handled more carefully and examined more critically. They should be collated—compared with descriptions either in the bookseller's catalogs from which they were ordered or with bibliographic descriptions in standard reference works and union lists. Because it is so time-consuming, cataloging rare books is expensive.

A catalog entry for a rare book should tell enough about its physical make-up to distinguish it from others. This requires that more attention be paid to the transcription of the title page and that the physical description be more elaborate, with a collation by gatherings as well as by pages.[27] The copy described should be that in the collection, not an ideal copy, and details are usually included on paper, plates, type, and binding. Abbreviated references to standard bibliographic descriptions and listings are usually added. Today's

computerized catalogs have the advantage of easily providing numerous additional access points, such as illustrators, engravers, printers, binders, and previous owners.

Similar to that of archival materials, the housing of rare books is designed to limit direct access by patrons to prevent theft, mutilation, or rough handling. Subdued light, low temperatures, and humidity control to prevent mold or dessication are all important. Atmospheric pollution has now been added to the age-old enemies of books. To protect their books from over-zealous users, librarians often provide portable lecterns which reduce the risk of piling other books on top of the rare ones. Glass plates may be used as a means of keeping the leaves open. Many librarians prohibit the use of pens. Normally, photocopying and photographing are permitted only at the discretion of the librarian. Even if the material is no longer protected by copyright, copies may be limited to personal study and research only. Special permission must usually be sought from the library for reproduction of the photographs. The overriding concern is always to protect the material for future use.

BUILDING AND DECORATIVE ARTS SAMPLES

Although organizing building and decorative arts samples is primarily done by architectural and interior decoration firm librarians, these materials are frequently found at colleges and universities which have courses in these studies.

To indicate the problems, a specific interior design library in Cleveland, Ohio, will be used as an example. At this firm, the librarian is a liaison between the firm's designers and the vendors and distributors which advertise their products. The librarian must organize the materials, provide a check-out system, and maintain a collection which consists of 15,000 samples of fabric, 500 books of wallpaper samples, 450 catalogs on furniture, 3000 carpet samples, and 1500 vertical files containing publicity brochures and other important ephemera. In addition to the file copies, there are often other trade brochures or sample books from which the designers can cut examples of specific patterns. Inventory must be taken each year. Changes in prices must be indicated; discontinued items, eliminated. Out-of-date material must be replaced, which frequently necessitates ordering the latest material or seeking new outlets. There are also about 200 books and subscriptions to 40 serials.

The basic organizational scheme is the "Standard Filing System: Classification and Filing Numbers," which is cited in the *AID Standard Filing System 1971 Issue*.[28] There are 20 major sections—furniture, lamps, wall

coverings, paints and finishes—with numerous subdivisions under each term. From this organization, the products may need additional sub-sections. For instance, "Wall Coverings" has a division for "Wall Papers" which can be broken down into such categories as "Antique papers," "Hand-printed papers," or "Silk-screen papers." This could be further delineated by pattern—floral, stripes, figures—and color—reds, blues, greens. The librarian must study the ways in which the material will be used prior to organizing it. For instance, in architectural libraries, the samples are frequently classified according to the system used by the *Sweets Catalogues.*

One of the biggest problems with most special collections is that they are uncataloged with no records of the existence of either the whole or the numerous entities which compose the collection. In order to gain access to the material and to establish some form of bibliographic control, many librarians have developed special files for the material. A Company File would contain the following data: (1) a short code number which can be used on the other file cards; (2) complete names, addresses, and telephone numbers of the firm's home office and local representative; (3) an indication of any showroom activity of the firm; (4) the discount given; (5) a listing of the merchandise and services provided; and (6) the title of any publicity brochure and the date of the last issue. Subject File Cards can include the type of product—such as "Tables-dropleaf"—followed by the companies which make this product and notations on any specific differences from firm to firm. This type of data is especially suited for computerization.

NOTES

[1]See Evelyn Samuels's "Special Libraries—Special Problems: Preservation of Art Library Materials," *ARLIS/NA Newsletter* 9 (Summer 1981): 141–45, which discusses illustrations in books; correct storage for art books, folios, and portfolios; care of leather bindings; care of photographs and microforms; and the environmental storage of microforms. In addition, there is a good list of bibliographic references.

[2]For a list of some microform sets pertinent to art, see Jones, pp. 194–201, 211–15, 238, 243–44.

[3]See the two articles published under "Microforms in the Art Library," *ARLIS/NA Newsletter* 8 (December 1979): 1–6. Jacqueline Sisson's "The Role of Microforms in Collection Development" includes a discussion of bibliographic control, microform supplies, and serials. Charles Chadwyck Healey's "Microfiche in the Art Library—A Reply to Some Criticisms" discusses such problems as difficulty in reading microfiche, lack of browsing, and expense. For a special use of this media, see Harold B. Schliefer's "The Utilization of Microforms in Technical Services," *Microform Review* 11 (Spring 1982): 77–92. For a bibliography, see Paula Cniarmonte's "Microforms Bibliography: Revised Edition," *ARLIS/NA Newsletter* 9 (February 1981): 47–48. For a discussion which includes a 20-point checklist for purchasing microforms, see Virginia Carlson, "Microforms" in *Art Library Manual*, edited by Philip Pacey (New York: Bowker Publishing Company, 1977), pp. 236–55.

[4]The articles in _Microform Review_ 8 (Summer 1979) included: Evelyn Samuel's "Planning a Microform Center for the Art Library," Jacqueline D. Sisson's "Microforms and Collection Development in Art Research Libraries," Janis Ekdahl's "Visual Resources on Fiches for Art Scholars," Melva J. Dwyer's "Fine Arts Microforms: A Canadian Experience," Charles Chadwyck-Healey's "The Reproduction of Visual Material on Microform: Our First Five Years and the Future," Karen Wilson's "Chicago Visual Library," Michael J. Gunn's "Colour Microforms and Their Application to the Visual Arts," Jimmie Y. Davis' "Micropublishing in Color," and Peter Ashby's "Illustrated Reference Teaching and Beyond: The Microfiche Approach."

[5]See Nik Pollard, "Printed Ephemera," in _Art Library Manual_, edited by Philip Pacey (New York: R. R. Bowker Company, 1977), pp. 316–36; and Alan Clinton, _Printed Ephemera: Collection, Organization and Access_ (London: Bingley, 1981). Also see, Shirley Miller, _The Vertical File and Its Satellites: A Handbook of Acquisition, Processing and Organization_ (Littleton, CO: Libraries Unlimited, 1971).

[6]See Jane Block's account of the ARLIS/NA conference session on Artists' Ephemera, _Art Documentation_ 1 (December 1982): 185–86.

[7]Refer to Donald Anderle, "The Artists' Files at the New York Public Library," _ARLIS/NA Newsletter_ 6 (November 1978):101–02.

[8]As reported in Abid's 1980 questionnaire survey of 75 art museums, of the 45 (60%) respondents, 29 (64%) who answered maintained an archive. See Ann B. Abid, "Archives in Art Museums: A Preliminary Survey," _ARLIS/NA Newsletter_ 8 (February 1980): 42–43. Also see Claudia Hommel, "A Model Museum Archives," _Museum News 58_ (November/December 1979): 62–69, which discusses the finding of Diego Rivera's working cartoons for his frescoes at the Detroit Institute of Arts and the archives which were established at that museum; and Catherine Stover, "Museum Archives: Growth and Development," _Drexel Library Quarterly_ 19 (Summer 1983): 66–77.

[9]There are a number of works on the management of archives. David B. Gracy II, _An Introduction to Archives and Manuscripts_ (New York: Special Libraries Association, 1981); "Management of Archives and Manuscript Collections for Librarians," edited by Richard H. Lytle, special issue of _Drexel Library Quarterly_ 11 (January 1975); Theodore R. Schellenberg, _The Management of Archives_ (New York: Columbia University Press, 1965). Also valuable are the publications of the Society of American Archivists, such as: Maynard J. Brichford, _Archives and Manuscripts: Appraisal and Accessioning_ (Chicago: Society of American Archivists, 1977); David B. Gracy II, _Archives and Manuscripts: Arrangement and Description_ (Chicago: Society of American Archivists, 1977); Sue E. Holbert, _Archives and Manuscripts: Reference and Access_ (Chicago: Society of American Archivists, 1977); Mary Lynn Ritzenhaler, _Archives and Manuscripts: Conservation_ (Chicago: Society of American Archivists, 1983); Timothy Walch, _Archives and Manuscripts: Security_ (Chicago: Society of American Archivists, 1977). Also valuable is the quarterly journal of the Society of American Archivists _The American Archivist_ (v. 1– 1938–). For museums, see William A. Deiss, _Museum Archives: An Introduction_ (Chicago: Society of American Archivists, 1984); and Lawrence J. Fennelly, _Museum, Archive and Library Security_ (London: Butterworths, 1982). For an interesting article directly relating to art libraries, see Philip Pacey, "Ephemera and Art Libraries: Archive or Lucky Dip?" _Art Libraries Journal_ 5 (Autumn 1980): 26–39. For an outline of questions to ask prior to beginning a collection, see Carole Cable, "The Collection Development Policy for Architectural Archive Collections," _ARLIS/NA Newsletter_ 7 (February 1979): 16–17.

[10]On manuscript collections, see especially: Ruth B. Borodin and Robert M. Warner, _The Modern Manuscript Library_ (New York: Scarecrow Press, 1966); Kenneth Duckett, _Modern Manuscripts: A Practical Manual for their Management, Care, and Use_ (Nashville, TN: American

Association for State and Local History, 1975); Charles Hamilton, *Collecting Autographs and Manuscripts* 2nd ed. (Normal, OK: University of Oklahoma Press, 1961); Lucile M. Kane, *A Guide to the Care and Administration of Manuscripts* 2nd ed. (Nashville, TN: American Association for State and Local History, 1966).

[11]See Gracy (Note 9), p. 1.

[12]John Bidwell, "Collecting Eric Gill: Art and Typography," paper presented at the ARLIS/NA 1985 Los Angeles Conference at the Pre-conference Workshop: Rare Books for Art Libraries.

[13]*National Union Catalog of Manuscript Collections 1959/1961* (annual) (Hamden, CT: Shoe String Press, 1962–); National Historic Publications and Records Commission, *Directory of Archives and Manuscript Repositories in the United States* (Washington, DC: National Archives and Records Service, 1978).

[14]Names and locations of commercial conservation laboratories may be obtained from the American Institute for Conservation of Historic and Artistic Works, 1522 K St. N. W., Washington, DC 20005.

[15]Linda M. Matthews, "Copyright and the Duplication of Personal Papers in Archival Repositories," *Library Trends* 32 (Fall 1983): 223–40.

[16]On automation, see *Automating the Archives: Issues and Problems in Computer Applications*, edited by Lawrence J. McCrank (White Plains, NY: Published for American Society for Information Science by Knowledge Industry Publications, 1981); Michael Cook, *Archives and the Computer* (London: Butterworths, 1980); H. Thomas Hickerson, *Archives & Manuscripts; An Introduction to Automated Access* (Chicago: Society of American Archivists, 1981); William J. Maher, "Administering Archival Automation: Development of In-House Systems," *The American Archivist* 47 (Fall 1984): 405–417; Trudy Huskamp Peterson, "Archival Principles and Records of the New Technology," *The American Archivist* 47 (Fall 1984): 383–393.

[17]These include SPINDEX, developed by the National Archives and Records Service; SELGEM, developed by the Information Systems Division of the Smithsonian Institution and used for museum cataloging; and GRIPHOS, developed at the State University of New York (SUNY), Stony Brook, and marketed by the Museum Computer Network. GRIPHOS has been used at the Photographic Archive of the Yale Center for British Art and at the International Museum of Photography at the George Eastman House. Also available is MARCON, a product of Automated Information Reference Systems that has been applied in a number of university archives records centers.

[18]The literature on these works is vast, see Clive Phillpot, "Artists' Books and Book Art," in *Art Library Manual*, edited by Philip Pacey (New York: Bowker Publishing Company, 1977), pp. 355–63. *Art Documentation* 1 (December 1982): 169–78, edited by Clive Phillpot, has under the heading "An ABC of Artists' Book Collections" a number of excellent articles: William Dane's "Artists' Books," Harlan Sifford's "Artists' Books Collecting and Other Myths of Art Librarianship," Joanne Paschall's "Artists' Books—Access and Publicity," Janet Dalbert's "Acquisition of Artists' Books."

[19]Clive Phillpot, "Two Decades of Book Art," *Arts in Virginia* 23 (1982/83): 44–55.

[20]Janet Dalberto, "Collecting Artists' Books," *Drexel Library Quarterly* 19 (Summer 1983): 79–87.

[21]Anne Edgar, "Franklin Furnace," *Art Documentation* 1 (December 1982): 172–75.

[22]Write for catalogs: Art Metropole, 217 Richmond Street West, Toronto, M5V1W2, Canada; Printed Matter, 7-9 Lispenard Street, New York, NY 10013; Writers & Books, 892 South Clinton Avenue, Rochester, NY 14620.

[23]A good introduction to rare books is Roderick Cave, *Rare Book Librarianship* 2nd rev. ed. (London: Clive Bingley, 1982). For the language of the antiquarian book trade, see John Carter,

ABC for Book Collectors 5th ed., rev. (New York: Knopf, 1981). On prices, see Van Allen Bradley, *Book Collector's Handbook of Values* (New York: Putnam, 1975).

[24]J. M. Edelstein, "Catalogs: Auction, Collection, and Salon," paper delivered at the ARLIS/NA 1985 Los Angeles Conference, Pre-conference Workshop: Rare Books for Art Libraries.

[25]*American Book-Prices Current* (New York: American Book-Prices Current. v. 1– 1894/95–), an annual; and *The Bookman's Price Index* (Detroit: Gale Research, v. 1– 1964–), irregularly published.

[26]*AB Bookman's Weekly* (Newark: Antiquarian Bookman, 1948–), *Directory of American Book Specialists*, edited by R. H. Patterson (New York: Continental Publishing Co., 1974); *American Book Trade Directory* (New York: Bowker, 1915–); *Bookdealers in North America* 7th ed. (London: Sheppard Press, 1976–78); *Directory of Dealers in Secondhand and Antiquarian Books in the British Isles* 4th ed. (London: Sheppard Press, 1984); *European Book Dealers, A Directory of Secondhand and Antiquarian Books on the Continent of Europe* 4th ed. (London: Sheppard Press, 1979).

[27]On cataloging rare books, see especially Paul Shaner Dunkin, *How to Catalog a Rare Book* 2nd ed., rev. (Chicago: American Library Association, 1973). For more complex methods see the classics: Arundell Esdaile, *Esdaile's Manual of Bibliography*, rev. ed. by Roy Stokes (New York: Barnes and Noble, 1967); Fredson Bowers, *Principles of Bibliographic Description* (Princeton: Princeton University Press, 1949); Philip Gaskell, *A New Introduction to Bibliography* (New York: Oxford University Press, 1972).

[28]*AID Standard Filing System 1971 Issue* (New York: American Institute of Interior Designers, 1971).

Part III

INFORMATION SERVICES

A prime concern of art librarians, the retrieval of data takes the form of answering user's questions, disseminating information, and assisting patrons in utilizing the library. External sources of information have become an important—and increasingly demanding—aspect of the librarian's duties. Online bibliographic database searches have resulted in a greater use of interlibrary loans and in the necessity for library networking. These concerns are discussed in this section.

10

Dissemination of Information

INTRODUCTION

Basic to the art librarian's philosophy must be assisting patrons in locating the data they need. This requires that the librarian be familiar with the art resources described in Part II as well as know and understand the vocabulary of the various art disciplines plus the major styles, monuments, and artists included in art historical references. It is important for those professionals without the necessary art background to study materials that will help them obtain this expertise. This chapter discusses how librarians provide service to their clientele through (1) answering their questions, (2) aiding them in understanding the organization and use of the collection and (3) circulating materials.

REFERENCE QUERIES

One of the most important aspects of a librarian's job is the dissemination of information by answering constituents' questions. In most situations, librarians do not have time to do extensive research or to assist each patron individually for long periods of time. In order to provide uniform, consistent service, a written policy should be formulated; one which indicates the extent to which the reference staff should search for information, both for the person who inquires by telephone and for the patron who comes into the building. The policy will depend upon the kind and size of the library.[1] Some public

institutions allow a maximum of five minutes to search for the answer to a telephone query; others propose a limit of from three to five sources to be checked. In an academic situation, librarians should instruct students in methods of library use and assist them in finding materials, but must not do the research for them. In museum and business offices, the librarians may be expected to compile bibliographies for curators and associates. Computer searches of the online bibliographic databases or the files of the bibliographic utilities, which will be discussed in the next chapter, are an integral part of some libraries' reference service.[2]

Unfortunately, patrons do not always specify the exact information they want. It is only by clearly defining the question and its scope that the proper research tools can be selected. After receiving an initial request for information, the librarian must clarify the exact kind of data sought and determine the depth to which the patron wishes to dig for the answer. Without this discussion, called the reference interview or negotiation, the question may not be clearly understood, and time will be wasted researching the wrong query.[3] The reference librarian should be aware of the average user's tendency to formulate a general question when a specific one is intended. It is not unusual in a public library to hear, "I'd like to know what you have on Leonardo," when in actual fact—as brought out by question-negotiation—what is wanted is a reproduction of the *Last Supper* to take to a Sunday School class.

A query can often be made more precise by narrowing the focus or by the introduction of geographical or chronological parameters. Terminology sometimes complicates the problem since the researcher may need to translate from one vocabulary to another. For example, the term *soft sculpture*, which is used in *Art Index*, is not found in *ARTbibliograhies MODERN*, where *soft art* is the preferred phrase. Specific materials answer questions for various categories. The librarian has to decide which source is best suited to the inquiry.

Certain basic resources will be constantly used for reference questions. These materials, which were discussed at length in Chapter 4, should be accessible to the information desk from which the questions are answered. If the librarian does not know which specific research tool to consult, one of the Core Art Bibliographies described in Chapter 3 can usually be used as a lead-in to find the necessary reference data. Writing the call numbers for the books owned by the library in these Core Art Bibliographies will facilitate finding the material when it is required. If no answer to a query can be readily located, the librarian should provide the sources that were consulted, so the patron will know what references were perused. Some institutions, such as the

American Institute of Architects Library, have a specific search form to assist their clientele. As illustrated in Example 10/1, the sources that were consulted are included, as are the subject headings that were used.

The librarian's reference role centers around the ability to interpret queries in terms of the resources available. Certain forms of materials can be expected to yield various kinds of answers. One good method of learning the best resources for specific kinds of questions is to make a list of the types of common queries accompanied by the available reference works that might supply the answers.[4] Although veteran librarians have acquired this knowledge over the years, a list of this type will aid non-librarian assistants as well as novices. If there is an inadequate amount of pertinent material in a specific category, the librarian will know in which areas special purchases should be made. A few examples of kinds of recurring queries follow.

Quick References

Some queries are simple, factual ones that are relatively easy to answer. Requests for addresses or names of personnel in museums, art schools, antique dealers, or organizations can usually be answered by referring to such resource tools as *American Art Directory, International Directory of Arts, The World of Learning, The Official Museum Directory,* and *International Art & Antiques Yearbook.* Reference works that are published on a regular basis, such as these five, must be purchased frequently in order to have the latest data.

It is important to note that not all of these sources record identical information. Stocking several ostensibly similar items is usually desirable. Thus, for example, for the patron moving to Allentown, Pennsylvania, who asks if there is a museum or art gallery located there and what hours they are open, both *The Official Museums Directory* and the *American Art Directory* list the Allentown Art Museum and its hours. The former cites an additional facility—not strictly speaking a museum—the Lehigh County Historical Society. The latter includes the Muhlenberg College Center for the Arts. Each of these directories record other important information. The *American Art Directory* can also answer such inquiries as: "We are moving to North Carolina and would like to know if there are any open exhibitions in which my wife can show her paintings." *The Official Museums Directory* has an index of museums by categories, such as art, architecture, audio-visual and film, and costume. The *International Directory of Arts* and *International Art & Antiques Yearbook* report data for such location questions as where to have paintings restored.

AMERICAN INSTITUTE OF ARCHITECTS LIBRARY
SEARCH FORM

In attempting to answer your request for information, we have checked the following
sources:

APPLIED SCIENCE & TECHNOLOGY INDEX (New York, H.W. Wilson)

 years/vols._____subject headings_____

ARCHITECTURAL PERIODICALS INDEX (London, Royal Institute of British Architects)
 years_____subject headings_____

ART INDEX (New York, H.W. Wilson)

 years/vols._____subject headings_____

BOOKS IN PRINT (New York, R.R. Bowker)

 years_____subject headings_____

BUSINESS PERIODICALS INDEX (New York, H.W. Wilson)

 years/vols._____subject headings_____

ENCYCLOPEDIA OF ASSOCIATIONS (Detroit, Gale)

ENGINEERING INDEX (New York)

 years_____subject headings_____

GEODEX SYSTEM/A (Sonoma, Ca., Geodex International, 1974-1979) Ceased publication.

 nos._____subject headings_____

READER'S GUIDE TO PERIODICAL LITERATURE (New York, H.W. Wilson)
 years/vols._____subject headings_____

Example 10/1. A library search form developed by the librarians of the American Institute
of Architects.

Frequently, queries concern simple definitions of terms or identification
of artistic schools or groups. Quick, short answers are available in a number
of general and specialized dictionaries, from the five-volume *McGraw-Hill
Dictionary of Art* to the more compact *Oxford Companion to Art*. Often, it

is necessary to extend the search to more specialized sources. For example, the El Paso Spanish Artists' Association, formed in the late 1950s, is not in the above references, but can be found in the *Phaidon Dictionary of Twentieth-Century Art*.

Some kinds of questions require the art librarian to keep special lists for quick reference. What exhibition is now at the Metropolitan Museum of Art? How long will it stay there? Is there a catalog? These types of queries can only be answered by the librarian who has scanned local and national newspapers and magazines for announcements. One publication which is frequently used is *ART NOW/U.S.A.: The National Art Museum and Gallery Guide*. This monthly magazine provides a selected listing of current museum and gallery exhibitions, reporting information on more than 1100 galleries and museums. For convenience, a notebook with exhibition information can be compiled and kept up to date by the clippings from periodicals and newspapers. Other libraries have card files of certain data, such as the changes in the names of local streets to assist architectural researchers using the *Sanborn Maps* of individual cities.

Information on Artists

One of the most frequent requests is for biographical information on particular artists, architects, or designers. Many of these queries can be answered by one of the art biographical dictionaries most institutions own. During the negotiation period, the librarian must determine the exact person of whom the person is speaking. If a freshman college student asks for the full name of an artist called Greco, there is a strong probability that the person in question is El Greco, the 16th-century Spanish painter. But there are other artists named Greco. The French biographical dictionary compiled by Bénézit lists 13 with this name. The longest entry is for "Greco (Domenikos Theotokopoulos. Domenico Theocopuli, Theotocopuli dit el).'' The three variant spellings of his name precede the article "El" used in his nickname. If the patron has just attended a sculpture exhibition, the artist sought might be the 20th-century Italian Emilio Greco. During the negotiation process, the country where the person resided, the century in which he or she lived, and the primary media in which the artist worked should be learned in order to facilitate finding the correct information. The biographical dictionaries by Bénézit and Thieme-Becker provide information on little-known artists along with famous ones. Art encyclopedias, such as those published by McGraw-Hill and Praeger, both of which include El Greco and Emilio Greco, contain entries only for the most important artists.

Brief biographical information about living artists may sometimes be

obtained from the various "who's who" type books, such as *Who's Who in American Art*. If the patron desires data on an artist who is not listed in the general biographical dictionaries, other reference works will need to be consulted. For contemporary artists, these might consist of *International Directory of Exhibiting Artists, Contemporary Artists,* or *Current Biography Yearbook*. If no entry is found in one of these volumes, the lead-in tools of *Biography Index* or *Index to Artistic Biography* might help locate a reference work that will include the subject of the research.[5] In one search for information on the contemporary American artist, Marie Johnson, it was found that *Who's Who in American Art* had no entry, but *Index to Artistic Biography* provided a source which reported biographical material and indicated that she is a black artist. Although the library did not have the book—*Black Artists on Art* by Samella S. Lewis and Ruth G. Waddy—which was cited by this reference tool, enough data was provided to allow the librarian to locate a brief biography in a work the library owned, *Afro-American Artists* by Theresa D. Cederholm.

In obtaining information on artists, a wide range of materials can be searched. Patrons should consult the pertinent abstracting/indexing services—especially *RILA* and *ARTbibliographies MODERN*. Frequently, catalogs of famous libraries can be used to discover specific entries. For instance, the student who wanted to locate a 1960s article that had something to do with Raphael and elephants found no leads in either *Art Index* or *Répertoire d'art et d'archéologie* for those years. *RILA* and *ARTbibliographies MODERN* did not begin publication until after that date. Fortunately, the *Index to Art Periodicals Compiled in the Ryerson Library* of the Art Institute of Chicago revealed an article listed under the Italian artist's name for Matthias Winner's "Raffael malt einen Elefanten."

The depth and urgency of the knowledge required by the patron must be ascertained. If information is being sought on an artist in order to determine an approximate current value of a work of art which the person owns, more detailed data will be needed. Athough librarians can not provide any estimate of the value of a work of art, they can inform their users of references which may provide some guidance. This could include the patron compiling a bibliography—as well as a chronology and catalog entry—and utilizing materials throughout the library, and if time permits, from interlibrary loans.[6] If the biographical directories are not adequate, references such as the following should be consulted: (1) the library's catalog for books and catalogs owned by the institution, (2) Freitag's bibliography, (3) catalogs of holdings of famous libraries, (4) abstracting/indexing services, (5) references on artists who displayed their works in past exhibitions, and (6) books that provide data on past auctions. Although librarians can not instruct each individual in the intricacies of art research, pointing these patrons toward

books that will assist them will be rewarded tenfold, for an educated clientele may result.

Works of Art

Works of art are frequently the subject of queries. Patrons may wish to learn the monetary value of a work they own, desire a reproduction of a specific painting, or as in the case of curators, want to know as much as possible before purchasing a particular piece or including it in an exhibition. If the work is by a well-known artist, some of the latest prices in the indices of current auction sales, which were discussed in Chapter 6, can be used to discover a recent value placed on similar works.

In some communities, experts from the New York auction houses—such as Sotheby Parke Bernet and Christie's—offer verbal appraisals of items; for written ones, a fee is charged. The *Professional Appraisal Services Directory* provides an annual listing of members of the American Society of Appraisers. For information on the subject, the two-part article, "Appraising Appraisers," might be suggested.[7] In addition, the library should mention local gallery directors or museum curators who might voice an opinion on the work, although no monetary appraisal or guarantee of authenticity will be provided.

Questions frequently involve the location of reproductions of art objects. For instance, a request for an illustration of *Bunker II With Manny Mercer Up*, by Sir Alfred Munnings, proved to be easier to answer than might have been expected in view of the relative obscurity of this 20th-century, English sporting artist. The painting was located, under the artist's name, through the *Art Index*, which referred to illustrations in *Apollo* and *Country Life*. Even a rather vague request for a reproduction of such items as ivory netsukes of a monkey and a wild boar from the Tokugawa period can often be located through the *Sculpture Index*. Somewhat more complex is the problem of the patron who wants to obtain two- or three-color reproductions suitable for a dentist's office. A number of sources might be suggested, among them are: *Art Index, Art in Time, Index to Reproductions of American Paintings*, and the UNESCO catalogs of reproductions of paintings. This is an open-ended type of question which the librarian really can not answer; only guidance can be given to the patrons who then must make the decision about which references to use.[8]

Research on a work of art may require the formation of a catalog entry for that piece.[9] Care must be taken to learn the various titles under which a particular work might have been known, since the owners of art objects have the right to name and rename any works they possess. Translations of titles can also cause confusion. Accession numbers—which serve as unique

identifiers for specific objects—can also be a problem, because accession procedures may change over the years, resulting in multiple numbers for one object.

Iconographical Questions

Iconographical problems, which deal with symbolism, must be clearly defined. If the symbolism for a rose is desired, either the *Dictionary of Subjects and Symbols in Art* or *Signs and Symbols in Christian Art* might first be consulted.[10] The patron must know the relationship of the flower to objects and people represented in the work of art. As both dictionaries state, a red rose refers to the Virgin Mary, who was a rose without thorns. But if there were roses in a woman's lap, the painting probably depicts St. Elizabeth of Hungary; roses mixed with apples in a basket could represent St. Dorothea. How the symbol is used and the historical time period in which it was depicted are particularly important in iconographical questions. For instance, the Phrygian hat—the pointed, cone-like cap worn by the Persian sun-god Mithras—was placed on representations of the three Magi in early Christian art. The same hat was used as a symbol for Liberty during the French Revolution.

"I need to give a class presentation on Christ Healing the Blind. Where can I find information on the various ways this subject has been depicted over the years?" One of the best references for detailed discussions of New Testament scenes is *Iconography of Christian Art*. Volume I covers Christ's birth, childhood, baptism, temptations, and miracles; Volume II is on Christ's Passion. Unfortunately, the other two volumes of this German series—one covers the Resurrection and Ascension; the other, the Church—have yet to be translated into English. The first volume has a discussion of this biblical scene that differentiates Christ's miracles related in the Gospels of Mark and Luke from the ones recorded in John. In addition, references to the biblical verses are given, and more than 30 black-and-white illustrations are reproduced; the visual material ranges in style from early Christian to Baroque. For a more detailed research, *Lexikon der christlichen Ikonographie* and *Iconographie de l'art chrétien* can be used.

The search for interpretations of secular iconographical themes is usually more complex. Frequently, the sacred and the secular are intertwined, in which case the major Christian iconographic reference sources can be used. In addition, two good sources deal specifically with secular themes: Van Marle's *Iconographie de l'art profane* and Tervarent's *Attributs et symboles dans l'art profane*. For research on secular subjects, one must frequently turn to the monographic and journal literature on individual topics as well as to

a variety of original source materials such as mythologies and emblem books.[11]

Interdisciplinary Problems

In order to place specific works of art in context and to understand them better, references in disciplines other than art may be needed.[12] These may include works classified under such headings as literature, history, religion, philosophy, geography and travel, education, and science, Not every library or division of an institution will have a vast supply of these resource tools. In many cases, the art librarian will refer the patron either to other sections of the library or to different institutions. But regardless of the availability of the material, librarians should be able to offer a few titles of specific works, bibliographies for locating pertinent materials, or directions for continuing the search elsewhere.

Art historians will need to have materials on both art and history. The collections of university and public libraries will include a separate history section. Unfortunately, because many of these works are geared toward economic and political history, the collections are not always adequate for art historians who frequently require material on social history. "I need to locate information on how women and children were regarded in France during the time of Louis XVth and XVIth" is not an unusual request from this clientele. A list of resource tools that discuss political intrigues or economic changes will not suffice. The answer to this type of query may require books on various aspects of social history—such as James Laver's *The Age of Illusion: Manners and Morals 1750-1848, The History of Childhood* edited by Lloyd de Mause, or Warren E. Roberts' *Morality and Social Class in Eighteenth-Century French Literature and Painting.* But other types of references will also be useful, such as the costume books that illustrate and discuss clothing and the influences upon it. François Boucher's *20,000 Years of Fashion: The History of Costume and Personal Adornment* contains numerous reproductions of works of art; a glossary of terms; brief historical discussions for specific historical periods; details on fabrics, hairstyles, and accessories; and lengthy bibliographies.

Although placed outside the jurisdiction of most art departments—by being classified in the 300s by the Dewey Decimal System and the GTs in the LC Classification—fashion and costume are important for researchers who are studying works of art.[13] The art librarian may need to purchase fashion and costume books, references on gems and jewelry, and works on military and ecclesiastical attire. In addition, knowledge of some of the practical aspects of costumes may be required. "For our exhibition on the art of the Japanese

tea ceremony, I would like to have some of the volunteer guides wear Japanese kimonos. How are they worn?'' For the museum educator with this type of problem, books such as *A Step to Kimono and Kumihimo*—which has color photographs that explain step-by-step this procedure—may be necessary.

ASSISTANCE IN UTILIZING THE ENTIRE COLLECTION

Art librarians must constantly inform their constituencies concerning various aspects of their institutions to assure the full utilization of the collections. This requires an active, sometimes aggressive, campaign to assist and instruct people in finding data. Helping users to interpret the entries in the library's catalog of the collection is essential. Informative materials should be developed and new reference tools demonstrated. One effective method of disseminating information on the library's collection is through developing slide or videotape programs.[14] Although these require time, money, and expertise, they have the advantage of assisting patrons when they need the help. Remember, the more patrons learn about the library, the more independent they will become, and the more they will use it.

Idiosyncracies of the Library Catalog

With alterations in the cataloging rules, and in some institutions a change in the format of the library catalog, the art librarian must become more aware of the difficulties patrons have in utilizing this tool. If the library has several kinds of catalogs, more than one classification scheme, or has used different sets of cataloging rules, these facts should be indicated so that the patron can locate all of the material on a subject. Users may not be aware that a card catalog may have been frozen on the date the online public access catalog was begun or that the COM catalog has not been updated for six months. It is the art librarian's duty to instruct and assist the constituency in the full utilization of the library's collections. This may require that instructive signs be made and placed where the patron will be sure to see them, or it may entail more individualized assistance from the librarian.

In the various user studies which have been conducted, estimates of the failure rate of patrons searching for information in the library's catalog have ranged from 10 to 74%.[15] When a search of the catalog is difficult or unproductive, many patrons will not request assistance from the library staff. In a study of an academic library, Lyn Westbrook found this number to be as high as 40%.[16] The constituency who most frequently requested assistance was college seniors, 23% of whom sought help. But in the same

situation, none of the freshmen and only 18% of the faculty turned to the reference staff. The study also found that 41.4% of the patrons did not know who were librarians and that 16.2% were not sure where to locate them. Westbrook discovered two broad categories of obstacles—attitudes and information. Unfortunately, 17.6% of the patrons perceived the librarians as unwilling to assist them; 38.9%, that the librarians were too busy. Of the respondents, 15% believed that the librarians were either not helpful or might not be competent. The patrons' lack of knowledge about the card catalog was also a problem. For instance, about 59% believed that either most of the books owned by the library were not cited or were not sure of what the card catalog contained. And worst of all, 40% of the constituency were unsure of the extent of the librarian's knowledge of this same tool. Obviously, if the validity of Westbrook's study were to hold true for art libraries, librarians need to reconsider the reasons patrons might perceive them in this unfavorable light.

In many institutions, especially in academic and public libraries, cataloging of the material is done by a separate department, over which the art librarian has no control. The policy for organizing the works in the collection may conflict with the perception of users' needs on the part of the art librarian, who while being able to voice objections, may have no influence over the resulting policy. Because the catalog department personnel determine what entries will be included and the way in which they will be cited, each system has its own idiosyncracies. The quality of the catalog system determines, to a great extent, how useful the collection will be to patrons. Items that are not listed or that are entered in a confusing manner cannot be readily found.

Some of the problems are concerned with (1) the methods of classifying and filing special materials, (2) the rules that catalogers follow, (3) the lack of cross references, and (4) the absence of analytical cataloging. Certain materials within a library's collection are under-used, because patrons do not know of their existence or how to utilize them. The material in vertical files, archives, and microforms is often difficult, if not impossible, to locate in many catalog systems. Librarians must make a special effort to make patrons aware of these valuable resources, which were discussed in Chapter 9.

Catalog entries are subject to the rules that are followed in cataloging the material. Unless the library has been recently established, the catalog may embody several different sets of rules and, perhaps, more than one classification scheme. With AACR2, the formation of certain entries was altered. Librarians who adopted the revised code had to decide how the patron could be made aware of these changes. To reorganize all of the records into one unified system was more costly than some institutions could afford. Unfortunately, often not enough cross references were added to inform the patron of these modifications.

In catalog entries for artists, the rule now states that the most frequently used form of a name in English is to be the one employed. For instance, Paolo Cagliari, called Veronese, is filed under "Veronese." Tiziano Vecelli is cited under the anglicized "Titian." The catalog rules enter a book that contains mainly reproductions of an artist's *œuvre* under the name of the artist as the author or creator. This is difficult for many patrons who do not consider the words *artist* and *author* to be synonymous. In a divided catalog, the entries that are listed in the author-title file are usually not repeated in the subject section. Unless reminded of these peculiarities, the patron will not know the full extent of the library's collection.

One major source of difficulty for art library patrons involves entries for catalogs of museum collections or exhibitions. These materials may be entered under title, a personal name, or that of a corporate body. As with artists' names, museums are entered under the most commonly used form of their names. For instance, the former entry, "Harvard University. Busch-Reisinger Museum of Germanic Culture," is now "Busch-Reisinger Museum." A description of selected works from the gallery's collections entitled *Art Treasures of the Rijksmuseum*, with a text by B. Haak and published by Abrams, is entered under Haak. But a work entitled *All the Paintings of the Rijksmuseum in Amsterdam* written by members of the Department of Paintings of the Rijksmuseum and published by the museum is entered under the museum's name. The distinction to the cataloger hinges not only upon authorship responsibility, but upon emanation, that is, by whom it is issued. It is unlikely that even the sophisticated user will comprehend the differences and will find these two entries for ostensibly similar works puzzling. Yet, provisions for additional access points would ensure that the records can be located easily.

The LC subject headings can often cause problems for patrons. For instance, chronological subdivisions are not consistently handled, which results in a a mixing of periods and styles. Thus, LC assigns a term "Art, Victorian," which is a style, but also "Art, Modern - 19th century - Great Britain," which is a time period. Geographical subdivision is achieved in two ways: "Art, French" and "Art - France." That the first refers to art produced by Frenchmen and the second to art that is situated in France but that may have been produced by Americans is a distinction that probably escapes many researchers. And how is a neophyte to distinguish between the LC subject headings, "Humans in art" and "Human beings in art?" LC's scope note explains that the latter is used for works on techniques depicting the human body; the former for works on the representation of humans in art, but it is doubtful that users read scope notes.

Often a patron must have a firm grasp of art history in order to complete a successful search, knowledge that not everyone possesses. For instance,

if a work of art is permanently located, there is no subject heading for the artist. If it is movable, the heading is the artist's name, followed by the title of the work.[17] While this treatment may make some sense in the case of objects like bridges—although even they have been known to be peripatetic, witness the so-called London Bridge now in Arizona—it is hardly defensible in the case of altarpieces. There is the anomoly of a subject entry for the Isenheim Altar as a title subheading under the artist Mathias Grünewald, but the altar of Nicholas of Verdun has a sole subject entry as "Stift Klosterneuberg. Verduner Altar." The difference relates to location, as the Isenheim Altar is no longer *in situ* but at the Musée Unterderlinden, Colmar, France. But how many art patrons can, or should be expected, to make the distinction? Nor is LC consistent. *The Adoration of the Mystic Lamb Altarpiece*, still in St. Bavo's Cathedral in Ghent, is entered as a title subheading under the names of both artists—Jan and Hubert Van Eyck. Furthermore, titles of works of art are by no means static and are often subject to change. Clearly sometimes the only search strategy is to try anything and everything.

In principle the cataloging code is trying to achieve maximum consistency, but unfortunately, even if a rule is consistently applied, it may conflict with the client's expectation or common usage. For instance, patrons may have no trouble finding the Metropolitan Museum of Art. But if they look for the Benaki Museum in Athens—a well-established English form of the name—it turns out that it is entered under its transliterated form, Mouseion Mpenaki. The dilemma, of course, can be rectified by judicious and generous use of cross references and careful attention to the authority files, which can be a tedious and expensive process. Since the widespread adoption of AACR2, the advent of computerization, and the increase in interlibrary cooperation, more attention is being paid to authority files.[18] The Art and Architecture Theraurus Project, discussed in Chapter 13, is one result of this concern.

No individual book can be analyzed in order to provide all of the access points that patrons may consider using. And yet, it is the analytical cataloging that was done at the Museum of Modern Art which makes the *Catalog of the Library of the Museum of Modern Art* so valuable to scholars. Art librarians frequently provide some form of analytical cataloging for their clientele, especially for works issued in a series, such as the *Pelican History of Art Series*, which may have entries for the authors, titles, and subjects of each work as well as for the series title. Although many librarians include entries for the individual titles of a recognized series, unfortunately, they usually do not provide access to books when several of them are published in a single volume. Nevertheless, this can be of the utmost value to patrons. For example, *Modern Art in Paris 1855 to 1900* consists of 47 volumes which contain reprints of exhibition catalogs. The volume *Exhibitions of Later Realist*

Art has eight exhibition catalogs concerned with the works of six artists: Jules Bastien-Lepage, Eva Gonzales, S. Lepine, J. de Nittis, Alfred Stevens, and J. J. Tissot. Yet in the LC record, the only artist used as a subject access is Alfred Stevens. The art librarian should devise some method by which patrons can gain access to the other artists. Ideally, additional subject entries could be made. If restricted as to what material is included in the library's catalog, the art librarian should locate a source which has analyzed the entries of the series or keep the publisher's publicity brochure for reference.

Developing Guides and Bibliographies

Guides to the library are often developed to assist patrons (1) in searching for references on specific subjects, (2) in locating and using special sections or materials of the institution, and (3) in looking for visual material. At the University of Houston, there are numerous four-page Library Guides—such as the one seen in Example 10/2, which shows the first page of the *Library Guide: Architecture*. This hand-out pamphlet describes the holdings and location of the university's collection of architectural resource tools and includes material on how to discover reference works on individual architects, major buildings, technical materials, cost estimates, historical styles, energy, as well as codes and standards. This is specific information on a particular subject which will assist students in using the library on their own.

Although libraries usually have a printout or record of their complete serial holdings, some academic institutions have a special art-serial guide that contains (1) a listing of the art-related indices and abstracts with their locations in the institutions and (2) a listing of the art and art-related serials—many of which have classification numbers and are shelved as monographs—with notations as to the volume holdings, the placement in the library, and the specific indices and abstracts that cover each periodical. This type of guide allows researchers to know immediately whether or not a specific volume is available in the library or must be obtained through an interlibrary loan. The guide can also be used by the librarian for evaluating serial holdings. Example 10/3 provides sample pages.

In some universities, art librarians have devised browsing guides for students, such as the one illustrated in Example 10/4. These sheets may provide (1) a list of the most popular periodicals in the field, (2) the LC or Dewey Decimal numbers that cover the subject, (3) the titles of some of the important references which the students might find useful to examine, and (4) any special reference tools available for that subject. Both handed out in classes and available at the library, a browsing guide is especially helpful to studio artists and designers. Any patron interested in a particular art discipline will also enjoy these browsing materials. Similar guides developed in public libraries are often called path-finders.

Library Guide

University Libraries
Central Campus

ARCHITECTURE

The University of Houston Libraries contain a wealth of information in the field of architecture. A large percentage of the materials is housed in the Franzheim Architecture Library, Room 3, Architecture Building. Anyone with a valid University of Houston ID card is eligible for borrowing privileges. With over 12,000 books and 120 journal titles in the areas of historical and current architecture, landscape architecture and urban design, this branch library can provide answers to a wide variety of questions. However, the successful practice of architecture is becoming increasingly dependent upon information produced for subject areas outside the traditionally defined field of architecture. Technical research on alternative energy resources, psychological studies on the influence of the built environment on different groups and reports dealing with the political aspects of urban planning are examples of the kind of resources that may be important to students and architects, but that may not be located in the Architecture Library. Some of the frequently asked questions dealing with architecture are answered below. Most can be answered with the resources of the Architecture Library alone; but for a few, a trip to the main library is essential. If you have difficulty finding or using these materials, or if you need more specific information, do not hesitate to consult with the library staff.

I. HOW CAN I FIND INFORMATION ON A SPECIFIC ARCHITECT?
 If the library owns a book that deals entirely with the work of one architect, it will be listed in the card catalog under the name of the architect or the firm with which he or she is associated. (For example, Philip Johnson is listed in the J's under Johnson, Philip, but Kevin Roche is in the K's under Kevin Roche & Associates.) If you cannot find your architect in the card catalog, you can then move on to biographical dictionaries, bibliographies and indexes to journals.

 Journal indexes will key you into the information published in architectural and design journals on both contemporary and historical architects. You should probably start with the <u>Art Index,</u> but the library also owns the <u>Avery Index to Architectural Periodicals,</u> the <u>Architectural Periodicals Index,</u> published by the Royal Institute of British Architects, and the <u>Architectural Index.</u> All of these are located on the index table in the center of the reading area. Look under the name of the architect or firm to find a list of articles, including essential information like title of the journal, volume number and pages. The two exceptions to this are the <u>Architectural Index,</u> where all architects are listed in a section under "Architect or Designer," and the <u>Architectural Periodicals Index,</u> where they are listed under the term "Architects." Each index covers a different group of journals and a different time period, so if you strike out on one, try another.

Example 10/2. First page of "Library Guide: Architecture," developed by Margaret Culbertson, Art and Architecture Librarian of the University of Houston-University Park.

ART INDICES AND ART PERIODICALS
IN THE NTSU LIBRARY

This guide to reference material in the NTSU library is divided into two
lists: (1) indices to periodical literature concerned with art and (2) art
and art-related magazines which are currently held by the NTSU library. The
former list cites the name of the index to periodical literature accompanied
by its abbreviation as used in this guide, its call number or location in the
library placed in parentheses, plus the year and volume with which the sub-
scription of the index commenced at NTSU. All references with the Z class-
ification (unless otherwise noted) are located in the Bib Area (Bibliographic
Area) on the main floor of the library. A&I Area indicates that the material
is located in the Abstract and Index Area on that particular floor of the
library. A&I, SL signifies that the material is in the Abstract and Index
Area in the Science Library (Information Sciences Building).
 The second list, which cites the art and art-related magazines held
by the NTSU library, gives the location number placed in parentheses before
the title of the magazine. Following the magazine title are any previous
(or continuing) titles the magazine may have, the holdings of the magazine
at the NTSU library, and an abbreviation for the indices of periodical
literature that index articles from that magazine.

INDICES OF PERIODICAL LITERATURE
and their abbreviations

Antiq	Antiques: Cumulative Index to Volumes I-LX, 1922-1951, (shelved before the bound volumes of Antiques, Lower Level), One volume.
Arch I	Architecture Index, (Z5941.A66), (1951)+
ARTbib M	ARTbibliographies Modern, (Z5935.L641), vol. 1(1969)+
Art Bul	Art Bulletin: An Index to Volumes I-XXX, 1913-1948, (shelved be-fore the bound volumes of Art Bulletin, Lower Level), One volume.
ADP	Art Design Photo, (Z5935.A7), vol. 1(1972)+
AI	Art Index, (A&I Area, Lower Level), vol. 1(1929)+
Avery	Avery Index to Architectural Periodicals, Columbia University, (A&I Area, Lower Level), 15 vols. plus 6 supplements.
Biog I	Biography Index: A Cumulative Index to Biographical Material in Books and Magazines, (Z5301.B5), vol. 1(1946-49)+
BRD	Book Review Digest, (Z1219.C96), (1905)+
BHI	British Humanities Index, (A&I Area, Lower Level), vol. 1(1962)+

Example 10/3. Excerpts from "Art Indices and Art Periodicals in the NTSU Library,"
compiled by Johnnye Louise Cope and Lois Swan Jones.

Some librarians formulate special bibliographies for their patrons. The
professional staff at the American Institute of Architects (AIA) in
Washington, D.C., have compiled almost 300 different bibliographies of
articles and recently published books. Available to the membership for a small

On the lower level of the NTSU Library are the magazines with A, B-BD, BH-BX, and N, classifications. The second floor houses the periodicals with C, D, E, F, G, and H classifications; the third floor: J, K, L, U, and V, classifications, and the first floor: P, and some Z. All the BF, Q, R, S, and T classes are located in the Science Library and the majority of the Z periodicals are found in the Library Science Library (LSL). Both the Science Library and the Library Science Library are found in the Information Science Building. All microform copies are located in Room 437 of the main library (Special Collections). // indicates that a publication has ceased.

(N)	AI. Art Insight (supersedes: Southwestern Art), no. 1(1979)//
(NA)	A.I.A. Journal (Journal of the American Institute of Architects), vol. 8(1947)+ AI, Arch I, Biog I
(Z)	ARLIS/NA Newsletter, vol. 1(1972)+ (shelved in LSL)
(LB)	A.V. Communication Review, vol. 1(1953)+ CIJE, Film LI
(AP)	Abitare, no. 42(1966)+ AI
(TP)	Adhesives Age, vol. 11(1968)+ EngI, CA
(N)	Advertising Techniques, vol. 1(1965)+
(NX)	African Arts/Arts d'Afrique, vol. 3(1970)+ AI
(N)	American Art Journal, vol. 1(1969)+ AI, ARTbiblio M, RILA, Rép
(N)	American Art Review, vol. 1(1973)+ AI
(N)	American Artist (continues: Art Instruction), vol. 3(1939)+ AI, ARTbiblio M, RG, Biog I
(TR)	American Cinematographer, vol. 54(1973)+ AI
(N)	American Craft (continues: Craft Horizons), vol. 39, no. 3(1979)+ AI, ARTbiblio M, RG, Film LI
(TS)	American Fabrics and Fashion (continues: American Fabrics), vol. 1(1946)+ AI
(NA)	American Institute of Planners. Journal. (continued by: American Planning Association. Journal of the American Planning Association), vol. 1-44(1935-78)
(NA)	American Institute of Planners. News.(continued by: American Planning Association. APA News), vol. 4-13(1969-78)
(CC)	American Journal of Archaeology, n.s. vol. 52-55,69(1948-51, 65)+ AI, HI
(NA)	American Planning Association. APA News (formed by the union of AIP News and TAB), vol. 14(1979)+
(NA)	American Planning Association. Journal of the American Planning Association (continues: American Institute of Planners. Journal), vol. 45(1979)+ AI
(N)	Amsterdam Rijks-Museum. Bulletin Rijks-Museum. Bulletin Mauritshuis, vol. 19(1971)+
(AM)	Antiques, vol. 1(1922)+ Antiq, AI, RG
(CC)	Antiquity: A Quarterly Review of Archaeology, vol. 39, no. 153(1965)+ Biog I, AI, BHI, HI, Rép
(TR)	Aperture, vol. 17(1972)+ AI
(NX)	Apollo, vol. 51(1950)+ AI, BHI, ARTbiblio M, ADP, RILA, Biog I, Rép
(DF10.J8)	Archaeological Reports, no. 1(1965/66)+ BHI, Rép
(CC)	Archaeology: A Magazine Dealing with the Antiquity of the World, vol. 1(1948)+ AI, Biog I, HI

fee to cover photocopying and mailing, these bibliographies cover 17 major subjects, such as architectural practice, commercial facilities, energy, plus the history and styles of architecture. In addition, the AIA librarians index articles from important magazines, because either the abstracting/indexing services are too slow or the serials are not covered. About 70 periodicals of this library's 450 active subscriptions are indexed on a regular basis.

To keep their users informed of current publications, some librarians

A BROWSING GUIDE FOR INTERIOR DESIGNERS

North Texas State University

MAGAZINES, the following have numerous color illustrations of how successful
 designers have developed and expressed the styles of their time and the
 desires of their clients. The N's and M's are located at the Lower Level;
 the TS's are in the Science Library.

ABITARE (AP)	INDUSTRIAL DESIGN (NK)
ARCHITECTURAL DIGEST (N)	INTERIOR DESIGN (NK)
CONNOISSEUR (AM)	INTERIORS (NK)
CONTRACT (TS)	(continues Contract Interiors)
DESIGN. London. (NK)	MAGAZINE ANTIQUES (AM)
DESIGN QUARTERLY (NK)	(continues Antiques).
DOMUS (NA)	

BOOKS in the following classifications will have illustrations of both interior
 architectural design and interior decoration:

NA 2815's through NA 3070's (especially NA 2850 - NA 2851)

NA 5000; NK 1700 - NK 3505; and 747's and 749's in the Dewey Decimal
 Section, Lower Level.

The following non-circulating books have numerous illustrations:

AMERICAN INTERIORS: ARCHITECTURAL DIGEST PRESENTS A DECADE OF IMAGINATIVE
RESIDENTIAL DESIGN, 1978. (NK 2004 .A7 1978)
 Illustrates thirty-five outstanding interior designs.

ENCYCLOPEDIA OF FURNITURE by Joseph Aronson, 1965. (NK 2205 .A7 1965)
 Photographs and line drawings of architectural features and furniture of all
 types and periods.

HISTORIC HOUSES RESTORED AND PRESERVED by Marian Page, 1976. (NA 7328 .P22)
 Elizabethan England and Colonial America; Palladian England and Federal America;
 Regency England and Grecian America; and the Romantic Era. Photographs of
 characteristic or outstanding features together with floor plans, some with
 dimensions. Especially rich in photographs of architectural features.

HOUSE AND GARDEN GUIDE TO INTERIOR DECORATION, 1967. (NK 2115 .H535)
 Illustrates use of space, color and pattern, stylistic problems, and other
 problems such as halls and staircases.

MODERN INTERIORS, 1969. (NK 2115 .M322)
 European interiors employing contemporary furniture, ornament, and color combinations.

NEW YORK TIMES BOOK OF INTERIOR DESIGN AND DECORATION edited by N. Skurka,
1976. (NK 2004 .S57)
 A variety of interiors accompanied by brief explanatory notes.

INTERIOR DESIGN PRODUCT FILE - Lower Level Humanities Desk

 A collection of publicity brochures and distributors' catalogues of
 manufacturing firms which sell materials such as furniture, draperies,
 wall coverings, floor coverings; many photographs of the products.

Example 10/4. "A Browsing Guide for Interior Designers," compiled by Johnnye Louise
Cope for the library of North Texas State University.

regularly photocopy the table of contents of serials from a list compiled by
interested parties and circulate the data to specific clientele. This encourages
these patrons to utilize the library facilities and to be aware of recent
publications. This Selective Dissemination of Information (SDI) service is

often an important duty of the business librarian, but this type of project is also used in academic and museum libraries. In some institutions, the user selects desired articles and the librarian supplies the full text.

Bibliographic Instruction, Demonstrations, and Symposia

At many academic institutions, librarians provide formal instruction for students.[19] This can be a separate, semester-length course in art bibliography or a one-class introduction to art-research tools. At some universities, the librarian conducts a brief session which introduces the collection to incoming faculty and graduate teaching fellows. If such classes or sessions do not exist, and the need is there, the art librarian should actively solicit the assistance of members of the art department in order to provide bibliographic instruction for students.

University courses on bibliographic instruction may be taught either as separate classes or in combination with historiography, in which case they may be team taught by the art librarian and an art historian. It is possible that librarians and professors may have different approaches to teaching students to use bibliographic resources.[20] There is ample evidence that scholars work from footnotes and bibliographies from their personal files and contacts in their field.[21] They tend not to use the library's painstakingly constructed access tools. Librarians must recognize that many bibliographic references are garnered in this fashion.

Students should be made aware that knowledge of access tools alone will not help them evaluate the quality of the information to which those tools have led them. Perhaps one aspect of research which would assist students the most is to learn various means for determining which authors are the experts in a given field. It is important to remember the warnings of Daniel J. Boorstin, The Librarian of Congress, about the distinction between knowledge and information.[22] As he said at the 1980 White House Conference, providing rapid, up-to-date information should not be the major emphasis of libraries, for although computers have made it possible to retrieve quickly the latest data, researchers still need scholarly in-depth, resource materials of all kinds.

Regardless of the extent of the bibliographic course, clear, well-thought-out goals and lesson plans must be devised before they can be implemented.[23] If there is no class on bibliographic instruction—and the likelihood of developing one, remote—the librarian should make every effort to encourage individual professors to plan for at least one period to be spent at the library in order for the students to obtain bibliographic instruction which is especially tailored to that particular course. For instance, in a Northern Renaissance Art History course, specific saints who are frequently

depicted in art were studied. The goal was to introduce the students to the hagiographical research tools at the same time they were studying the reasons these saints were popular in the art of this period. Example 10/5 illustrates the assignment. Because each person had a different saint, the students could help each other in locating pertinent data.[24]

Bibliographic instruction is often provided in an academic setting. But other art librarians need to consider providing this type of education. Although obviously on a different level, bibliographic instruction is important for museum docents and for special audiences of public libraries, such as patrons interested in buying or selling art. Librarians should not be complacent concerning the instructional needs of their constituency. Attending the workshops which the ARLIS/NA conventions sometimes have on bibliographic instruction will enable art librarians to discuss their specific problems with other professionals.

Museum librarians may wish to collaborate with education directors in planning symposia that either include lectures on some form of bibliographic instruction or provide hand-out sheets containing bibliographic data. At one museum a series of one-day symposia was planned around the theme—Fact Finding: Discovering Information on Works of Art. Using a three-lecture format, each symposium was on a specific type of work of art, the title changing appropriately with the medium discussed. The possibilities are many—prints, paintings, sculpture, photographs, films, textiles, or ceramics. By discussing various types of research and resource tools, the museum library's function was highlighted. Similar programs would be appropriate for public libraries.

As new materials and services are added, librarians need to publicize their existence. Usually libraries have a special shelf where important recent acquisitions are displayed. Demonstrations of new materials can provide patrons with needed expertise. This is especially true of database searches, which are discussed in the next chapter. But demonstrations can also be planned to illustrate such complicated research tools as the *Arts and Humanities Citation Index*. If a special period is set aside to illustrate the use of a recent addition, the librarian should check to be sure that the specific hours are the best time of day for the greatest number of people. Frequently, several demonstrations on various days need to be arranged.

CIRCULATION CONTROL

In addition to reference, circulation is one of the primary public services of the library. Those art librarians whose collections are within a main academic or public library building may be only peripherally concerned with circulation, although their advice may be sought on formulation of policy.

HAGIOGRAPHICAL RESEARCH
Dr. Lois Jones

Each student will choose one of the saints listed below. Since no two students may have the same saint, your choice must be cleared with the professor. Read Chapter 6 in Art Research Methods and Resources. Answer the following questions and submit a typed report using the same outline format: (due November 3)

1. All name variations; list the ones in Réau
2. Probable dates and nationality
3. Synopsis of life, footnote any discrepencies you discover
4. Date, if known, of canonization and feast day
5. Attributions, how can you distinguish this saint in art?
6. Patron saint or favorite saint of what country, city, area
7. Invoked for what reasons (such as illness, sudden death, etc.)
8. Describe at least two typical scenes in which the saint is portrayed and list at least four famous works of art which portray each scene. For each work of art, state artist's name, medium, probable date, and if possible, the location.
9. If any relics of the saint still exist, list the kind of relic and where the relics are located (i.e., the skull at Notre Dame, Paris)
10. Was the saint cited in the Roman Martyrology? Quote the entry and give the page numbers of the reference. Is the saint still listed?
11. Has this saint been popular in any special period of art history? Why was the saint popular?
12. Include a bibliography of specific books and articles on the saint. Be sure to check RILA, Art Index, and the bibliographies of the reference works you consult.

The following sources will assist you in your search: (some are on reserve; others are non-circulating)

Attwater, Dictionary of Saints (BX 4655, 8, A99)
Baring-Gould, Lives of the Saints (BX 4655, B3, vol. 1-15)
Bles, How to Distinguish the Saints (755, B617)
Butler's Lives of the Saints (BX 4654, B8, vol. 1-4)
Coulson, Saints (BX 4655, S28)
Didron, Christian Iconography (N7832, D4913, vol. 1 & 2)
Drake, Saints and Their Emblems (N8080, D7)
Ferguson, Signs & Symbols in Christian Art (N7830, F37)
Hall, Signs & Symbols in Christian Art (N7830, F37, C3)
Holweck, Biographical Dictionary of the Saints (BX 4655, H6)
James, Montague. Apocryphal New Testament (229, B471aj)
Jameson, Sacred and Legendary Art (755, J23, vol 1 & 2)
Kaftal, Saints in Italian Art (N8080, K25, limited access)
New Catholic Encyclopedia (BX 841, N44, 1967, vol. 1-16)
Réau, Iconographie de l'art Chrétien (N7830, R37, vol. 1-3) in 6 books
Roman Martyrology, edition by J. B. O'Connell (BX 2014, R4, 1962)
Voragine, Jacobus de, Golden Legend (244, J159, vol. 1-7 and BX 4654, J334)

SAINTS

Sebastian	Anthony of Abbot	Mary Magdalen
Nicholas of Barri	Stephen	Barbara
Ursula	Peter	John the Baptist
Francis of Assisi	George	Veronica

Example 10/5. A hagiographical research problem.

Academic art librarians whose libraries are separately housed may have to adhere to the policies set by the parent institution; they will also be responsible for overseeing their own circulation staff. Art school, museum, and business librarians will have to formulate policies as well as supervise circulation personnel. Generally, museum libraries are non-circulating, although exceptions are frequently made for curatorial staff.

Basically, the circulation department is concerned with: (1) charging material out to patrons, (2) discharging it upon return, (3) returning it to its proper location, and (4) keeping a variety of records and statistical data. The records should indicate such things as: (1) who has borrowed a given item, (2) what items are overdue, (3) when were they due, (4) who has overdue materials charged out, and (5) what has been lost and what should be withdrawn from the collection. The librarian must determine the kind of statistical information desired, such as how many items have circulated during a specific time period. Circulation statistics have been extensively employed to provide data for user studies. Policies need to be established for such things as length of loan periods, renewals, and fines.

In addition, the circulation staff often has other duties, ranging from checking the condition of the items returned—to see if they need repair, rebinding, or replacing—to overseeing the library's security system. This can be particularly important in the case of art books, which are often candidates for mutilation due to their extensive illustrative matter. Circulation personnel may have to assess fines, make change for photocopy machines, reshelve material, and undertake shelf reading (the process of systematically checking the shelves to see that the materials are in correct order). The circulation desk is often the chief point of contact which patrons have with the library. The service and treatment they receive greatly influence their impression of the library as a whole. Every attempt should be made to make it a favorable one.

Librarians were quick to adopt automated systems to handle the repetitive record keeping that circulation entails.[25] Many of these systems are flexible and allow the librarian to define policies for different categories of materials and patrons. These systems can compute fines, generate overdue and recall notices, as well as accommodate reserves and renewals. Statistical data are vital by-products of automated systems.

Early automated circulation systems relied only upon a brief machine-readable record for transactions; now the full MARC record is preferred. This permits enhancement and expansion of the system. Conversion of files from manual to machine-readable records is the starting point for many small libraries desiring automated circulation. Larger institutions may already have a base of machine-readable records.

NOTES

[1]For a lengthy discussion of reference services policy statements, including statements concerning online searches of bibliographic databases, see *Reference and Online Services Handbook: Guidelines, Policies, and Procedures for Libraries,* edited by Bill Katz and Anne Clifford (New York: Neal-Schuman Publishers, Inc., 1982); and Diana M. Thomas, Ann T. Hinckley, Elizabeth R. Eisenbach, *The Effective Reference Librarian* (New York: Academic Press, 1981).

[2]Darryl Barrett, "Computer as a Supplement to Reference Searching," *ARLIS/NA Newsletter* 9 (December 1981): 241–42.

[3]Gerald Johoda, Braunagel Johoda, and Judith Schiek, *The Librarian and Reference Queries* (New York: Academic Press, 1979).

[4]William J. Dane, "Networking and an Art Library," *Drexel Library Quarterly* 19 (Summer 1983): 56–65. Dane lists six categories: individual artists/specific works of art; art objects, antiques, collectibles; art bibliography/methodology; art professions/trades; visual materials; and inter-disciplinary themes.

[5]For a list of 259 directories of artists who lived in the United States and Canada, see "Artist Directories and Catalogs: State, Province, Area, and Local—A Selected Bibliography," *ARLIS/NA Newsletter* 9 (Summer 1981): 145–53.

[6]Jones details this methodology.

[7]Lee Rosenbaum, "Appraising Appraisers," *ARTnews* 82 (November and December 1983).

[8]For sources for reproduction of works of art, see Jones, pp. 203–15; for a discussion of their use, pp. 62–63.

[9]Jones details this methodology; see "Chapter 4: Research on Individual Works of Art," pp. 85–106.

[10]Ibid, for methodology, pp. 92–104; for list of references, pp. 223–32.

[11]See Sarah Scott Gibson, "Humanist and Secular Iconography, 16th to 18th Centuries, Bibliographic Sources: A Preliminary Bibliography," *Special Libraries* 72 (July 1981): 249–60.

[12]For a discussion of non-art references, see Jones, pp. 104–06, 112–113; for examples, pp. 184–86.

[13]Arntzen/Rainwater, Jones, and Ehresmann *A&DA* list costume references.

[14]See Milicent Palmer, "Creating Slide-Tape Library Instruction: The Librarian's Role," *Drexel Library Quarterly* 8 (July 1972): 251–67; Jerrold Kemp, *Planning and Producing Instructional Media* 5th ed. (New York: Harper & Row, 1984).

[15]There are many catalog use studies, some now regarded as classics. See, for example, Sidney Louis Jackson, *Catalog Use Study: Director's Report* (Chicago: American Library Association, 1958); Ben-Ami Lipetz, "Catalog Use in a Large Research Library," *Library Quarterly* 42 (January 1972): 129–39; and T. Saracevic, W. M. Shaw, and P. B. Kantor, "Causes and Dynamics of User Frustration in an Academic Library," *College & Research Libraries* 38 (January 1977): 7–18.

[16]Lyn Westbrook, "Catalog Failure and Reference Service: A Preliminary Study," *RQ* 24 (Fall 1984): 82–90. Westbrook used a questionnaire format to study the University of Chicago's Regenstein Library during the summer, 1981.

[17]"Subject Headings for Individual Works of Art, Architecture and Analogous Artifacts and Structures," *ARLIS/NA Newsletter* 9 (December 1980): 7–11.

[18]On authority files—the records of personal and corporate names, series and subjects in the form established by the library, and the list of references made to them—see *Authority Control: The Key to Tomorrow's Library: Proceedings of the 1979 Library and Information Technology Association Institute*, edited by Mary Ghikas (Phoenix, AZ: Oryx Pres, 1982).

[19]See Betty Jo Irvine, "Bibliographic Instruction for Graduate Art History Students," *Art*

Libraries Journal 3 (Autumn 1978): 28, 33–34; Evelyn Samuel, "Art Bibliography on Slides," *ARLIS/NA Newsletter* 6 (May 1978): 47; and Carole Cable, "The Object, the Signal, the Information," *Research Strategies* 2 (Spring 1984): 60–64.

[20]Stephen K. Stoan, "Research and Library Skills: An Analysis and Interpretation," *College & Research Libraries* 45 (March 1984): 99–109. Stoan also points out that scholars do not believe that most library indexing schemes are either comprehensible or reliable.

[21]For a major study for information-seeking habits of scholars, see *Information Requirements of Researchers in the Social Sciences* (Bath, England: Bath University of Technology, 1971), 2 volumes. See also Stieg's and other user studies which were discussed in Chapter 3.

[22]"Remarks by Daniel J. Boorstin, The Librarian of Congress at White House Conference on Library and Information Sciences," *Journal of Information Science* 2 (September 1980): 111–13.

[23]John MacGregor and Raymond G. McInnis, "Integrating Classroom Instruction and Library Research," *Journal of Higher Education* 48 (January/February 1977): 17–38. Although not on art, the following article discusses instructional methods by which the classes are course-related, demonstrated, and gradated: James R. Kennedy, Jr., Thomas G. Kirk, and Gwendolyn A. Weaver, "Course-Related Library Instruction: A Case Study of the English and Biology Departments at Earlham College," *Drexel Library Quarterly* 7 (July-October 1971): 277–97. For a collection of articles on how to conduct seminars, workshops, and educational programs, see American Society of Association Executives, *Education Programs* (Washington, DC: American Societey of Assocation Executives Publications); available at 1575 Eye Street, N. W., Washington, DC 20005.

[24]This was an assignment given in an undergraduate course. The Art History professor devised the problem, but the art librarian presented the library references.

[25]See Richard W. Boss and Judy McQueen, "Automated Circulation Control Systems," *Library Technology Reports* 18 (March-April 1982): 125–266. Also see, Leo H. Settler, Jr., "Retrospective Conversion: Getting Started," *Journal of Library Administration* 5 (Spring 1984): 7–9.

11

External Sources
of Information

INTRODUCTION

Technological developments have improved library service by greatly extending access to the world's storehouse of information. More and more frequently, librarians are called upon to mediate between the information-seeking patron and the vast amount of art data, much of which is—or will be in the future—electronically stored. The potential for better service is enormous; the librarian must ever strive toward full realization of that potential. Two of the main methods by which librarians obtain information from external sources for their patrons are through (1) online bibliographic database searches and (2) the use of interlibrary loans and networking.

ONLINE BIBLIOGRAPHIC DATABASES

Due to their speed, currency, and flexibility of search strategy, online bibliographic databases have become an essential part of art research. Curators and art historians require data on past exhibitions as well as current information on artists and works of art. Locating sales catalogs through *SCIPIO* may be necessary for curators, dealers, and collectors. Educators have access to a vast store of knowledge through the *ERIC Database*. Studio artists may want the latest results on the use of recently developed chemicals

or new combinations of various components. Architects need references to engineering problems created by the latest building materials as well as government specifications and regulations. In addition, because a review of the literature is an important aspect of any thesis or dissertation, academic art librarians must frequently advise students who are beginning this phase of their studies.

For their patrons, some libraries provide free access either to one of the bibliographic utilities—such as OCLC or RLIN—or to a commercial vendor, such as DIALOG or BRS. Other institutions charge for these services, which were discussed in Chapter 2. The tremendous variation in policies results from the size, wealth, and philosophy of the institutions. Basic to the decision is the issue of whether or not online computer searching is considered just another information tool or a separate library service.

An online policy manual should be written to assist librarians in day-to-day operations. In her article, Mary Pensyl provides some excellent guidelines for writing such a policy, starting with establishing the purpose, goals, and mission of the online reference facility.[1] Some important procedural matters which need to be delineated are: (1) why it is needed, (2) who will use it, (3) what criteria should be used in deciding which queries should be searched, (4) if it will be autonomous or integrated with the reference service, (5) when it will be available, (6) to what extent a search should be made, (7) if there should be a charge, and (8) if so, what the charge should be. Although these questions, among others, should be considered prior to instituting online bibliographic searches, the availability of such a service should be an integral part of all art libraries.

How many and which vendors a library will use depends on the clientele to be served. Since each vendor has slightly different ways of conducting a search, it can be confusing for the database librarian to shift constantly from one set of computer commands to another. But with the proliferation of personal computers, patrons may do their own searches through one specific vendor and expect the library to provide access to the others. The trend may be towards ultilizing more vendors, rather than fewer.

There are several software packages which will assist database searchers by translating online searching commands into those used in the files of such vendors as DIALOG, BRS, or ORBIT. As Henry Pisciotta explains in "Database Searching with Gateway Software," these software packages can help minimize problems caused by searching various database systems: (1) fewer commands will need to be memorized, (2) more flexibility will be allowed in editing and eliminating irrelevant citations, and (3) costs can be reduced. Pisciotta's article evaluates some of these software packages.[2]

Familiarity with the various online databases and the subjects they cover—as illustrated in Example 11/5 at the end of this chapter–is essential for all

art librarians. Even if the art librarian is not responsible for the actual search, knowledge of the ways these investigations are conducted must be obtained in order to help patrons in the initial formation of their research plans. Although in large libraries there are usually specially trained personnel to assist researchers, in some institutions—such as museum and business libraries —the librarian may conduct the search. This section provides information on (1) searching online bibliographic databases, and (2) assisting patrons in utilizing these computer files.

Conducting the Search

Most database searches are made online, which means the investigator is in direct communication with the computer. This allows the researcher to interact with the computer and thus, direct the investigation more closely. In order to communicate with most online bibliographic databases, Boolean logic must be used.[3] This is the method of formulating a search statement by using certain terms—AND, OR, and NOT—in an algebraic-type equation. For example, if a project is concerned with Romanesque symbolism, the search statement might be *symbolism AND (Romanesque OR medieval)*. The *OR* indicates that either of the terms which are in parentheses is acceptable. The *AND* signifies that *symbolism* must be associated with one of the words in the second grouping.

One of the greatest assets of a computer search is being able to find material in which two or more ideas or subjects are related. The search statement can be limited by the addition of the term *NOT*. For example, *symbolism AND (Romanesque OR medieval) NOT Gothic* is a request to exclude any citations which contain the word *Gothic*. The term *NOT* must be used with discretion. For instance, in the above search, an article entitled "Medieval Symbolism Prior to the Gothic Period," would be excluded, and yet this article would probably be pertinent to the study. Remember *OR* expands a search; *NOT* limits it; *AND* is a linking operator which also limits.

In the above search, citations which have the word *iconography* instead of *symbolism* would not be located by the computer. In order to obtain all relevant citations, the search statement must include synonyms which might have been used by the authors or the database indexers. In this case, the statement might read—*(iconography OR symbolism) AND (Romanesque OR medieval)*.

There are other methods of improving the search. Truncation of a word allows the computer to locate any terms derived from a specific root. For instance, *symbol?*, in which the truncated command *?* is used, would allow the computer to choose symbol, symbols, or symbolism. To indicate that two words must be used together a *(w)* is placed between them. *Middle (w) Ages* means that *Middle* must immediately precede the word *Ages*. A *(wl)*

allows up to one word to be placed between two words. For example, *book (wl) hours*, dictates this order and permits the inclusion of one word—such as *of*—between *book* and *hours*. These are the search procedures used in the DIALOG system.

Although vendors have standardized the search methods for the databases that they market, these search methods vary from vendor to vendor. Thus DIALOG uses a *?* for truncation, while BRS has a *$*. In the former system a *(w)*, for *with*, between two words signifies that the terms must be next to each other in that specific order. BRS uses *ADJ*, for *adjacent*. Each vendor usually provides extensive documentation that specifies the intricacies of searching its databases. In addition, there may be special manuals for specific databases. Sometimes librarians need to obtain additional advice from the personnel of the vending company. The quality of the instruction manuals and the helpfulness of the vendor's staff frequently influence the preferences of the database-search librarian for one company over another.

Each computer file can be searched by various strategies. Example 11/1 provides an illustration of the options in the DIALOG system. For *Art Literature International (RILA) Database*, the Basic Index includes words from the abstracts, descriptors, identifiers, subject headings, and titles, all of which indicate the subject of the document. Each of these fields can be searched separately, or all of them can be utilized in a free-text search. The reason that the publishers and authors are excluded from a free-text search is that these two fields would increase the amount of irrelevant material found. For example, if these fields were included in a free-text search of *Viking AND (Medieval OR Middle (w) Ages)*, the computer would discover any works written by an author named Medieval which were published by Viking Press. Other search options are also available. For the *Art Literature International (RILA) Database*, these include such items as author, type of document, title of serial, name of exhibition sponsor, year of exhibition, publisher, name of series, and name of reviewer. In addition, the search can be limited in this specific database to English or non-English languages. In DIALOG, each database has its own special Basic Index plus additional indices and limiting suffixes.

In an actual online search for material on Romanesque iconography—*(iconography OR symbol?) AND (Romanesque OR medieval OR Middle (w) Age?)*—from *Dissertation Abstracts Online*, the command was given for a free-text search, which for this particular file included descriptors and titles. In *Dissertation Abstracts Online*, through DIALOG, the files date from 1861 and contain more than 872,500 entries. The database had 107 references in which the word iconography was included; 1472 for symbol?; 99 for Romanesque; 2620 for medieval; and 315 for Middle (w) Age?. As the numbers indicate, the broader term, *medieval*, has more entries than the

narrower term, *Romanesque. Symbol?* and *medieval* were used more often in titles and as descriptors for dissertations and theses than were the other three terms: *iconography, Romanesque,* or *Middle Ages.* For the combination of all five terms, there were 32 references. Not all of these listings were relevant to the topic. Because the computer picks up each entry with the combination of the given terms, what will be included in the list depends upon how the title and descriptors are composed. One dissertation was entitled *The Public Figure: Political Iconography in Medieval Mesopotamia.* Since both the words *iconography* and *medieval* were present, the citation was included. This search took about ten minutes; the computer cost was under $10.

Once a search strategy is formulated for one database, this methodology can be temporarily saved to be used for another database controlled by the same vendor. DIALOG provides access to both the *Dissertation Abstracts Online* and *MLA Bibliography Database*; the former is the computer form of several University Microfilms International printed publications— *Dissertation Abstracts International, American Doctoral Dissertations, Comprehensive Dissertation Index,* and *Masters Abstracts*—the latter corresponds to *Modern Language Association International Bibliography.* To save time and money, the search strategy was reserved and utilized in the *MLA Database.* This computer file, which contains more than 578,500 records, has entries dating from 1970. The five terms were well represented in the database—221 entries for *iconography*; 6285 for *symbol?*; 265 for *Romanesque*; 13,089 for *medieval*; and 297 for *Middle Ages.* There were 222 entries that had some combination of these words. To narrow the search, the computer was asked how many entries contained the word *Fr?nc?,* which can refer to France or French. When the investigation was limited, there were only four entries. The search and printing of these few citations required 6.7 minutes for a computer-time cost of under $5.

One of the advantages of computer searches is the expand concept, whereby an author, artist, or concept can be displayed with the terms which have been indexed that have similar spellings. For instance, in a search to locate the correct spelling of a contemporary artist, the computer was asked for an expansion on the name "Fisher, V." Two terms or names that preceded this one plus nine which followed it were listed accompanied by the number of citations there were for each item cited. Thus, the computer can assist patrons in finding correct names and terms as well as learning which have the most citations.

In order to save time and money by shortening the time actually spent online, librarians need to be familiar with various types of search strategy. For instance, in checking for a dissertation on the dance motif in Bruegel's works, both methods of spelling Bruegel were used with */TI* and */DE*—to indicate the painter's name had to be in the title or the descriptors—

FILE 191 ART LITERATURE INTERNATIONAL (RILA)
 DIALOG FILE 191

SAMPLE RECORD DIALOG Accession Number

```
       ┌000134   → 9 7826  (1983)
AN=──────Textiles by William Morris and Morris & Co., 1861-1940 ←────────────/TI
EX=──────→Exhibition shown:  Birmingham, GBR, City Museum and Art Gallery, 13 Mar-3
         May 1981 ←──────────────────────────────────────────────────────────LY=
         ┌Contributor(s):  By Oliver FAIRCLOUGH and Emmeline LEARY;  introd. by
CN=──────┤ Barbara MORRIS
         117 p.  88 illustrations, 24 color; bibliography; index; 171 works shown ←────NT=
BN=──────→ISBN 0-500-27225-5   Price: L5.50
LA=──────→Language(s): In English
DT=──────→Document Type: exhibition catalogue
```

```
          An account of the various branches of Morris and Company's textile
              productions--embroideries, printed fabrics, woven fabrics, carpets and
              tapestries. Discusses the dyes used, techniques, sales, and fabric
              types. An introductory essay provides a wider context for the history    ←──/AB
              of Morris & Co., including the involvement of Pre-Raphaelite designers,
              such as Burne-Jones. (Staff, RILA, UK)
          Descriptors: Birmingham (GBR), City Museum and Art Gallery; Morris,
              William, British artist, author, 1834-1896--exhibitions-- textiles;
              Morris and Co., Ltd., design firm (London, GBR)--textiles; textiles,
              British--Morris and Co.; Burne-Jones, Edward, British painter,          ←──/DE
              1833-1898--and Morris and Co.; media and techniques, textiles--Great
              Britain--Morris and Co.; Pre-Raphaelitism--and Morris and Co.;
              embroidery, British--Morris and Co.; rugs, British--Morris and Co.;
              tapestry, British--Morris and Co.
          Section Heading(s): 79--NEO-CLASSICISM AND MODERN ART--artists,
              architects, photographers; 97--COLLECTIONS AND EXHIBITIONS--exhibition   ←──/SH
              list; 78--NEO-CLASSICISM AND MODERN ART--decorative arts
         ┌Subject Nationality: British
/ID──→   │ Subject Period: 1834-1896
         └Subject Style, Medium, Form: tapestry; textiles
```

SEARCH RECORD

BASIC INDEX

SUFFIX.	FIELD NAME	INDEXING	SELECT EXAMPLES
/AB	Abstract[1]	Word	S WOVEN(W)FABRICS/AB
/DE	Descriptor[2]	Word & Phrase	S MEDIA(1W)TECHNIQUE?/DE
			S MORRIS, WILLIAM?/DE
/ID	Identifier[3]	Word & Phrase	S BRITISH/ID
			S 1834-1896/ID
/SH	Section Heading and Code	Word & Phrase	S MODERN(W)ART/SH
			S NEO-CLASSICISM/SH
			S 78/SH
/TI	Title	Word	S WILLIAM(W)MORRIS/TI

.If no suffix is specified **all** Basic Index fields are searched. [2]Also /DF.
[1]Abstracts present for over half of the records. [3]Also /IF.

ADDITIONAL INDEXES

PREFIX	FIELD NAME	INDEXING	SELECT EXAMPLES
AA=	Author Affiliation	Word	S AA=(BROWN(W)UNIV?)
AN=	RILA Number (Main)	Phrase	S AN=9 7826
AU=	Author	Phrase	S AU=LYON, DANNY?
BN=	International Standard Book Number (ISBN)	Phrase	S BN=0500272255
CN=	Contributor	Word	S CN=(OLIVER(W)FAIRCLOUGH)
CS=	Degree-Granting Institution	Phrase	S CS=EMORY UNIVERSITY
DN=	Dissertation Number	Word	S DN=DA8116179
DT=	Document Type	Phrase	S DT=EXHIBITION CATALOGUE
DY=	Year Degree Granted	Word	S DY=1983
EX=	Exhibition Sponsor and Location	Word	S EX=(CITY(W)MUSEUM)
			S EX=BIRMINGHAM
EY=	Exhibition Year	Word	S EY=1981
JN=	Journal Title	Phrase	S JN=ARTWEEK
LA=	Language	Word	S LA=ITALIAN
LC=	Library of Congress Card Number	Phrase	S LC=82-90609
NT=	Notes	Word	S NT=ILLUSTRATIONS
PU=	Publisher Name and Location	Word	S PU=ABRAMS
			S PU=BARCELONA
PY=	Publication Year	Word	S PY=1983
RA=	Reviewer Affiliation	Word	S RA=(UNIV?(1W)YORK)
RE=	Reviewer Name	Phrase	S RE=ALBRIGHT, THOMAS
RN=	RILA Number (Book Reviews)	Phrase	S RN=9 8787
RY=	Publication Year (Book Reviews)	Word	S RY=1983
SE=	Series	Word	S SE=(STEDELIJK(W)MUSEUM)
SL=	Summary Language	Word	S SL=FRENCH
UD=	Update	Phrase	S UD=8501

LIMITING

Sets and terms may be limited by Basic Index suffixes, i.e., /AB, /DE, /DF, /ID, /IF, /SH, and /TI (e.g., S S5/TI), as well as by the features listed below:

SUFFIX	FIELD NAME	EXAMPLES
None	Publication Year	SELECT S4/1983
/ENG	English Language	SELECT S3/ENG
/NONENG	Non-English Language	SELECT S3/NONENG

SORTING

SORTABLE FIELDS	EXAMPLES
Online (SORT) and offline (PRINT). AU, JN, PY, RY, TI.	SORT 4/ALL/AU PRINT 5/5/1-50/JN

FORMAT OPTIONS

NUMBER	RECORD CONTENT	NUMBER	RECORD CONTENT
Format 1	DIALOG Accession Number	Format 5	Full Record[1]
Format 2	Full Record except Abstract	Format 6	Title and DIALOG Accession Number
Format 3	Bibliographic Citation	Format 7	Bibliographic Citation and Abstract[1]
Format 4	Full Record[1] with Tagged Fields	Format 8	Title and Indexing

DIRECT RECORD ACCESS

FIELD NAME	EXAMPLES		
DIALOG Accession Number	TYPE 002312/5	DISPLAY 003415/3	PRINT 000459/7

191-2 (October 1985)

Example 11/1. Verso of a DIALOG Blue Sheet for *Art Literature International (RILA)*
Database, a bibliographic service of the J. Paul Getty Museum Art History Information Program
of the J. Paul Getty Trust.

```
File  35:DISSERTATION ABSTRACTS ONLINE 1861 TO JULY 85
(Copr XEROX Corp)

      Set   Items  Description
      ---   -----  -----------
?SS (BRUEGEL OR BRUEGHEL)/TI,DE AND DANC?
      S1      1    BRUEGEL/TI,DE
      S2      2    BRUEGHEL/TI,DE
      S3    908    DANC?
      S4      1    (BRUEGEL OR BRUEGHEL)/TI,DE AND DANC?
?T/5/

 4/5/1
598717   ORDER NO: AAD77-19889
  THE DANCE IN THE ART OF PIETER BRUEGEL THE ELDER..  288 PAGES
  MAJZELS, CLAUDINE  (PH.D.  1977  UNIVERSITY OF PENNSYLVANIA).
  PAGE 1075  IN VOLUME 38/03-A OF DISSERTATION ABSTRACTS INTERNATIONAL.
  FINE ARTS
  DESCRIPTOR CODES: 0357
  INSTITUTION CODE: 0175
?LOGOFF
```

Example 11/2. Results of a search for the dance motif in Bruegel's works using both spelling variants of Bruegel's name. The search was made using *Dissertation Abstracts Online* through DIALOG (service mark registered, U.S. Patent and Trademark Office). From University Microfilms International and DIALOG Information Services, Inc.

accompanied by *DANC?* In searching *Dissertation Abstracts Online*, only one pertinent reference was discovered, as Example 11/2 illustrates. In this case, it was faster to type both name variants than to ask for an expansion of the artist's name.

Assisting Patrons in Utilizing Databases

Before being able to assist their constituents with computer searches, librarians must be aware of the assets and liabilities of the various databases.[4] Example 11/5 at the end of this chapter is a chart of art and art-related databases arranged by principal subjects covered. The chart lists (1) specific databases plus the names of any hard-copy equivalents placed in parentheses; (2) the names of the vendors; (3) the dates of the earliest records which the files contain; (4) the number of entries in the files as of July 1985; (5) the frequency with which the files are updated; (6) the types of data available—abstract, bibliographic citation, or full text of the articles; and (7) the kinds of materials or historical periods covered.

The dates the files cover is especially important, because if information published prior to this date is also needed, the researcher must either search the printed abstracts or indices which are not part of the database or discover other means for locating the required material. In Example 11/5, there are two entries for *COMPENDEX Database*, a file that is the equivalent of the

printed volumes of *Engineering Index*. The database from DIALOG has computer tapes dating from 1970, the one from BRS, since 1976. These databases are obviously not the same size.

The number of records in a database can be a surprise to the patron. The variation is tremendous, from more than 2 million citations in such files as *REMARC* to under 10,000 in the *Ontario Education Resources Information Database*. Some databases are updated daily—such as INFOBANK—others, only periodically. Usually databases are updated with a greater frequency than the printed versions can be sent to a library and placed on a shelf ready for use. This is one of the greatest assets of database searches—their currency of information.

The databases that provide abstracts—such as *ARTbibliographies MODERN* and *Art Literatature International (RILA)*—are especially helpful in aiding researchers in determining which references might be essential to their study. Full-text databases, such as *The New York Times*, are important if the material can not be located by other means. These databases are more expensive, not only per hour online but in the time required for the computer to type the article completely.

Knowing the serials and types of subjects covered by a database is needed for a productive online search. If the database corresponds to a printed volume, such as the *Art Literature International (RILA) Database*, this data can be gleaned by consulting the hard-copy publication. But for the databases which do not have printed equivalents—such as *Magazine Index Database*—this information must be obtained by contacting the producer. Because a computer file can change dramatically, when the producer purchases additional tapes and loads the material into the database, the librarian must not only obtain the latest information, but keep it current.

Art historians should be reminded that such databases as *Art Literature International (RILA), ARTbibliographies MODERN,* and *Repertory of Art and Archeology* only provide citations for material indexed since the 1970s. The files of *Art Index Database* date from only October 1984. For early works, other methods—usually manual checking of printed copies—must be used to obtain pertinent material. In addition, the historic periods covered by the databases must be considered: *ARTbibliographies MODERN* only includes references on art of the 19th and 20th centuries; *Art Literature International (RILA)*, art since the 4th century; and *Repertory of Art and Archaeology*, art of the paleo-Christian era to 1939. For instance, none of these databases covers classical Greek art, although *Art Index Database* does. Researchers must clearly understand the liabilities of each database.

Because the tighter and more refined the search statement, the quicker and more profitable the search, consideration must be given to any thesaurus which might be available. Some database producers have published either

a thesaurus or a list of subject headings that will provide the researcher with an idea of the terms which were preferred by the computer indexers. For instance, *Thesaurus of ERIC Descriptors* will assist users of the *ERIC Database*; *RILA Subject Headings* will assist users of the *Art Literature International (RILA) Database*. These should be used prior to the search.

Once a database is searched, the pertinent citations must be obtained. A computer search is sometimes useless unless the material which is listed in the printout can be located so the patron can read it. If the library or an institution in the area has the past issues of *The New York Times*, the citations provided by *INFOBANK*, the database which includes *The New York Times* through NEXIS, become more relevant. If the newspaper is not available, the patron should consider using *The New York Times Database*, also through NEXIS, which can provide the full text of all articles.

Most researchers will need assistance in formulating their search statements and in choosing the specific databases best for their studies.[5] In order to assist them in these decisions, librarians should (1) provide search request forms which patrons are to complete, (2) interview requesters as to their needs and expectations, (3) aid in the formulation of search strategies, (4) help in the selection of appropriate databases, (5) conduct the searches, and (6) evaluate the results.[6] One of the primary reasons for using search-request forms is to encourage patrons to think of relevant subject terms and, if possible, of pertinent bibliographic citations. Librarians can scan these citations for descriptors which can be used to retrieve other references. In addition, request forms provide documentation of the formats of the searches, information on the charges, and data which can be used for future statistical analysis.

If a general database-search form has not been developed, the librarian should compile one. Example 11/3 is an online database-search strategy worksheet wihich is used by the professor of the Art Bibliography/Historiography class at North Texas State University (NTSU). Because the course is concerned with the methodology of research, each student is asked to state the problem of the study as well as to answer certain questions concerning it. This strategy worksheet is completed before students arrive at the NTSU Library for a search. Example 11/4 is the database-search form developed by the NTSU database-search librarians. The start and stop time, in the top right-hand corner, refers to the interview period between student and librarian. The statement which the students sign is used, because, in the past, some students naively thought that they only had to pay for relevant citations. The questions on the form have allowed the NTSU librarians to generate statistics which can be used in evaluating this computer service.

In order to assist students in bibliographic computer searches, librarians

should have available for their perusal folders that contain specific material on each database: (1) the data provided in Example 11/5 at the end of this chapter, (2) a list of the various serials covered by each database, (3) any manual which is written specifically on that file, and (4) any thesaurus or list of subject headings which would aid the researcher. For students who have never conducted an online search, the librarian might recommend that the student read the first part of this chapter. Brief instructions on using Boolean logic plus a questionnaire, such as the ones in Examples 11/3 and 11/4, may help the researcher pinpoint the needed material. In addition to assisting individual students and scholars in database searching, librarians should provide special workshops and demonstrations for their constituency. These could range from beginning introduction in computer usage to lectures on refining the computer search. The more researchers understand about database searches, the more they will use them.

INTERLIBRARY LOANS AND NETWORKING

The end result of an online database search may be that the information desired can be obtained from a given source, but one that is not available in the art library. The patron should then be offered the option of an interlibrary loan (ILL).[7] Vital to the operation of this cooperative system is the correct identification or verification of the source wanted and its location.[8] Most libraries use a standard form and adhere to the regulations of the *Interlibrary Loan Codes, 1980*.[9]

There is a great deal of cooperation among art libraries, although some will not lend certain types of materials. On the other hand, sometimes photocopies or microforms of restricted materials will be provided, subject to the provisions of the copyright laws as well as the fees levied for service and copying. Some libraries also impose restrictions on types of users; for instance, undergraduate students may be excluded. The lending library may set the length of the loan period and may request that the item not leave the premises of the borrowing institution. It is the responsibility of the requesting library to see that any restrictions, such as in-library use, are honored as well as to observe the loan period and to return materials promptly and well packed to prevent damage.

The Interlibrary Loan Policies Directory is a useful and practical guide to various libraries' policies.[10] There is no point in asking for a hard copy of a dissertation from a library if its policy is not to lend this type of study. There are a number of items which are seldom lent: multi-volume reference works, rare books, encyclopedias, dictionaries, theses, dissertations, manuscripts, current periodicals, nonprint materials, folios, and catalogues

```
┌─────────────────────────────────────────────────────────────────┐
│                      Online Database                            │
│                  Search Strategy Worksheet                      │
│                                                                 │
│                                                                 │
│   1. State the problem of your study:                           │
│                                                                 │
│                                                                 │
│                                                                 │
│   2. Try to put the subject to be searched in a statement       │
│   using mostly nouns. (Use as few words as possible, 3 or       │
│   less)                                                         │
│                                                                 │
│                                                                 │
│   3. What synonyms can be used for these words:                 │
│                                                                 │
│      Word          Synonyms                                     │
│                                                                 │
│   a.                                                           │
│                                                                 │
│   b.                                                           │
│                                                                 │
│   c.                                                           │
│                                                                 │
│                                                                 │
│   3. Utilizing Boolean logic, try to put the subject of this    │
│   search in an algebric-type statement.  (If you have never     │
│   used Boolean logic, ask the librarian for a copy of           │
│   Searching an Online Bibliographic Database.)                  │
│                                                                 │
│                                                                 │
│                                                                 │
│                                                                 │
│   4. Do you have the title of an article or book which covers   │
│   the subject you are searching? _____yes _____no If yes,      │
│   what is the title, author, and publication data?              │
│                                                                 │
│                                                                 │
│   5. Name 3 or more magazines, journals, or newspapers which    │
│   are most likely to publish the information you are seeking:    │
│                                                                 │
│   a.                                                           │
│                                                                 │
│   b.                                                           │
│                                                                 │
│   c.                                                           │
│                                                                 │
│   d.                                                           │
│                                                                 │
└─────────────────────────────────────────────────────────────────┘
```

Example 11/3. An online database-search strategy worksheet used for an Art Bibliography/Historiography class.

6. What time span needs to be covered? Material published
 ___within the past year only, ___within the past 5 years,
 ___within the past 10 years, ___any time, past and current

7. Methods of searching: ___free-text, ___title, ___author,
 ___descriptor (major), ____ Other, specify:

8. About how many citations do you expect to obtain?

9. Methods for limiting the search: ____publication year,
 ___publisher, ___journal name, ___document type (i.e.,
 book, exhibition catalog, article), ___honored person
 (for Festschriften), ___language, please specify:
 ____all, ___English only, ___English plus:_____
 Other means for limiting:

10. If too few citations are found, do you wish to broaden
the search? ___no, ___yes. If yes, how should this be done?

11. Do you need ____abstracts, if available,
 ____bibliographic citations, ____full-text articles.

12. Do you want the citations printed ___online, ___offline.

Name _____ Date_____
Use of search: ___thesis/dissertation, ___class paper,
 ___term paper, ___professional research, ____other

NORTH TEXAS STATE UNIVERSITY LIBRARIES

DATE	NAME/NAME & DEPARTMENT	ID#/ACCOUNT#	Rele-vancy	Dates cov-ered	Costs	Off-line prints	Format	No Search	START TIME	STOP TIME

LEVEL/POSITION		OFFLINE PRINTS		SEARCH STRATEGY

NTSU	NON-NTSU	number date rec'd

O Undergraduate	O Student
O Master's	O Faculty/staff
O Doctoral	O Public
O Faculty/staff	

NAME OF CLASS

LOG ON TIME	LOG OFF TIME	TIME USED	FILE	COST PER DATABASE

CIRCLE ONE:	CIRCLE ONE:	TOTAL DATABASE
DIALOG		SERVICE CHARGE
DOW JONES	CASH	
BRS		TOTAL CHARGE
WILSON	ACCOUNT	
OTHER		

SEARCHER:	DATE PAID	AMT PAID	RECEIPT #

I hereby request the NTSU Libraries to perform a computer lit-
erature search and agree to pay for this search. I realize that
the Libraries cannot guarantee that all references of interest
will be retrieved or that those which are retrieved will be
highly relevant. I further understand that the information I
provide will be an important factor to the search. The time-
liness, accuracy, and completeness of the databases are beyond
the control of the Libraries.

Signature

Example 11/4. An online database-search worksheet, developed by the online database librarians at North Texas State University, Denton, Texas.

raisonnés. The time involved in securing materials varies greatly depending upon how long it takes for the request to be verified, submitted, transmitted, and located at the lending library. Increasing costs and the fact that large art libraries are called upon to provide most of the loans have led many of these institutions to impose service fees.

It is absolutely essential that an accurate bibliographic description of the needed item be secured. Forms are usually supplied to users who are asked to indicate not only bibliographic data, but the source from which this information was obtained. Because users vary in their ability to complete this task, it is necessary to verify the information they supply. Rechecking will also confirm that the material is not in the home library. The basic printed locating tools are union catalogs or lists that indicate which libraries have what items. The primary ones are the *Union List of Serials in Libraries of the United States and Canada* and *New Serial Titles* for serials and the Library of Congress *National Union Catalogs* for monographs. There are also various regional and local union catalogs. The names of holding libraries are indicated by means of alphabetic codes; translations of the codes appear in each volume.

Some union lists are available through machine-readable databases, the most notable of which are OCLC, RLIN, UTLAS, and WLN. In the OCLC ILL system, for example, after the librarian verifies the titles requested at the terminal, the location codes for the holding libraries in the region are also provided. If no library in the region owns the item, the system will expand the search beyond the local area until it is found. The item can then be requested via the terminal. After receiving the request, the lending library will respond with a message indicating the terms of availability. Clearly such an online system expedites loans far beyond the capabilities of the more conventional methods of the mail service or teletype-writer. Even if the art library, which has access to the bibliographic utility, does not participate in the ILL system, the verification process is accelerated. If one has established a working relationship with certain libraries, it is also possible to telephone requests. These should be followed by the appropriate ILL form so that the lending library may keep its records in order.

It is important to remember that, as good as the automated systems are, there are certain limitations. For instance, older materials may not have been entered into the computer and for imprints that date prior to the late 1960s, it may also be necessary to check the *National Union Catalogs* or regional lists as well. On the other hand, in a search for *Rosso Fiorentino* by Evelina Borea published in 1965, OCLC quickly revealed ten locations for this edition and one for a Spanish translation. Without the computer database, a search to verify material would take considerably longer. The *National Union Catalogs* have no listing for the Borea book. It is, however, cited in the *Library*

Catalog of the Metropolitan Museum of Art. With the exception of data on the requesting institution, OCLC does not yet give holdings information for serials in terms of what volumes and years are held. The *Union List of Serials* and *New Serial Titles* may need to be used for that information.

Another limitation is that imposed by the copyright law in its provisions regarding photocopying, which is a large part of many interlibrary loans.[11] The law allows "fair use." Guidelines for this concept have been developed by the national Commission on New Technological Uses of Copyrighted Works (CONTU).[12] A library may make: (1) copies of up to five articles in a single periodical published within the last five years, (2) copies of up to five small excerpts from longer publications, (3) copies of unpublished works for purposes of preservation and security, (4) copies of published works for purposes of replacement of damaged copies, and (5) copies of out-of-print works that cannot be obtained at a fair price. If more copies are being made than those allowed, the serial subscriptions may need to be revised.

Due to the rising costs of all materials, some libraries have banded together to form cooperative units.[13] The largest cooperative loan venture in the United States is the Center for Research Libraries in Chicago. Founded in 1949 by ten universities, it now has more than 100 members and over 3 million volumes which it makes available to its members and associate members. Originally conceived as a storehouse for rarely used materials, freeing shelf space for its members, this consortium also buys little-used serials and books to augment its collection and to save members the cost of buying items that will seldom be needed. Finally, it operates as an interlibrary loan center which lends materials to its members.

Some regions, such as the New York State Interlibrary Loan Network, have highly developed and efficient regional networks for interlibrary loans. Others, such as the AMIGOS Bibliographic Council, Inc., provide a network for libraries over a greater geographical area. The more than 200 AMIGOS members consist of state, school, medical, academic, museum, and corporate libraries in Mexico and seven U.S. states—Arizona, Arkansas, Kansas, Louisiana, New Mexico, Oklahoma, and Texas. It was in 1974 that the first institution used the AMIGOS system, which started as a shared cataloging system with OCLC. AMIGOS provides numerous services: interlibrary loan assistance, resource sharing via OCLC, training and consulting, tape extraction, COM catalogs, computerized reference service, retrospective conversion, and current cataloging. The non-profit corporation has membership meetings, technical sessions, various training series, and two publications—a quarterly, *Que Pasa?*, and a monthly technical newsletter, *Bits and Tidbits.*

The AMIGOS member libraries utilize the OCLC ILL System for the majority of their interlibrary loan transactions. The *Guidelines for Use with*

the AMIGOS Interlibrary Loan Code, a booklet which describes the protocol for the member libraries, suggests free photocopying of up to 50 pages for other AMIGOS members. By using the OCLC Union List Component of the Serials Control Subsystem, three union lists that provide individual holdings have been created: Arkansas Union List of Serials, Association for Higher Education of North Texas Union List of Serials, and Oklahoma Union List of Serials. Another aid for AMIGOS members is the Name-Address Directory which provides the ILL policy statements for each participating library.

In addition to highly structured systems, there are libraries within a community or region which have non-binding agreements. This informal networking system may involve purchases—especially of expensive items. The librarians may also agree on specific subjects which will be the special province of their institutions. This does not mean that the other librarians do not purchase at all in an area designated for someone else, but that at least one area librarian will purchase the key works on the topic. An example of local networking is the cooperation between the Amon Carter Museum and the Kimbell Art Museum of Fort Worth, Texas. The Association of Research Libraries (ARL) is involved in a similar cooperative effort on a much larger scale.[14]

Example 11/5
Databases and Their Primary Subjects

Subjects and databases (hard-copy title)	Vendors	Date of earliest record	Number of entries July 1985	Updated	Type of text[a]	Coverage of files
ARCHITECTURE/DESIGN						
On-Line Avery Index to Architectural Periodicals	RLIN/Class	1980+	19,640	Daily	Cit	Architectural design and history; over 500 serials
ART, GENERAL						
Art and Archeology (Art et archéologie: Proche-Orient, Asie, Amérique)	QUESTEL-Francis-H, Chapter 526	1972+	26,000	Quarterly	Abst	Near Eastern, Far Eastern, & Pre-Columbian art & archaeology
Art Index Database (Art Index)	WILSONLINE	Oct. 1984+	17,000	Twice/wk	Cit	Coverage from ancient Greece to contemporary
Art Literature International (RILA)	DIALOG-File 191	1973+	81,000	Semi-annual	Abst	Art since 4th century. Exhibition catalogs, serials, Festschriften
ARTbibliographies MODERN Database (ARTbibliographies MODERN)	DIALOG-File 56	1974+	83,400	Semi-annual	Abst	1800 to present, exhibition catalogs, serials
Arts & Humanities Search (Arts & Humanities Citation Index)	BRS	1980+	595,000	Biweekly	Cit	Citations concerning work by artists and authors, from about 7000 periodicals
Repertory of Art and Archaeology (Répertoire d'art et d'archéologie)	QUESTEL Francis-H, Chapter 530	1973+	150,000	Quarterly	Abst	Art from paleo-Christian era to 1939; exhibition catalogs, serials, Festschriften
ART/SALES						
ArtQuest (Art Sales Index)	Art Sales Index/Ltd.	Oct. 1970+ Sculpture added 1983+	600,000	9-10 times/yr	Cit	Worldwide auctions of paintings, drawings, sculpture; some 80,000 artists

Name	Source	Coverage	Records	Frequency	Type	Description
SCIPIO	RLIN/CLASS	1599+	47,000	Daily	Cit	Title-page data on auction catalogs owned by five museums
BIOGRAPHY						
Biography Master Index (*Biography & Geneology Master Index*, 2nd ed.)	DIALOG- Files 287 (A-M) & 288 (N-Z)	1980+	2,361,000 names	Periodic	Cit	Index to data in 375 references; nearly 2 million persons
Biography Index Database (*Biography Index*)	WILSONLINE	July 1984+	14,000	Twice/wk	Cit	Scans 2600 serials & collective biographies
BOOK REVIEW						
Book Review Index Database (*Book Review Index*)	DIALOG- File 137	1969+	1,383,000	3 times/yr	Cit	Reviews in 380 journals
CURRENT INFORMATION						
INFO BANK	NEXIS	1969+	2,360,000	Daily	Abst	120 different publications—*New York Times, Washington Post, Los Angeles Times, Time, Newsweek, Wall Street Journal, Advertising Age, Women's Wear Daily*
National Newspaper Index	DIALOG- File 111	1979+	1,003,000	Monthly	Cit	Covers *New York Times, Christian Science Monitor, & Wall Street Journal;* added 1982—*Los Angeles Times & Washington Post*

[a]Types of text are abstracts (abst), citations (cit), and full-text articles (full).

(continued)

Subjects and databases (hard-copy title)	Vendors	Date of earliest record	Number of entries July 1985	Updated	Type of text[a]	Coverage of files
New York Times	NEXIS	1980+	427,000	Daily	Full	All data in this newspaper including magazine sections
Newsearch	DIALOG-File 211	Current month only	varies: 1,200-54,000	Daily	Cit	Indexes material from over 1700 serials
NDEX	ORBIT	1976+	almost 2 million	Monthly	Cit	Covers U.S. newspapers from Los Angeles, Chicago, Detroit, Denver, Washington, D.C., Houston, Atlanta
DISSERTATIONS						
Dissertation Abstracts Online (Dissertation Abstracts International & Masters Abstracts)	DIALOG-File 35	1861+	872,500	Monthly	Cit; abst 1980+	99% of all U.S. dissertations, selectively Canadian & European ones; includes some master's theses since 1962
Dissertation Abstracts International (Dissertation Abstracts International)	BRS	1861+	872,500	Monthly	Cit; abst 1981+	Same as above
EDUCATION						
ERIC Database (Resources in Education & Current Index to Journals in Education)	DIALOG-File 1, BRS, ORBIT	1966+	561,500	Monthly	Abst	Covers education reports & 700 serials
Ontario Education Resources Information	BRS	1972+	8,500	Quarterly	Cit	A Canadian version of *ERIC*

					Type of text[a]	
ENCYCLOPEDIAS						
Academic American Encyclopedia	BRS	1983 edition	30,000 articles	Quarterly	Full	Multitude of subjects; includes bibliographic citations for subjects
Encyclopedia Britannica 3	NEXIS	1982 edition+	180,000 articles	Annual	Full	Printed version plus current yearbooks
ENGINEERING						
COMPENDEX (Engineering Index)	DIALOG-File 8, ORBIT	1970+	1,415,000	Monthly	Abst	Covers 3500 serials & conference reports
COMPENDEX	BRS	1976+	980,000	Monthly	Abst	See above entry
EIMET	ORBIT	Mid-1982+	200,000	Monthly	Cit	Covers 2000 engineering published proceedings
HISTORY						
America: History and Life (America: History & Life, Parts A, B, & C)	DIALOG-File 38	1964+	204,000	3 times/yr	Abst	U.S. & Canadian history, area studies, & current affairs
Historical Abstracts (Historical Abstracts, Parts A & B)	DIALOG-File 39	1973+	220,500	Quarterly	Abst	Covers world history since 1450, excludes U.S. & Canadian references; covers 2000 serials from 90 countries
HUMANITIES						
Eighteenth-Century Short Title Catalog	RLIN/CLASS	1701-1800	168,700 (500,000 when complete)	Daily	Cit	Data on English-language books on literature, culture, history of 18th century
Humanities Index Database (Humanities Index)	WILSONLINE	May 1984+	43,000	Twice/wk	Cit	Covers 300 serials
Magazine Index	DIALOG-File 47	1959-March 1970, 1973+	1,700,000	Monthly	Cit; full for 84 serials 1983+	435 popular American magazines; includes serials covered by *Reader's Guide to Periodical Literature*

(continued)

[a]Types of text are abstracts (abst), citations (cit), and full-text articles (full).

Example 11/5 (*continued*)
Databases and Their Primary Subjects

Subjects and databases (hard-copy title)	Vendors	Date of earliest record	Number of entries July 1985	Updated	Type of text [a]	Coverage of files
MLA Bibliography Database (Modern Language Association *MLA Bibliography*)	DIALOG-File 71, BRS	1970+	578,500	Annual	Abst	Covers about 3000 serials plus book reviews and essays in *Festschriften*
Readers' Guide Database (*Readers' Guide to Periodical Literature*)	WILSONLINE	1983+	155,000	Twice/wk	Cit	Covers 182 popular U.S. & Canadian serials
			LIBRARY			
Bibliographic Index Database (*Bibliographic Index*)	WILSONLINE	Nov. 1984 + current edition	12,000	Twice/wk	Cit	Covers 1900 serials plus books & pamphlets
Books in Print (*Books in Print*)	DIALOG-File 470, BRS		950,000	Monthly	Cit	Listings of books of some 12,000 U.S. publishers
California Union List of Periodicals	BRS	1984+	67,000 serials	Every 2 years	Cit	Bibliographic and location file of serials in 1000 California institutions
Cumulative Book Index Database (*Cumulative Book Index*)	WILSONLINE	1982+	128,000	Twice/wk	Cit	50,000/60,000 English-language books world-wide
LC MARC (*NUC Books*)	DIALOG-File 426	1968+	1,984,000	Monthly	Cit	Covers English-language books 1968 + ; other languages added 1970–1979
LC/LINE (*NUC Books*)	ORBIT-A (1968–1983) B (1984+)	1968+	almost 2 million	Weekly	Cit	Same as above
Library Literature Database (*Library Literature*)	WILSONLINE	Oct. 1984	6,000	Twice/wk	Cit	Covers 189 publications
LISA (*Library & Information Science Abstracts*)	ORBIT	1969+	70,000	6 times/yr	Abst	Covers 300 serials

REMARC (*NUC Books*)	DIALOG-File 421 (Pre 1900), File 422 (1900-39), File 423 (1940-59), File 424 (1960-69), File 425 (1970-80)	1897-1969 for English language & 1980 for others	2,409,000	Periodic	Cit	Covers NUC listings which are not in *LC MARC*
Ulrich's International Periodicals Directory Database (*Ulrich's International Periodicals Directory*)	DIALOG-File 480, BRS	1980+	127,000	Every 6 weeks	Cit	References to serials from 65,000 publishers in 181 countries
PHOTOGRAPHY						
ICONOS Database	QUESTEL	1839+	17,000 photographs	Weekly	Abst	Identifies photographs in French collections; provides catalog entries
TRADE AND INDUSTRY						
Advertising & Marketing Intelligence Service	NEXIS	1979+	160,000	Weekly	Abst	Covers 60 trade and professional publications, including *Advertising Age*
Textile Technology Digest	DIALOG-File 119	1978+	116,100	Monthly	Cit	Covers 650 patents, standards, conferences
Thomas Register Online (*Thomas Register of American Manufacturers*)	DIALOG-File 535	latest edition	127,000	Annual	Cit	Covers 123,000 U.S. manufacturers; 102,000 trade or brand names
Trade & Industry Index	DIALOG-File 148	1981+	914,000	Monthly	Cit; full for 99 serials 1983+	Full coverage of 300 serials plus selective indexing of 1200 others. Includes *Women's Wear Daily* & *Advertising Age*

[a]Types of text are abstracts (abst), citations (cit), and full-text articles (full).

NOTES

[1]See Mary E. Pensyl, "The Online Policy Manual," in *Reference and Online Services Handbook*, edited by Bill Katz and Anne Clifford (New York: Neal-Schuman Publishers, Inc., 1982), pp. 25–32; and Pauline Atherton and Roger Christian, *Librarians and Online Services* (White Plains, NY: Knowledge Industries Publications, 1977). The online policy manuals of the University of Houston (ED 174 221) and the University of Massachusetts at Amherst Libraries (ED 144 557) are available through ERIC.

[2]Henry Pisciotta, "Database Searching with Gateway Software," *Art Documentation* 4 (Spring 1985): 3–5.

[3]For an overview, see Carol H. Fenichel and Thomas H. Hogan, *Online Searching: A Primer* (Marlton, NJ: Learned Information, Inc., 1981); and Darlene Brady and William Serban Rustan, "Searching the Visual Arts: An Analysis of Online Information Access," *Online* 5 (October 1981): 12–32. For specific examples relating to art, see Jones, pp. 23–25, 63–68, 103, 116, 124, 169–71, 261–62, 265.

[4]Ilene R. Schechter, "Art Database Searching," *Art Documentation* 1 (Summer 1982): 91–92; and Paula A. Baxter, "Utilizing an Art Database in an Academic Library," *Art Documentation* 2 (Summer 1983): 89–90.

[5]Janet M. Dommer and M. Dawn McCaghy, "Techniques for Conducting Effective Search Interviews with Thesis and Dissertation Candidates," *Online* 6 (March 1982): 44–47.

[6]See Prudence W. Dalrymple, "Closing the Gap: The Role of the Librarian in Online Searching," *RQ* 24 (Winter 1984): 177–85.

[7]In Westbrook's study, 41.5% of the patrons who responded to the questionnaire either do not use or never consider using an interlibrary loan. See Lynn Westbrook, "Catalog Failure and Reference Service: A Preliminary Study," *RQ* 24 (Fall 1984): 82–90.

[8]See Jones, pp. 25, 259–70.

[9]Interlibrary Loan Committee, Reference & Adult Services Division, American Library Association, *Interlibrary Loan Codes, 1980: International Lending Principles and Guidelines, 1978* (Chicago: American Library Association, 1980).

[10]Leslie R. Morris, *The Interlibrary Loan Policies Directory* (Chicago: American Library Association, 1984).

• [11]Like many laws, the copyright law may be open to interpretation; for this reason, as much as possible should be read on the subject. The entire issue of *Library Trends* 32 (Fall 1983) was devoted to "Current Problems in Copyright," edited by Walter C. Allen and Jerome K. Miller. The issue contained: Nancy H. Marshall, "Register of Copyrights' Five-Year Review Report: A View from the Field," pp. 165–82; Roger D. Billings, Jr., "Fair Use Under the 1976 Copyright Act: The Legacy of Williams & Wilkins for Librarians," pp. 183–98; Jerome K. Miller, "Copyright Protection for Bibliographic, Numeric, Factual, and Textual Databases," pp. 199–209; F. William Troost, "A Practical Guide to Dealing with Copyright Problems Related to Emerging Video Technologies in Schools and Colleges," pp. 211–21; Linda M. Matthews, "Copyright and the Duplication of Personal Papers in Archival Repositories," pp. 223–40. Also see Nancy Marshall, "Copyright: Major Challenges Ahead," *Wilson Library Bulletin* 57 (February 1983): 481–84; and Carolyn Owlett Hunter, "The Copyright Law and Art," *Art Documentation* 1 (October 1982): 139–40.

[12]For a discussion of CONTU, see *Bowker Annual of Library and Book Trade Information* 28th ed. (New York: R. R. Bowker, 1983), p. 57.

[13]William J. Dane, "Networking and the Art Library," *Drexel Library Quarterly* 19 (Summer 1983): 52–65. For an annotated bibliography, see Sylvia Krausse, "Automation and Networking in Interlibrary Lending," *Art Documentation* 2 (December 1983): 197–99.

[14]*The Research Libraries Group, Inc. Annual Report, 1982–1983* (Stanford, CA: RLG, 1983). ARL will use the *RLG Conspectus* (see Chapter 3) as the basis for their National Collections Inventory Project (NCIP) to identify fields for primary collecting reponsibilities of member libraries.

Part IV

COLLECTION DEVELOPMENT AND LIBRARY MANAGEMENT

All art librarians, whether in large or small institutions, have administrative and managerial responsibilities. The extent of these will vary with the degree of autonomy allowed by the parent institution. This section includes chapters on collection development and acquisitions, cataloging and preservation of materials, management and budget, and personnel and the physical environment. Although not all art librarians will be equally involved in these aspects of administration, they should be aware of the problems and concerns of the essential elements of managing an art library. This section constitutes a general introduction to these topics.

12

Collection Development and Acquisitions

INTRODUCTION

Collection development requires a clear concept of the library's objectives and its users and their needs, which should be reflected in a formal collection development policy statement. Also needed is a thorough knowledge of the existing collection and of techniques for collection analysis. Finally, equally important is familiarity with the art-book trade, the art-periodical press, the primary art-review media, and, in some cases, with the antiquarian and out-of-print market.

A variety of tasks are subsumed under the general term *collection management*. Formerly, much of what the collection manager does was simply referred to as acquisitions. However, in current parlance, acquisitions is more often restricted to the actual securing of materials. Encompassing a much broader range of activities, collection management should begin with an analysis of the collection and its users—as discussed in Chapters 1 and 3—and proceed to a systematic program of collecting. Depending upon the library, collection development activities may be the responsibility of one person, or they may be apportioned among several.[1] This chapter discusses various aspects of collection management for an art library: (1) collection development policy statements, (2) methods of selection and deselection, and (3) the acquisition of materials.

FORMULATING A
COLLECTION DEVELOPMENT POLICY

A collection development policy is a statement embodying the library's objectives in terms of the materials needed to accomplish those objectives; for an example, see Appendix D. Combining both theoretical aims and day-to-day practice, this valuable tool acts, at the same time, as a planning mechanism and a communication device. The written collection policy should identify short- and long-range needs and establish priorities in the allocation of the budget. This policy should include the collection levels—discussed in Chapter 3—which were chosen.

As stated in the Resources and Technical Services Division (RTSD), *Guidelines for Collection Development*, a collection policy

(a) enables selectors to work with greater consistency toward defined goals, thus shaping stronger collections and using funds more wisely; (b) informs library staff, users, administrators, trustees, and others as to the scope and nature of existing collections, and the plans for continuing development of resources; (c) provides information which will assist in the budgetary allocation process.

A library's policy for deselection (that is, identification of works which may be removed to remote storage locations or discarded) should be coordinated with its collection development policy.[2]

Many smaller art libraries either do not have collection development policies or have only rudimentary ones. Nevertheless, there are a number of good reasons for having a written policy.

(1) It forces the staff to review and state formally the objectives of the library and to identify its users. Priorities can then be established in terms of allocation of funds. For example, the library of an art school will have as its top priority serving the curricular needs of its students and faculty. Secondly, if funding permits, it may provide recreational materials, such as recordings of popular music for studio artists.

(2) It establishes standards for selection—inclusion, exclusion, and deselection of materials.

(3) It functions as an information device, describing the scope of the collection for library, staff, users, administrators, parent bodies, and other institutions.

(4) It helps keep selection in balance; a selector's personal prejudices and enthusiasms are better channeled or kept under control working with accepted criteria, thus, the Dada expert does not dominate the acquisitions budget.

(5) It can be used as an in-service training mechanism for new employees, because it helps orient staff to the collection and sets forth assumptions that

are otherwise unwritten, or unspoken, thus providing guidelines for making routine decisions.

(6) It provides the necessary continuity when there is staff turnover in the library or in the parent institution, as when faculty changes at a college or university, or curators at a museum.

(7) It helps to determine budget allocations and to ensure a professional operation.

Having decided to formulate a collection development policy statement, how does one do it? Fortunately there are a number of guidelines and samples available for models, both for data collection and the final product. Paramount among them are the previously mentioned RTSD guidelines and some of the SPEC kits of the ARL.[3] Although the latter pertain to research libraries, they are, nonetheless, adaptable to other types.

Richard Gardner in *Library Collections: Their Origin, Selection and Development* lists the following as the usual components of policy statements, although many statements may omit some or combine them in a different order:[4]

(1) An introduction provides the reasons for writing the policy, how and by whom it has been written, and a description or profile of patrons.

(2) Philosophy and goals should clearly state library objectives in terms of the community served.

(3) The selection statement is an extensive section that may cover all or some of the following points: Who is responsible for selection? What criteria for selection are to be used, such as: authoritativeness, accuracy, impartiality, recency, scope and depth of coverage, appropriateness, relevancy, organization, style, technical and physical aspects of the material, inclusion of bibliographies and appendices or cost? What primary selection aids are to be used, for example, Arntzen/Rainwater, Jones, etc.? What levels, if any, are imposed by languages and special formats?

(4) The section on problem areas should cover such topics as duplication of materials, replacement of worn or lost items, binding decisions, and textbooks and dissertations.

(5) Special formats is a section that may cover the following: periodicals, newspapers, pamphlets, manuscripts, microforms, slides, photographs, films and other graphic material, computer-based data files, and local information files.

(6) As far as gifts are concerned, it is customary to compose a separate statement which includes the options of accepting, discarding, or selling the material. Most libraries try to apply the same criteria for gifts as for purchased materials; not all gifts are added to the library collection.

(7) The weeding or selection section may include assignment of

responsibility for the process as well as an indication of what is to be weeded.

(8) A statement on intellectual freedom is included in many policies, which reproduce the ALA "Bill of Rights" and the joint statement of the ALA and the American Book Publisher's Council, "Freedom to Read."[5]

(9) It is extremely important to make provision for periodic review of the statement in order to remain up to date. Generally, policies should be flexible enough to accommodate change; the review should not necessarily entail rewriting. Finally, policies should never be allowed to become out of touch with reality or to fossilize into unwarranted constraints.

An independent art library policy statement may omit many of the preceding elements. For example, the director of a museum library may not feel the need of a statement on intellectual freedom; smaller libraries may require considerably less detail. In "Drafting and Implementing Collection Development Policies in Academic Art Libraries," Nancy Pistorius discusses the various aspects which must be considered.[6] Pistorius defines three stages: (1) identifying elements on which to base the policy, (2) writing the statement, and (3) implementing the resulting policy. A checklist of elements which should be included in the policy, an outline for the policy format, and a bibliography are also provided. Appendix D of this book contains excerpts from a university policy statement which could be used as a model by other types of art libraries.

In the long run, the value to the art library—no matter how small or large—of drawing up a collection development policy cannot be sufficiently emphasized. Too often, day-to-day procedures are based on unarticulated assumptions that are not warranted. The process itself forces the staff to look at clientele, policies and procedures, and their interrelationships. A valuable planning tool, the resulting document will be a useful guide to those selecting materials on an ongoing basis and will help ensure continuity.

METHODS OF SELECTION AND DESELECTION

Responsibility for selection varies widely from library to library. In a small art school, museum, or business library there may be only one person who does everything, including collection development. In larger museum libraries, the head librarian is usually the chief selector, although responsibility for specific subject areas or types of materials, such as reference works, may be delegated to other staff members. In large academic and public library systems, where art librarians are often subject bibliographers and specialists, selection may occupy a major portion of their time. In many public library systems, materials are centrally chosen for the main library as well as for

the branches. In this case, information and opinions should be sought from the branch librarians about their clientele. Clearly, in the case of an academic library, liaison with the faculty is vital, although the extent of faculty involvement differs drastically from institution to institution. The same will be true for a museum library and the curatorial staff.

The selector has first to be aware of what material has been issued in the various media. Some of these have already been discussed: exhibition, auction, and trade literature; serial publications; visual resources; and other special formats were treated in Chapters 6 through 9. There are a number of publications which can be used for identifying material for purchase; some are general, others are primarily art-related.

Because of the need to obtain materials quickly, most selection is done on the basis of publishers' advertisements. One of the best methods for identifying important art publishing firms and distributors is to attend professional conferences—such as ARLIS/NA, CAA, AAM, and NAEA—which have displays of the latest literature. Consultation with library colleagues and staff members of the institution—such as curators and faculty—is also important. A list of publishing firms and their addresses is recorded in such works as *Books in Print, International Directory of Arts,* and *Literary Market Place*—the latter publication categorizes the firms by subject. In order to market their products, publishers (1) issue seasonal and annual catalogs plus a multitude of announcements and fliers, (2) advertise in a number of periodicals and newspapers ranging from *The New York Times* and the *Times Literary Supplement* to *Art Journal* and *Art Documentation,* and (3) exhibit their publications at professional meetings.

Many fliers and advertisements are difficult to interpret, because they do not provide enough information. Advertisements often do not indicate that a work has been previously published under another title, such as an exhibition catalog, or as part of a series for which there may be a standing order. A title alone is not to be trusted. For instance, Emanuel Stickelberger's *Holbein in England,* even though it has 23 illustrations, is not a discussion of the painter's work, but a novel based on his life. So, too, a work entitled *The Pig in Art* may sound like an iconographical study of St. Anthony's companion, but is in fact a picture book of this porcine animal.

Once a book has been published, it will appear with cataloging information from the Library of Congress in the *Weekly Record,* an R. R. Bowker publication. Art librarians may have problems with this otherwise excellent publication, since (1) much art material falls outside the regular trade channels and is, therefore, not included, (2) books issued by small and private presses and publishers are not likely to appear, and (3) this publication is limited to U.S. imprints.

Each month the entries from the *Weekly Record* are cumulated, rearranged by Dewey Decimal Classification numbers, and issued as the *American Book Publishing Record* (*BPR*), which contains an author-title index. A parallel work, the *Cumulative Book Index* (*CBI*), published by the H. W. Wilson Company, is a dictionary listing of author, title, and subject entries. Its scope is broader than *BPR* in that it includes English-language books published outside the United States. For Canadian materials, one may refer to the monthly *Canadiana: Publications of Canadian Interest Received by the National Library of Canada*, which cumulates annually, and the annual *Canadian Books in Print*.

Comparable sources are available for Western European countries. Great Britain, France, and Germany have true national bibliographies which attempt to list all publications issued within those countries. Most other European countries have national and trade bibliographies in one form or another.[7] In other parts of the world, the book trade is not as well organized. Unless a library is purchasing a great deal abroad, subscriptions to these tools are costly, in both money and space. Furthermore, the art librarian frequently needs considerably more data than these publications alone provide.

Familiarity with the output of art specialty publishers will help in determining whether or not to purchase immediately. The art librarian must keep up to date with the current trends. For instance, in 1983 *Publishers Weekly* contained an interesting three-part series covering changes in art book publishing during the last decade.[8] With less well-known publishing houses, it is often best to reserve judgment and wait for reviews or recommendations from patrons and colleagues. In some public library systems, it is not possible to order without a prior published critique. Reviews aimed at the book trade and art librarians—such as *Choice* and *Art Documentation*—are reasonably up-to-date.[9] The same cannot be said of the reviews in the scholarly art history journals—such as *Art Bulletin* and *Burlington*—where the time lag can be as great as two years. By that time, a book is either out of print or the pressing need for it may have gone unmet.

By far the most useful reviews appear in *Art Documentation* and The *Art Libraries Journal*. The extensive, critical signed reviews, which are frequently comparative, usually appear soon after the work is published. Among the library-oriented review media of value to the art librarian are the "Forecasts" appearing in each issue of *Publisher's Weekly*, which is limited to popular trade books; *Library Journal*, which is oriented toward trade books for public libraries; and *Choice*, which is aimed at the college and university library audience. Reference books are reviewed in *RQ* and *College and Research Libraries*, two ALA journals. Other sources for reviews of reference books include *Wilson Library Bulletin, References Services Review,* and *American Reference Books Annual* (*ARBA*).

Many librarians prefer to examine materials before selecting them regardless of the availability of reviews. The use of an approval plan—discussed in more detail later in this chapter—makes it possible to inspect the actual work. Approval plans are more often used by academic and large public libraries than by small libraries. While these plans have undoubted merit, they have also been criticized as encouraging librarians to delegate part of their collection development responsibilities to publishers' representatives or to jobbers.

Deselection—also called weeding—is the process of determining what materials should be discarded, replaced, or relegated to storage—the latter is the preferred method of research libraries. Until space becomes an immediate problem, most librarians tend to delay making decisions about what to do with duplicates and rarely or little-used items. It has been suggested that this reluctance is a result of an underlying American conviction that big is best and to the tradition that one of the library's functions is to preserve. More probably, librarians postpone weeding, because of the time and cost involved and of the frequently subjective nature of the decisions that have to be made.

There are other reasons for deselection than a space crisis. As usual, there are variations according to type of library. A public library tends to want the latest materials; indeed studies have indicated that usage increases following weeding, because people can more easily locate what they want.[10] In a large system, there is often a storage repository for material discarded, in order that at least one copy is retained. Business libraries also operate on the premise of ready availability of the most up-to-date information. Art research libraries, on the other hand, are far more reluctant to discard anything, on the theory that we cannot forsee what use future generations will make of the materials.

Criteria commonly used in deselecting include: (1) physical condition, (2) duplication, (3) out-of-date editions, (4) unsound content, (5) age, and (6) use. Poor condition often means the item has been heavily used and is, therefore, a candidate for repair or replacement. Items that were once ordered in duplicate or multiple copies to satisfy heavy demand may have lost popularity, such as duplicates requested by faculty for course work. Older editions should always be compared with new ones before being discarded to ascertain whether or not important information has been deleted. This kind of judgment requires time and effort—as much as was expended in the first place. The determination of unsound content presupposes subject expertise.

The two remaining criteria, age and use, have been the targets of research which can assist librarians in the decision-making process. Basing deselection on age is not considered to be as successful in the humanities and arts as

it is in the sciences, because determination of the age beyond which materials are infrequently used is more difficult. Various cut-off dates have been employed: the copyright date, the imprint date, the purchase or acquisition date, and sometimes even the date the book was shelved. One must be careful in using age as a criteria not to toss out the classics in the field. Unfortunately, the discarding of material just because it is out-of-date may also illustrate ignorance of the discipline. In one large library, all of the ancient travel books—Baedecker, Murray, and Michelin guides—were cast out. Yet, these materials are important resource tools for art historians.

There is a very large body of literature on use studies relating to weeding.[11] Much of this research is summarized in Stanley J. Slote's *Weeding Library Collections*.[12] Slote himself has contributed the notion of deselection based on what he calls shelf-time period, which is the estimate of the length of time a book remains on the shelf between successive uses. This method depends upon the availability of good circulation records, but if they do not exist or for non-circulating books, a system of dots or marks on the spines of the books may be used. Care must be taken in utilizing this type of count. Not all books are used in the same manner. In art, many of the patrons are browsers who consult numerous books without checking them out of the library.

Not all materials that are removed from the collection have to be discarded. Most research libraries have developed some form of storage, usually of the compact variety. The decision to send materials to storage should be made with the advice of the primary users—faculty or curators. Since it is important to make decisions about storage based upon what will cause the least inconvenience to patrons, effective delivery mechanisms must be established.

A few other aspects of deselection should be mentioned. Any weeding at a local level should take into account the needs of neighboring institutions and other members of networks to which the library may belong. It is usually agreed that at least one copy of a work be kept locally available. Other problems arise when public institutions are forbidden by law to give away or destroy what is considered to be public property. Similar restrictions may have been attached to gifts. Before embarking on a deselection program, the librarian should ascertain what constraints of this nature may exist.

Collection development is obviously linked to the acquisitions function; in small libraries, they may be coincidental. In large systems where the art librarian may be in charge of setting up blanket or approval plans, a liaison with the acquisitions department is important. The choice of dealers, vendors, and booksellers should be a joint decision, since art librarians and acquisitions librarians may possess different views of the art materials market. The selection of blanket or approval plans, as well as the purchase of out-of-print materials, clearly will have an impact on the acquisitions staff and should be discussed with them.

ACQUISITIONS

Once materials have been selected, they must be acquired. Several aspects of the acquisition process should be considered.[13] The availability of the desired items must first be ascertained, the best method for purchase determined, and the necessary records for control of the entire process must be devised and maintained. Some libraries have established extensive exchange programs, which, while not requiring a choice of vendor, do entail record keeping. The same is true of gifts. In a large system with centralized processing, the art librarian is involved in only a few of the mechanics of ordering. In a one-person institution, the librarian will have to set up the whole procedure. Clearly, much acquisitions work can be done by clerks or para-professionals, but in a small library some of the tedious routines will inevitably fall to the professional. Because acquisitions work involves repetitive operations, it has been a prime target for automation. A manual of procedures—which if it does not exist, should be written—is helpful in training personnel and in clarifying the process.

Several patterns of organization are possible, and variations occur according to type of library. Nevertheless, the following functions are common to all: (1) bibliographic verification of orders requested, (2) maintenance of files for materials on-order and those in-process, (3) update and review of files to claim or cancel orders, (4) unpacking and sorting of orders and verifying of invoices, (5) maintenance of records of payment and encumberance of funds, and (6) forwarding of materials to the catalog department, which may include affixing ownership marks and accession numbers.

The first acquisitions problem consists of two steps: (1) to determine if the library already owns the material or if it is on order and (2) to verify the bibliographic information submitted with the request and, if necessary, to augment it. The second problem is to determine the source from which it will be acquired. Most libraries acquire the majority of their materials by purchasing them, either by obtaining items as they are required or through contracting for an automatic purchase plan. Gifts and exchanges can also be important sources of acquisitions. Acquisition of special materials—such as catalogs of all kinds, government publications, microforms, slides, artists' books—were discussed in the appropriate chapters of Part II.

Searching and Bibliographic Verification

Searching and bibliographic verification may involve some interesting detective work, if the information available is faulty or incomplete. To help reduce costly pre-order searching, the acquisitions staff is grateful for any documentation—such as catalogs, review references, or advertisements— that can accompany an order request. In order to determine if an item is

already in the library, a search must be made of (1) the library's own catalog, (2) the file which shows the orders that are outstanding, and (3) the file for those that have been received and are in-process. Without an adequate bibliographic entry, the item may be missed and a duplicate order result. Because a library's catalog has more access points than the order files, which are usually arranged by title alone, an item may be found in the catalog under a secondary entry, such as an editor, which would not appear in an order file. So, too, the catalog indicates variant spellings of a name, which the order file does not.

Although many librarians search their own files first, afterwards having to search only those titles not located, it is quickest to verify titles online and as an alternative to search the national and trade bibliographies. An online search will usually yield the full correct citation and supply missing pieces such as indication of a series. The search will identify the cataloging form of the author's name—if there is an author—title, edition, place of publication, publisher, date, number of volumes in the series (if applicable), ISBN or ISSN number, and the list price. At whatever stage the record is found, the information discovered in the pre-order search is then available to the catalogers who, theoretically, need only to bring it up to date.

The bibliographic tools favored by acquisitions librarians for searching will vary depending on the type of library and, of course, on the date and language of the publication sought. Those most used include *Books in Print (BIP)* which is available online through both DIALOG and BRS, *Publisher's Trade List Annual (PTLA)*, *National Union Catalog (NUC)*, *Cumulative Book Index (CBI)*, *American Book Publishing Record (BPR)*, *Forthcoming Books, Canadiana*, *British National Bibliography (BNB)*, OCLC, and RLIN. The bibliographic utilities—OCLC and RLIN—are the fastest.[14] Some booksellers offer a variety of supplemental bibliographic services and tools. For example, for customers who use their Standing Order Services, Blackwell North America issues a monthly microfiche list of series—unnumbered, numbered, monographic, regular, and irregular—and books that are frequently revised.

Following are some examples of the kinds of anomalies that are revealed in the searching process. Acquisitions librarians have to determine how exhaustively they wish to search before ordering. Clearly, sometimes a point of diminishing returns is reached when the order may be sent, even if all the bibliographic information is not found.

Frequently, subtitles are confused with titles. *Court Life and the Arts Under Mughul Rule* is actually a subtitle for a monograph entitled *The Indian Heritage*. If no catalog entry has been made for the subtitle, a search of the catalog alone will not uncover that fact, but it can be found in the *British*

National Bibliography under the subject as well as the title. More easily resolved is a search for an erroneous title. A work entitled *Medieval and Renaissance Illuminated Manuscripts in Austrian Galleries* was requested. In actual fact, the title read . . . *in Australian Galleries*.

Perhaps the greatest puzzles are presented by series. A request for *Hieronymus Bosch* by Patrick Reutersward resulted in a library ordering a copy of a work it already owned. It was cataloged as part of an unanalyzed series, *Figura*. To further complicate the matter, *Figura* is part of another series, the *Acta Universitatis Upsaliensis*. Unfortunately, a series within a series is not an unusual situation. Book sets—called continuations—and monographic works in series are usually purchased by means of standing orders, as are frequently revised editions.

Purchasing

When searching and verification are completed, the purchase can be made. Although libraries acquire materials in a variety of ways, there are several principal means by which items are purchased: (1) wholesale vendors or jobbers, (2) a blanket or approval purchase plan, (3) book stores or dealers, (4) publishing companies, (5) subscription agents for serials, and (6) the out-of-print market. Factors determining which method of purchase is the best include: (1) who offers the best discount, (2) who provides the best service in terms of rapid and accurate filling of orders and prompt adjustment of mistakes, and (3) who can adapt billing to local requirements.

Many art librarians feel strongly that service should outweigh cost in making a decision about a jobber. Wholesale houses have been quite responsive to librarians' needs and have worked to provide them with valuable financial and management information, such as the average cost per title per subject field. Wholesalers have also developed flexibility in billing procedures and many offer online computer facilities for transmitting orders. Usually they give higher discounts than publishers because they can utilize mass-production techniques. Discounts vary according to the volume of purchases and types of material, and may be as high as 35 to 40% for trade books from jobbers. But most art materials fall into the specialty, scholarly, or technical category and are discounted at a lower rate, which may range from 20% to nothing at all.[15] In some cases, a jobber may even charge a fee if the work is not in stock and is difficult to locate. However, blanket order and approval plans may result in savings to the library. Obviously, the advantage of dealing with one or a few jobbers, rather than ordering from multiple sources, is the substantial decrease in paperwork—fewer orders, fewer invoices, fewer payments.

Because wholesalers prefer dealing in quantity, they may not offer the best service for smaller libraries. The librarians of these institutions may choose to deal with smaller jobbers. But because their stock may not be as large, the chances of obtaining special materials is reduced or slowed. Unfilled orders may range from 30 to 50% of the number of titles requested, a discouragingly high figure. Although some librarians claim that publishers do not always provide good service when orders are small, others have found this not to be the case. Frequently, art publishers are specialists themselves and are able to handle individual orders promptly and accurately. The increase in paperwork is offset by the service given.

For smaller libraries, there is a useful American Library Association publication, *Guidelines for Handling Library Orders for In-Print Monographic Publications*, which specifies the form that library purchase orders should take and the type of information to be furnished.[16] This work also includes suggestions for establishing claims—requesting missing items—cancellations, returns, invoicing, and payment procedures. A good line of communication with the vendor—whether publisher, bookstore, or jobber—is of the utmost importance. For manual order systems, multiple-copy order forms in a variety of formats are available from library supply houses. Forms can include (1) *report slips* for dealers to check off such information as not yet published, out of stock, out of print, or order cancelled and (2) *claim slips* for librarians to retain until such time as they wish to inquire about an order not received.

Art librarians order much material that either falls outside of the regular distribution channels or is best obtained from specialty distributors. In addition, many art libraries have to secure materials from abroad. One of the most satisfactory methods is to establish relations with overseas book dealers, such as B. H. Blackwell Ltd. in England, Otto Harrassowitz in West Germany, and Martinus Nijhoff in the Netherlands. These companies offer world-wide acquisitions services, including various standing order and approval plans both for monographs and serials. They also will undertake retrospective purchasing. A number of other more specialized dealers may be located by consultation with colleagues.[17] For the addresses of publishers, art book dealers, and specialty distributors, consult such references as *Books in Print, American Book Trade Directory, International Directory of Arts, or Fine Arts Market Place.*

Most libraries maintain standing orders with either publishers or jobbers for certain books that appear in series, such as the *Pelican History of Art* and G.K. Hall's *Reference Publications in Art History.* A further extension of this standing order system are the approval and blanket order plans which many librarians have established.[18] Standing and blanket orders imply acceptance of the items sent; an approval plan allows the library return

privileges. Although there have been fewer of the former in recent years, they still may be used if the entire output of the publisher is desired, for example, all publications of a university press. It is also possible to arrange with publishers for their entire output in given subject fields. For instance, Princeton University and Cornell University are noted for their scholarly art publications.

Jobbers, too, are willing to supply by categories, for instance, the entire list of Far Eastern art published by university presses in North America. In other cases, the librarians develop a profile of materials needed in various categories. Using the profile, the dealer selects and sends specific titles, which the librarian either accepts or rejects. This type of operation, which is called an approval or gathering plan, has several advantages: supplying materials rapidly, saving staff time, and reducing record keeping. The disadvantages arise when the library's profile is not entirely clear, or the jobber does not interpret it adequately. Arguments over returns may ensue. While many librarians like to have a book in hand when accepting or rejecting, sometimes a marginal item is accepted, because it is easier than to return it—making it a prime candidate for deselection at a later date, thereby doubling the time spent on an unwanted book. More seriously, the jobber may overlook items that the library's selectors would have chosen. By the time it is discovered, the books may be out of print.

Susan Davi in "Automatic Acquisition Plans for the Art Library" considers a number of factors related to approval, blanket, and standing order plans.[19] Discussed are the selection of vendors, profile specifications, the advantages and disadvantages of these plans, and the steps to achieve a successful plan. And most importantly, she covers special topics for an art library, such as how-to books/studio techniques, photography, museum and foreign publications, and series.

Libraries purchase from local book stores especially when there are sales or when an item is needed quickly. In the latter case, the local bookstore is usually the fastest supplier if the book is in stock. When they travel, some librarians make it a practice to visit the large discount bookstores—like the Strand Bookstore in New York City, which specializes in art books—to take advantage of the lower prices. One of the problems with this approach is that duplicates may inadvertently be purchased.

Because art books are expensive, some librarians prefer to wait, if the book is not in immediate demand, for reductions or publishers' remainders. Remainders are books that were printed in too large a quantity and have not sold at full price. They may have been overpriced in the first place, may have been of more limited interest than the publisher originally expected, or may have become dated or replaced by newer works. Remainder lists are

sources for books that were overlooked when they were originally published or that were not purchased because they were too costly. Public librarians often acquire duplicate copies from these lists, and all types of libraries find replacement copies on them from time to time.

But there is one thing of which librarians must be aware: some remaindered books are in actuality reprints, often reissued under a different publisher's name. This happens because sometimes the original work was overpriced for the market, but when it was remaindered at a lower price, it sold well. The remainderer, anticipating that production costs can be kept low, makes an arrangement with the original publisher to buy the rights and reprints a large number of copies. Another practice is to acquire the rights to a book and then break it up into parts, printing each separately. The librarian must take care to see that the institution does not already own the original whole work. Familiarity with the catalogs of the large remainder houses, such as Publisher's Central Bureau and Barnes and Noble, will acquaint librarians with titles that have been on lists for years. Of course, there are often true bargains to be had through these same houses.

Another source of reduced materials are the publisher and vendor displays at national conferences. New titles can usually be ordered at 20 to 40% off list price, and the exhibitors sometimes sell their wares on the last day of the exhibit at substantial discounts. Conferences and meetings in general are particularly important sources of all kinds of information for acquisitions librarians. At these gatherings, librarians can exchange information on such topics as vendor and subscription-agent performances, new sources for elusive items, and automated systems.

While some serials—particularly society and institution publications—are ordered directly from the publisher, most librarians employ a subscription agent, such as EBSCO Subscription Service or F. W. Faxon Company. Most large agents will undertake to supply foreign materials, but sometimes these serials must be ordered directly from abroad. Unfortunately, unlike book wholesalers, subscription agents do not generally give discounts to libraries; instead they charge for their service. Some publishers even have higher subscription rates for libraries than for individuals and, indeed, often higher than for other types of institutions. Aside from the saving in paperwork, the agent's greatest help can be in claiming missing issues, renewing subscriptions automatically, and generally keeping the library informed of the frequently unpredictable behavior in which serials seem to indulge. Because even the best subscription services have lapses, the serials librarian must be alert to all sorts of potential changes in numbering, date, frequency, and format. If claims are not made quickly, it may be impossible to obtain a missing issue. But one must be aware that some serials are habitually late.

There is no point in claiming the September issue of a magazine, if during the past five years, it has never arrived until November. Inexperienced librarians are well advised to read as much on the subject of serials as possible—in such periodicals as *Art Documentation, The Serials Librarian, Serials Review,* and *Library Resources and Technical Services*—and to discuss problems with colleagues.

Frequently a book is selected as an in-print item and is then discovered to be out of print. In fact, this is now happening with more frequency, as publishers drop books from their inventory to reduce their taxes. Many smaller libraries will try to substitute another work at this point or, if it was recently in-print, turn to the remainder houses. But in many cases, it is necessary to try the second-hand or rare-book market. Because out-of-print books can be difficult to locate, most librarians do not seek one individual title, but instead develop a list of desired or needed works, which can either be checked against items advertised in dealers' catalogs or submitted to out-of-print dealers. The desiderata list should be reviewed periodically, since sometimes a particular book will no longer be needed because another title has been substituted for it. This is more likely to happen in a public rather than in a university or museum library, where the dictates of research usually require a specific title.[20]

Out-of-print book dealers, known in the trade as o.p. dealers, regularly issue catalogs of the items they have available. If something is listed that the librarian wants, a fast move, by telephone or cable, is usually necessary. Scarce items are sold quickly. A librarian can also submit the desiderata list to o.p. dealers. It is advisable to send the list to one dealer at a time, and usually with a time limit for supply. Otherwise, if several dealers have the same list, they may enter into competition with each other to secure a book, a process that will inevitably raise the price. Second-hand and antiquarian catalogs vary in the amount and accuracy of information they provide. If their institutions buy heavily in the o.p. market, librarians should develop working relationships with the antiquarian dealers who have established reputations for good and reliable service and who will then be on the lookout for special works for them.

Libraries also advertise in *The Library Bookseller*—formerly called *TAAB*—or in the *AB Bookman's Weekly,* the journal of the antiquarian book trade. In this case, offers come to the librarian, and with them sometimes a dilemma: whether it is better to wait for another offer. The difficulty is that a better one may not materialize, and in the meantime the first book offered will have been sold to a different institution. Another means of securing o.p. items is to employ a search service. Names and addresses of dealers and search services may be found in the *American Book Trade*

Directory or the *AB Bookman's Weekly*; some advertise regularly in *Library Journal* and *American Libraries*. An annual listing is found in the *AB Bookman's Yearbook*. Large, well-endowed institutions may turn to auction houses. Rare books are sold at Sotheby's, Christie's, and other houses, all of whom usually issue catalogs before the sale, including statements of edition and condition. Condition is a factor which should be considered, particularly if the price is high.

Another avenue that some art libraries follow is to order a microform of the desired item, if the o.p. title cannot be located or if it is too expensive. Microform publishers issue catalogs, such as University Microfilms' *Books on Demand* and Microform Review's *Guide to Microforms in Print*. While microforms hold up well, they, too, can be expensive. In *Books on Demand*, cost is quoted in cents per page plus binding per volume. Two other sources of information are the *Directory of Library Reprographic Services* and the *National Register of Microform Masters*. The cost of items located in these catalogs will vary depending upon individual library pricing structures. A major disadvantage of microforms is that the illustrations are not always of acceptable quality.

Automated Acquisitions Systems

Because so much acquisition work involves routine procedures, automated processes were an early development. The number of options continues to grow. Librarians hoping to implement automated acquisition systems have several factors to consider. It is important to determine just what features a library most needs. For instance, public libraries tend to want speedy receipt of orders, while academic libraries want to update information on availability of funds. The minimum requirements of a system should include pre-order searching—of both the library's own files and catalogs as well as the vendor's files—ordering, receiving, claiming, cancelling, and invoice processing. The production of management data should also be a requirement. At a minimum this would cover amounts expended, status of ordered items, and dates of shipment and receipt. The major systems currently available are those offered by (1) the bibliographic utilities, (2) turnkey vendors or those who have stand-alone systems, and (3) jobbers.[21]

The bibliographic utilities systems have an advantage in that they have the foundation of an already established database, but their very size, particularly OCLC, makes them somewhat cumbersome.[22] Vendors of stand-alone systems offer quick delivery at relatively low and predictable prices, but the systems may have to be adjusted to individual requirements. One advantage some turnkey vendors—such CL Systems, DataPhase Systems, and Geac

Canada—have is that they began as circulation systems which can now be expanded to include acquisitions functions.[23]

Several book jobbers—such as Blackwell/North America, Baker and Taylor, and BRODART—offer online ordering systems. Generally, these are the least expensive but also the least flexible. Although some can generate orders to other vendors, they are most useful if the library orders primarily from that particular jobber. On the other hand, these book dealers offer a variety of services, such as production of catalog and book cards, spine labels, lists of new titles, and a wealth of management information. They have been particularly responsive to library needs and have even scrapped expensive systems under development, recognizing that the market could not carry them.[24]

In addition to the major systems, it is possible to purchase a special software package from another library or library consortium, such as WLN or Northwestern University Library's NOTIS III. But some software is produced for specific computers and cannot be transferred to different equipment. Even if it can be, if the purchasing library wants to make changes, it may be necessary to utilize an in-house data processing expert to alter the software. The microcomputer offers enormous potential for a small library to enjoy a linked or integrated system, which was discussed in Chapter 2. For very large libraries, microcomputers are still too small to support integrated systems.

Although many automated systems have been designed, unfortunately, serials seem to have a penchant for eluding control. Even the best system has trouble dealing with an announcement that Volume 23, Number 1, 1985, will appear before any numbers of Volume 22, 1984. The major bibliographic utilities—OCLC, RLIN, UTLAS, and WLN—have all introduced serials automation systems, but there are also systems developed by subscription agencies.[25] For example, Faxon's LINX system provides for check-in, ordering, claiming, and fund accounting, while EBSCONET primarily supports check-in and bindery operations.

Large museum libraries purchase so much abroad—and all art libraries order so many materials that fall outside the regular trade channels—that for them, perhaps the best that the automated systems can do is to generate the paper and accounting work and provide status reports. The microcomputer offers an ideal means of accomplishing these functions. All librarians are now concerned with the integration or interface of systems as well as costs per transaction. Unfortunately, very few know how much their current manual systems are costing. There is at present no ideal system but many possible ones. Librarians are again well advised to keep up with the

literature, such as *Library Technology Reports, Online, Library Software Review,* and *Small Computers in Libraries* and to discuss the options with their colleagues.

Gifts and Exchanges

Art libraries are sometimes the recipients of gifts, some of which can be very valuable. Although gifts of money are easy to deal with, it is wise to see that no restrictions accompany them. Gifts of materials pose slightly different problems.[26] Often they are things the librarian would not want to add to the collection, but at the same time the gift may come from a donor whom the librarian does not wish to alienate. Tact and diplomacy are called for, but is is sensible for the librarian to make sure that unwanted items may be discarded. It is not advisable for the librarian to set a value on gifts, although rough estimates may be made for non-tax purposes. If the donors want to obtain tax deductions, it is best to refer them to standard lists of book prices, such as *American Book Prices Current, Bookman's Price Index* for older titles, or *Books in Print* for new titles. If the gift is quite valuable, the donor may want to obtain the services of a professional appraiser, such as a local rare book dealer, a member of the American Appraisal Society, or an expert from one of the auction houses, such as Sotheby Parke Bernet or Christie's.

Frequently, materials that are difficult to purchase or that are otherwise unobtainable are received through exchange with other libraries and institutions. One prevalent and simple form of exchange, which is really more a gift program, is for a librarian to prepare lists of duplicates or unwanted materials and to circulate these compilations to other libraries. This method involves two problems: (1) the lists take time to compile and (2) the recipients must move quickly if they want something, as usually only one copy is available. In addition, more elaborate systems of true exchange have developed, whereby a university or a museum will exchange its publications—such as bulletins, annual reports, catalogs of permanent collections, special exhibition catalogs, and monographic works—with similar publications from another institution. Clearly such a system will not work unless each institution has something to give in return, but many libraries are willing to give more than they receive, because it is the only way to get certain needed publications. Sometimes, too, the cost can be charged off as goodwill or a sense of noblesse oblige to help less well-endowed exchange partners. Others feel that they must stick to some sort of reciprocity to balance exchanges either by pricing them or by reckoning on a piece-for-piece basis, regardless of price. Some time may be spent in locating suitable partners. The exchange list should be reviewed annually. For instance, it makes makes no sense for a museum of contemporary art to receive exhibition catalogs on medieval tapestries.

Exchange programs entail record keeping and a fair amount of correspondence. Some form of thanks or indication of receipt must be sent to the partner, and if a serial item fails to arrive, a polite enquiry is usually made. In addition, there is a danger that expected material may not arrive and by the time it is realized, it is too late to purchase. One method of assuring that all pertinent exhibition catalogs are obtained is by checking the lists in the *Worldwide Art Catalogue Bulletin*.

Particularly valuable for materials from museums that fall outside the regular book and periodical trade channels, and are therefore hard to identify, exchange programs are also important sources for foreign materials when purchase is sometimes difficult, either owing to faulty distribution channels or currency restrictions.[27] Many libraries will purchase special items, other than their own publications, in order to reciprocate a foreign exchange.

At the Amon Carter Museum, the librarian categorized the exchange list into a five-tier system: (1) Group A, institutions which receive everything that this Fort Worth museum publishes; (2) Group B, those institutions which receive about 75% of the publications; (3) Group C, specialized institutions, such as those with photography collections; (4) Group D, discretionary group of institutions such as those with collections of Americana; and (5) Group E, institutions sent publications as a courtesy, such as local libraries—art, public, and academic. This classification system was developed for a computer system which generates the mailing labels. The system is capable of producing standard letters of acknowledgement or claims.

NOTES

[1]For good overviews and discussions of collection management, see Richard K. Gardner, *Library Collections, Their Origin, Selection, and Development* (New York: McGraw-Hill, 1981); *Collection Development in Libraries*, edited by Robert D. Stueart and George B. Miller, 2 volumes (Greenwich, CT: JAI Press, 1980); William A. Katz, *The Selection of Materials for Libraries* (New York: Holt, Rinehart and Winston, 1980); Paul H. Mosher, "Collection Development to Collection Management: Toward Stewardship of Library Resources," *Collection Management* 4 (Winter 1982): 41–44; and G. Edward Evans, *Developing Library Collections* (Littleton, CO: Libraries Unlimited, 1979). As an example of more specialized works, see John Rylands, "Collection Development and Selection: Who Should Do It?" *Library Acquisitions: Practice & Theory* 6 (1981): 13–17; Wanda V. Dole, "Collection Development in the 80s," *Art Documentation* 1 (May 1982): 49–50; Nadene Byrne, "Selection and Acquisitions in an Art School Library," *Library Acquisitions: Practice & Theory* 7 (1983): 7–11.

[2]American Library Association, Resources and Technical Services Division, Collection Development Committee, *Guidelines for Collection Development*, edited by David L. Perkins (Chicago: American Library Association, 1979), p. 2.

[3]SPEC (Systems and Procedures Exchange Center) kits of the Association of Research Libraries are collections of materials submitted in response to questionnaires sent to the member libraries. The kits vary in quality, but are often valuable as indications of trends and models. Examples are: *Collection Development Policies* (SPEC kit # 38), 1977; *Approval Plans in ARL*

Libraries (SPEC kit # 83), 1982; and *Collection Description and Assessment in ARL Libraries* (SPEC kit #87), 1982 (Washington, DC: Association of Research Libraries, Office of Management Studies).

[4]See Gardner (Note 1), pp. 226–28.

[5]Reprinted frequently; see Gardner (Note 1), pp. 321–35.

[6]Nancy Pistorius, "Drafting and Implementing Collection Development Policies in Academic Art Libraries," in *Current Issues in Fine Arts Collection Development*, Occasional Papers No. 3 (Tuscon, AZ: Art Libraries Society of North America, 1984).

[7]For national and trade bibliographies, see Eugene P. Sheehy, *Guide to Reference Books* 9th ed. (Chicago: American Library Association, 1976), *Supplement*, 1980; *Second Supplement*, 1982.

[8]Barbara Braun, "Art Books," *Publisher's Weekly*: #1 "A World of Change" 224 (August 19, 1983): 22–37; #2 "Reaching for an Audience" 224 (October 21, 1983): 24–33; #3 "Leftovers— and New Directions" 224 (October 28, 1983): 24–30. Discusses characteristics of major U. S. and British art publishers including remainder and reprint houses.

[9]James Casey in his Ph.D. dissertation—*Assessment of Quality in Book Selection: An Evaluation of the Effectiveness of Opinions Rendered by Peer Reviews in American History Journals* (Cleveland: Case Western Reserve University, 1985)—found a correlation between the first review to appear and the acceptance of the book by scholars in the field. Therefore, perhaps selectors can rely upon the first review to appear as an indication of potential usefulness.

[10]See Gardner (Note 1), p. 213.

[11]Herman H. Fussler and Julian L. Simon, *Patterns in the Use of Books in Large Research Libraries* (Chicago: University of Chicago Press, 1969); John Budd, "Libraries and Statistical Studies: An Equivocal Relationship," *Journal of Academic Librarianship* 8 (November 1982): 278–81; D. E. Christiansen et al., "Guide to Collection Evaluation Through Use and User Studies," *Library Resources & Technical Services* 27 (October/December 1983): 432–40.

[12]Stanley J. Slote, *Weeding Library Collections* 2nd ed. (Littleton, CO: Libraries Unlimited, 1982). Another popular book on weeding is Joseph P. Segal, *Evaluating and Weeding Collections in Small- and Medium-Sized Public Libraries: The CREW Method* (Chicago: American Library Association, 1980). See also, D. K. Gapen and S. P. Milner, "Obsolescence," *Library Trends* 30 (Summer 1981): 107–24; G. V. Hodowanec, "Literature Obsolescence, Dispersion and Collection Development," *College & Research Libraries* 44 (November 1983): 421–43; Philip Schwartz, "Demand Adjusted Shelf-Availability Parameters: A Second Look," *College & Research Libraries* 44 (July 1983): 210–19. For a brief annotated bibliography, see Ferris Olin, "Weeding the Library Collection," *ARLIS/NA Newsletter* 9 (February 1981): 55–56.

[13]For basic textbooks and manuals that cover acquisitions work, see Rose Mary Magrill and Doralyn J. Hickey, *Acquisitions Management and Collection Development in Libraries* (Chicago: American Library Association, 1984); Marty Bloomberg and G. Edward Evans, *Introduction to Technical Services for Library Technicians* 4th ed. (Littleton, CO: Libraries Unlimited, 1981); Wallace John Bonk and Rose Mary Magrill, *Building Library Collections* 5th ed. (Metuchen, NJ: Scarecrow Press, 1979); Stephen Ford, *The Acquisition of Library Materials* rev. ed. (Chicago: American Library Association, 1976); Theodore Grieder, *Acquisitions: Where, What and How* (Westport, CT: Greenwood Press, 1978); *Library Technical Services: Operation and Management*, edited by Irene P. Godden (Orlando, FL: Academic Press, 1984).

[14]For a discussion and bibliography, see J. Douglas Archer, "Preorder Searching in Academic Libraries: A Bibliographic Essay," *Library Acquisitions: Practice & Theory* 7 (1983): 139–44. Also of interest, Scott Bullard, "Books-in-Print Online: BRS in the Acquisition Department: A Report on the ALA/RTSD Acquisition of Library Materials Discussion Group, Held January 26, 1982 at the Denver Convention Complex," *Library Acquisitions: Practice & Theory* 6 (1982): 243–45.

[15]Richard K. Gardner, *Library Collections, Their Origin, Selection, and Development* (New York: McGraw-Hill, 1981), pp. 33–34.

[16]American Library Association, Bookdealer-Library Relations Committee, *Guidelines for*

Handling Library Orders for In-Print Monographic Publications (Chicago: American Library Association, 1973).

[17]See also: *Acquisition of Foreign Materials for U. S. Libraries* 2nd ed., edited by Theodore Samore (Metuchen, NJ: Scarecrow Press, 1982); Robert G. Sewell, "Managing European Automatic Acquisitions," *Library Resources & Technical Services* 27 (October/December 1983): 397-405.

[18]William J. Dane, "Art Departments and Standing Orders: A Symbiotic Relationship," *Art Documentation* 2 (December 1983): 185-86. In his article, Dane suggests a maximum of 10 to 15% to the total budget for standing order acquisitions. See also Dan Stave, "Art Books on Approval: Why Not?", *Library Acquisitions: Practice & Theory* 7 (1983): 5-6; Douglas Duchin, "The Jobber as a Surrogate Acquisitions Librarian," *Library Acquisitions: Practice & Theory* 7 (1983): 17-20; Anna H. Perrault, "A New Dimension in Approval Plan Service," *Library Acquisitions: Practice & Theory* 7 (1983): 35-40; John H. Reidelbach and Gary M. Shirk, "Selecting an Approval Plan Vendor: A Step-by-Step Process," *Library Acquisitions: Practice & Theory* 7 (1983): 115-22. See also John Nicoll, "The Economics of Book Publishing," *Art Libraries Journal* 3 (Winter 1970): 17-24; and "The Economics of Art Publishing," *ARLIS/NA Newsletter* 8 (Summer 1980): 113-18, which included three short articles—Gabriel Austin's "The Prices of Books on the Arts," Brian Gold's "Exhibition Catalogues," and Richard Martin's "Art Periodicals."

[19]Susan A. Davi, "Automatic Acquisition Plans for the Art Library," in *Current Issues in Fine Arts Collection Development*, Occasional Papers No. 3 (Tucson, AZ: Art Libraries Society of North America, 1984).

[20]For a discussion and bibliography on out-of-print acquisition practice, see Thomas D. Kilton, "Out-of-Print Procurement in Academic Libraries: Current Methods and Sources," *Collection Management* 5 (Fall/Winter 1983): 113-34.

[21]A good review of automated systems and what they should include can be found in Richard W. Boss, *Automating Library Acquisitions: Issues and Outlook* (White Plains, NY: Knowledge Industry Publications, 1982).

[22]Gay D. Henderson, "Automated Acquisitions and the Shared Database: LCS," *Library Acquisitions: Practice & Theory* 7 (1983): 91-95; John Earl Keeth, "Automated Acquisitions and the Shared Database: OCLC," *Library Acquisitions: Practice & Theory* 7 (1983): 97-99; Jeanne E. Boyle, "Automated Acquisitions and the Shared Database: RLIN," *Library Acquisitions: Practice & Theory* 7 (1983): 101-07.

[23]Shirley Leung, "The INNOVACQ 100 System: Experience of a Pilot User," *Library Acquisitions: Practice & Theory* 7 (1983): 127-38.

[24]See K. J. Bierman, "Vendor Systems and On-Line Ordering," *Journal of Library Automation* 13 (September 1980): 170-81; and Sharon C. Bonk, "Integrating Library and Book Trade Automation," *Information Technology and Libraries* 2 (March 1983): 18-25.

[25]For a special application of the RLIN acquisition subsystem, see Cynthia D. Clark and Christina L. Feick, "Monographic Serials and the RLIN Acquisitions System," *Serials Review* 10 (Fall 1984): 68-72.

[26]Alfred Lane, *Gifts and Exchange Manual* (Westport, CT: Greenwood Press, 1980). For an amusing but realistic view of gifts, see Wanda V. Dole, "Gifts and Block Purchases: Are They Profitable?" *Library Acquisitions: Practice & Theory* 7 (1983): 247-54. Available from the Cleveland Museum of Art, for a fee, is a 37-page *Gifts and Exchange Manual* compiled in 1983 by Julie Stielstra.

[27]For foreign exchanges, a library can also have recourse to the Universal Serials and Book Exchange, Inc. (USBE). Set up after World War II, it is one of the oldest library cooperative ventures and membership is open to any library. However, it has been primarily involved with scientific and technical materials. For additional information see *The Bowker Annual of Library and Book Trade Information* 29th ed. (New York: R. R. Bowker, 1984).

13

Cataloging and Preservation

INTRODUCTION

Once materials have been acquired, they must be organized to facilitate retrieval and preserved for future generations. These are the concerns of this chapter. Because special cataloging treatment is usually given to auction catalogs, trade literature, government publications, microforms, visual resources, and building and decorative arts samples, these items were discussed in the appropriate chapters of Part II.

CATALOGING

The library's chief mechanism for bibliographic control of its own collections is its catalog. In order to construct a catalog, elaborate systems for bibliographic description have been embodied in codes, extensive classification schemes created, and networks of subject headings designed. Because these various devices were created for a general library, they often cause problems for an art library collection.

Cataloging for art libraries is done in one of two ways: in the library itself by the institution's own personnel or in a central catalog department. The pattern of the centralized department is most prevalent in large public or academic library systems. While catalogers responsible for art materials may

have expert subject knowledge, they must often conform to a system that, in many respects, will give less than ideal results for the art library, particularly in the areas of choice of access points and classification.

The Library of Congress has had an overwhelming impact on all cataloging processes in this country. Cataloging rules and options as interpreted by LC are followed implicitly in most cases. The distribution of its cataloging products and aids—such as the *National Union Catalog* (*NUC*) printed book catalogs, MARC (machine-readable cataloging) magnetic tapes, and cataloging-in-publication (CIP) data—provide a mine of information for the American catalog librarian. Canadian librarians are similarly served by the National Library of Canada. Cataloging code interpretations and options are published quarterly in the *LC Cataloging Service Bulletin*. Many libraries use the *Library of Congress Subject Headings*, abbreviated *LCSH*, and its supplements and the Library of Congress classification scheme.[1] In addition, the LC maintains the editorial offices of the Dewey Decimal Classification and assigns Dewey class numbers as well as its own LC numbers to a great many works.[2]

Because of the availability of cataloging data—through the Library of Congress, the bibliographic utilities, the *Weekly Record*, the *American Book Publishing Record* (*BPR*), and other printed sources—much cataloging today is merely copy cataloging. The cataloger or a technical assistant compares the work in hand with the copy available and accepts it as is or makes appropriate, often slight, modifications. If the library belongs to a computer network, location of cataloging copy is greatly facilitated. For those libraries with limited budgets, joining with other local institutions in a cooperative arrangement offers the means of acquiring cataloging copy less expensively.

An art library collection frequently contains material, such as exhibition catalogs, for which either no cataloging copy is available or for which existing records are unsuitable and must be greatly modified. In addition, exhibition catalogs are published in almost every known language. Only the largest institutions are likely to employ personnel with varied linguistic skills. It is often difficult to locate a cataloger who is adept in more than one modern European language. Even so, a great deal of original cataloging must be done. This usually falls within the province of the professional staff member.[3]

Due to the ease with which many of the records can be edited, the role of the professional cataloger is often primarily organizational and supervisory. Policies and procedures must be established to ensure a smooth work flow. Generally, operations involve the following:

(1) Pre-cataloging search for a record, which should be coordinated with—and not duplicate—pre-order verification;

(2) Cataloging by matching the work in hand with the record located in the search and copying it;

(3) Cataloging by using a record which requires editing;

(4) Performing original cataloging; and

(5) Creating and/or maintaining the authority files for names, series, and subjects, many of which are now part of the central bibliographic utilities' databases.

The work of the catalog department will be aided by a manual of procedures and codification of decisions. Not only can it be used as a guide to local practice where it deviates from the norm, but it can also be used as an in-service training device for new personnel, if it presents routines in a sufficiently detailed and logical fashion. In addition, public service librarians can use it as an aid to catalog interpretation. If a procedures manual has not been written, the librarian should develop one by utilizing any of the basic library textbooks as a guide.

Whatever form the catalog assumes—card, microform or COM, or online public access—there are several basic processes involved in constructing it. A distinction is usually made among the processes, even if they are all performed by the same person. These include (1) bibliographic description, (2) choice of access points, and (3) classification of material.

Descriptive Cataloging

Descriptive cataloging usually refers to the preparation of the bibliographic description and the selection of catalog access points other than subject headings. For most North American libraries, rules for descriptive cataloging are embodied in the second edition of *Anglo-American Cataloguing Rules* (AACR2).[4] A primary objective of this code is to achieve consistency in treatment of different formats, names, and choices of access points. Older libraries will have catalogs that were developed under a variety of rules and principles and, therefore, will be inherently inconsistent, unless all changes were incorporated as new codes were established. Because codes are designed to cover general cases, they were often thought to be inappropriate for local or special conditions, which resulted in modifications. In recent years, the development of online and shared or cooperative cataloging programs has brought great pressure for all libraries to conform to a single standard. As costs have increased, it has become apparent that local variations are expensive in terms of processing time and that non-adherence to the standard tends to negate the value of cooperation. On the other hand, there is apprehension that loss of local modifications may carry a hidden cost in decreased service to the user. Not only do patrons often find the catalog difficult to use, but even reference librarians have accused catalogers of

Third-level description:

 Wittkower, Rudolf.
 Art and architecture in Italy, 1600 to 1750 /
 Rudolf Wittkower -- 3rd rev. ed., reprinted with
 corrections and augmented bibliography --
 Harmondsworth, Middlesex ; New York, N.Y. : Penguin
 Books, 1980.
 664 p. : ill. ; 21 cm. -- (The Pelican
 history of art).
 Bibliography: p. 581-621.
 Includes index.
 ISBN 0-14-056116-1 (pbk.) : $16.95.

Second-level description:

 Wittkower, Rudolf.
 Art and architecture in Italy, 1600 to 1750 /
 Rudolf Wittkower -- 3rd rev. ed., reprinted with
 corrections and augmented bibliography --
 Harmondsworth, Middlesex : Penguin Books, 1980.
 664 p. : ill. ; 21 cm. -- (The Pelican
 history of art).
 Bibliography: p. 581-621.
 Includes index.
 ISBN 0-14-056116-1 (pbk.).

First-level description:

 Wittkower, Rudolf.
 Art and architecture in Italy, 1600 to 1750 --
 3rd rev. ed. -- Harmondsworth, Middlesex, 1980.
 664 p.
 Bibliography: p. 581-621.
 Includes index.
 ISBN 0-14-056116-1 (pbk.).

Example 13/1. Bibliographic records for a monograph, illustrating three levels of description.

creating an esoteric instrument that they alone can use successfully.[5] Nevertheless, with the advent of more powerful and less expensive computer hardware and software, it is hoped that the day may arrive when standards can be enforced and local adaptations accommodated.

The elements of the bibliographic description specified by AACR2 are based upon the various International Standard Bibliographic Descriptions (ISBDs) as formulated by the International Federation of Library Associations (IFLA).[6] Among the purposes of ISBD is standardization to facilitate the international exchange of bibliographic data. To this end, the description must be complete in itself without regard to access points. Mandatory and optional data elements within the description are prescribed by AACR2. The three levels of description illustrating the varying amount of detail at each level are shown in Example 13/1.

```
020        0140561161 (pbk.) : ≠c16.95
043        e-it---
100  1 0 Wittkower, Rudolf.
245  1 0 Art and architecture in Italy, 1600 to 1750 / ≠cRudolf
           Wittkower.
250        3rd rev. ed., reprinted with corrections and augmented
           bibliography.
260  0 b Harmondsworth, Middlesex; ≠aNew York, N.Y. : ≠bPenguin
           Books, ≠c1980.
300        664 p. : ≠bill. ; ≠c21cm.
440  b 4 The Pelican history of art.
504        Bibliography: p. 581-621.
500        Includes index.
```

Example 13/2. Bibliographic record for a monograph with MARC codes.

The briefer first- or second-level descriptions may be adequate for many small- or medium-size libraries. In the first or lowest level, the name of the publisher and any series information are absent, as is the statement of responsibility—the author, creator, or corporate source of the material. Moreover, the physical description includes only pagination. The third level, which includes any second place of publication, is very similar to the second form.

For input into an automated system, each element of bibliographic information would be coded according to the MARC format, the standardized communications format enabling the computer to recognize and manipulate these elements. Example 13/2 shows the preceding record coded with the MARC tags, indicators, and subfield codes.[7]

In 1980 the Library of Congress published the *National Level Bibliographic Record-Books* (*NLBR-Books*), which specified two levels of record—minimal and full. As a result many libraries plan to follow LC's lead and catalog certain categories of material at the minimal level. However, if the LC minimal level is followed, the subject (or 600) field is not included, entailing loss of important access points. If a library is a member of a cooperative network, it must conform to the network standards when inputting records, but unwanted elements may be suppressed for its own catalog. For example, OCLC has defined two levels—K and I—in their *Bibliographic Input Standards*, which, while not identical to LC, are similar.[8] Some RLIN members subscribe to a base-level standard for books and for abbreviated cataloging of exhibition catalogs. In fact, the RLIN Art and Architecture Program Committee has recommended that the code of practice among their members be at a slightly higher level than the RLG base-level cataloging standard.

Application of the code to exhibition catalogs—those backbones of the art library—is frequently difficult. These materials seem to defy standardization. Publication information may be missing or ambiguous and the physical package is often odd. For example, the publication date of an

exhibition catalog of Romare Beardon's painting had to be inferred from data in the book. The reproductions of the paintings indicated dates of 1972 and 1973. The catalog was received by the library in 1977; no cataloging copy could be found. The cataloger, therefore, settled on a date of "[between 1973 and 1977]." In another example, a Dutch exhibition catalog on Constantjn Huygens recorded only the exhibition dates with the publishing information on the verso of the title page, "Uitgeverij Terra Zutphen." Knowing that "Uitgeverij" is the equivalent of "published by," the cataloger deciphered "Zutphen" as the place of publication and "Terra" as the publisher. And as to odd packaging, the catalog for the Los Angeles exhibition of Billy Al Bengston's work had a sandpaper cover. A note to this effect had to be made and the item placed in a pamphlet binder.

Certain aspects of description for serials should also be noted. AACR2 mandated a significant change in designating the title page of the first issue of a serial as the chief source of information; prior to AACR2, the latest issue was used. As a result, if the library does not own the first issue, the cataloger may have to undertake an extensive search in such sources as an online database, *Union List of Serials* (*ULS*), or *New Serial Titles* (*NST*). Example 13/3 illustrates two types of entries: (1) for a journal that is still publishing and is, therefore, referred to as live and (2) for a publication that has changed its name and is, consequently, considered dead. Example 13/4 shows entries for the same serials with the MARC codes. Under the principle of successive entry, every time a serial undergoes a change of title, or, if entered under a corporate body, the name of that body changes; a separate entry with separate descriptions is made. If patrons want the earlier or later files, they must look them up separately.

Note that in the entry for the live serial in Example 13/3, the statement of responsibility, Worcester Art Museum, is included in the transcription. Both serials have been described with numeric and chronological designations beginning with the first issue. This is done regardless of whether the library has that issue or not. The date of publication is given, even if it duplicates the date in the numeric-chronological area. The frequency of publication is repeated in the notes unless it is obvious from the title. But it is important to realize that many librarians do not fully catalog serials but rely instead upon their serial records alone. In doing this, the main entry, or chief access point, becomes the only entry; description may be minimal. It is useful to remember that LC is using enhanced level I cataloging for serials.

Access Points

AACR2 makes a clear distinction between the choice of entry and the form that the entry should take. For instance, to say that Pliny's *Historia naturalis* should be entered under his name, does not indicate the form of the name prescribed by the code. It should, in fact, be Pliny the Elder. The cataloger

Open entry for a live serial:

```
Journal / Worcester Art Museum.   -- Vol. 1 (1977-78) --
      Worcester, Mass.:  The Museum, 1979-
         v. :  ill. ; 28 cm.
      Annual.
      Merger of:  Worcester Art Museum Bulletin, new
ser.; and, Annual report/Worcester Art Museum.
      Includes:  Annual report of the trustees and
officers.
```

Closed entry for a dead serial:

```
College art journal. -- Vol. 1, no. 1 (nov. 1941)-
      19, 4 (summer 1960). -- [New York] : College Art
      Association of America, [1941-1960].
      19 v. :  ill. ; 23 cm.
      Quarterly.
      Called also: CAJ, v. 11, no. 2-
      Continues: Parnassus.
      Continued by: The Art journal.
      Designations vol. and no. dropped with 14, 3,
spring 1955.
```

Example 13/3. Bibliographic records for a live and a dead serial.

must be careful to notice that in older catalogs and in many bibliographies, the name was entered in the Latin form, "Plinius Secundus, C." These variant forms must be linked by means of references.

Control of names and references is achieved by means of an authority file, which is a record of authorized headings for personal and corporate/conference names, uniform titles, series, topical subjects, and geographic names with an indication of the references made to them. These references either indicate when the heading is not used or when there is a related heading. For example, there should be a reference from "Scott, M. H. Baillie" to "Scott, Mackay Hugh Baillie, 1865-1945," which is the authorized heading. "Housing, see also Industrial housing" is an illustration of a related subject term. Searchers use these authority files not only to determine the AACR2 accepted form of a name, but to see what specific subject headings are assigned to topics, what headings are related, as well as the LC class numbers that are appropriate for many subjects. Individual libraries can now rely upon the shared general online authority files which are already available through OCLC and RLIN.

There are certain major provisions of AACR2 for formulating entries with which art librarians should be familiar. For example, one underlying principle is the determination of authorship responsibility, although the rules severely limit the concept of corporate authorship. As a result, museums and galleries are rarely used as main entries. The cataloger must make additional entries

```
010        79643712
022 0      0193-9564
050 0      N870=b.A413
082        708/.144/3
130 0 0    Journal (Worcester Art Museum)
222 1 0    Journal - Worcester Art Museum
245 0 0    Journal /≠cWorcester Art Museum
246 1 8    Worcester Art Museum Journal≠f1977/78-
260 0 0    Worcester : ≠bWorcester Art Museum, ≠cc1979-
265        Worcester Art Museum, 55 Salisbury Street Worcester,
           Mass. 01608
300        v. : ≠bill. ; ≠c28 cm.
362 0      Vol. 1 (1977-78)-
580        Formed by the union of: Worcester Art Museum, Worcester,
           Mass.  Worcester Art Museum bulletin; and, Worcester Art
           Museum.  Annual report of the trustees and officers.
650     0  Art - ≠xPeriodicals
610 2 0    Worcester Art Museum - ≠xPeriodicals.
780 1 4    ≠tAnnual report of the trustees and officers
780 1 4    ≠tWorcester Art Museum bulletin≠x0364-734x
```

```
035        (OCoLC)1642589
245 0 0    College art journal.
246 0 0    Art journal
260 0 1    New York : ≠bCollege Art Association of America, ≠c
           -1960.]
300        v. : ≠bill. ; ≠c24-28 cm.
362 1      Began with: Vol. 1 (Nov. 1941).
362 1      Ceased with: Vol. 19, no. 4 (summer 1960).
500        Description based on: Vol. 19, no. 4 (summer 1960).
530        Also issued on microfilm.
650     0  Art - ≠xStudy and teaching - ≠xPeriodicals.
650     0  Art - ≠xPeriodicals
710 2 0    College Art Association of America.
780 0 2    ≠tParnassus≠g1929-1941
785 0 0    ≠tArt journal≠x0004-3249≠g1960-
```

Example 13/4. Bibliographic record for serials with MARC codes.

under their names to ensure access. In addition, the cataloger must remember that an institution is entered under the name it used at the time of the publication in hand. For example, the Musée royal de l'Afrique centrale has entries under two other names: Musée du Congo belge and Musée royal du Congo belge. All names must be linked by means of "See also" references. Artists can be considered authors. For instance, a book on Milton Avery containing 48 illustrations and 20 pages of text is entered under his name, although the title page clearly states "Text by Bonnie Lee Grad."

Editors are not chief access points, and most serials are now entered under their titles rather than under the name of the sponsoring body. Entry by title causes long files beginning with generic terms such as *Journal, Report,* or

Bulletin. Such a file is tedious to search manually, and in the machine searching environment, these words may be suppressed as yielding too many entries.

In many instances, application of AACR2 has altered the manner in which catalogers treat artists' names. Formerly a great deal of time was spent searching a variety of reference tools in order to verify the real name of an artist. At the present time, the choice must be the name the artist prefers to use or the most commonly known name. Thus, "Charles Rogers Grooms" is entered as "Red Grooms" and the old heading "Tintoretto, Jacopo Robusti, known as, 1512 to 1594" has become simply "Tintoretto, 1512–1594."

To facilitate the retrieval of records, most catalogs provide the needed references and multiple access points. The prime drawback to the liberal provision of added entries is cost. Indeed, in libraries with centralized processing, adding entries may not be possible without creating individual department files, which have long been the anathema of administrators. For instance, a university's central processing department may have a policy of not making added entries for such items as publishers' series. But, as an example, the fine arts librarians know that their clientele, having located one book, will ask for other titles in the various *Time-Life Series*. To resolve this problem, discussions between public services and technical services personnel are in order. Ideally, there should be considerable leeway in the matter of access points; additional entries should be made for any reasonable approach a researcher might take.

Because a book can be shelved in only one place, but may treat many topics, librarians have used multiple subject headings to overcome this limitation. Furthermore, the network of cross references displays other aspects of a topic that are not evident from a one-place classification order. In a closed-stack library, where browsing is not possible, the subject catalog assumes even greater importance as the user's only guide to the subject content of most of the collection.

Subject catalogers follow three basic steps in analyzing a document. First, the work is examined and its subject content determined. Second, aspects or points of view of the author are considered as are interrelationships if two or more subjects are involved. The third step is to translate the subject and its aspects into a particular controlled vocabulary or system. The same process is followed when assigning subject headings from a list, indexing terms from a thesaurus, or providing class numbers from a classification scheme.

At present there is no entirely satisfactory list of subject terms available to the art librarian. The most used terms are those contained in the *Library of Congress Subject Headings List* (*LCSH*), which may be utilized with any classification scheme. Because *LCSH* is designed for a general library, there

are innumerable headings beginning with "Art" which create enormously long files. Some of this could be avoided if terms were not inverted; for example, "Flemish art" instead of "Art, Flemish."[9]

Reliance upon the Library of Congress entails an understanding of its policies. First of all, LC follows the principle of specificity, whereby a heading is assigned which expresses the special subject of a work, rather than a broader topic that encompasses the special one. The heading for a work on American painting—such as John Wilmerding's *The Genius of American Painting*—is "Painting, American" not "Art, American." This necessarily limits the number of subject headings assigned. On the other hand in many instances, LC assigns a general heading as well as a specific one. An example is their treatment of biographical works. The person about whom the work is written is assigned a heading to which is added the subject heading for the primary occupation with the subdivision "Biography." For instance, a work on the life of Winslow Homer would receive the subject headings: "Homer, Winslow" and "Painters—United States—Biography."

Another problem is the method by which individual works of art are listed. If the work of art is permanently located, there is a subject entry under its name. But if the art piece is movable, the subject entry is under the artist's name followed by the title of the object. For example, "Michelangelo Buonarroti, 1475-1564" is a subject entry. However, books on the Sistine Chapel—which was decorated by a number of artists in addition to Michelangelo—are not placed under the Italian artist's name but under the subject heading for the chapel, "Vatican. Capella Sistina." A reasonable solution has been proposed whereby a subject heading will be used for the artist, if known, with a subdivision for individual works.[10]

Some libraries do not follow *LCSH* exactly, but instead make modifications to the basic list; both LC and RLIN provide fields for locally assigned subject headings and classification notations. A few libraries may adopt an in-house scheme. In the latter case, guidelines may be found in the main principles governing the system formerly used at the Thomas J. Watson Library of the Metropolitan Museum of Art.[11] However, to facilitate computerization, this New York library closed its card catalog on July 1984, and a new catalog that incorporates LC subject headings was started. Librarians with a unique subject heading system should weigh the advantages of a nationally accepted system against the cost of in-house maintenance. As the bibliographic utilities permit addition of local subject headings, the utmost flexibility now seems possible.

Many art librarians have come to believe that they have had, and will have, little influence on LC in the matter of revision of subject headings. Changes in LC practices have been recommended by various groups, such as the Subject Analysis Committee of the American Library Association Resources

and Technical Services Division, the Art and Architecture Program Committee of the Research Libraries Group, and ARLIS/NA. Even groups, such as these, with subject expertise and working first-hand knowledge have had little impact.

Many library organizations have supported the Art & Architecture Thesaurus, a project which has been funded—at various times—by the Council on Library Resources, the National Endowment for the Humanities, the Andrew W. Mellon Foundation, and the J. Paul Getty Trust.[12] The Art & Architecture Thesaurus will cover three subject areas: Architecture, Decorative Arts, and Fine Arts. In trying to compile a list of the most commonly used terms in these disciplines, the initial compilation was the merging of the vocabulary used in four publications: *Avery Index to Architectural Periodicals, Library of Congress Subject Headings (LCSH), RIBA Architecture Periodicals Index*, and *RILA: International Repertory of the Literature of the Art.*

How varied the subject headings or descriptors can be is illustrated by those assigned to the article by Iain Boyd Whyte, "The End of Avant-Garde: The Example of 'Expressionist' Architecture." In searching the *Avery Index*, there was one subject access point to this article—"Expressionism (Architecture)." In *RILA*, there were three—"Architecture, German/and Expressionism (1916–1922)," "Dada/exhibitions and development of German architecture," and "Expressionism/Germany/architecture." But if the Art & Architecture Thesaurus (AAT) had been used, there would have been two: "Avant-garde in Germany/20th century" and "Expressionist architecture in Germany/20th century."

The AAT will consist of two types of sections: (1) hierarchical, which will indicate the relationship between terms and (2) alphabetical, which will provide preferred or main terms, non-preferred or lead-in terms, and a rotated index which will display—in context—each word in a multi-word term. If, as many art librarians hope, the AAT becomes a separate file in RLIN's authority system, it will provide a standardized indexing vocabulary online for the entire field of art documentation.

Classification of Materials

Classification in the United States is used primarily as a shelving device. In an open-stack library browsing is facilitated by classified arrangement which is also a useful corollary to the subject catalog. The classification scheme can display logical associations that are not readily apparent in a dictionary catalog. In North America, the most widely used classification schemes are the Dewey Decimal and the Library of Congress. Academic libraries have tended to use LC; the public libraries, Dewey. Business and

research libraries often utilize special schemes or variants of Dewey and LC.[13] LC call numbers are readily available through the bibliographic utilities and other printed sources. Although the Library of Congress assigns Dewey class numbers to a wide variety of materials, book numbers must be added if a unique call number is desired.[14]

Using either classification scheme will scatter works about artists working in different media. Both schemes separate drawings from prints, although art museums sometimes house those media together. Dewey accommodates photography at 770; LC, in TR. In some institutions, this will result in photography references being housed in another building, with such technical materials as engineering and science. In both schemes, materials on aesthetics will be widely separated from art. In Dewey, they are found in class 100, in LC, in BH. Because the Dewey 700s encompass not only fine and decorative arts, but music, recreation, and performing arts, the consequence is some strange bedfellows. Materials on music, theater, ballet, darts, bowling, roulette, poker, soccer, horse racing, hunting, and fishing may all fall within the bailiwick of a fine arts library classified by Dewey.

The use of either scheme may result in cross classification by which a reference could be classified in either of two or more places. For example, Dewey provides for Art in Christianity at 246. Books dealing with the religious significance and purpose of works of art are classified under this number, but references treating the creation, description, and critical appraisal of religious art works are classed in 700. This is often an impossible distinction to make. Furthermore, with Dewey, close classification or specificity is achieved only at the expense of very long notations. Closer classification with shorter notations is possible with LC's pigeon-holing system. An example of the difference in length between some Dewey notations and those of LC are the following class numbers assigned to the catalog—*West 79/The Law: An Exhibition of Contemporary Art Reflecting Aspects of the Law*. The Dewey number reflects the focus of the exhibition, while the LC number does not:

Dewey: 709′.73′0740176581
LC: N6512.W43

It should be noted that the Library of Congress indicates two appropriate places to truncate the Dewey number by the use of the prime marks.[15]

Whatever classification is used, it is important to try to maintain consistency in assigning numbers. This is achieved by checking the shelf list—the inventory of the library's holdings arranged by call number—to see how the notation was used in the past and by noting what subject headings have been associated with particular class numbers. Occasionally a central catalog department may use a class number that seems inappropriate in the art library. For example,

in one library, a work on the architecture of monastic libraries in Italy in the 15th century was assigned a Dewey number of 027.68, which denotes libraries of religious organizations but has nothing to do with architecture. When this happens the librarian should consult with the cataloger about the possibilities of selecting a more suitable classification. Many art libraries have more than one classification scheme. Some institutions, having decided to switch from Dewey to LC, have not yet completed the process, leaving a split collection. If this is the case, adequate guidance must be provided the patrons.

A number of special schemes and variants of Dewey and LC have been devised to overcome some of their drawbacks. These classification systems enjoy local, if not widespread, popularity. But it should be remembered that maintaining them is tedious, and even though they are specially designed, they do not, as a rule, permit any closer classification than Dewey or LC. Among these are (1) the original Metropolitan Museum of Art Library classification, which is still used by the Cleveland Museum of Art; (2) the currently used Metropolitan Museum scheme; and (3) the system used by the Art Institute of Chicago. The classification schemes of the Fine Arts Library of the Fogg Art Museum at Harvard University and the National Gallery of Art in Washington, D.C., are adaptations of LC. Although not used much in North America, there are other systems, such as the Universal Decimal, Bliss' Bibliographic Classification, and a faceted scheme developed by Peter Broxis in England.[16]

CONSERVATION/PRESERVATION

While preservation of the collection has always been of paramount importance, it is only since the late 1950s that the magnitude of the problem of deterioration has been widely acknowledged.[17] Primarily a concern of the research institutions with enormous retrospective collections, nevertheless, all librarians are responsible for the proper care of materials. For instance, some publishers issue books with such poor bindings that they should immediately be rebound. However, it is sometimes difficult to rebind art books due to their coated paper which increases their weight. Loose or tipped-in plates may need to be firmly attached. The librarian must be able to distinguish between those items that can be repaired from those that need conservation attention.

Because of its high percentage of acid, paper made after 1860 is the most likely to deteriorate. Books published during the war years, especially those of World War II, are particularly vulnerable. A number of attempts have

been made to employ mass deacidification techniques, but even after treatment the paper remains very fragile. The technique of mylar encapsulation has been used to arrest disintegration in posters, newspapers, maps, and letters. The Library of Congress Preservation Office issues a series of free *Preservation Leaflets* which cover a number of aspects of this problem.[18]

Art books are especially susceptible to vandalism. Plates that have been ripped out or torn need to be repaired and reinserted. An archival-quality adhesive must be used; never use non-library tape or rubber cement. Because so many art books are expensive, some type of limited access should be considered for circulating libraries. When books or serials have been identified as being in poor condition—with loose or damaged bindings; brittle, damp, or mildewed paper; or torn or missing pages—a number of options can be considered.[19] Items can be discarded if other copies in good condition are available or another edition can be substituted. Books can be rebound, unless the paper is too brittle or the gutter margins too narrow. Books can be returned to the stacks—as they are or wrapped in acid-free paper—tied with cloth tape which can be purchased from library-supply houses. Valuable books can be placed in commercially produced or custom-made, acid-free boxes, which are expensive. A reprint edition can be obtained if the paper used is durable and the reproductions are of high quality. Microforms can be ordered, but illustrations will not be comparable. Photoduplication is a widely used means of replacement, both for entire volumes and for missing pages or sections. Unfortunately, the photographs of illustrations are usually substandard. Copies should always be made on permanent/durable paper. A combination of solutions can be effective. The text can be photocopied on archival-quality bond paper, and the reproductions can be encapsulated in mylar.

All art librarians should have some knowledge of basic conservation measures and should examine the procedures used in their own libraries for processing, handling, and storage. Those segments of the collection that need attention should be identified by asking such questions as, What needs to be preserved and in what order? Good collection management must include preservation considerations. As Paul Mosher has defined it, collection management is "the systematic, efficient and economic stewardship of library resources."[20]

It is advisable for librarians to formulate organized plans to help cope with disasters, such as fire, flood, or broken water pipes. An excellent planning guide, which also deals with methods of prevention of catastrophe, is Hilda Boehm's *Disaster Prevention and Disaster Preparedness*.[21] Before a

catastrophe occurs, the librarian should have compiled lists for the following:

1. Library staff members who have been assigned responsibilities during a disaster with their home phone numbers;

2. Priorities for salvage, including floor plans that indicate the location of items to be saved first;

3. Outside resource people with experience in salvage operations and their phone numbers; for example, a professional photographic laboratory equipped to process water-damaged prints and negatives;

4. Sources for emergency materials, especially a cold storage facility; the more quickly water-damaged books can be frozen, the more likely the fatal growth of mold will be retarded. Copies of the plan should be posted throughout the library, and the staff reminded from time to tme of its existence. Periodically the library's insurance coverage should be reviewed, since collections tend to accrue in value with age.

NOTES

[1]Library of Congress, Subject Cataloging Division, *Library of Congress Subject Headings* 9th ed. (Washington, DC: Library of Congress, 1980). With quarterly supplements cumulated annually; also available in a microform edition, cumulated quarterly. Library of Congress, *Library of Congress Classification: Classes A–Z*, 34 volumes., various editions (Washington: Library of Congress, 1917–); Library of Congress, Subject Cataloging Division, *L.C. Classification— Additions and Changes* (Washington, DC: Library of Congress, 1928–) (issued quarterly). Indispensable guides to the LC classification and to *LCSH* are Lois Mai Chan, *Immroth's Guide to the Library of Congress Classification* 3rd ed. (Littleton, CO: Libraries Unlimited, 1980); Lois Mai Chan, *Library of Congress Subject Headings: Principles and Applications* (Littleton, CO: Libraries Unlimited, 1978).

[2]Melvil Dewey, *Dewey Decimal Classification and Relative Index* 3 volumes, 19th ed. (Albany, NY: Forest Press, 1979); Melvil Dewey, *Abridged Dewey Decimal Classification and Relative Index* (Albany, NY: Forest Press, 1979); Library of Congress, Decimal Classification Division, *Dewey Decimal Classification: Additions, Notes and Decisions* (Washington, DC: Library of Congress, 1959–) (Irregularly issued). A valuable guide to the Dewey Decimal Classification is Jeanne Osborn, *Dewey Decimal Classification, 19th edition; A Study Manual* (Littleton, CO: Libraries Unlimited, 1982).

[3]A number of basic cataloging textbooks and manuals are available. Among them are Lois Mai Chan, *Cataloging and Classification: An Introduction* (New York: McGraw-Hill, 1981); Ronald Hagler and Peter Simmons, *The Bibliographic Record and Information Technology* (Chicago: American Library Association, 1982); Bohdan Wynar, *Introduction to Cataloging and Classification* 6th ed. (Littleton, CO: Libraries Unlimited, 1980). A simpler manual, very valuable for small libraries, is Arthur Curley and Jana Varlejs, *Akers' Simple Library Cataloging* 7th ed. (Metuchen, NJ: Scarecrow Press, 1984). Two useful manuals which are more specialized are Arlene Taylor Dowell, *Cataloging with Copy: A Decision-Maker's Handbook* (Littleton, CO: Libraries Unlimited, 1976); Donald L. Foster, *Managing the Catalog Department* 2nd ed. (Metuchen, NJ: Scarecrow Press, 1982). To keep up to date, consult *Cataloging Service Bulletin*, no. 1– (Washington DC: The Library of Congress, 1978–), (issued quarterly), which supersedes *Cataloging Service*, bulletins 1–125 (1945–1978).

[4]*Anglo-American Cataloging Rules* 2nd ed. (Chicago: American Library Association, 1978).

Useful in conjunction with the code are Margaret F. Maxwell, *Handbook for AACR2: Explaining and Illustrating Anglo-American Cataloguing Rules* (Chicago: American Library Association, 1980); Art Libraries Society of North America, *AACR2 Goes Public*, Occasional Papers No. 1 (Tucson, AZ: Art Libraries Society of North America, 1982); Sally E. Tseng, *LC Rule Interpretations of AACR2*, 1978-1982, cumulated ed. (Metuchen, NJ: Scarecrow Press, 1982). There is also an abridged version of the code: Michael Gorman, *The Concise AACR2, Being a Rewritten and Simplified Version of Anglo-American Cataloging Rules*, 2nd ed. (Chicago: American Library Association, 1981). Reviewed in *Art Documentation* 2 (Summer 1983): 121.

[5]See, for example, the article by Daniel A. Starr, "Behind AACR2: An Introduction for the Reference Librarian," *AACR2 Goes Public* (Tucson, AZ: Art Libraries Society of North America, 1982), p. 7. "The reference librarian's approach is wary . . . as if every time he uses the catalog he asks himself, 'Now where did they hide it this time?' ".

[6]International Federation of Library Associations, *International Standard Bibliographic Description for Monographic Publications* 1st standard ed. (London: IFLA, Committee on Cataloging, 1974). ISBDs also have been published for cartographic materials (1979), nonbook materials (1976), serials (1974), and printed music (1980).

[7]Library of Congress, Automated Systems Office, *MARC Formats for Bibliographic Data* (Washington, DC: Library of Congress, 1980-). (Looseleaf for updating)

[8]Library of Congress, *National Level Bibliographic Records—Books* (Washington, DC, Library of Congress, 1980); OCLC, Inc., *Online Systems Bibliographic Input Standards* (Dublin, OH: OCLC, Inc., 1980).

[9]See, for example, Marcia Collins, "Final Draft—Cataloging Advisory Committee: Subject Headings for works of Art," *ARLIS/NA Newsletter* 6 (May 1978): 39-43.

[10]For discussions of LC use of subject headings, see *Art Documentation* (and its predecessor *ARLIS/NA Newsletter*) CISSIG (Cataloging and Indexing Systems Special Interest Group) columns, and especially sections compiled by Anna Smislova of the Library of Congress Humanities Division—"Art Subject Headings: General Principles," *Art Documentation* 2 (May 1983): A1-A8; and "Architecture Subject Headings," *Art Documentation* 2 (Summer 1983): A9-A13. Also see Ed Blume, "LC Practice on Subject Headings," *ARLIS/NA Newsletter* 4 (Summer 1976): 134-35; and the CISSIG Column edited by Karen L. Meizner, "Answers from L. C." *Art Documentation* 4 (Spring 1985): 17.

[11]Celine Palatsky, "Art Library Subject Headings System: The Metropolitan Museum of Art," *Special Libraries* 67 (August 1976): 371-76.

[12]See Pat Molholt and Toni Petersen, "The Role of a Thesaurus in Automated Data Retrieval," in *Census: Computerization in the History of Art*, edited by Laura Corti (Pisa: Scuola Normale Superiore and Los Angeles: The J. Paul Getty Trust, 1984), Vol. 1. (See also Chapter 2, Note 18). See also Toni Petersen, "The AAT in the Online Catalog Environment," *Art Documentation* 1 (December 1982): 183-85.

[13]See, for example, Peter Broxis, *Organizing the Arts* (Hamden, CT: Archon Press, 1968); Eileen Markson, "Archaeology and the Library of Congress Classification: Problems and Solutions," *ARLIS/NA Newsletter* 7 (October 1979): 123-25; "Library Classification Schemes and the Visual Arts," edited by David J. Patten, *ARLIS/NA Newsletter* 4 (Summer 1976): Supplement 1-12; William B. Walker, "Art Books and Periodicals: Dewey and LC," *Library Trends* 23 (January 1975): 451-70; "CAC Report on Alternative Classification Number," *ARLIS/NA Newsletter* 7 (October 1979): 125-28.

[14]For various discussions, see Patten (Note 13), which includes "Classification and the Art Library User: Some Theoretical Considerations" by Christina H. Bostick and Carol Mandel; "Library Classification in the Arts," by Sherman Clarke; "The Metropolitan Museum of Art Library Classification System: How It Works" by Donya D. Schimansky; "The Photograph and Slide Library of the Metropolitan Museum of Art: A 68-Year View of Classification" by Priscilla Farah; "The National Gallery of Art Library Artist Classification Scheme" by Jane

Collins; "The Crafts and Dewey's Decimals" by Joanne F. Polster; "Classification at the Archives of American Art" by Nancy Zembala.

[15]Note also that the Dewey number is "unfinished" and requires the addition of a book number (represented in the LC number by .W43). Book numbers are usually assigned using a Cutter table: C. A. Cutter, *Two-Figure Author Table* (Swanson-Swift Revision, 1969); *Three-Figure Author Table* (Swanson-Swift Revision, 1969); and *Cutter-Sanborn Three-Figure Author Table* (Swanson-Swift Revision, 1969). These books are distributed by Libraries Unlimited, Inc., Littleton, CO.

[16]See Notes 13 and 14. Also see International Federation for Documentation, *Universal Decimal Classification*, Abridged English Edition (London: British Standards Institution, 1948); Henry Evelyn Bliss, *A Bibliographic Classification* (New York: H. W. Wilson, 1940–53; a 4-volume work with updates, the art section is being revised); Peter F. Broxis, *Organizing the Arts* (Hamden, CT: Archon Press, 1968).

[17]For a full discussion of preservation problems and a guide to procedures, see Susan G. Swartzburg, *Preserving Library Materials: A Manual* (Metuchen, NJ: Scarecrow Press, 1980). Susan G. Swartzburg's *Conservation in the Library: A Handbook of Use and Care of Traditional and Nontraditional Materials* (Westport, CT: Greenwood Press, 1983) contains chapters on the technologies of videodiscs and computers. Heidi Kyle, *Library Materials Preservation Manual: Practical Methods for Preserving Books, Pamphlets, and Other Printed Material* (Bronxville, NY: Nicholas T. Smith, 1983) includes a list of exact materials and tools to be used in certain preservation techniques accompanied by a description of the procedures. Carolyn C. Morrow, *Conservation Treatment Procedures: A Manual of Step-by-Step Procedures for the Maintenance and Repair of Library Materials* (Littleton, CO: Libraries Unlimited, 1982) is also recommended. For a work specifically on photographs, see Robert A. Weinstein and Larry Booth, *Collection, Use and Care of Historical Photographs* (Nashville, TN: American Association for State and Local History, 1976). For a view of art library problems, see Evelyn Samuel, "Special Libraries— Special Problems: Preservation of Art Library Materials," *ARLIS/NA Newsletter* 9 (Summer 1981): 141–45.

[18]The titles are #1 "Selected References in the Literature of Conservation," #2 "Environmental Protection of Books and Related Materials," #3 "Preserving Leather Book Bindings, #4 "Marking Manuscripts," #5 "Preserving Newspapers and Newspaper-Type Materials."

[19]For useful discussions of procedures to follow in identifying preservation candidates, see Christinger Tomer, "Identification, Evaluation, and Selection of Books for Preservation," *Collection Management* 3 (Spring 1979): 45–54; Mary Jane Pobst Reed, "Identification of Storage Candidates Among Monographs," *Collection Management* 3 (Summer/Fall 1979): 203–14; and Mark E. Cain, "Analyzing Preservation Practices and Environmental Conditions: A Committee Systems Approach," *Collection Management* 4 (Fall 1982): 19–28.

[20]Paul H. Mosher, "Collection Development to Collection Management: Toward Stewardship of Library Resources," *Collection Management* 4 (Winter 1982): 41–48. See p. 45.

[21]Hilda Boehm, *Disaster Prevention and Disaster Preparedness* (Berkeley, CA: Task Group on the Preservation of Library Materials, University of California, 1978). See also Peter Waters, *Procedures for Salvage of Water-Damaged Materials* 2nd ed. (Washington, DC: Library of Congress, 1979). For a bibliography and a list of libraries with emergency plans, see Deirdre E. Lawrence and Susan G. Swartzburg, "Emergency Plan for Art Libraries," *Art Documentation* 3 (Summer 1984): 58–60.

14

Management and Budgets

INTRODUCTION

Management is sometimes said to be synonymous with decision making, of which there are three levels: top or strategic, middle or tactical, and lower or operating. Art librarians occupy positions at all levels. Addressed primarily to those at the entry level, this chapter and the following one are designed to present an overview of the field of management as well as provide references to some of its voluminous literature. In spite of the tremendous number of articles and books on general library management, there is practically nothing written specifically for the art library. Librarians who are new to administration should avail themselves of the many continuing education opportunities. Regular courses of study, short courses, workshops, and symposia are frequently offered at various institutions.[1]

At each of the three management levels, it is useful to think in terms of the library as a system which can be defined as an orderly grouping of separate but interdependent parts operating within a given environment and whose objective is to give service to a group of users.[2] The environment and the user group are the distinguishing factors for the art librarian.

General management theory and techniques are applicable to the operation of all libraries. The art library is no exception in that its managers must be concerned with the same principles of planning, organizing, controlling, staffing, and directing as their counterparts in other libraries. These institutions also share the salient feature of being part of larger entities which, with the exceptions of libraries of business firms, are all nonprofit

organizations.[3] Another point of similarity is that they have all emphasized their educational and service funtions. A librarian of a small institution will probably not employ all of the management procedures discussed in this introduction to the subject, but all art librarians must be as aware of them.[4]

Some authors make a distinction between management and administration; others use the terms synonymously—a practice which will be followed in this book.[5] This chapter is concerned with (1) the management principles of planning, organizing, and controlling for accountability and (2) budget and finance. Chapter 15 deals with the human elements of staffing and the physical environment of the library facility.

LIBRARY MANAGEMENT

Most librarians are managers in that they are usually supervising someone else, whether other professionals, paraprofessionals, clerical workers, student assistants, or volunteers. But many have management responsibilities that go well beyond supervision of personnel, that is, they have to plan, organize, staff, lead, and control and prepare reports for accountability. In addition, librarians must aggressively promote their libraries, needs, and services.

Not only must art librarians have a clear concept of the goals and objectives of their library, but these must be related to those of the parent institution, to which they are accountable. At the end of the year, administrators must submit an annual report which usually includes such items as (1) number of volumes of monographs and serials added, (2) circulation and interlibrary loan statistics, (3) gifts and grants received, (4) staff changes, (5) any special projects, and (6) staff activities. The last usually includes books and articles published, professional papers presented, and conference participation. The task of writing such a summary is facilitated by the collection of data throughout the year and the reading of other institutions' reports. For an example of an annual report of an art museum library, see Appendix E.

There are several schools of management theory, such as the Scientific, the Human-Relations Oriented, and the Decision Theory Schools. All three have developed theories and techniques that may be applied to the operation of art libraries.[6] Librarians must decide for themselves which school, or which elements of each school, are best suited to their own style. Because people differ, they all have distinct and diverse skills in dealing with each other. Adaptability and flexibility are important attributes for both managers and non-managers, but the ability to communicate is the most important skill of all.[7]

Essentially seeking to coordinate individual efforts toward the achievement of group goals, managers attempt to establish a framework in which these goals can be achieved with the least expenditure of time, money, and materials

as well as with as little personal conflict or dissatisfaction as possible. Some factors are always outside the administrator's control. For instance, the external environment such as a museum, university, or public library is a given factor. The institution may set wage rates within which the librarian as manager must operate. The important aspects of library management are (1) planning and setting policy, (2) organizing, and (3) controlling for accountability.

Planning and Policy

The first task of good management is planning, which logically precedes all other functions.[8] And yet, a natural tendency exists to deal with today's problems rather than to think of the future, and to become trapped in day-to-day operations. But planning is essential, for it establishes a relationship between where one is and where one wants to be. Underlying this process is the need to ensure that everyone understands the library's purposes and objectives as well as the methods that will be used to attain them. A plan will indicate what is to be done, how it is to be done, when it is to be done, and who is to do it.

Planning should have the following aims: (1) to counteract uncertainty and change and (2) to help managers achieve control and to ensure efficient and economical operation by focusing on objectives. Unfortunately, in many areas of operation, libraries are frequently faced with maximum uncertainty and the possibility of imminent change. For example, the cost of art books and serials is constantly rising, but not necessarily at predictable rates.[9] The advent of microcomputers has made possible many alterations in routine operations as well as improved research capabilities. But, computerization often carries hidden and not always predictable costs and may be a threat to the library staff, unless handled with care. Factors such as these make it difficult for librarians to make long-range plans. Although the same can be said for many enterprises, it does not make planning any easier. Short-term plans, such as the next year's budget, are far more tractable.

The need for establishing objective goals against which to measure performance cannot be stressed sufficiently. The basic steps in the planning process include: (1) establishing objectives, (2) developing a statement about the environment within which the library operates, (3) formulating, evaluating, and deciding upon alternate courses of action, (4) setting policies, and (5) providing for feedback.

The basis of all planning is the formulation of clearly stated objectives. At the broadest level they are organization-wide, but specific objectives may be based upon activities which also need to be considered. Statements of objectives should include reference to (1) the users served, (2) the services and materials requested, (3) the personnel resources required, (4) the budget

available or needed, and (5) the milieu in which the library operates. Planning cannot be done in a vacuum.

Objectives must be set with full consideration of the economic, political, social, and technological aspects of the environment. The very process of defining and articulating these parameters serves to focus the staff's attention on the institution and its goals. It may also reveal the nature of previously recognized problems as well as unrecognized opportunities. Too often short-range plans are made without any effort to integrate them with long-range plans. The result is that decisions about immediate situations are not taken with reference to their effect on long-term objectives. Disassociation of long- and short-term plans sometimes results from a lack of communication among the various levels of management, because usually long-range planning is carried out by the top level, but short-term planning is delegated to middle-level managers.

The next steps in the planning process are usually to search for and evaluate alternative courses of action. Having done that, a course of action, or perhaps several courses, must be selected. It is important to remember that a plan must include decisions, otherwise it is just a planning study. Even after a decision is made, it may then be necessary to formulate additional supportive plans. A plan should never be so rigid that it cannot be changed or altered to conform to changing circumstances. Flexibility, or the ability to modify a plan, is frequently critical, but is often possible only within limits. For instance, a museum library may decide to establish an online catalog system. A number of possible routes are available—purchase of a turnkey system, adaptation of an existing system, or subscription to a bibliographic utility. After these alternatives are evaluated, one ultimately must be chosen. At that point plans for implementation must be made and realistic timetables established.

One result of planning is the establishment of policies. Policies differ from objectives in that objectives emphasize aims, while policies emphasize rules and are usually stated in the form of procedures. Policy making, which goes on at all levels of library operation, may relate to acquisition of materials, personnel appointments and promotion, cataloging priorities, as well as many other activities. Without policies, it is very difficult to delegate authority and to clarify relationships, because guidelines are needed for decision making at all levels. Lack of policies causes the same questions to be considered time and time again, with the risk of resolving the same question differently. This can cause not only inconsistencies but also conflict.

Written policies have many advantages. Because they are readily accessible to everyone, misunderstandings can be more easily and consistently resolved. They can be tools in the teaching of new employees. The process of writing them forces clearer thinking about the activity involved. Most importantly, a policy should not be inflexible or outdated; it must allow for a certain

latitude in application. For example, although it may be the policy of a public library that the Fine Arts Department is responsible for all items classified in the Dewey class 700, sound recordings may be exempt.

In addition to a written policy statement, there will be a need for rules and procedures, which should be based upon the clearly articulated policy statement. Rules prescribe specific actions for given situations in order to create uniformity of action. Procedures, which are guides to action, are often chronological. For example, library policy may state that materials selection is to be carried out by the fine arts librarian. Procedures designed to implement policy will indicate how and when orders are to be processed, whereas rules will state that orders must be placed with the lowest bidder.

Once the plans are implemented, provision must be made for feedback, as the systems approach requires evaluation at each stage. For example, there will be a vastly different timetable for installing an online public access catalog for an art library which has all of its bibliographic records in machine-readable form than for a library which has only a portion of its records in that format. Evaluative measures must be devised to test the efficiency of the cataloging process as well as user satisfaction—or dissatisfaction. Depending upon the outcome of such evaluative studies, adjustments may have to be made. Users may object to the format of the record display, but it may be too costly to modify it. Once again it becomes a question of evaluating alternatives and choosing among them.

An example of a planning process which is used by many libraries is the technique called Management by Objectives. This process was first clearly articulated by Peter Drucker:

> This approach involves the establishment and communication of organizational goals, the setting of individual objectives pursuant to the organizational goals, and the periodic and the final review of performance as it relates to the objectives.[10]

Management by Objectives offers potential to clarify responsibilities and to establish better relationships between supervisors and staff. The process relies not only upon a clear statement and succession of objectives but upon the establishment of bench marks against which to measure performance. Tasks must be delegated with a clear indication of who is to do what. Team effort should be stressed as the underlying rationale. Other requisites of Management by Objectives are (1) clear communications and (2) personal accountability in which each individual is accountable for the achievement of assigned objectives.

Organizing for Operation

Organizing is a technique of assuring smooth operation and promoting leadership. People work most effectively if they are sure of their roles and how they relate to one another. Organizing consists of (1) the logical grouping

of activities necessary to attain objectives, (2) the assignment of these groups to managers with authority necessary to supervise, and (3) the provision of appropriate coordination among the parts, both horizontally and vertically. The results of this process may be graphically displayed by means of an organizational chart.

An organizational structure should clarify who is to do what and who is responsible for what results. The structure should be designed so as to remove obstacles to performance and to furnish decision-making support and communication networks. In grouping activities, it is first necessary to identify and classify them in the light of human and material resources available. The designated head of each group should have the authority necessary to perform the activities. In addition, the groups should be tied together horizontally and vertically through authority relationships and information flows.

Formal organizations should be flexible in that there should be room for discretion, for taking advantage of individual talents, and for recognizing varying individual preferences and capabilities. Yet, individual effort in a group situation should always be channeled toward organizational goals to reduce the danger of loyalty to a function and not to the enterprise.

Appropriate designs of organizational structure obviously depend upon specific situations. Although librarians are usually free to organize their own departments, most art librarians will have little opportunity to alter the parent institution's organizational chart which will indicate the officer to whom they are to report. However, by studying the situations in similar types of institutions through interviewing colleagues, a librarian may make an effective plea for change.

Most libraries today are organized by function in which related activities are combined. For instance, technical services departments combine acquisitions, cataloging and catalog maintenance, serials, binding, and book processing. But often subjects and sometimes the format of resources—such as periodicals, pictures, and slides—are used as organizing principles. Nor is it unusual to find all three principles operating within the same library.

The graphic representation of the organization on charts shows how departments are linked by lines of authority.[11] Every art library should have such an organizational chart available to all the staff in order that they will understand relationships within the library. Scrutiny of the organizational design can disclose weaknesses, duplication of effort, unclear lines of authority, failure of communication, and obsolete practices.

It must be recognized that a chart may fossilize any organization. Change introduced by automation or a drop or increase in financial resources may necessitate corresponding alterations in the chart. It is a tool, not an icon. Furthermore, because they show only formal authority relationships and do

not exhibit how much authority exists at any given point, organizational charts have important limitations. Frequently, these charts show structures as they are supposed to be or used to be, not as they really are. Managers should also recognize that informal channels, such as the grapevine, exist and can often be used to influence employee attitudes.

Accountability

The task of managers is to monitor plans to ensure that they succeed. This process depends upon accountability and the availability of information and control techniques, one of the most widely used of which is budgeting. Control is used by managers not in the sense of restraints placed upon a system or an individual, but as a means to achieve the desired outcome of a plan. It involves the measurement and correction of activities of subordinates to make sure that objectives are being accomplished. Essential to accountability is a clear definition of responsibility, good communication, and a system for regular feedback. Once again, it is important to take note of the political and social environment within which the art library functions, because the parent institution represents the overall governing authority.

Many libraries are legally bound by constitutional provisions, charters, or special laws applicable to the institution as a whole. In academic libraries, the trustees, the chancellor or president, and—to a lesser extent—faculty and student committees may all exercise varying degrees of control. Museum librarians may be responsible to a governing body of trustees and a director. A city manager or city council may exercise jurisdiction over a public library. Internal control within the art library may rest with its own management, but many outside agencies are also involved in such aspects as standards, certification, and accreditation. Federal, state, and local laws regulate planning, construction, and maintenance of buildings through ordinances and regulations, building codes, zoning, and fire regulations. Copyright, federal funding, and legislation place other restraints on library operations. Additional bodies that may exert external control include unions and political bodies. Through collective bargaining, unions can regulate hiring, salaries, working conditions, and fringe benefits. Even Friends of the Library groups may expect to have some say in the direction the library will take in return for their support.

The basic control process involves three steps: (1) establishing standards, (2) measuring performance against these standards, and (3) correcting deviations from standards and plans. Standards are criteria of performance and may be stated in either qualitative or quantitative terms. While control techniques should be objective, there are many activities for which it is difficult to develop quantitative standards. And many activities are simply hard to measure. But if librarians do not make the attempt, they will not

be able to arrive at standards. Theoretically, the development of reliable measures should precede the setting of meaningful standards.

In recent years, there have been endeavors to formulate measures of library performance, such as the availability and accessibility of materials. These measures generally require the application of statistical methods to the activities being studied. While there is a scarcity of art-related statistical studies published in the literature, art librarians should become familiar with the methods reported in the general library literature and adapt them to their own use.[12]

In order to make good management decisions, art librarians should become familiar with the kinds of statistics that may be required. Statistics are needed (1) for support for budget requests, (2) for resource allocation, (3) for management forcasting, and (4) to compare and contrast different library holdings and operations.[13] With the exception of the librarians in the large research centers, art librarians have not set standards for methods of collecting statistical data. As a consequence, useful comparative studies are not possible.

All techniques are devised for the purpose of controlling time, cost, quantity, and quality. Some are really used only in large systems—such as cost-budget analysis and operational research—but budgeting is used by all art libraries.[14] Operations research is not usually applied, because of the complexity of the techniques involved and the use of mathematical models. But because it does have predictive capabilities, operations research may be expected to become more prominent in the future.

The literature is replete with methods for undertaking management studies and time-and-motion studies as well as for preparing flow process charts, decision trees, and decision tables.[15] Areas for study include production delays, jobs that are repetitive, and jobs that require frequent movement of people, forms, or equipment.[16] Common to all management studies is the following sequence of events: (1) defining the problem, (2) gathering the data, (3) analyzing the present system, (4) devising a new or revised system, (5) implementing the new system, and (6) evaluating the new system. For example, the widely used PERT (Program Evaluation and Review Technique) or CPM (Critical Path Method) involve (1) identifying all the key activities in a particular project, (2) devising the sequence of activities and arranging them in a flow diagram, and (3) assigning durations of time for the performance of each phase of the work.[17] The biggest disadvantage of PERT is an overemphasis on time as well as an almost complete disregard of cost. The latter has led to the use of PERT/COST. Although PERT/COST is a method reserved generally for complex, large library systems, the logical structuring of events could be used at almost any level, since process charts are extremely valuable tools for discovering bottlenecks.

BUDGETING

Budgeting is probably the most prevalent type of management tool for planning and control.[18] Simply defined, a budget is a plan of action expressed in monetary units. The kinds of commonly used budgeting systems include: (1) line-item, (2) zero-based, (3) formula, and (4) planning-program. The control factor is that the budget can be used as a periodic evaluation of whether or not the plan is being achieved. The process of budgeting is a continuous, year-round activity, not something that is done once a year and then mercifully relegated to oblivion. Because requests for financing must be explicit, art librarians at all management levels spend great amounts of time in budget review, analysis, and presentation.[19] This can be a frustrating experience due to the fact that at many institutions budgeting is often a political process. For instance, at some colleges and universities, the art librarian may need to convince the faculty-budget committee that art students require books as well as easels and blow torches.

Several types of budgeting are used by libraries; combinations of types are not unusual. The art library often adopts, or is constrained to adopt, the budgeting method used by the parent organization. Public institutions often have to submit proposed budgets two or three years in advance. This presents problems in terms of forecasting rising expenditures for materials and personnel. One of the difficulties which art librarians constantly encounter is that of securing sufficient funding for materials budgets.

The most common type of budget is the traditional, line-item budget. Expenditures are divided into broad categories for items, such as salaries, materials, equipment, and supplies. To prepare a line-item budget, the librarian usually reviews what was spent in the preceding year and supplies new figures with allowance for inflation or cost of new programs and services. Such a budget is relatively easy to prepare and understand. But such a budget does not contain any mechanism for review of the effectiveness of past practices, and it is often difficult to transfer funds from one category to another. For example, in some institutions the serials allocation cannot be used to purchase equipment or vice versa, even if the money is available in the alternate category.

The opposite of line-item budgeting is zero-based budgeting (ZBB), which does not accept any existing activities or programs as given.[20] Zero-based budgeting is a process requiring justification in detail of every item without reference to what has happened in the past. It uses the concept of decision packages. The lowest unit for which the budget can be prepared, a decision package requires a description of each activity within that management unit. Once all of the packages are identified, they are ranked in priority order.

All below a cut-off level are eliminated. Thus, a zero-based budget depends on an annual or biennial reappraisal of purpose, methods, and resources. This requires librarians to justify their budget requests in detail as well as to rank the items in order of priorities. ZBB forces consideration of such questions as: (1) are there more effective ways of performing the operations and (2) what would happen if certain programs or services were eliminated? Theoretically, it is a flexible system, but it does require an inordinate amount of time as well as familiarity with systems analysis and analytical techniques.

Zero-based budgeting is often viewed as threatening by the staff. Quantification of meaningful workload and performance measures must be devised, and as stated above, some activities are more easily measured than others. Reference service and collection development, for instance, are activities that seem to resist quantification or evaluation in any but subjective terms. Among the rather simplistic quantitative measures that have been used is to evaluate reference service in terms of the number of questions asked and the time consumed in finding the answers. Admittedly, ZBB requires a great deal of time and effort on the part of the staff. However, the combining of planning, budgeting, and operational decisions into one process can be beneficial to the organization as a whole because it focuses on analysis and decision making. Although ZBB attempts to make more realistic priorities, because of the complexity of the system, art librarians seldom use it, unless it is required by the parent organization.

Formula budgeting is often used by a large university library to help ensure that each unit will receive its fair share of money. For a specific department, resources are allocated according to predetermined factors, such as weighted combinations of numbers of students, faculty, courses, and circulation. Formulas, such as those proposed by McGrath, have been used for materials allocations, while the ACRL standards provide formulas for holdings, staff, and facilities.[21] Formula budgets are relatively easy to prepare and provide a means of equitable distribution; they are usually realistically defensible. On the other hand, most of them depend upon the arbitrary assignment of weights.

A survey by Elizabeth Douthitt Byrne of allocation methods used in 25 academic art libraries revealed that very few (8%) received allocations based on formulas.[22] In 40% of the cases, it was reported that the director alone made the decisions. Nevertheless, she advocates encouraging art librarians to investigate the potential of formula budgeting, because the process itself forces examination of policies, procedures, and assumptions.

Planning-Programming Budgeting Systems (PPBS) involves a more analytical approach, but is difficult to implement. It has been criticized for

a tendency to concentrate on ends without regard for the means and to become highly political in nature. PPBS, which also requires a degree of centralization, provides a comprehensive and analytical basis for decision making, but its implementation is substantially more complex than some other budget processes. Using PPBS forces librarians to think primarily in terms of allocating resources rather than controlling operations. This system has enjoyed a wide vogue among public and academic library administrators.

Keeping accurate records of what has been disbursed and encumbered as well as what remains, is the final aspect of budgeting. In large systems, accounting may be centrally administered; but in small art libraries, the librarian will be responsible for the bookkeeping. Fortunately, a number of manuals of accounting techniques are readily available.[23]

ALTERNATE FUNDING: GIFTS AND GRANTS

Depending upon the type of library, funds may come from local, state, regional, or federal sources or from some combination of them. Funds come from foundations, endowments, gifts, and/or tuition. They may come directly to the library or to the parent institution, which then earmarks them for library use. Frequently, because funding is inadequate, alternative sources must be sought. Art librarians should be aware of the possibilities and actively seek them out. There are four major potential sources for additional funding: individual donors, foundations, corporations, and government.[24] Before pursuing fund-raising activities on their own, art librarians should consult with the administrator and the development officer of the parent institution so as to coordinate efforts.

Individuals and groups of individuals—such as a Friends of the Library organization or museum docents—represent an important segment of the gifts and fund-raising market. The best approach is to ask for support for special programs or to have a desiderata list of projects or purchases, classified into several different financial sizes—one for every pocketbook.

Art librarians should follow the techniques of professional fund raisers. These money raisers use a five-step approach to individuals: (1) identifying potential donors; (2) securing an introduction, often through a third party; (3) cultivating an acquaintance before actually asking for a gift; (4) actually soliciting; and (5) finally, and most importantly, showing appreciation. First efforts are not always successful, as it takes time to develop solicitation skills for which few librarians have been trained. If the parent institution has a

development office, help may be obtained from this body. Reading some case studies will impart a good background.[25]

In the United States, there are about 26,000 foundations which support worthy projects.[26] They are usually grouped as follows:

1. Family foundations;
2. General foundations which include the large, well-known ones, such as Rockefeller and Ford, and others that are identified with particular areas, such as Carnegie and education;
3. Corporate foundations which are empowered to give away up to 5% of the corporation's adjusted gross income;
4. Community trusts made up of smaller foundations whose funds are pooled for greater impact.

Matching interests and scale of operations is an essential element in identifying foundations to approach. For example, the Andrew W. Mellon Foundation and the Pew Memorial Trust of Pennsylvania have been interested in both the arts and libraries, but they prefer to fund large-budget, extensive projects.

Excellent resources are available for researching foundations through the efforts of the Foundation Center, a nonprofit organization with research centers in New York, Washington, and Chicago that collect and distribute information exclusively on foundations. In addition, the Foundation Center maintains libraries in New York, Washington, Cleveland, and San Francisco which have extensive collections of foundation materials and are staffed with helpful and knowledgeable professionals. The Center further maintains a network of collections housed in co-operating libraries in the 50 states, Canada, Mexico, Puerto Rico, and the Virgin Islands. Their publications include the *Foundation Grants Index*, a listing of grants distributed in the past year, indexed by foundation, subject, state, and other categories.[27] The *Foundation Directory* is a listing with descriptions of over 2500 foundations that either have assets of over $1 million or award grants of over $100,000 annually.[28] This directory provides up-to-date information on the general characteristics of each foundation, the types of grants that have been awarded, the annual level of giving, officers and directors, location, particular fields of interest, and contact persons. The directory is augmented by a bimonthly current awareness publication, the *Foundation News*, which gives information on recent grants of $5000 or more as well as on new funding programs and changes in existing foundations. Also available is the *Source Book Profiles*, a bimonthly, looseleaf subscription service providing comprehensive information on individual foundations. Finally, the Center publishes annual COMSEARCH printouts on individual subjects in paper or microfiche format. This service is also available through an online database of DIALOG.

Corporate giving differs from that of foundations in certain respects. First, the level of giving will vary with current income. A corporate foundation or gifts division has to be attuned to the desires of the stockholders in terms of what to support. More attention is paid to the benefit the corporation can reap in terms of goodwill or publicity. But they often have an interesting flexibility in what they can give. Among the tangible means of support are (1) goods—furniture, typewriters, or computers; (2) services, such as printing; and (3) space that can be used for a fund-raising event or an exhibition. Corporations have been under-utilized by libraries, but effective corporate fund raising depends primarily upon the identification of good prospects. It is advisable to look first at local corporations and then at corporations which have a track record in support of the arts, such as Borg-Warner, which has been active in the purchase of contemporary art. Review any personal relations or contacts that might be profitable and think in terms of specific capabilities of the company, such as possible provision of items like furniture or paint.

Art librarians have looked for some time to various federal and state government funding agencies for support, such as the National Endowment for the Arts (NEA) and the National Endowment for Humanities (NEH). Federal programs for colleges and universities are funded under the College Library Resources Program authorized by the Higher Education Act (HEA). Public library funding has been available under the Library Services and Construction Act (LSCA), administered by the various state agencies. At the state level, there are programs administered by the state libraries and by state Humanities and Arts Councils.

Normally, federal and state grants require the most paperwork. One must be aware that the main criterion for award will be an assessment of the proposal's potential contribution to the public interest. As there is heavy competition for funds, only an innovative proposal which demonstrates how the art library can make a unique contribution to the specific purpose of the program has much chance of success. Note also that funding is not always available for announced programs. It is essential to keep up with developments in Washington or Ottawa as well as the state or provincial capital and to be aware of deadlines for submission of proposals.

Since writing proposals is sometimes called a fine art in itself, librarians may need to utilize some of the publications which will aid them in finding a path through the maze of federal programs. The Department of Education issues *Federal Programs for Libraries: A Directory*, which includes information on nine federal programs designed to assist libraries directly and 76 other federal programs that are library related.[29] One can also consult the *Catalog of Federal Domestic Assistance (CFDA)*, an annual publication listing all

currently funded federal programs.[30] Its numerous indexes can be used to locate programs that may be of benefit to a given library.

There are a number of published guides to help the grant-seeker; they are augmented on a regular basis by new ones.[31] It is important to follow closely the guidelines issued by the government agency or the foundation in preparing the proposal. Generally, each proposal consists of the following elements:

1. A cover letter describing the history of the proposal, and which, if any, persons at the funding agency, have been contacted;
2. The proposal, describing the project, its uniqueness, its importance, and any other information required by the guidelines;
3. The budget for the project; and
4. The personnel who will be working on the project and their resumés.

The proposal itself should be well organized, readable, and geared to the criteria established by the funding agency. If the first effort is rejected, most funding agencies are willing to offer advice on where the project went wrong and on how to improve it. A second attempt should be made.

NOTES

[1]These are plentiful. Two examples are (1) the Library Management Skills Institutes offered at various locations by the Association of Research Libraries, 1527 New Hampshire Ave., N. W., Washington, DC 20036 and (2) Management Seminars held at Miami University, Center for Management Services, 103 Laws Hall, Oxford, Ohio 45056.

[2]For the classic work on systems, see C. West Churchman, *The Systems Approach*, revised and updated (New York: Dell Publishing Co, 1979).

[3]On the managing of nonprofit organizations, see Daniel L. Conrad, *Managing Nonprofit Agencies for Results: A Systems Approach to Long Range Planning* (San Francisco: Public Managment Institute, 1979); and Patrick J. Montana and Diane G. Borst, *Managing Nonprofit Organizations* new ed. (Saranac Lake, NY: American Management Association, 1977).

[4]G. Edward Evans, *Management Techniques for Librarians* 2nd ed. (New York: Academic Press, 1983), p. 3.

[5]A. J. Anderson, "'Management' and/or 'Adminstration'" *Journal of Library Administration* 5 (Summer 1984): 5–11. Evans (Note 4), p. 25, maintains that librarians are managers rather than administrators, and yet when they set policy, they perform an administrative function.

[6]A general discussion of the various schools may be found in the excellent introductory text by Harold Koontz, Cyril O'Donnell, and Heinz Weihrich, *Essentials of Management* 3rd ed. (New York: McGraw-Hill, 1982). For library texts, with extensive bibliographic references (Note 4); Robert D. Stueart and John Taylor Eastlick, *Library Management* 2nd ed. (Littleton, CO: Libraries Unlimited, 1981); Edward R. Johnson and Stuart H. Mann, *Organization Development for Academic Libraries* (Westport, CT: Greenwood Press, 1980); J. M. Orr, *Libraries as Communication Systems* (Westport, CT: Greenwood Press, 1977); David Smith, *Systems Thinking in Library and Information Management* (New York: Bingley, 1980); Maurice Marchant, *Participative Management in Academic Libraries* (Westport, CT: Greenwood Press, 1976). See also Ellis Mount, *Special Libraries and Information Centers: An Introductory Text* (New York:

Special Libraries Association, 1983); and *Management Strategies for Libraries: A Basic Reader*, edited by Beverly Lynch (New York: Neal-Schuman, 1985).

[7]See Evans (Note 4), p. 12: "Lack of (or poor) communication is the most frequently identified organizational problem."

[8]Stueart and Eastlick, (Note 6), discuss a number of elements and techniques that contribute to the planning process. For example, standards may be used against which to measure acceptable and unacceptable services; forecasting may be utilized to predict trends. One popular method of forecasting which they discuss is the Delphi technique that involves using panels of experts to predict future developments.

[9]Both the *Bowker Annual* and the *Library Journal* report these statistics annually.

[10]Peter F. Drucker, *The Practice of Management* (New York: Harper & Row, 1954), p. 131. Also Peter Drucker, *Management: Tasks, Practices, Responsibilities* (New York: Harper & Row, 1974).

[11]For examples of organizational charts, see, for instance, Stueart/Eastlick (Note 6).

[12]One of the most useful texts on performance measurements that includes extensive bibliographic references is Paul B. Kantor, *Objective Performance Measures for Academic and Research Libraries* (Washington, DC: Association of Research Libraries, 1984). Other sources are *Quantitative Measurements and Dynamic Library Service*, edited by Ching-chih Chen (Phoenix, AZ: Oryx Press, 1978); and Rosemary Ruhig Du Mont and Paul F. Du Mont, "Measuring Library Effectiveness: A Review of an Assessment," *Advances in Librarianship*, edited by Michael Harris (New York: Academic Press, 1979), Volume 9, pp. 103-41. For a good summary of the kinds of statistics needed for MIS (management information systems), see Edwin Cortez, "Automation and Management Information Systems," *Journal of Library Administration* 4 (Fall 1983): 21-33.

[13]See *Library Data Collection Handbook*, edited by M. J. Lynch and H. M. Eckard (Chicago: American Library Association, 1981); and F. W. Lancaster and M. J. Joncich, *The Measurement and Evaluation of Library Services* (Washington, DC: Information Resources Press, 1977).

[14]See Abraham Bookstein and Karl Kocher, "Operations Research in Libraries," in *Advances in Librarianship*, edited by Michael Harris (New York: Academic Press, 1979), Volume 9, pp. 143-84.

[15]See especially Fred J. Heinritz and Richard M. Dougherty, with the assistance of Neal K. Kaske, *Scientific Management of Library Operations* 2nd ed. (Metuchen, NJ: Scarecrow Press, 1982); and H. William Axford, "Academic Library Management Studies: From Games to Leadership," in *Advances in Librarianship*, edited by Michael H. Harris (New York: Academic Press, 1980), Volume 10, pp. 39-61.

[16]See Charles McClure, "Management Information for Library Decision Making," in *Advances in Librarianship*, edited by Wesley Simonton (New York: Academic Press, 1984), Volume 13, pp. 2-47.

[17]Heinritz/Dougherty (Note 15), pp. 233-63; Koontz, O'Donnell, and Weihrich (Note 6), pp. 496-502.

[18]For general discussions on budgeting, see texts listed in Note 6. See also Ann Prentice, *Financial Planning for Libraries* (Metuchen, NJ: Scarecrow Press, 1983).

[19]For helpful information on the budget preparation process, see Margo C. Trumpeter and Richard S. Rounds, *Basic Budgeting Practices for Librarians* (Chicago: American Library Association, 1985). Also includes tables, figures, and worksheets.

[20]Ching-chih Chen, *Zero-Base Budgeting in Library Management* (Phoenix, AZ: Oryx Press, 1980).

[21]See Stueart/Eastlick (Note 6), pp. 162-76. See also bibliography in Elizabeth Douthitt Byrne, "The Allocation of Book Funds in Academic Art Libraries," in *Current Issues in Fine Arts Collection Development*, Occasional Papers No. 3 (Tuscon, AZ: Art Libraries Society of North America, 1984). For information on McGrath's formulas, see William E. McGrath, Ralph

C. Huntsinger, and Gary R. Barber, "An Allocation Formula Derived from a Factor Analysis of Academic Departments," *College & Research Libraries* 30 (January 1969): 51–62; and William E. McGrath, "A Pragmatic Book Allocating Formula for Academic and Public Libraries with a Test for Its Effectiveness," *Library Resources & Technical Services* 19 (Fall 1975): 356–69. For some discussions of the problems with McGrath's formula, see Peter Sweetman and Paul Wiedemann, "Developing a Library Book–Fund Allocation Formula," *Journal of Academic Librarianship* 6 (1980): 268–76; and Jasper G. Schad, "Allocating Materials Budgets in Institutions of Higher Education," *Journal of Academic Librarianship* 3 (1978): 328–32. For ACRL standards, see American Library Association, Association of College and Research Libraries, "Standards for College Libraries," *College and Research Library News* 9 (October 1975): 277–79.

[22]See Byrne (Note 21).

[23]For accounting in a one-person library, see Brian Alley and Jennifer Cargill, *Keeping Track of What You Spend: The Librarian's Guide to Simple Bookkeeping* (Phoenix, AZ: Oryx Press, 1982). Also G. Stevenson Smith, *Accounting for Librarians and Other Not-for-Profit Managers* (Chicago: American Library Association, 1984).

[24]For a good discussion of fund raising, see Philip Kotler, *Marketing for Nonprofit Organizations* 2nd ed. (Englewood Cliffs: NJ: Prentice-Hall, 1982).

[25]Ibid., p. 444.

[26]Ibid., p. 429.

[27]*Foundation Grants Index: A Cumulative Listing of Foundation Grants* 13th ed. (New York: Foundation Center, 1984). Foundation Center, 888 South Avenue, New York, NY 10106. Foundation Center, 1001 Connecticut Ave., N. W., Washington, DC 20036. Foundation Center-Cleveland, 1442 Hanna Bldg., Cleveland, OH 44114. Donor's Forum, 208 South LaSalle St., Suite 600, Chicago, IL 60604. Foundatin Center-San Francisco Library, 312 Sutter St., San Francisco, CA 94108.

[28]*Foundation Directory* 10th ed. (New York: Foundation Center, 1985).

[29]Lawrence E. Leonard and Michael Buchko, *Federal Programs for Libraries: A Directory* 2nd ed. (Washington, DC: Office of Education, U. S. Department of Health, Education and Welfare, 1979).

[30]*Catalog of Federal Domestic Assistance* (Washington, D.C.: Office of Management and Budget, 1985).

[31]See Emmett Corry, *Grants for Libraries: A Guide to Public and Private Funding Programs and Proposal Writing Techniques* (Littleton, CO: Libraries Unlimited, 1982); Virginia P. White, *Grants: How To Find Out About Them and What to do Next* (New York: Plenum Press, 1975); and Frea E. Sladek and Eugene L. Stein, *Grant Budgeting and Finance: Getting the Most Out of Your Grant Dollar* (New York: Plenum Press, 1981).

15

Personnel,
Physical Environment,
and the Future

INTRODUCTION

The successful performance of personnel is the key factor in provision of library service. The majority of art libraries have small—often one-person—staffs, a fact which has ramifications in terms of the amount and kind of work each individual will have to perform. Because even in a small library, the largest allocation in the library budget is for personnel, effective management of human resources is imperative for efficient operation.[1] A successful manager will harmonize individual and organizational objectives, recognizing that the human factor is an unpredictable variable. Since the subject of staffing and personnel is a vast one, only an overview of significant aspects is included in this book.

Because it is easy to become accustomed to what already exists, library administrators should try to look at the physical plant from a fresh viewpoint. Although more and more art librarians have an opportunity to plan a new building or a portion of one, the majority are concerned with revamping existing spaces. This chapter is concerned with personnel management, the physical environment, and the future of art librarianship as a discipline.

265

PERSONNEL MANAGEMENT

Personnel management involves staffing the library with competent employees—evaluating and improving their performance as well as facilitating their personal career development. The supervisor is the key to the employees' attitudes toward their jobs which affect both the quantity and quality of their work. A necessary part of direction is performance evaluation. The personnel manager has not only to hire and fire but to direct employees—both paid and volunteer—and to act as a role model for them. It is often stated that the most important aspect of the supervisory role is effective communication. This section is concerned with (1) staffing, (2) performance evaluation, (3) communication skills, and (4) volunteers in the library.

Staffing

In order to staff the library, managers must (1) identify the personnel needs of the institution, (2) analyze the tasks and write job descriptions for each position, (3) recruit and select the employees, (4) train the new staff members, and (5) ensure the continuing development of individual staff members. Identification of personnel requirements is the first step in planning. Without knowing what personnel will be needed and what experience to demand, people cannot be intelligently recruited or trained.

The ARLIS/NA *Standards for Art Libraries and Fine Arts Slide Collections* offer guidelines on staffing both libraries and slide collections. The number of persons to be employed at professional, para-professional and support levels is apportioned according to the number of users served and number of volumes held. In the case of slide collections, the staffing formula is based on the number of slides held as well as those which are added yearly and circulated weekly. While recognizing that many highly competent practitioners with broad professional experience do not hold the master's degree in library science, nevertheless, the *ARLIS/NA Standards* stipulated that in the future such a degree from an accredited school should be required. In addition, art librarians need to be familiar with the basic subject literature of art. The *Standards* specify that for certain careers, the librarian should have an M. A. in art history or in the subject field covered by the library. All too frequently, academic programs have been oriented more toward the scholarly library— university or museum—than toward the smaller special, college, or art school library. These programs have failed to take into account the needs of those libraries whose clientele are often far less sophisticated in library use than is a scholarly researcher and whose literature needs may differ markedly.

One or two languages, in addition to English, may be required. The most common foreign languages for art librarians are German, French, and Italian,

although for some positions, Oriental, Slavic, or Classical Latin or Greek may also be needed. The *ARLIS/NA Standards* suggest that para-professionals should have bachelor's degrees, preferably in art or an art-related subject, and a reading knowledge of a language other than English.

The ARLIS/NA *Standards* recommend a ratio of professionals to support staff. For an academic branch library, 25% professional librarians to 75% support staff; for a museum library doing its own technical processing as well as for public libraries, 40% to 60%. In the small art library, it is sometimes difficult to separate professional from nonprofessional work. Usually recruited locally, non-professionals will outnumber the professionals and, particularly in small libraries, will be given important assignments. The support staff must be fully integrated into the group effort; it is important not to foster the development of a professional-clerical caste system. Because of inevitable scheduling problems and a need to get the work done, para-professionals—who are usually college graduates, often with subject expertise—may be called upon to assist with professional aspects of reference service, cataloging, and acquisitions. That they perform well and satisfy patrons should not tempt librarians to abdicate their own responsibility. Foresight, imagination, and tact are called for in dealing with assignment of duties in accordance with the training, skills, and salary ranges of the individual staff members, both professional and non-professional.

For each position in the library, there should be a job description which (1) lists all important duties and responsibilities of the employee, providing the authority to perform these tasks, and (2) outlines the relationships with other positions and supervisors. The job description should provide a clear idea of performance requirements because supervisors and employees both need to know what criteria are being used to evaluate an employee's qualities. Usually the skills and background knowledge required will be part of this document. Other explicit statements about qualifications may include estimates of the percentage of time spent on each activity, which can be ascertained from a task analysis study and from direct observation. Examples of library job descriptions may be found in G. Edward Evans, *Management Techniques for Librarians.*[2]

Job analysis can serve other purposes as well. If the work does not occupy an employee's full time and effort, other ways of getting it done—or other ways of utilizing the employee's time—should be considered. Each year the librarian should consider the personnel situation in the light of the following questions:

(1) How many of the present staff can or should be promoted?[3]
(2) How many should not be promoted, but are capable of continuing at the present level?

(3) How many should be candidates for replacement?

(4) How many are near retirement?

(5) How many resignations are expected?

(6) How many new positions are needed, and how many are likely to be funded?

Once the determination is made to search for new staff, the librarian must clearly understand what is acceptable in terms of applicable legal requirements.[4] Applicants should be allowed an adequate amount of time in which to apply. If the period is too brief, there will be a disappointingly small pool of applicants.[5] Well-designed application forms can reveal a good deal of information, such as (1) whether the applicant has shown steady career growth and progress or has simply moved from one position to another, for no apparent reason and within a short period of time, and (2) if there are any unexplained gaps in the work history. Care must be taken because certain questions may not be legally asked, particularly those concerning race, religion, age, and sex.

The selection process for new employees will obviously relate to the specific situation, but useful general questions will elicit such information as: (1) what were your specific duties in your last position? (2) what did you achieve in that job? and (3) why do you want to make a change? Information gained from the application form and the interview must be supplemented by that obtained from references and occasionally by testing. Some librarians believe that the only useful tests are those designed to measure skills, such as typing, filing, or numerical abilities; however, it is not unusual for prospective employees to take tests designed to ascertain their knowledge of the cataloging code or the basic reference tools.

An individual may possess a number of skills, in different degrees, the relative importance of which varies with the position. For example, technical skills might include an ability to perform online cataloging of Chinese books or to be adept at online database searching. Conceptual skills include the ability to recognize significant elements in a situation and their interrelationships, while design skills usually relate to problem-solving abilities which enable a person to design workable solutions to a problem. Most important are the interpersonal skills, those involving the ability to work with people. Having planned and organized around the institution's goals and activities, modifications may have to be made in the light of individual employees' capabilities or limitations.

The first days or weeks can be crucial for integrating a new employee into the library. An overload of information may discourage the person, but a lack of information will have even more serious consequences. Make sure that a general introduction is provided to the library: its objectives, functions, clientele, history, and organization. The specific requirements of the new employee's position must be explained in full. An introduction to the other

personnel is also essential. Policies, practices, and regulations of the institution should be made clear. In most institutions, there is a personnel manual, which explains benefits, such as vacation, insurance, and retirement.

In a study of the 1985 offerings at the 54 ALA-accredited library schools, 47 (87%) responses to a questionnaire were returned. With respect to art librarianship, 41 (87.2%) offered no courses in this field.[6] In light of these statistics, librarians must be aware of the importance of training new staff members as well as providing opportunities for continuing education for all of the staff. It is essential to remember that computer skills are like those of a foreign language. Do not expect employees to be fluent and proficient in either unless they have been thoroughly trained and allowed time to maintain this expertise.

Staff development opportunities—such as continuing education courses, workshops, and professional conferences—should be encouraged. Active participation—presenting papers, developing specialized bibliographies for distribution, and committee service—should be fostered. Every effort should be made to secure funds to enable staff attendance. A policy should be established so that these travel funds are dispersed fairly.

The library's personnel system is the responsibility of the parent body. Thus, overseeing fringe benefits, insurance and retirement programs, and establishing vacation practices will be the responsibility of the personnel officer of the institution. A variety of federal and state laws affect personnel management in libraries. These include laws about discrimination, collective bargaining, right to strike, minimum wages, equal pay, worker's compensation, social security, and occupational health and safety.

Performance Evaluation

One of the supervisor's major tasks is to appraise performance. People want to know not only what is expected of them but where they fit into the overall enterprise. Attempts to measure performance can be both objective and subjective. Appraisal can be made against verifiable objectives, such as the number of books cataloged per week. But many library operations, such as cataloging and reference service, seem to resist measurement. Some traits—such as competency in analyzing and synthesizing, judgment, and initiative—will have to be assessed subjectively. Employees should be informed if these kinds of attributes are to be part of a performance appraisal. It is also important to have a plan for any corrective action that may be required.

In order to have ample time to evaluate new employees and to prevent arbitrary and unfair dismissals, libraries establish a probation period, generally of six months. During that time employees should be given frequent periodic performance reviews in writing, prepared by the immediate supervisors and supplemented by personal conferences.

Performance reports may also be used to determine an employee's potential for promotion.[7] In the case of unsatisfactory performance, it is essential to have a continuing written record of the employee's shortcomings. If not thoroughly informed concerning the guidelines set by the institution to conform with federal and state statutes, library administrators need to consult the manager of the Personnel Department. Because the legal ramifications make it difficult to dismiss or take disciplinary action against someone, librarians should be alert to the procedures now required.

Performance evaluation should provide the employee with a sound basis for professional growth. Particularly to be avoided is anything which would generate anxiety and tension. On an on-going basis, the supervisor should comment, both formally and informally, on the employee's performance. Evaluations offer an opportunity to discuss long-term problems and goals. Constant informal evaluations, and occasional written comments can significantly reduce staff stress. Although there is a natural tendency to avoid any unpleasantness and to let problems slide, supervisors should discuss performance problems as they occur. All such discussion should be carefully documented for future reference and follow-up. If this is done, employees will know that something is wrong. Criticism should be private; for instance, it is counterproductive to reprimand a reference librarian in front of a patron because the librarian has incompletely answered a reference question. Assistance should be offered diplomatically, and the situation discussed in a private office.

Communication Skills

Supervisors should be leaders, acting as the liaison between the art library employees and the administration of the parent institution. The process by which leading is primarily accomplished is through effective communication. Although in a large library a great formality may exist, most art libraries are small in terms of staff and tend to be close-knit groups. But the natural— and it is to be hoped—friendly informality should not be allowed to interfere with effective work relationships.[8]

It is helpful to know what motivates people and to be aware of the different ways in which people perceive themselves and others. Because all too often people see only what they want to see, supervisors must anticipate the results of this sort of selective perception. In dealing with people, flexibility is important. No effective administrator depends upon rules, formulas, or one single system for handling every person and problem. Each individual case should be approached as though it were unique.

Many library problems can be related directly to communication failures. Basically, supervisors need to: (1) define who needs to know what and why; (2) collect information before an event, rather than during or after the fact;

(3) encourage all levels of staff to communicate without intimidation; (4) provide a clear picture of each staff member's place in the organizational structure and in the chain of command; and (5) ensure that administrators are visible.[9] Bi-weekly or monthly staff meetings provide an effective vehicle for improving communication among staff members.

Administrators must decide when to write and when to give oral directions or information. Policies, procedures, and routing instructions should all be written, but will be more effective if accompanied by oral explanations. Orally transmitted decisions should be followed by a written confirmation. In addition, there are times when it is important to leave a written record of events for later reference. This is especially important for personnel evaluations. Generally people respond to requests more favorably than to demands, although certain people may require the latter. Unclear orders will produce poor staff effort because the staff will be uncertain of their assignments. Nothing will destroy credibility more quickly than to issue orders that are unreasonable.

The librarian should remember that successful oral communication is a two-way process. Even in giving a simple straightforward order, it should be geared to the level of understanding of the person to whom it is addressed. A discussion should be focused, but absolute commitment to an idea or position should be avoided. Other people's ideas should be heard and not rejected without due consideration. Proper credit should be given if someone else's ideas are adopted. Employees should be encouraged to contribute ideas and to ask questions, but library managers must not abdicate their decision-making and supervisory roles. Tact is probably the most essential element in maintaining clear, open, and honest communication with the staff. Recognition—a basic human need—of employees' efforts is one of the most effective ways to ensure good performance.[10]

Participative management, the ultimate in recognition of employees' ideas, has become a popular concept for librarians.[11] Its success depends primarily upon the establishment and maintenance of formal channels of communication by means of committees. In this situation, the entire staff—professionals, para-professionals, clerical staff, part-time and full-time employees—all participate in the management of the library. Meeting in the requisite small groups can take an inordinate amount of time, and as a result, service to the public may suffer. A more realistic solution is consultative management, whereby the staff participates in the decision-making process—particularly as it affects their work—but with the ultimate decision being reserved to the person with the authority and accountability for the tasks involved.

There are certain other areas in which the supervisor must remember to make an effort to communicate with the members of the staff. On a regular

basis, managers should read not only library literature—such as, *Journal of Academic Librarianship* and *Journal of Library Administration*—but also business-oriented publications—such as *The Harvard Business Review*. Relevant articles should be routed to the professional staff on a regular basis.

Volunteers in the Library

Museum librarians have been more concerned about the use of volunteers than have academic, public, or other special librarians. Perhaps because many museums have volunteer-docent programs, working in the library has seemed a natural extension. Many professionals believe that if there are tasks to be accomplished, these duties should be entrusted to professionally trained and correspondingly compensated employees. The use of volunteers, in their eyes, diminishes the value of the paid employee—professional or clerical.[12] Nevertheless, other art librarians believe that volunteers can provide many valuable services in doing things that simply might not get done otherwise. Among these librarians, there is general agreement that on-going duties and responsibilities should be undertaken by the paid staff, but that a number of useful, special projects can be assigned to volunteers.[13]

In the event that the librarian decides to employ volunteers, there are some general guidelines that should be followed. As with paid staff, a business-like atmosphere should be established by using application forms and interviews. A trial probationary period and a regular schedule should be set. Volunteers should be supervised and mistakes corrected as sensitively as possible.

Because library school students may also wish to volunteer to gain experience, various arrangements can be made with them. Librarians seem to prefer contractual agreements with library schools, whereby academic credit is given for work. A modest salary, which may be shared with the university, is sometimes paid. Of course, then the student is no longer a volunteer. These formal arrangements put a burden on the staff who are then obligated to ensure that the student receives a meaningful, structured learning experience and is not simply relegated to file, shelve, or check in periodicals. Usually enthusiastic and diligent workers, students frequently state that their internships or field-work experiences have been among the most important parts of their library education.

THE LIBRARY FACILITY

Because it is easy to become accustomed to what already exists, administrators should try to look at the library facility from a fresh viewpoint. Although some art librarians have had the opportunity to plan a new building